FORCES *of* CHANGE

Published by the National Geographic Society
1145 17th Street N.W., Washington, D.C. 20036

First Printing, April 2000

Library of Congress Cataloging-in-Publication Data

Forces of change : a new view of nature / Daniel Botkin ... [et al.].
 p. cm.
 Includes bibliographical references (p.).
 ISBN 0-7922-7596-9
 1. Natural history. 2. Earth. 3. Human Ecology. 4. Global enviromental change. I.
 Botkin, Daniel B.

QH45.2 .F67 2000
508--dc21

 99-087996
 CIP

Printed in U.S.A.

FORCES of CHANGE

A New View of Nature

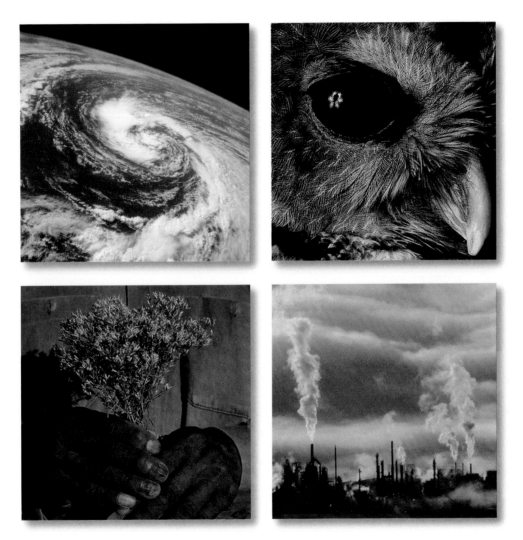

Smithsonian
National Museum of Natural History

IN ASSOCIATION WITH

NATIONAL
GEOGRAPHIC

WASHINGTON, D.C.

Contents

Observe constantly that all things take place by change, and accustom thyself to consider that the nature of the Universe loves nothing so much as to change the things which are and to make new things like them.

—MARCUS AURELIUS

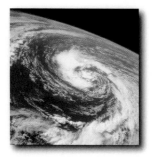

A South Atlantic sunset, seen from a space shuttle, illuminates smoke from South African fires.

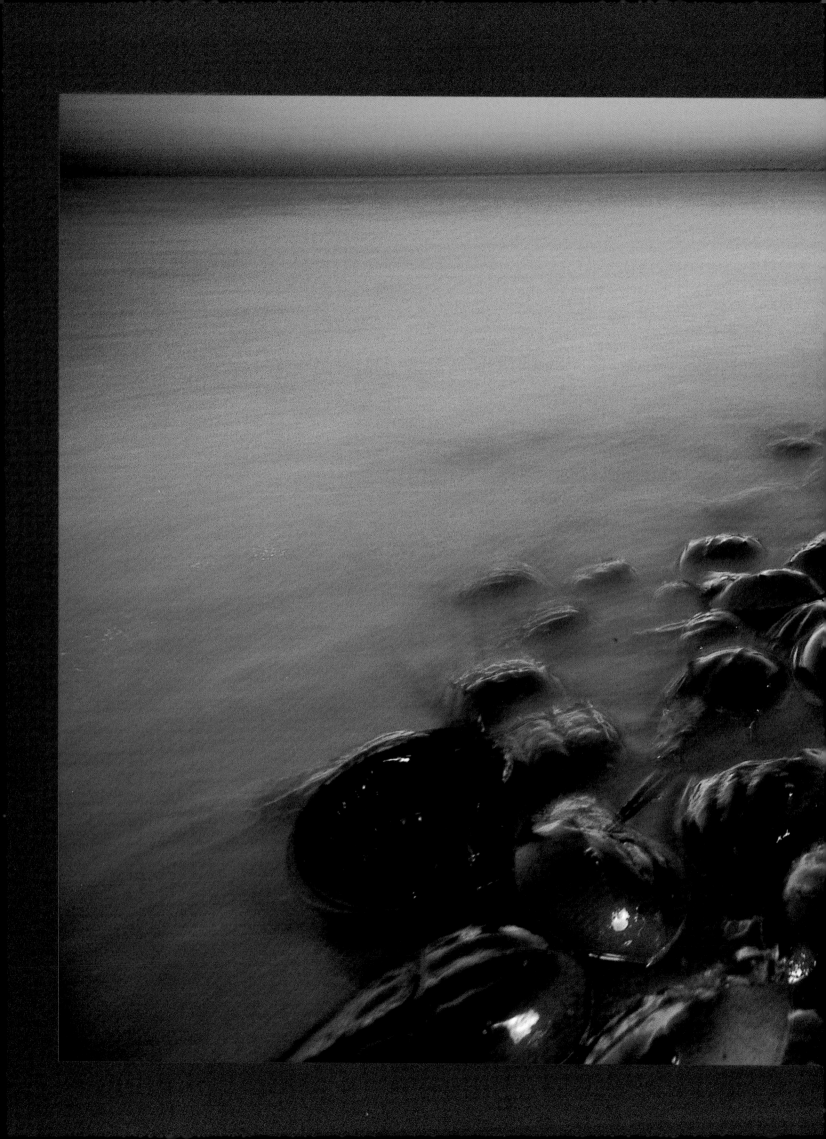

Among Earth's most ancient creatures, horseshoe crabs gather on a beach in Delaware in their continuing cycle of reproduction.

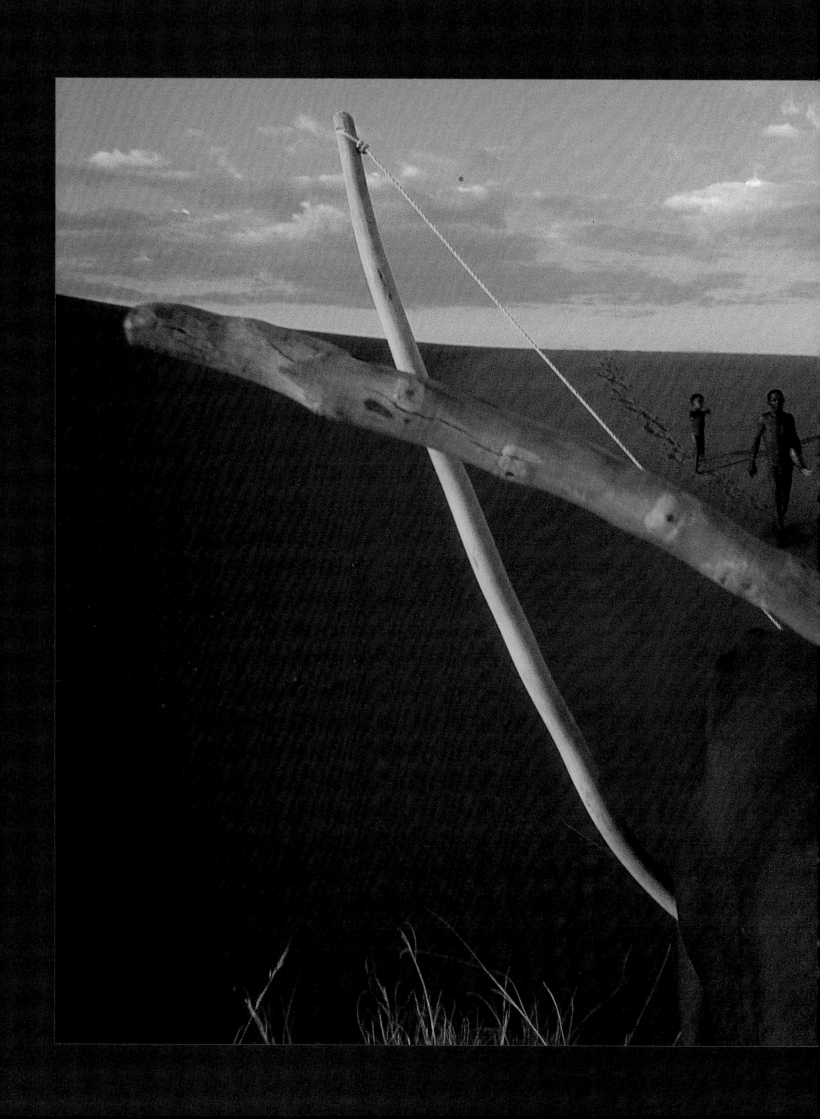

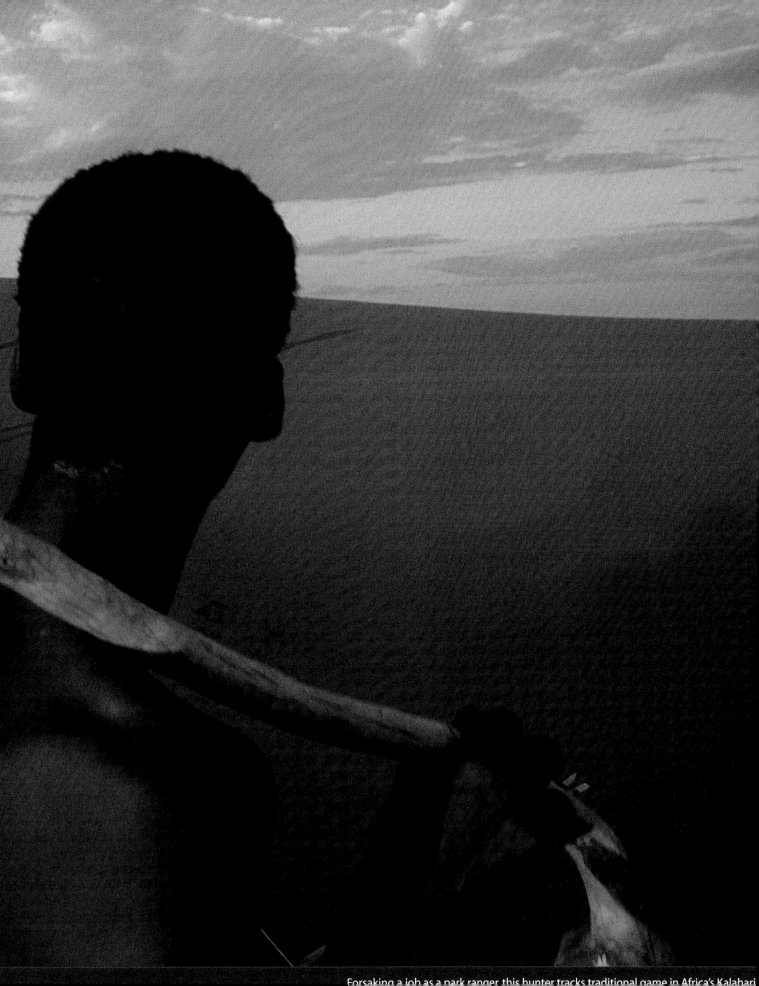

Forsaking a job as a park ranger, this hunter tracks traditional game in Africa's Kalahari

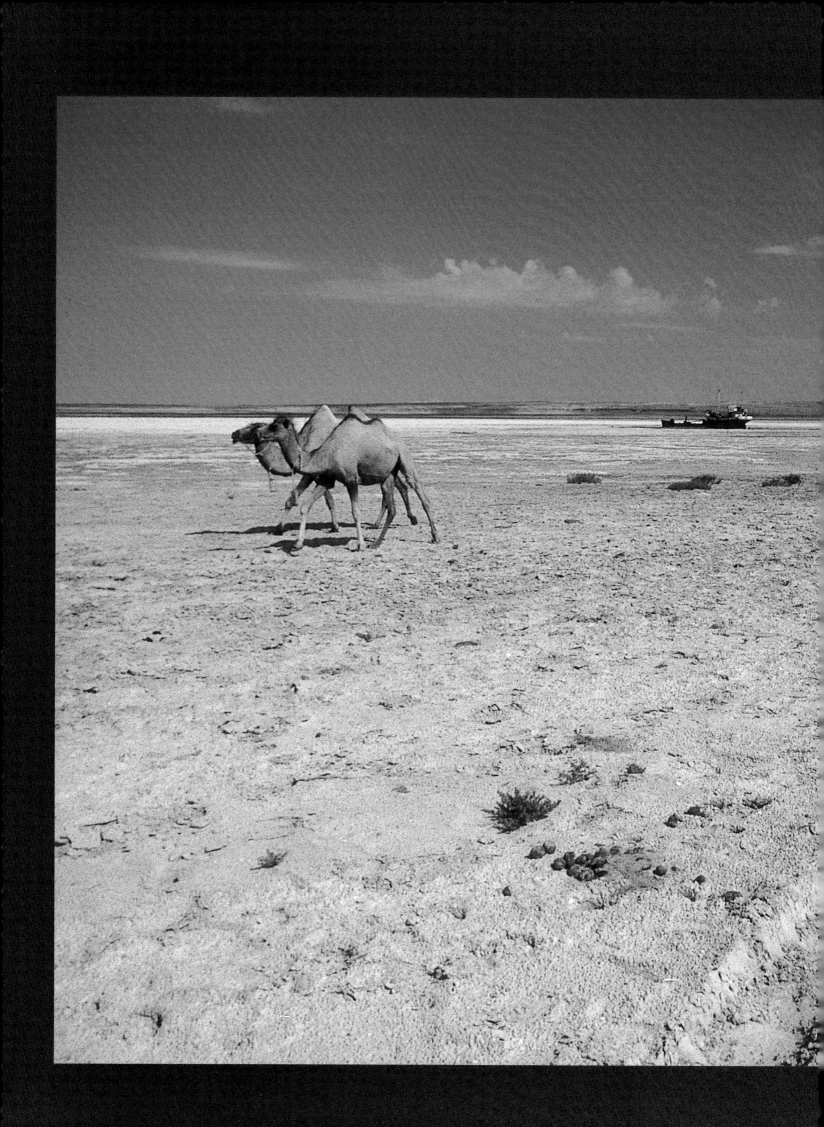

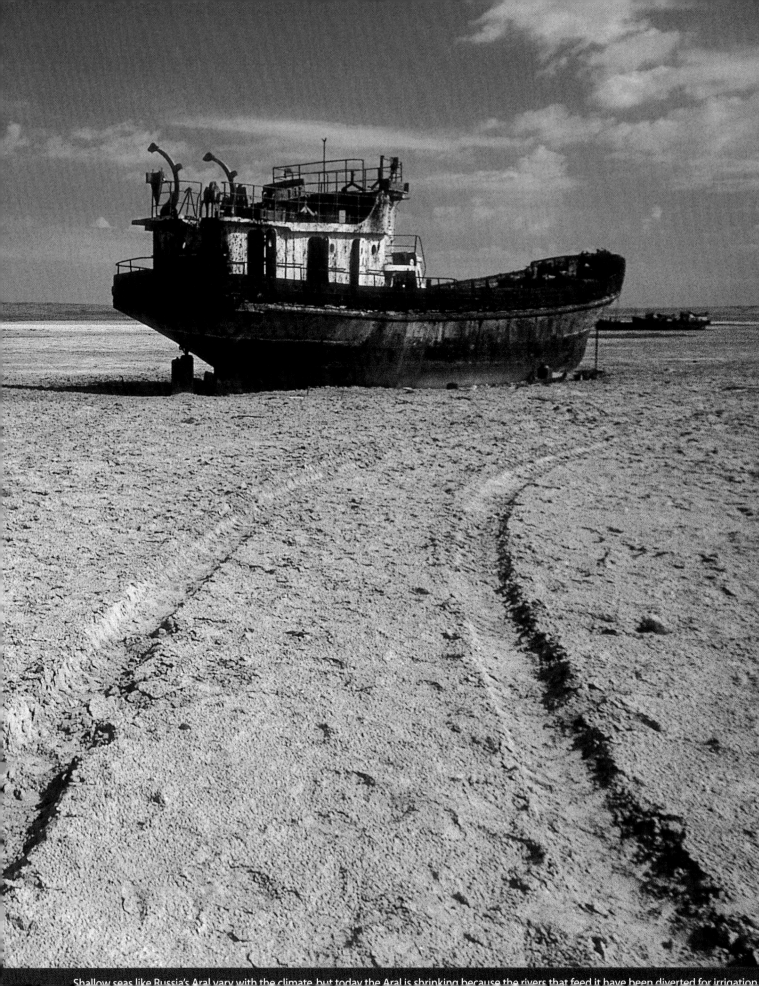

Shallow seas like Russia's Aral vary with the climate, but today the Aral is shrinking because the rivers that feed it have been diverted for irrigation.

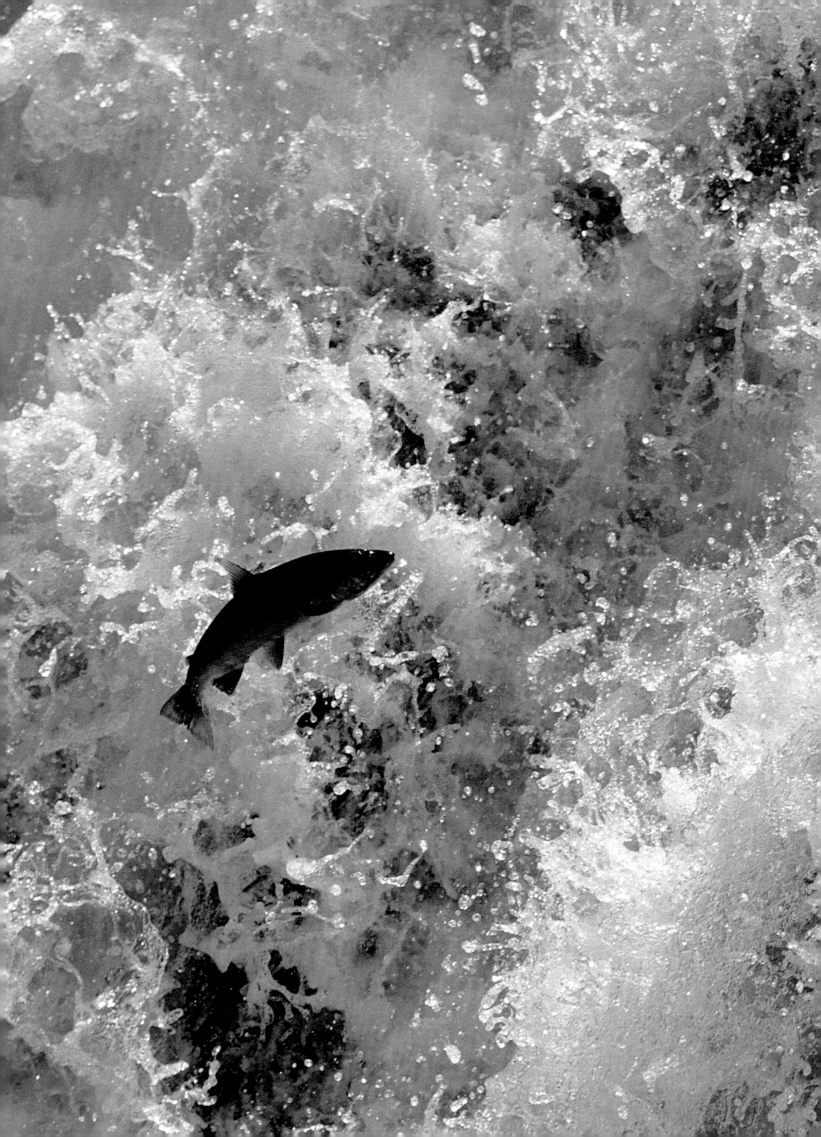

Daniel B. Botkin

The Nature of Change

In the past decade it has become fashionable to speak of change as natural, and to discuss life from a planetary perspective. New scientific methods and instruments allow us to track changes in the environment—past and present—with ever greater precision; advances in satellite imagery and other technologies allow us to watch global phenomena such as El Niño unfold in real time. We would seem to be well on our way to accepting a new view of nature, one that accommodates its complexity, dynamism, and unpredictability. But changing one's outlook on something as fundamental as nature isn't easy. Older, more comforting beliefs maintain a strong hold on us. Down deep, we still wish for nature's benevolent constancy.

As we enter the new millennium, the headlines present us with stories of impending climate change, ecological crises, and wrenching social changes, making it more important than ever that we come to terms with the idea that change is the rule, not the exception, for life on the Earth. In seeking to conserve and manage our living resources, we must learn how to work within these forces of change. We must learn to replace our idea of static beauty and perfection in biological nature with a new appreciation of the dynamics and processes in ecological systems.

Throughout the history of western civilization, for several thousand years, people have generally believed that there existed a great balance of nature, that nature, left alone, would inevitably achieve a permanent form and a constant structure. "Who cannot wonder at the harmony of things, at this symphony of nature which seems to will the well-being of the world?" wrote the Roman orator and statesman Cicero in the first century B.C. Nature was a still life, perfect and beautiful in its constancy—like the beautiful landscape paintings of the 19th-century Hudson River School, Bierstadt's "Sunset in the Yosemite Valley" and Church's "Morning in the Tropics." According to this myth, if nature's balance is disturbed, it recovers, attaining once again its original, pristine state. This permanent, fixed

Overcoming natural and man-made changes, salmon return to their annual spawning grounds.

condition was believed best for all life, including human beings. There was a divinely ordained place and purpose for every creature, and every creature was in its place—a great, harmonious chain of being.

The balance of nature provided an explanation about how nature worked. But how did nature come about, and if nature was supposed to be perfect, why was it often not that way? A person explains how an unknown thing works based on what he already knows. Before the time of complex machines, what people knew best were living things: their own bodies and the bodies of animals and plants. An ancient answer to how nature worked and why nature was not perfect lay with this explanation, known as the organic myth of nature. In this view, nature is alive, either in fact or metaphorically, operating like a living creature. The imperfections in nature were therefore easily explained: Mother Nature was growing old and less fertile. Mountains were wrinkles on her skin, proof that she was aging.

With the rise of science and modern technology in the 17th and 18th centuries, and the blossoming of science in the 19th and 20th, the organic myth gave way to a new explanation. People now had complex machines as a basis for explanation. The Earth became the great machine created by the omnipotent and omniscient engineer. A new kind of perfection was seen in motion and dynamics, in the beautiful formulation of Newton's laws of motion, in the elegant elliptical paths of the planets through the cosmos.

The new, machine-based view had several important effects on our attitudes toward nature. A machine-nature has a maximum power output and can be run at steady-state. It can be invented and reinvented, engineered and reengineered. Like any 19th century machine—a waterwheel or clockworks—it could supposedly be explained with a few variables. Machine-nature reinforced belief in the balance of nature. According to both, nature could be maintained in a fixed condition and a variation from this fixed condition was undesirable.

The science of ecology flowered in the 20th century as a child of the machine age, its models, metaphors, and mathematical approaches inherited from engineering and the physical sciences. For natural resources that we wanted to extract and use, the machine myth led to the idea that ecosystems can supply a fixed and predictable level of output, known as the maximum sustainable yield, that we can consistently exploit without fear of depleting the resource. This concept continues to dominate management and conservation practices in applied fields such as fisheries, wildlife, and forest management.

For many years I have followed the way that professional fisheries biologists have recommended managing the world's great fisheries. This management has been a great curiosity, because it has been purposeful, well-meaning, but generally a failure, producing crashes in populations of the fish under management—the decimation of the California sardine industry (immortalized in Steinbeck's *Cannery Row*) in the 1950s, the disastrous crash of the Peruvian anchovy fishery in the 1970s, and the steep decline of Atlantic

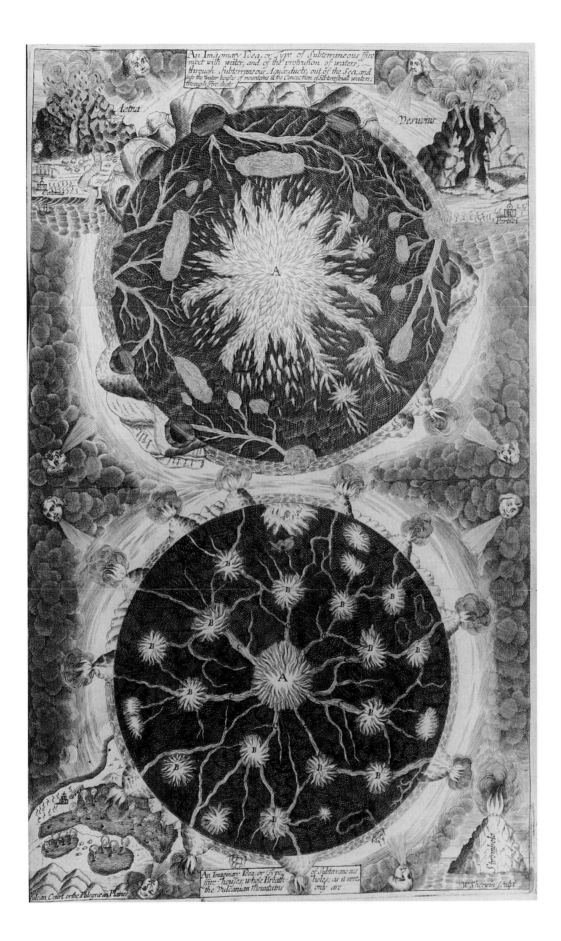

OLD VIEWS OF NATURE

Seventeenth-century Jesuit scholar Kirtcher visualized the interior of a volcano much as a living organism, with channels of lava serving as its life blood. Such biological metaphors of the Earth, though later supplanted by mechanical metaphors, continue to shape many of our attitudes toward nature.

menhaden, cod, and other commercially important species on the Grand Banks off Newfoundland in the last quarter of the 20th century are spectacular examples. What happened? Operating under the idea of the balance of nature, fisheries managers assumed the environment was constant, and based harvest levels on normal years. But in an inherently variable system such as the ocean, what, if anything, is normal? Such a faulty understanding of how nature works inevitably led to overfishing during years of poor upwellings and other natural fluctuations, resulting in eventual failure of the fisheries.

Although professional ecologists and environmental scientists generally agree that some kinds of changes are natural, the balance of nature idea is alive and well, and infiltrates proposals for conservation as well as management. Environmental planners are often urged to seek a static biological landscape, one assumed to have existed thousands of years ago, before the first humans arrived in North America. It is a landscape in which people are interlopers upsetting the balance of nature, destroying what a recent article in the journal *Conservation Biology* called the "purely natural condition that might serve as an absolute benchmark for planners."

But if nature is always changing, what is natural? If we wish to return a landscape to its natural condition, which of its many conditions should we choose? For much of North America the condition that persisted for the longest time during the last 30,000 years was a continental ice sheet. Is that what we should choose? Obviously not. Instead, we should realize that for any area there is no single pristine state of nature, as assumed in the balance of nature idea, but rather a set of nature's designs, each of which may have persisted for a thousand years or more and each of which could be considered natural. And within each of these general conditions, short-term changes—fires and storms, for example—are natural as well. We have a choice of what is natural, so long as we allow natural changes to occur.

If the balance of nature idea is so unrealistic, contradicted by so many observations, why does it remain so appealing to many of us? It persists, in part, because of its strong ties with western religious tradition: a benevolent, perfect, and all-powerful God could only make a perfect world. Seen in this way, to deny nature's perfection is to deny the perfection of God. And aside from the religious connection, the balance of nature idea is also a comforting image of nature. We like to believe that the forests and streams we visited as children will remain the same, with the same fishing holes, abundant wildlife, and familiar trees. A salmon fishermen would like every year to be one of great, unvarying abundance; the old concept of a maximum sustainable yield would suit him just fine if it were possible. People have to make a living, and want some reliability; a harvest that varies greatly from year to year is not desirable.

The balance of nature idea also persists because of what I call the Pandora's Box

Dilemma: If we accept one kind of change as natural, doesn't this open the door to others, bad as well as good? Must we accept them all? But once we understand that nature changes, we can examine the kinds, rates, and amounts of change that are natural. These natural changes can give us a basis for distinguishing the acceptable from the unacceptable. In the history of life on Earth there are kinds of changes that have existed for a long enough time, and been frequent enough, so that species have been able to evolve and adapt to them. If we introduce a change that is natural in kind, rate, and amount, then it is likely to be benign. If we introduce a change that is novel in kind, rate, or amount, then we need to be concerned, because species have not had an opportunity to evolve and adapt to it. Its effects are likely to be undesirable. For example, there is nothing in nature like a plow, and we should be careful in our use of plowing, even though this is, from a human perspective, an ancient technology. Chemicals that never existed before human invention, but which our modern technology releases into the environment, must be treated with great care. But, unfortunately, this goes against still another reason that many of us cling to the balance of nature idea: it provides an easy solution to the problems of management and conservation, one that requires no knowledge. If nature unerringly maintains itself in a state of perfect balance, then the solution to all environmental problems would be to leave nature alone. Nature would know best. It would always return itself to that single state that was best for itself and for us.

It is clear what we must do, but it will be hard to do it. We have to accept the naturalness and inevitability of change. But we must also understand the patterns of natural change. We must understand the natural set of states and how rapidly they change. This requires regular and sound scientific observations and measurements on all scales of space and time, from the fall of a tree in a forest to global changes over millennia. But to support such research and maintain such records will require an unprecedented degree of commitment and cooperation from all sectors of society.

The transition that we are going through today for biological nature is analogous to what the 17th and 18th century transition was for the cosmos. Just as new observations of the motion of the planets showed that changes for planets were natural, but followed explicit and understandable as well as beautiful rules, so today we are struggling to accept new conceptions of change in biological nature. The transition is more difficult because biological nature is made up of complex systems we barely understand, and for which we lack yet a set of formal, mathematical rules comparable to Newton's laws of motion. Indeed, the complexity of ecological systems may never allow such elegance and simplicity. But perhaps as we learn to accept their complexity and their dynamism, we can see in them a new kind of order, a new source of beauty and inspiration. The powerful images and insights in this book can help us through this transition, and open our minds to a new, dynamic view of nature.

Introduction

Alan Cutler

New Frontiers, New Explorations

Three and a half centuries after Columbus crossed the Atlantic and made his historic landfall in the West Indies, six small wooden ships departed from Hampton Roads, Virginia, on a voyage around the world. Officially called the United States South Seas Exploring Expedition, and led by Lieutenant Charles Wilkes, it was the young republic's first venture overseas with the explicit purpose of scientific discovery. When the ships set sail in August of 1838, on board was a youthful band of naturalists, scientists, ethnographers, artists, and cartographers.

During the four-year voyage, the scientific team collected thousands of natural history specimens—birds, mammals, corals, mollusks, plants, minerals, rocks, and fossils—many of them new to science. They painted portraits of Polynesian royalty and amassed cultural objects by the crate. They compiled data on the winds and currents of the Pacific Ocean and produced hundreds of charts and maps. But the single most momentous event came two years into the voyage. Three of the ships were probing the cold, uncharted waters far to the south of Australia, when lookouts spied on the southern horizon the blue peaks of mountains looming above the ice. Others sailing in the far south had made landfalls on islands and desolate points of land, but Wilkes and his companions were the first to surmise that what they had found was a vast, unexplored continent. They proceeded to map more than 1,400 miles of coastline.

The continent was Antarctica, the last of the world's great landmasses to become known to man. After thousands of years of dispersal and migration around the globe, crossing continents, hopping from island to island, our wandering species had at last, almost literally, reached the end of the Earth. Human populations had long before found their way to the remotest Pacific islands. They had carved niches for themselves in the rain forests of Amazonia and the severe environments of Tibet, the Sahara, and the high Arctic. And during this time the Antarctic continent had remained unknown and untouched.

Salt crystals from a meteorite reveal water—an essential ingredient of life.

Today, when there is more information available about Antarctica than any one person could ever hope to absorb, and when, for a price, one can visit Antarctica, it is difficult to imagine the thoughts and emotions of these 19th-century voyagers as they skirted the fringe of a newfound continent. And given the rigors of handling a sailing ship in the rough polar seas, perhaps few of them stopped to ponder the broader implications of their discovery. Certainly none would have perceived the fragility of the Antarctic environment or been able to foresee how quickly commercial seal and whale hunting would deplete its abundant marine mammal populations, driving some species nearly to extinction before the century's end.

But the start of a new millennium provides an opportunity to consider how new ideas, new discoveries, and the accelerating pace of change fit into the larger patterns of nature and human history. Looking ahead to the new century, preparing for its challenges and uncertainties, is perhaps a little like glimpsing a new continent on the horizon—the vista is expansive and exciting, but more than a little overwhelming, too.

"Forces of Change," a program of exhibits, public events, and publications developed by the Smithsonian's National Museum of Natural History, is intended to provide a forum where scientists, scholars, writers, and the public can explore a broad range of scientific and social questions, relating to change, both natural and human-induced. The growing public awareness of potential climate shifts, diminishing biodiversity, and other environmental and social issues is enough to make change a timely and provocative theme. But the complexity of the issues that confront us and of the underlying forces of change leads inevitably to more basic questions—questions regarding our relationship with nature and our complicated, often ambivalent, attitudes toward change.

Answers that have emerged so far often come from unexpected places. The frozen, austere continent encountered by the Wilkes Expedition has become the focus of intense scientific research, a unique natural laboratory of global change. In its ice is a record of the world's climate, written in layers of dust, gas bubbles, and chemical variations, that extends back tens of thousands of years. Its sediments and rock strata constitute an archive of evolution, extinction, and geological change spanning hundreds of millions of years. Answers to questions about the history (and future) of the world's oceans, the evolution of Australia's strange animals, and the global cataclysm that wiped out the dinosaurs may be found on the Antarctic continent and beneath its surrounding seas. And despite the continent's isolation, reports of DDT in the flesh of Antarctic penguins, the waxing and waning of ozone holes, and scenarios of global warming and ice sheet collapse attest to its continuing intimate link with the affairs of the rest of the planet—and its surprising vulnerability to human disturbance.

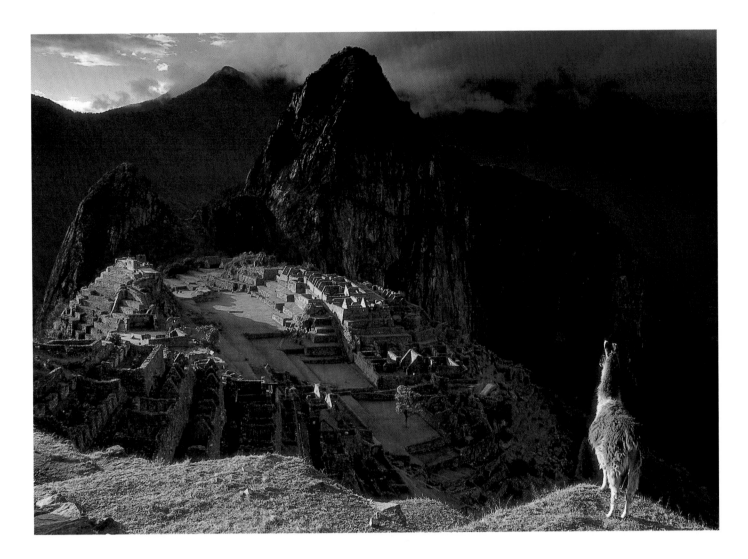

ABANDONED HOME

City in the clouds of the Andes, Machu Picchu is a spectacular example of a population center that thrived for a time—then fell into utter disuse. Natural changes or cultural evolution can transfer a metropolis into a mausoleum within the span of just a few generations.

The Earth is a vast, dynamic, complex, and highly interconnected system. For convenience, and by habit, we sort the many different aspects of this system into scientific categories—geology, chemistry, meteorology, biology, anthropology, and economics. The Earth's natural systems and subsystems, however, have no respect for such intellectual boundaries—its processes and elements form an interactive whole. The minerals in a soil, the acidic rainwater soaking into the ground, the roots of a plant, and a gardener's metal spade all converge in a flower bed to yield, under certain conditions, prize-winning zinnias. The soil alone is far too complex a mixture of humus, clay minerals, water, and dissolved ions for the categories "biological," "geological," and "chemical" to be of much use. And are the cultivated flowers—the combined product of years of selective breeding and millions of years of natural selection—artificial or natural?

The connections of a suburban garden system extend far beyond the edge of its tilled soil. The sand, silt, and clay of the soil might have been brought to this spot by an ancient river or glacier, with perhaps an admixture of dust carried here by the wind from a desert on another continent. To counteract the soil's acidity the gardener may add particles of limestone, derived from the residue of fossil algae or an ancient reef, that was quarried, pulverized, packaged, and then trucked across the country.

At the sunny edge of this garden, there is a shrub with shiny leaves and pink blossoms. The shrub, a rosy periwinkle, is native to the dry forests of Madagascar, island of lemurs and other evolutionary exotica. The gardener's niece, recently diagnosed with leukemia, is being treated with vincristine, a medication derived from an extract of rosy periwinkle plants. And although the higher levels of carbon dioxide put into the air by the burning of fossil fuels haven't helped the garden plants to grow noticeably faster, the spate of unusually severe summer droughts has certainly made it hard to raise a decent vegetable crop the past few seasons. When the gardener reads in her newspaper's science section that unusual weather during recent austral summers has made it tough for penguins on the Antarctic Peninsula to raise their chicks, she may or may not make a connection with the wilted tomatoes in last summer's garden.

The complexity, unpredictability, and inherent dynamism of nature in all its manifestations run counter to the expectations and desires of many people. In 1990 Daniel Botkin published a provocative and influential book in which he explored our often idealistic perceptions of nature and our misguided desire for constancy and harmonious balance in nature. These misperceptions, arising from religious, cultural, and psychological roots, hamper our ability to understand natural systems. And unless these outmoded beliefs are discarded, Botkin argued, they will continue to thwart our best efforts to deal effectively with today's environmental challenges and those we confront in the new millennium. A gardener trying to control

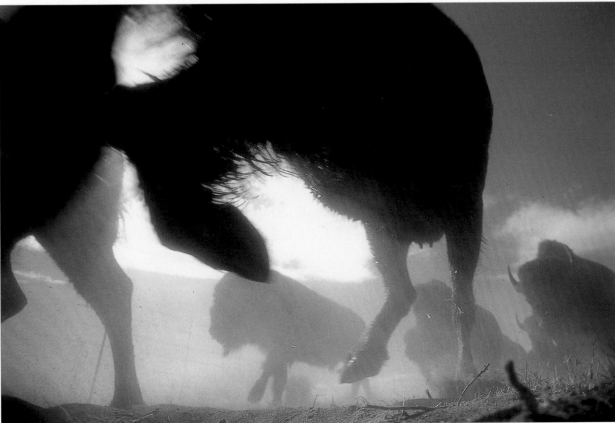

NATURE'S CHANGING FACE

Humans may see a wilderness such as Minnesota's Boundary Waters region (top) as a pristine example of nature in balance—but not long ago glaciers scoured this landscape. Similarly, billions of bison hooves (bottom) and the animals' grazing habits helped shape America's prairies.

aphids with pesticides and a scientist trying to predict the future stability of the West Antarctic ice sheet with a computer simulation are in comparable predicaments—there are just too many variables and unknowns to know for sure what nature will do next.

Botkin pointed out several aspects of natural systems that are particularly difficult for people to accept and that are often ignored or inadequately considered in scientific investigations and by environmental policies.

The first is the prevalence and universality of change. As Dorion Sagan and Eric Schneider observe, change is a fundamental property of life. All living things depend on a constant flow of energy and exchange of matter in order to survive. Adaptation and change are the primary business of life. And the physical Earth, as geologists have come to learn in the 20th century, and as John McPhee and William Melson describe, is equally dynamic, though on a far longer time scale. Over the billions of years that our planet has been in existence, huge plates of its crust have shifted and jostled one another, mountain ranges have risen and fallen like breaking waves, and the world's climate has fluctuated between greenhouse and icehouse conditions. In parts of the world most recently covered by continental ice sheets, such as Canada and areas of Northern Europe, ecosystems are still recovering from the glacial conditions and the crust, formerly weighed down by miles of ice, is still rebounding to its former elevation. Every place has a history; for no region or location in the world can it be said that there is a single, pristine, natural state, or a stable, unvarying, normal climate. Climatologists such as Jonathan Overpeck are finding that through the millennia large areas of the globe have been abruptly jolted by rapid changes in climate—climate surprises—and there is no reason not to expect more of these in the future.

Many of us have difficulty accepting such uncertainty or believing that chance can play such an important role in nature. This attitude has roots in religious doctrine, what Botkin refers to as the divine order of nature, but is also an outgrowth of the methods and assumptions of classical physics, epitomized by Isaac Newton's deterministic "clockwork" universe, in which the natural world worked in perfect synchrony like the inner workings of a pendulum clock. Scientists have come a long way since Newton's time—chance and probability are key aspects of Darwin's theory of natural selection, the laws of thermodynamics, quantum theory in physics, and other modern theories—but the influence of Newton and his mechanistic assumptions remains strong. To scientists, engineers, policy makers, and taxpayers, uncertainty and frankly probabilistic answers to questions can appear unscientific and evasive, yet predicting earthquakes, disease and pest outbreaks, and hurricanes is complicated by uncertainties inherent to the natural forces that make these events happen.

Related to our discomfort with chance and the unpredictability of changes is the assumption that they are somehow unnatural or inevitably destructive. Stephen Jay Gould

has spent the better part of his career championing the idea that quirky, punctuational change is at least as much the norm in nature as is gradual, linear change: Organisms can evolve and form new species in sudden, unpredictable bursts of change after eons of stability. Likewise, species can become extinct as a result of a random, catastrophic event, such as an asteroid impact, regardless of the Darwinian fitness it enjoyed during better times. Ecologists are now also recognizing the value of "disturbance"—fires, storms, and floods—in maintaining the health and biodiversity of some ecosystems. Many species can survive only in periodically disturbed habitats. Cones of jack pines will release their seeds only after being scorched by a forest fire. Prairie grasses depend on lightning strikes to ignite fires and on grazing by herds of bison to stimulate their growth and keep other plant species from invading their habitat.

These ideas of constant change, complexity, and unpredictability are difficult enough to comprehend when applied to rocks, soils, rivers, plants, animals, and the myriad other facets of nature. But adding people to the equation creates new levels of complexity—and vastly raises the stakes. Human beings have a long history of directly or indirectly nudging species over the brink, and David Quammen describes the swath our species has cut through the world's biodiversity as human populations spread to the far corners of the planet. The process has not stopped, and we may learn its costs too late to slow it.

Whatever successes we may have in reconciling our conceptions of nature with change and instability, the fact remains that people will still want to feed themselves on a regular basis, and will want to keep themselves, their loved ones, and their property out of harm's way. Fires, floods, and volcanoes all demonstrably contribute to sustaining the Earth and its ecosystems. But they also tend to conflict with the material interests of humans.

This is why it is especially important that discussions about how we should relate to nature in the future be opened up to as wide a range of voices as possible. George Horse Capture and Helena Norberg-Hodge write of two cultures, one in Montana and the other in the northern extreme of India, that made their peace with nature centuries ago, only to have it disrupted by outside forces. During the 1980s mining interests and the global demand for gold reached into Montana and onto the land of the A'aninin people, and, with their machinery and explosives, took away something sacred—an entire mountain. High in the Indian sector of the Tibetan Plateau the mountains all remain in place, but beginning in the 1970s the Ladakhi people have had to struggle to preserve their cultural traditions and environmentally benign lifestyle against a rising tide of consumer culture and western-style development schemes. Edward Ayensu, writing of Africa, warns of something different. By ignoring or suppressing the indigenous knowledge and inventiveness of people in so-called developing countries, the world misses opportunities to harness skills for solving global problems, particularly in the areas of biodiversity

and herbal medicine. Bringing in appropriate technology—better telecommunications systems, for instance—can stimulate this process without displacing traditional lifestyles.

To accommodate realities of nature and the needs and rights of diverse cultures around the world, we need to restructure political and economic decisions, making processes to accommodate nature's complex systems. Gretchen Daily suggests that to begin we need to identify the connections between natural ecosystems and our economic and political systems—especially those that provide economic or social benefits, or "ecosystems services." Insects pollinate crops for free, forests purify water, and the entire biosphere maintains a gigantic genetic library holding the codes for potential medicines, crops, fuels, and other valuable products. Nature, in its unobtrusive way, has been bankrolling human societies for millennia; it is time we included its contributions in our economic calculations and decision-making. And, if we are coming to understand that human beings have a place in nature, we must also grant that nature has an honored place in our society.

The Wilkes Expedition is remembered today as a seminal event in the development of American science. On returning home after four years of intensive scientific research, specimen collecting, and mapmaking, expedition members were greeted not by acclaim but by controversy and confusion. Their claims of sighting a new continent were not believed. Recriminations among the officers regarding disciplinary practices during the voyage led to a court-martial and public reprimand of Wilkes. Despite the clear scientific value of the expedition's extensive biological, geological, and ethnographic specimens, no branch or institution in the government had the resources to properly curate them. Instead, members of Congress and other influential figures raided the collections for souvenirs.

Thanks to the single-minded determination of Wilkes and his colleagues, the bulk of the expedition's collections and data remained intact. In 1857 the collections were turned over to the fledgling Smithsonian Institution to establish a National Museum of the United States. The collections formed the nucleus of what is now the National Museum of Natural History, where scientists, scholars, artists, and other specialists, working in the tradition of the Wilkes Expedition, continue to expand the frontiers of our understanding of nature. The frontiers are less well-defined than they were 160 years ago, and they extend far beyond our planet into outer space, back in time to the origins of the universe and life, and to scales of size much larger and smaller than a person can genuinely comprehend.

To explore these new frontiers, we use tools that were not available to 19th-century explorers—spacecraft, electron microscopes, gene-sequencers, computers—and bring with us ideas and perspectives that reflect the intervening century and a half of cultural change. But the basic challenge is the same: to respect and to understand as best we can the complex, shifting web of processes and interdependencies that we call nature.

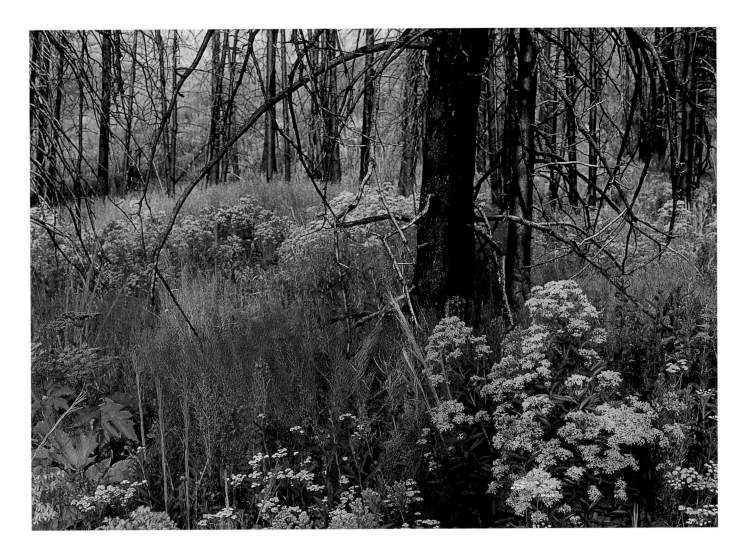

FROM ASHES, NEW LIFE
Forest fires torched vast tracts of Yellowstone National Park to blackened cinder, yet just a decade later lush growth carpeted the former forest floor. The cycle of destruction and regeneration replays throughout nature, from lava-carved volcano slopes to spreading river floodplains.

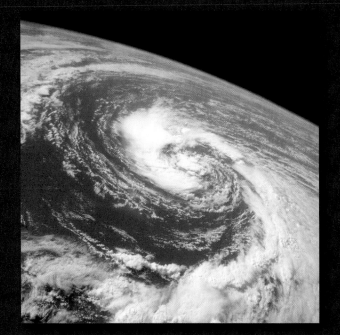

Forces of Nature

Images from space show the Earth as a serene blue orb, with only the

white swirls of clouds hinting at its dynamism. Understanding the Earth

begins with understanding its physical systems, the natural forces that

have made it hospitable to life and continue to shape its evolution. As

each of these essays suggests, this is no easy task. Our planet

operates on scales much grander than the human brain is equipped to

comprehend. The constant motion of the atmosphere and oceans

is driven by the sun's energy, and the slow, but occasionally violent,

movement of the crust by the Earth's own heat.

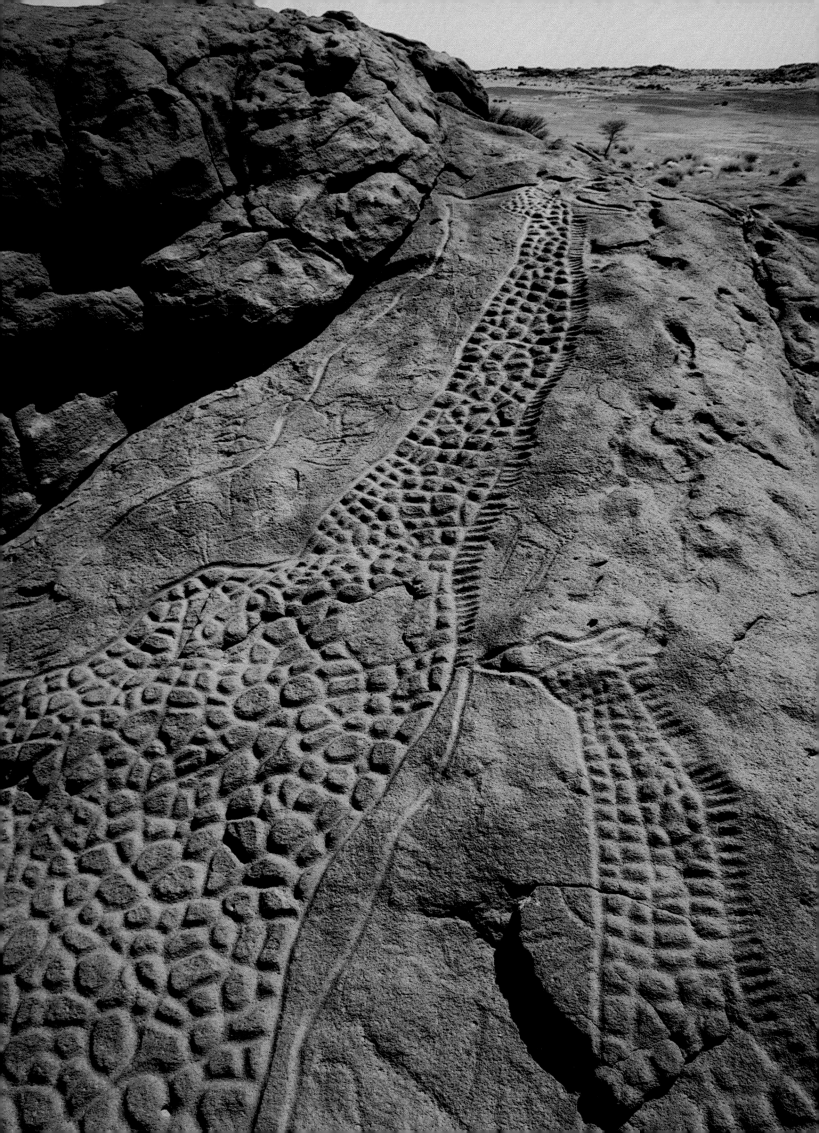

Climate Surprises

Jonathan Overpeck

CLIMATE HAS BEEN TRADITIONALLY ASSUMED TO BE BOTH STABLE AND PREDICTABLE, EXCEPT WHEN DISRUPTED BY UNUSUAL CONDITIONS. BUT RELICT SAND DUNES, TREE RINGS, AND OTHER RECORDS OF PAST CLIMATES SHOW EVIDENCE OF MEGADROUGHTS AND OTHER CLIMATE SURPRISES OVER THE PAST 2,000 YEARS. SUCH EVENTS ARE LIKELY TO RECUR WITHOUT WARNING, SO SOCIETY MUST PREPARE TO ADAPT.

In the summer of 1998 withering heat and severe drought gripped the states of Texas and Oklahoma. By August, the President had declared all 254 counties in Texas federal disaster areas. The economic impact of the drought on the two states would ultimately approach $7 billion, leading to reports that the drought of 1998 was the nation's most severe since the 1930s.

But in 1988-1989, only ten years before—a two-year drought had inflicted economic damage that totaled almost $40 billion. And, of course, still farther back in time was the drought of true legend: the Dust Bowl of the 1930s. Before it was over, the Dust Bowl drought affected most of the lower 48 states, stretching, at its maximum (in 1934), from the Ohio River valley to California, and from Mexico to Canada. Temperatures exceeded 110°F in the central High Plains. In contrast, the drought of 1998 mapped like a bull's-eye on the state of Texas, with a little spilling over into the adjacent states; temperatures barely sneaked into the low 100's. Though the total economic impact of Dust Bowl drought has never been fully documented, its drama and impact on the land and people were immortalized by John Steinbeck in his epic novel *The Grapes of Wrath:*

The sun flared down on the growing corn day after day until a line of brown spread along the edge of each green bayonet. The clouds appeared, and went away, and in a while they did not try any more.... In the roads where the teams moved, where the wheels milled the ground and the hooves of the horses beat the ground, the dirt crust broke and the dust formed. Every moving thing lifted the dust into the air: a walking man lifted a thin layer as high as his waist, and a wagon lifted the dust as high as the fence tops, and an automobile boiled a cloud behind it. The dust was long in settling back again.

The drought of the 1930s was different. What made it so unusual, and so devastating, was its duration: it spanned the entire decade. How many of us, when reading accounts of the summer '98 drought, even momentarily considered what it would be like if such a drought were to last ten years? How many of Steinbeck's readers stopped to ponder the likelihood of another multiyear drought as bad—or worse—than the one that caused the Dust Bowl?

But as we enter the 21st century, and record-breaking global temperatures, destructive storms, and other extremes of climate get more and more

Ancient rock carvings of giraffes recall a distant, lush past in the Sahara Desert.

attention in the press, many people—scientists, policy makers, and others—are starting to asking these kinds of questions. Global warming, its possible human (greenhouse gas) roots, and its potential future consequences have become high-profile environmental concerns. Moreover, El Niño, a formerly obscure climatic phenomenon, has become so ingrained in the public consciousness that advertisers use it to sell everything from new roofs to ski vacations. We've also heard about its more serious impacts around the world: the floods, mud slides, droughts, fires, and coral-reef bleaching.

Gauging from all the reports, something must be going on with our climate. But it is hard for anyone, even specialists in the study of climate, to know just how much of this impression is due to our limited perspective and imperfect memories, and how much stems from genuine changes in the Earth's climate. After all, human populations worldwide continue to increase and crowd into regions that are susceptible to climatic extremes. Along the eastern U.S. seaboard, development has increasingly spread to parts of the coastline where it is more likely that hurricanes will threaten people, their homes, and, consequently, their pocketbooks. Similarly, as more and more people move to arid regions, like the western United States, the odds increase that they will be hit by droughts or floods. And our increasingly interconnected global economy means that we are more and more likely to feel the effects of climatic events anywhere in the world; a climate disaster in China, for example, may stifle the production of some goods and the demand for others, sending economic ripples throughout Asia and the rest of the world.

If we are going anticipate future climate risks to society, we need to understand to what extent the risks are brought on by our own actions—adding greenhouse gases to the atmosphere or building communities in disaster-prone areas— and to what extent they arise from the purely natural rhythms of climate change. Most importantly, we must acknowledge that Mother Nature may have many surprises in store for us as we move into and through the next millennium. A big question being asked now by scientists is whether, in the short history of climate research, we have seen the full range of climate behavior that Mother Nature might throw at us someday. Are the archives of our instrumental and satellite measurements from the last 150 years long enough or complete enough to tell us whether droughts on the scale of the Dust Bowl are likely to recur? How often? Can we rule out the possibility of even longer droughts—20 years, 50 years, or more?

The answer to these questions is unequivocally no. One and a half centuries of data does not begin to give us enough information on the extremes of natural climate cycles. We need to extend our search for changing climates by looking back centuries and millennia. Of course this takes some detective work. Without an archive of measurement from thermometers, rain gauges, and other meteorological instruments to help us decipher past climates, we need to rely on other kinds of clues.

In some cases past climate variations are stored away by biological processes. For example, year-to-year changes in temperature and rainfall can precisely determine how much a tree grew in a year. Since trees provide the opportunity to measure (for example, using tree-ring widths) annual growth going back hundreds to thousands of years, we can therefore reconstruct temperature and rainfall going back the same amount of time. In other cases, such as with corals, the record of past climate change is locked up by chemical processes. The changing temperatures of seawater in which a coral is growing alters the chemistry of each seasonal band in the coral. Bands can be counted back for centuries and their chemical makeup sampled without harming the coral, making it possible to get a record of how sea surface temperatures varied from season to season and year to year long before anyone with a thermometer was around to do the job. Ice cores drilled from Antarctica and the Arctic and from glaciers high in the mountains yield frozen

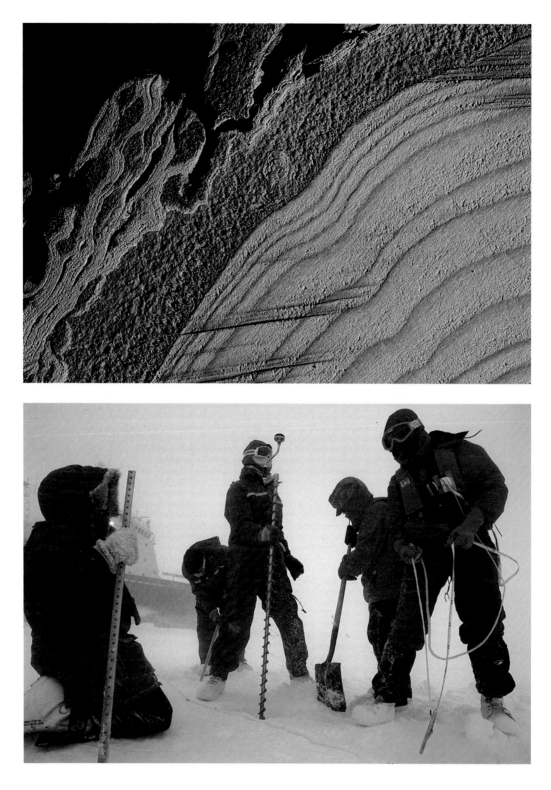

CORE BELIEFS

Accurate as any rain gauge, varying widths of tree growth rings (top) reveal wet and dry periods—
in this case, four years of drought. Similarly, core samples taken of glacial Antarctic ice (bottom) tell of long-
ago climate changes. Such samples may contain gases typical of Earth's atmosphere at a given time. And like
tree rings, the thicknesses of periodic ice strata give information about precipitation levels.

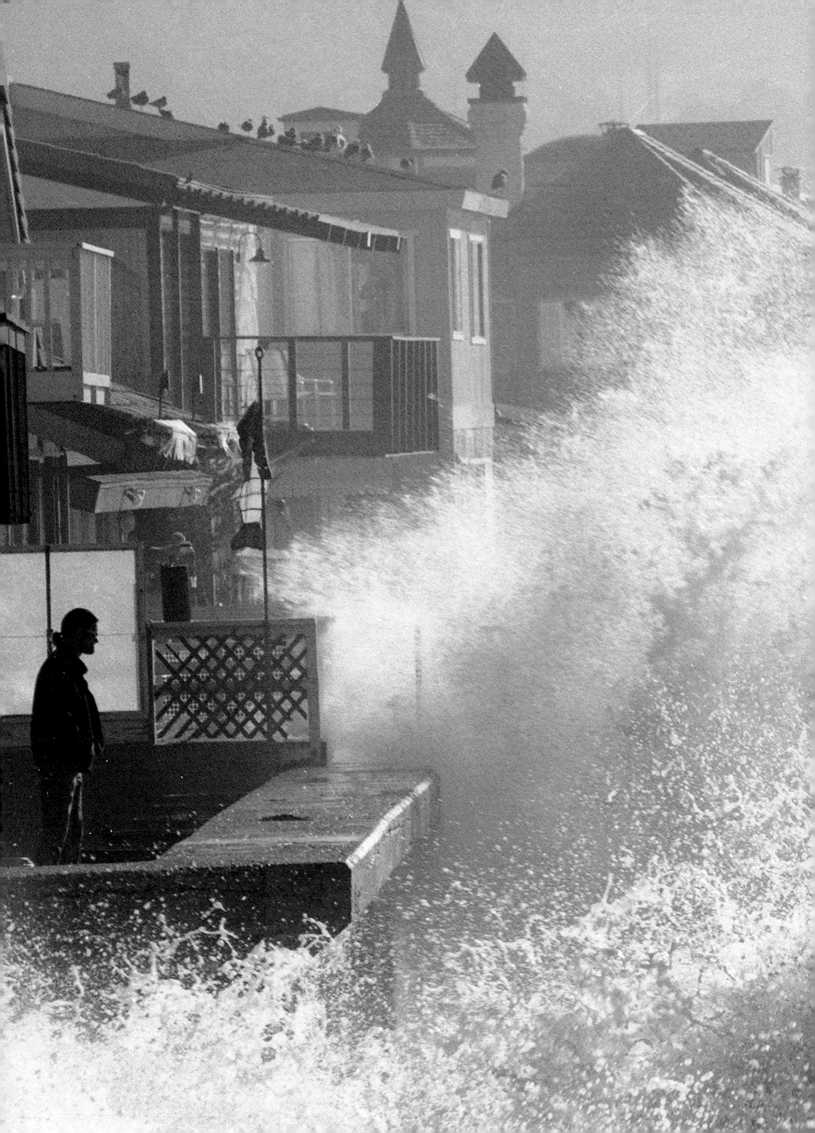

MUSCLE ON THE BEACH
Fed by the ocean-warming phenomenon known as El Niño, massive waves pound precariously situated homes on Solina Beach in California. Some scientists predict that global warming could cause the effects of weather patterns like El Niño to become increasingly extreme.

One never knows what will happen if things are suddenly changed.
But do we know what will happen if they are not changed?

— ELIAS CANETTI

records not only of past precipitation, but also of the former atmosphere. Both the ice and ancient air bubbles trapped within it provide samples of airborne dust, greenhouse gases and other climatically important constituents of the atmosphere. Lake and marine sediments piling up slowly on the lake or ocean bottom for hundreds and thousands of years contain an array of fossils and chemical indicators of what the local climate was like during the time they were being laid down. The list goes on. Modern paleoclimatologists now have a wide variety of natural archives and climate-reconstruction methods at their disposal. The climate histories they have unraveled clearly indicate that the climate shifts and events of the last hundred years, including the recent shifts in El Niño and the range of severe droughts, are but a subset of what could confront human societies of the future.

In fact, I can see evidence of just such an ancient climate shift from the vantage of my aircraft window each time I fly in and out of Denver, as I often do when traveling for my work. To the east of Denver stretches the High Plains, one of the breadbaskets of our country. From the ground the plains present an unchanging view of cattle and farms, mile after mile. But from the air I see something that astounds me today as it did when I first flew over the area in 1991. The flat, fertile plains are covered with the unmistakable shapes of forgotten, ancient sand dunes that once had moved across a desert-like landscape.

I have been lucky enough to visit some of these ancient deposits with two of the researchers who know them best, Dan Muhs and Rich Madole of the U.S. Geological Survey. Dan and Rich, with their colleagues, have found that among the tens of thousands of square miles of windblown sand and dust covering the U.S. High Plains are dunes that were actively moving within just the last 1,000 years. It had been assumed that they were far older relics of the Ice Age, when the Earth's wind and weather patterns were substantially different from those of today. But one

thousand years ago is comparatively recent. What is especially impressive is that these same dunes were not moving during the 1930s Dust Bowl—the worst drought recorded in U.S. history. What kind of drought could cause large areas of the High Plains to dry out into a Sahara-like desert?

We are now beginning to assemble a picture of these paleoclimatic events. Data from sources as diverse as the journals of early explorers, tree rings, lake sediments, river deposits, archaeological sites, and ancient dunes and other windblown deposits, reveal what the instrument records cannot: that multiyear droughts similar to that of the 1930s tend to occur at a rate of one or two per century. More surprising, however, is the growing paleoclimatic evidence for megadroughts—droughts lasting for decades, rather than just years. We now have good evidence that these truly extreme droughts have happened at a rate of two to three per thousand years, most recently during the 16th century, and that they affected much of North America. Not only did these megadroughts hit the High Plains, leaving the dunes and other windblown deposits there, but they also caused water sources in the Sierra Nevada and other western mountain ranges to go dry for decades at a time. The 16th-century drought even reached the Atlantic coast. Evidence from tree rings and historical journals suggest that this multiyear drought played a role in the disappearance of the earliest English settlement in North America—the so-called Lost Colony on Roanoke Island in North Carolina.

The devastating 1930s drought must have been a minor event when compared to the megadrought that got the sand dunes moving on the High Plains a thousand years ago. What caused these potentially devastating multidecade droughts? We know only that they were caused by entirely natural processes and—disturbingly—that they could happen again without warning.

Learning how to predict and prepare for a possible megadrought will be a true challenge for the 21st century. We need to understand that all aspects of our climate are subject to change. There

is no reason to expect that the average, or normal, climate of the next 30 years will be the same as that of the last 30 years. Because effective weather prediction is limited to four, five, maybe six days ahead, we generally rely on what has in the past been normal weather to anticipate and plan for what we think lies ahead. Many social and economic decisions are based on the assumption that the climate of the next year, next decade, and even next century will be much the same as that of the last 30 to 150 years. But continuing this way could become a costly mistake, particularly as we enter the new millennium, because we now know that climates are always changing. Normal climates are just snapshots along the way.

A new "climates-of-change" paradigm is emerging in climatology from a wide variety of climate observations, some, such as the dunes of the High Plains, recording changes hundreds and thousands of years in the past. We are learning how droughts and other local climate events fit into larger, more global phenomena, such as the current poster child of climate research: El Niño. During 1997 and 1998 a strong El Niño event affected much of the Earth. In the tropical Pacific heart of El Niño the event was clearly underway when surface winds reversed their usual orientation and began to push warmer-than-normal surface water into the eastern tropical Pacific. With the eastward shift of the warm water came heavy rains, drenching the region and leaving behind anomalous dry conditions in the western tropical Pacific. These changes meant devastating rains, snowfalls, floods, and mud slides for the west coast of South and North America, and major drought and forest fires for Papua New Guinea and Indonesia. Week after week, newspapers and televisions carried news of El Niño's effects around the world and the economic losses that soared into the billions of dollars.

But there is also a hopeful side to the El Niño story. The 1997-1998 El Niño marked the beginning of a new era in our ability to predict climate:

For the first time in human history, scientists and decision-makers were able to anticipate and plan for El Niño's devastating effects, saving lives, property, and money. But despite this success, climate researchers are only too aware that our understanding of El Niño and our predictive abilities are still very limited. In 1976 there was an abrupt and poorly understood warming across much of the Pacific that persists to this day. This warming in turn set the stage for the two strongest El Niños ever recorded. Additionally, before 1990, each El Niño tended to last just one or two years. But, after 1990, we were surprised by an event that lasted five years! And with these abrupt shifts in El Niño's behavior have come shifts in its impacts around the globe—reminders that climate can change in many ways that we still don't understand.

One of the most astounding contributions to the climate revolution has come from even farther back in time than the megadroughts of the High Plains. This was the discovery of extraordinarily abrupt "climate surprises" (as called by Wally Broecker of Columbia University) during the last glacial period, from 100,000 to 10,000 years ago. This was the Ice Age, when massive ice sheets covered most of northern North America and Europe, and the vegetation belts and ocean currents around the world were markedly different from today. Decades ago paleoclimatologists had found that these great ice ages were quasiperiodic phenomena—cold glacial periods and warm interglacial periods alternated approximately every 100,000 years. Further evidence indicated that subtle changes in the Earth's orbit around the sun served as the pacemaker for these cycles. This orbital theory dominated climate-change thinking for many years, along with the underlying assumption that gradual changes in the variables controlling climate change, such as slow shifts in the Earth's orbit, would cause correspondingly gradual changes in climate, such as the coming and going of ice ages over many thousands of years.

About ten years ago, though, new pieces of the ice-age puzzle were discovered that didn't seem to

fit this model. Paleoclimatologists studying an array of ice cores from Greenland and sediment cores from the North Atlantic began to uncover evidence that the ice ages were not simply long, slowly-changing cold periods. They were shot through with abrupt periods of ice-sheet collapse and regional climatic warming. What really caught the attention of climate scientists was the observation that many of these abrupt events, including regional annual average-temperature increases of more than 15°F, happened over mere decades or even years! The paradigm of gradually changing or stable climates began to fade into history. In its place came a new realization: Rather than shifting smoothly from one set of conditions to another, the world's climate systems tend to change abruptly—flip-flopping between stable states and spending little time in between. Climate surprises appear to be the rule, rather than the exception, of climate change.

The consequences of a similar climate jump would be devastating for our society, but, luckily for us, the chances of such an event in the near future are probably not large. Most theories advanced to explain the ice-age climate surprises assume glacial ice sheets far larger than the Earth has today. The ice caps of Antarctica and Greenland probably aren't big or unstable enough to generate an ice-age-scale climate surprise.

Does this mean that society is more or less free from the threat of climatic surprises in the future? Not at all. A whole new body of paleoclimatic evidence is emerging to suggest that warm climate surprises (as opposed to surprises during the cold ice ages) are much more common than previously thought. Add to this the fact that we are living in a warm interglacial period (and not an ice age), and the implication is that warm climate surprises in the form of extreme droughts or higher frequencies of damaging hurricanes may be the most significant climatic threat worldwide in the 21st century. A surprise megadrought lasting a decade or more could wreak havoc on our country. Even in the absence of any global warming, it

is possible that a future drought could start like the Texas-Oklahoma drought of 1998 and end up lasting for years, or even decades. It's hard to imagine the impact such a drought would have on our current economy, health, and lifestyle.

There are other reasons not to be complacent about future climate change. Over the last 150 years, the Earth has warmed significantly—by almost 1.5°F—and paleoclimatic records suggest this warming is the most dramatic in at least the last thousand years. Most climate scientists believe that some of this recent global warming is due to human-caused injections of greenhouse gases into the atmosphere, but it could be that some of the warming has natural roots as well. The greenhouse warming debate centers mostly on how big future human-induced climate changes will be. However, it might make sense for us all to recognize that climates of change are what Mother Nature is all about, and that the most important 21st-century challenge is to develop the tools for predicting the full range of future climate change, whether it be driven by natural or human causes, or both.

Back in the 1930s the United States was relatively empty and undeveloped compared to today. As I write, economic growth and development are booming across much of the U.S., and people continue to move into the regions of our country that are perhaps most vulnerable to climates of change. As this happens, our economy is also becoming more and more intertwined with those of other countries around the world, each faced with its own changing climate. To keep our economies strong—and more important to save lives and property—society and scientists alike need to perceive climate change as a natural, as well as human-induced, phenomenon. We still have much to learn from the climates of the past, but our biggest challenge will be to use this growing body of knowledge to develop both the scientific and social tools needed to anticipate and thrive as we face the changing climates to come.

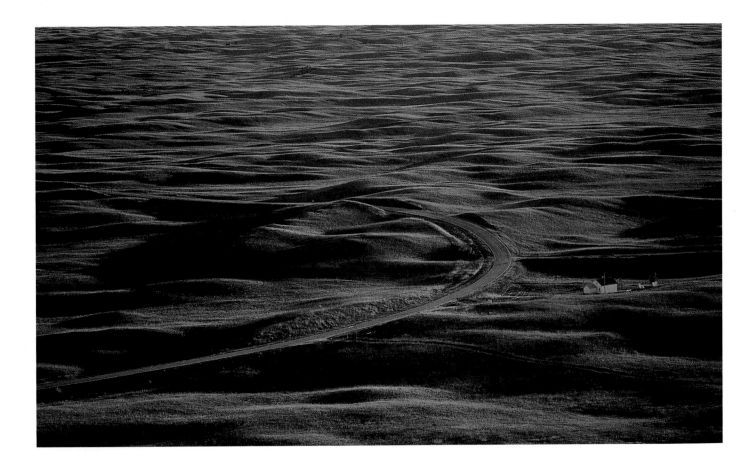

SANDS OF TIME

A sea of sand ripples across the plains of Nebraska (top), the remnants of towering Sahara-like dunes that once dominated the region's landscape. Even the great Midwest dust bowls created by severe droughts and land abuse in the 1930s (bottom) did not produce any landforms remotely as permanent. The dry period that produced Nebraska's sand dunes was no ordinary drought—it must have been a major climatological variation.

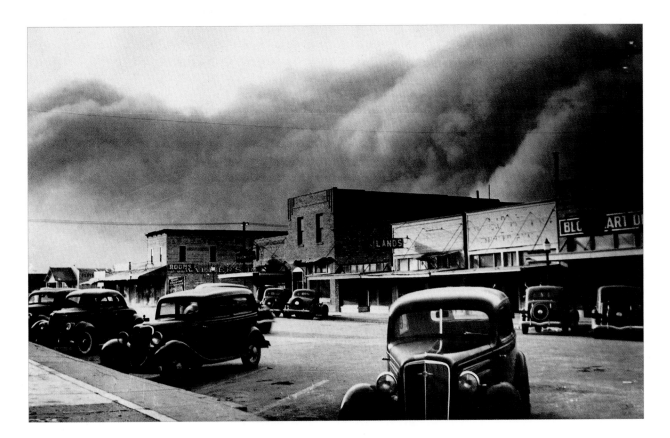

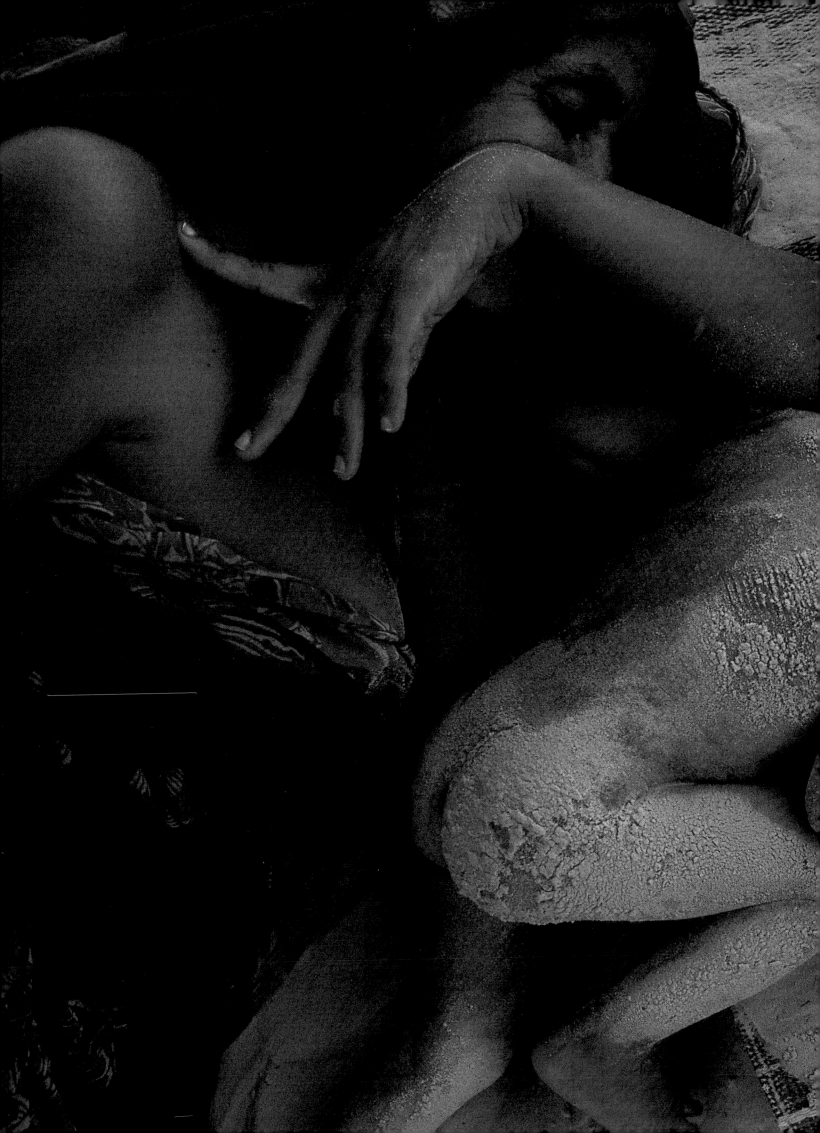

DRY SPELL
Blowing sand from a dry lake bed clings to Tinalbaraka walet Mohamed's eight-month-old daughter, Isha, as mother and children sleep on a sun-baked afternoon in Mali. Just 25 years ago lakes dotted the homeland of these nomadic Tuareg people. The rains stopped in the 1970s, but population growth and overgrazing did not."We used to fish, grow crops, have animals, and prosper," says Tuareg leader Mohamed Ali. "Now it is a country of thirst."

Winds of Change

MICHAEL GARSTANG

Great rivers of air flow in the atmosphere, linking together ecosystems as far-flung and dissimilar as land and sea, desert and rain forest. Winds near the equator can carry air 25,000 miles in a globe-encircling voyage in as little as 20 days. Within the air we breathe are some 120 chemical elements and compounds; winds are frequently burdened with minute particles of soil, dust, minerals, plant and organic material, sea salt, marine minerals,

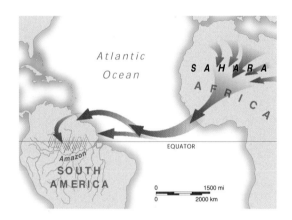

combustion products from burning forests and grasslands, agriculture and industry, as well as products of other human activities. At times, volcanic eruptions shoot enough gases and dust into the air to overwhelm all other constituents. There is a constant, but minute, rain of extraterrestrial dust from outside the Earth's atmosphere. Each year, approximately one billion tons of material are lofted from the Earth's surface by wind and carried around the world.

The main sources of windblown dust are, not surprisingly, the great deserts of the world's subtropical regions—most notably the Sahara. Photographs taken by U.S. astronauts

reveal huge plumes of dust rising off these dry lands. About half of all the dust entering Earth's atmosphere comes off the west coast of Africa and is blown out to sea across the North Atlantic Ocean. This creates a distinctive layer in the atmosphere known, appropriately enough, as the Saharan Dust Layer. Much of the dust is initially lifted off the ground by dust devils, small tornado-like vortices common in deserts and dry regions. I have seen as many as 30 dust devils spinning at once. They rise high above the hot desert surface to altitudes of at least 500 meters. At this altitude, they catch west-blowing winds and begin their long journey over land and sea.

Of course, what goes up (eventually) comes down, and this is where atmospheric scientists have made some of the most surprising discoveries. Airborne dust comes down, again and again, and circumnavigating dust falls on ecosystems far and wide and changes them. Over many thousands of years, winds have moved so much dust that almost no soil anywhere on earth can be attributed only to the local bedrock. This includes one of the richest and most famous ecosystems on Earth: the Amazon Basin rain forest, where some 22 chemical elements (including phosphate and potassium, critical elements for plant growth) come from Saharan dustfall. Such trace elements essential to the rain forest vegetation are nearly absent in the leached, nutrient-poor soils. In low-lying parts of the basin, river flooding will periodically replenish the soil, but in the higher and drier terra firma forest, atmospheric dust from Africa supplies virtually all the life-sustaining nutrients.

As part of a NASA-sponsored project to study the role of tropical rain forests in Earth's interconnected life-sustaining systems, I and my colleagues sampled Saharan dust in the air over the Amazon Basin. From these measurements we estimated that each year the eastern and central Amazon Basin receives a shower of about 13 million tons of Saharan dust.

But the trade winds blowing across the Atlantic generally aren't strong enough to carry enough dust to account for the quantities we measured in the air and rainfall of the central Amazon. Yet once we discovered that all episodes of Saharan dust incursions to the central basin coincided with large rainfalls, we began to understand the connections. The same powerful weather systems capable of bringing in larger-than-average amounts of moisture to produce the heavy Amazon rain are capable of carrying larger-than-average amounts of dust over long distances. Any time the birth of one of these storm systems in the Amazon Basin coincided with a large plume of Saharan dust over the western tropical Atlantic, great quantities of that dust plume were sucked into the Amazon Basin by the storm system. When there were storms over the Amazon but no dust plume over the western tropical Atlantic, heavy rains would fall but without much dust. It is the coincidence of two dissimilar events on opposite sides of the ocean—a desert dust storm and a rain forest storm system —that allows the barren Sahara to replenish the lush Amazon forest.

A dust devil rises above the Sahara (below), injecting specks of soil into the atmosphere. Carried westward by trade winds (map, opposite), the dust crosses the narrow central Atlantic Ocean to the humid Amazon basin of South America, (above , right), where airborne moisture condenses on the particles and falls as rain, adding nutrients to the leached rain forest soils.

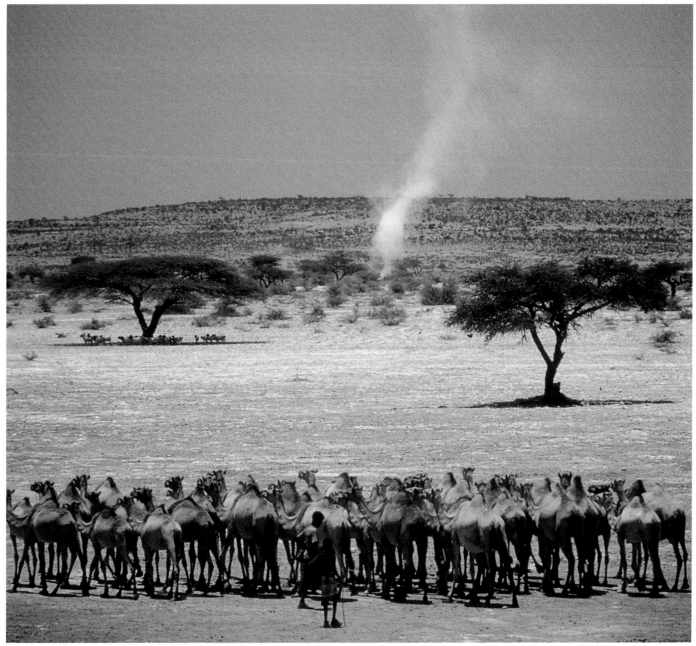

45

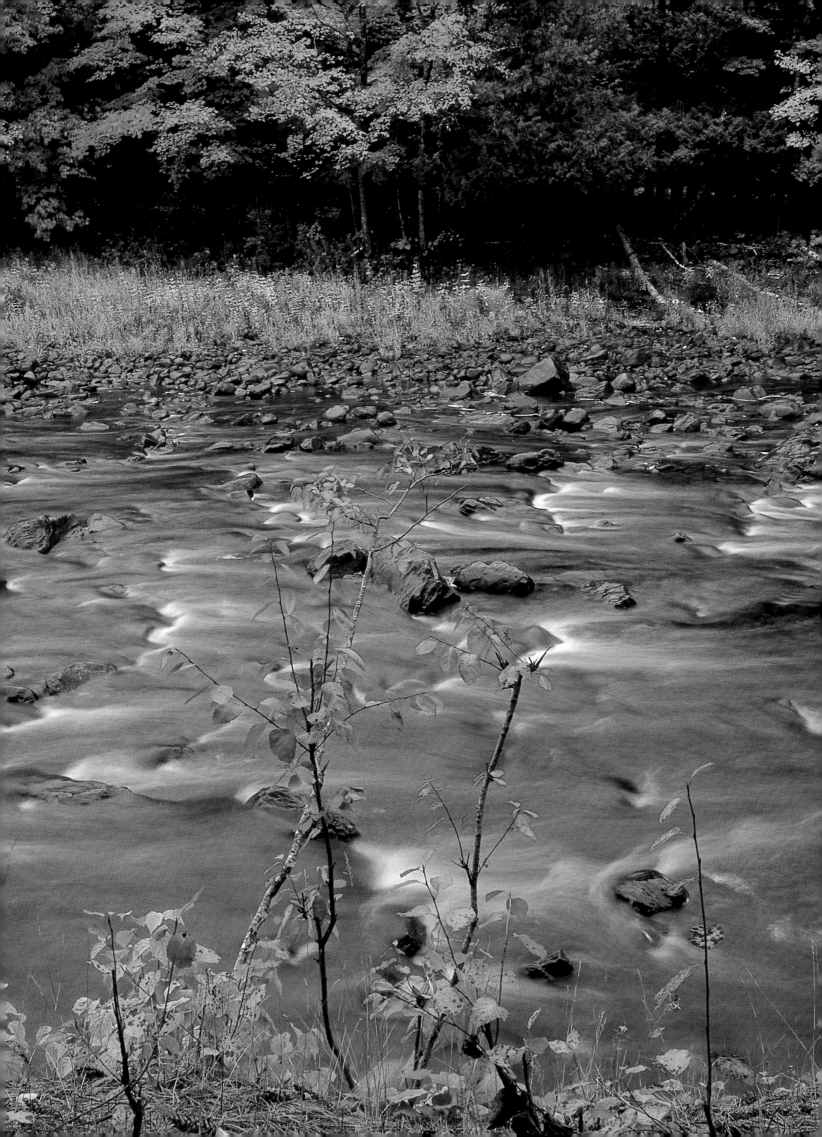

Streams of Consciousness

Alan Cutler

WATER IS THE ESSENCE OF LIFE ON EARTH AND FLOWING WATER THE PRIMARY SCULPTOR OF THE EARTH'S SURFACE. HUMAN SOCIETY HAS HAD A LONG AND INTIMATE RELATIONSHIP WITH RIVERS AND STREAMS, COMPLICATED BY THEIR VARIABILITY AND UNPREDICTABILITY—AND EVEN MORE BY OUR CLUMSY INSISTENCE ON TRYING TO CONTROL THEM.

In 1959 Little Falls Branch, a minor tributary of the Potomac River just outside of Washington, D.C., caught fire. The watershed of Little Falls Branch was no polluted industrial wasteland; it was residential, with comfortable neighborhoods that were home to diplomats, professionals, and government officials.

The creek had been contaminated by an oil spill, which then ignited. The fire burned for two days. Its heat was so intense that the Massachusetts Avenue bridge across the creek melted, shutting down a major route into the city. Commuters, most of whom had probably never noticed the creek, had to find other ways to get to their jobs at embassies and federal agencies. The fire thrust the obscure watercourse into a role usually reserved for larger bodies of water: it was a geographical barrier, an impediment (albeit minor) to the affairs of great nations.

I grew up along a nearby creek, Minnehaha Branch, in suburban Maryland. Minnehaha Branch did not have to burst into flames to capture my attention. It just had to be there, with its pools and riffles to wade through, rocks to flip over, and banks to dig into. My brother and I built dams across its channel, and then watched the water rise, spill over the sand embankments, and sweep the dam away. We scooped up tadpoles and frogs' eggs in mayonnaise jars. We sifted through the sand and gravel for gold, finding instead glittering flakes of mica and particles of black iron oxide (with a magnet you could collect it by the jarful). We raced floating leaves through the riffles, and watched sand grains on the bottom creep downstream with the current, some pausing in a hollow or on a bar, others tumbling steadily along or wafting upward on the occasional eddy. The creek offered unlimited possibilities for a young naturalist.

For sheer excitement nothing rivaled the floods. After a heavy rain the creek filled nearly to the tops of its banks, becoming a swift and fearsome torrent. Great waves of rushing brown water would rear up and froth where earlier we had stalked crayfish or skipped pebbles. It was an inspiring sight. Standing on the slippery banks, we heaved logs into the current, watching them disappear downstream with the other flotsam. The creek's flash floods—the way they transformed the placid Minnehaha Branch into a mighty Colorado—awed me as few natural spectacles have since.

Wise water management begins where rivers begin—upstream in bubbling waters like Michigan's Sturgeon River Gorge.

But the Minnehaha floods were no more natural than the flames of Little Falls Branch. They were the unruly consequence of how utterly the landscape had been transformed. Before we built our houses and paved our streets, the land around the Minnehaha, its soil and vegetation, had soaked up most of the rain as it fell. The water then made its way to the stream, not so much flowing as oozing, making stops along the way to replenish a root or leach some bedrock. Because the flow to the creek was slowed and buffered by the intervening sponge of plants and soil, the Minnehaha Branch would have maintained a fairly steady flow, its moderate fluctuations tied to the seasonal changes in precipitation. But when our houses went up, their roofs shedding water, and our streets and driveways paved so that our vehicles would not churn the ground into mud, the rainwater began to bypass the natural buffering system, moving directly from pavement to gutter to storm sewer to creek, the neighborhood runoff swiftly converging at more or less the same time on the creek's narrow channel. And so the water shot through it as if from a fire hose. It was a great show for the kids, but not how a woodland stream was supposed to work.

Nothing on Earth is so mysterious as water. Throughout history we have built settlements along watercourses, used river valleys and the rivers themselves as routes of commerce and exploration, availed ourselves of river water to irrigate crops and flush wastes. As symbol and metaphor, water is a staple of world mythology, religion, and literature. It falls out of the sky and flows downhill. It puts out fires and makes plants grow. Turn on the faucet and there it is.

But water poses a problem, too. Scientists, policy makers, and environmentalists tell us that, of the societal and environmental issues looming as the major challenges of the next century, the most formidable will involve water—fresh water for agriculture (crop irrigation is by far the biggest consumer of water), clean water for human health (each year water-related diseases claim the lives of more than five million people worldwide), and the preservation of wetlands and clean rivers for the vast number of plant and animal species that depend on them. More and more, human populations are crowding into arid regions, putting impossible demands on the meager water resources. Climate change, driven by human activities and natural cycles, seems likely to beset us with ever more extreme droughts, floods, and violent storms.

Water, or lack of it, is often what defines a natural environment. Whether the water flows, whether it freezes or stays liquid year-round, whether it is fresh or salty, whether it falls from the clouds in the summer or winter—these factors dictate the type of wildlife and how humans must interact with the environment if it is to continue to thrive. Yet this familiar and renewable resource confounds our best attempts to understand and manage it.

Water is an almost universal solvent; practically anything from minerals to elaborate organic compounds will dissolve in it to some degree. This makes water the perfect medium for complex biochemical reactions involving many kinds of molecules, and therefore the perfect liquid base for the sap of a living cell. All life functions are based on chemical reactions, which is why plants, humans, and other organisms are so completely dependent on water. A dehydrated cell is a dead cell. But water's chemistry is also its curse: All manner of toxins, carcinogens, and other bizarre creations of industrial chemistry are also readily dissolved in water, making it easy for them to contaminate water supplies and spread through ecosystems. Water is an equally efficient medium for conveying harmful substances as it is for conveying beneficial ones.

Water's molecular properties have their effects on grander scales, too. The volatility of weather and the violence of storms owe their origin to

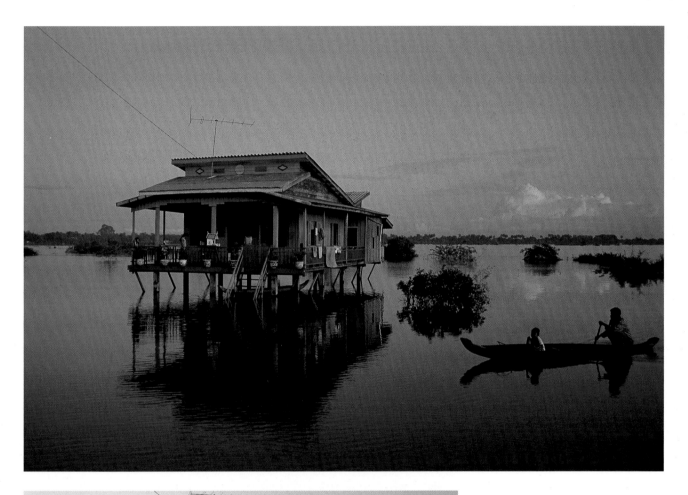

STILTING GROWTH

Living by rivers for many millennia, people have had to adapt to the extreme cycles of their flow. Periodic flooding in Cambodia's Mekong Delta was the worst in memory in 1991 (top). The river rose 25 feet, and thousands of acres of paddy fields were ruined. Still, traditional stilt houses were equal to the threat. Four months later (left) the waters had retreated and crops were growing in the fertile, silty soil left behind by the floods.

the simple process by which water enters the atmosphere: evaporation. When water is in a liquid state, its individual molecules easily jostle and move past one another; water flows. But the molecules are not completely independent of one another, forming temporary bonds called hydrogen bonds. These bonds have to be broken for the liquid to turn into gas, which takes energy.

A lot of energy. To evaporate any quantity of water—a drop—requires 540 times as much heat energy as it does to raise the temperature of that same water 1°C. This property of water, known as the latent heat of vaporization, explains why climbing out of a cold swimming pool into the hot sun can be an uncomfortably chilly experience. The thin film of water evaporating from the surface of your skin sucks heat from your body faster than the frigid pool water could. And this heat energy, like all energy, is conserved, and where the water vapor goes, it goes too.

If the vapor rises into the atmosphere and cools enough for it to condense back into a drop of water, the heat energy is released into the surrounding air. The air stays warm and so keeps on rising, causing more water vapor to condense, releasing still more heat, causing the air to rise still farther, causing more condensation, and on and on in an accelerating updraft. The rising column of air sucks other moisture-laden air up behind it, feeding and perpetuating the process. On a hot summer afternoon the result can be a thunderhead, which may put on a violent show of wind and lightning before dumping its water back onto the ground in a cloudburst. Hurricanes get their phenomenal destructive power from the latent heat absorbed during the evaporation of tropical seawater. The water is not even lukewarm—usually 80 degrees compared to our bodies' 98.6 degrees—but when the latent heat from thousands of square miles is concentrated into a single vortex, wind speeds can exceed 200 miles per hour, and the total energy released by the storm can match that of 400 20-megaton nuclear explosions. It is water vapor, with its transitions to and from liquid water, that keeps the atmosphere stirred up and makes the weather hard to predict.

This constant traffic of water in and out of the atmosphere, rising from the sea, falling on the hills and plains, soaking and scouring the solid earth, also shapes the landscape. Water is by far the most potent agent of erosion on the planet. The hills, ridges, and pinnacles of any given topography are generally the product of terrain worn down by the relentless action of water and ice. A prominence may stand in relief because its bedrock was particularly hard and unerodible, or because the channel of a primordial stream happened to twist one way instead of another, sparing the patch of ground from the brunt of erosion and down-cutting in the deepening stream valley.

Every geologic cataclysm or upheaval of rock and magma is ultimately tamed and defeated by water. There are few places on Earth where you can set your feet and not be standing on the corpse of a mountain range or volcano that had its peaks torn apart by ice and its flanks beveled by rain and snowmelt. Mountains raised in haste by plate tectonics will be flattened at leisure by erosion. There is more of the Appalachian Mountain chain lying pulverized off the Atlantic coast of North America than there is in the present-day mountain ridges. Walking along the Potomac River it's easy to find pebbles of the bedrock that many miles to the west holds up the ridges and crags of Appalachia. The pebbles, rounded from their journey thus far, are headed for the sea. The rest of the mountain rock will eventually follow them, though not in my lifetime, or even necessarily in the lifetime of our species.

Despite its preeminence as a force of erosion, it would be a mistake to think of flowing water simply in terms of destruction. Water is a force of renewal. Without the breakup and dissolution

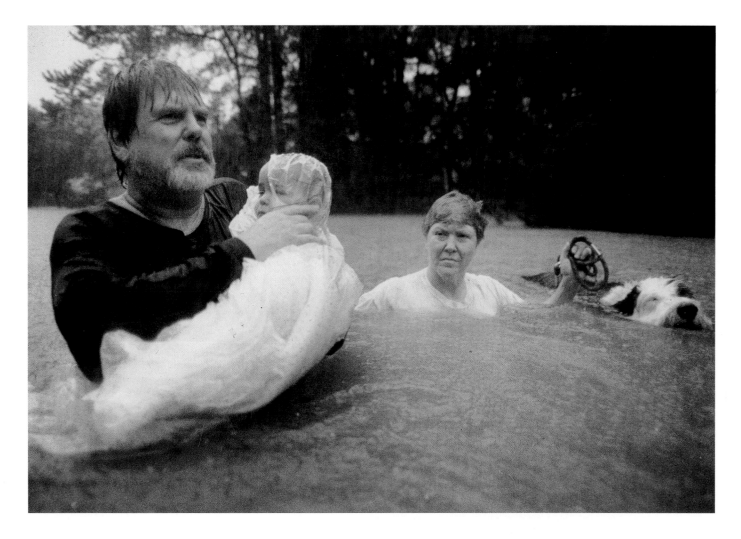

RIVER'S RAGE

As flood waters rise in Conroe, Texas, a couple who had been babysitting their grandchild struggle to safety. Torrential downpours in the fall of 1994 flooded vast areas of southern Texas. Along the San Jacinto River some 10,000 people were forced from their homes. Near the river's mouth in Houston the natural disaster spawned a man-made one when pipelines failed and gasoline, crude oil, heating oil, and natural gas poured from them and ignited, spreading a firestorm that engulfed woods, houses, boats, and barges.

Simple assessment of a river's floodplain ought to alert people to their chances of periodic inundation; still, development pushes ever closer to desirable waterfronts. Attempting to solve the dilemma, dams can be built to either block overflow at a river's banks or divert the river's flow completely. Holding back the flow of one of America's largest rivers, 726-foot-high Hoover Dam (right), in operation since 1935, domesticated the Colorado, whose floods once tore through the countryside. Still, such progress comes with a price: Hundreds of miles downstream, the Colorado now virtually disappears before reaching the sea, its waters diverted for human use.

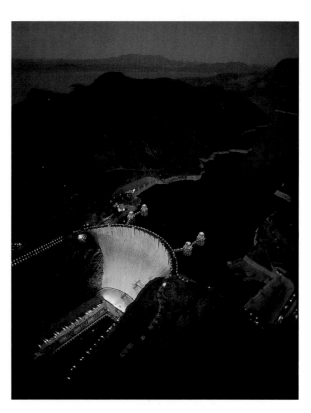

MAKING ITS BED
Fall sets maple and birch aflame along the east branch of Michigan's Fox River. The meandering stream wanders across its flood plain, and scars of former channels are visible in the lower growth near the river's banks.

CARVING THE EARTH

Slow but persistent, waters from Deer
Creek etch away at the Tapeats sandstone
at a rate of roughly one inch per century.
The sandstone itself was deposited 500
million years ago, when long-vanished
rivers carried the sand into an ancient sea.

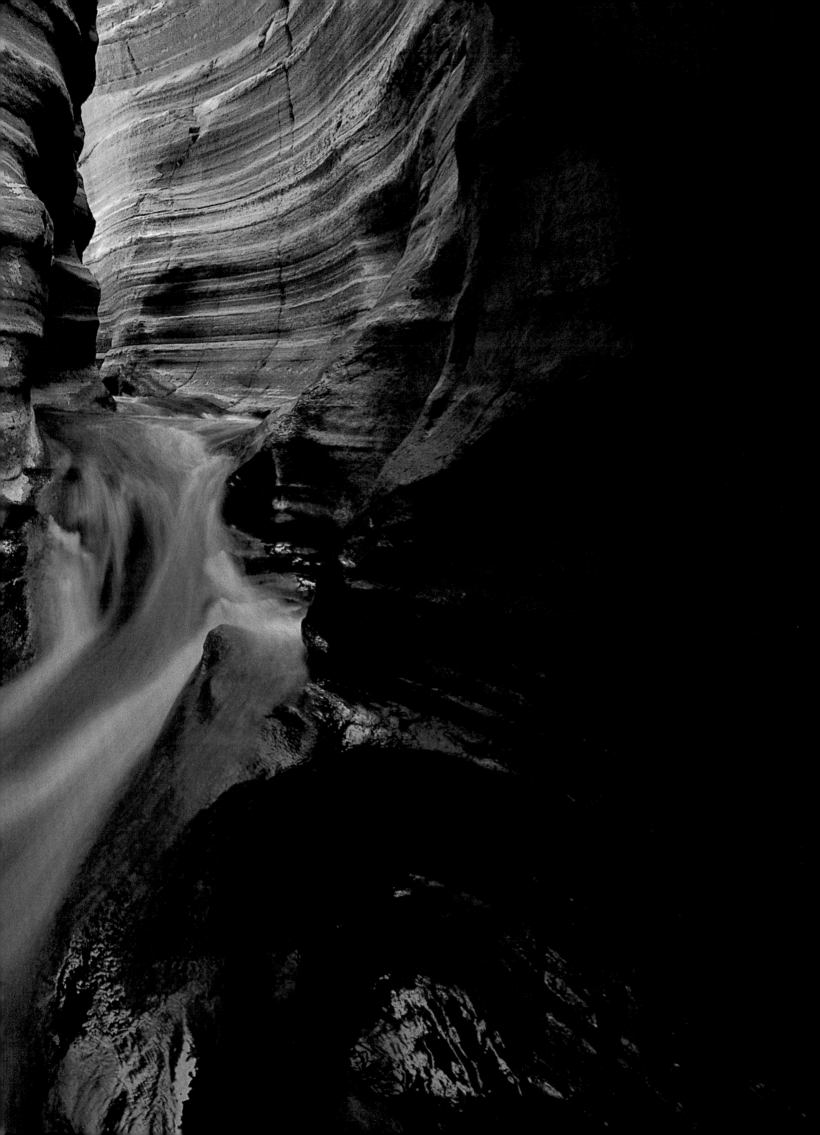

of rocks by the water that rains down over the continents, life on Earth, if it did not cease altogether, would become minimally productive. The erosion cycle is a nutrient mill, in which the rocks of the Earth's crust are ground into plant and plankton food and then washed downhill to the soils and waters of terrestrial and, ultimately, marine ecosystems. If erosion and weathering weren't constantly releasing fresh supplies of calcium, sodium, and other critical nutrients from the land's underlying rocks, the biosphere would ultimately wind down, because even the most efficient ecosystem's nutrient cycles always spill a little "downstream," with the ultimate nutrient sink being the oceanic abyss.

Standing at a river's edge or on the banks of a creek, what we see is not really where the system begins or ends. The real river extends far beyond the margins of its channel; it includes the whole of its watershed, the total extent of land on which its water collects and drains, including the sub-surface, which can feed the stream by seepage from groundwater. The river is part of the great hydrologic cycle, that connects the atmosphere with the oceans, with many detours through the biosphere and lithosphere. The river is far more than just its water. It is also the flotsam bobbing on its surface, the cobbles and boulders rolling downstream during its floods, the sand, silt, clay, and gravel entrained by its currents, the chemicals and minerals dissolved in its water. It is the floodplain, the gravel bars, the meanders, and the oxbows. It is also the plants, animals, fungi, and bacteria living not only within its channel but within its entire catchment. All are as much a part of the river system as any eddy or riffle—and not in a metaphorical sense, either. Chop down too many trees in the water-shed, build your house on the floodplain, and when the next hurricane roars in from the coast to drop its load of rain the connections will become very clear.

For centuries people have made the obvious comparison between the Earth's network of rivers and the human body's circulatory system: each carries through its branching channels the primary liquid for sustaining its life. Perhaps a better analogy was proposed in 1994 by Luna Leopold, one of the 20th century's influential and insightful students of rivers, now Professor Emeritus at the University of California at Berkeley. He suggested that, in their complexity, development, and behavior, rivers resemble nothing so much as an evolving biological species. River and stream channels, regardless of size, show an amazing consistency in their geometric shapes—meander bends, for example, develop according to well-defined mathematical relationships. But like individuals within a species each river system is unique, its individual pattern as recognizable as a human face. And in both rivers and species the complexity and integration of parts arise not from a fixed or predetermined plan but rather from the interplay between chance, history, and deterministic physical law. Both have histories, and each changes and adapts to changing conditions. The result is a idiosyncratic and changeable entity that defies generalization and, as Leopold remarked, "has a heritage, but no beginning."

Before his death in 1948 Aldo Leopold, Luna's father and a prescient thinker about the environment, wrote an essay on the lumberjack Paul Bunyan and Wisconsin's fabled Round River. Round River, the story went, had no beginning or end. Its channel formed a closed loop, perpetually flowing into itself. Bunyan and his team of loggers discovered the miraculous river while on a lumber drive: After floating their logs for miles on the swift current they were startled to realize that it was carrying them around and around, always through the same territory.

Leopold saw in the story of Round River a parable of nature and of our species' perpetually unsettled relationship with it. Too often we don't

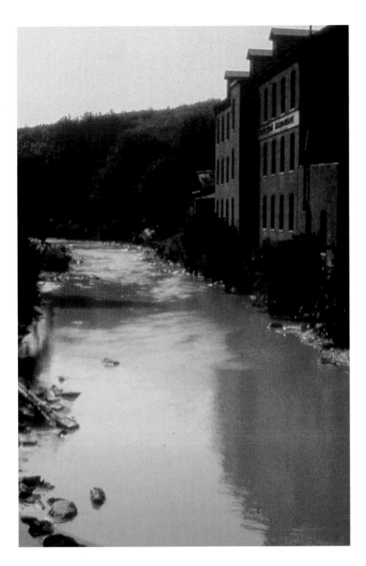
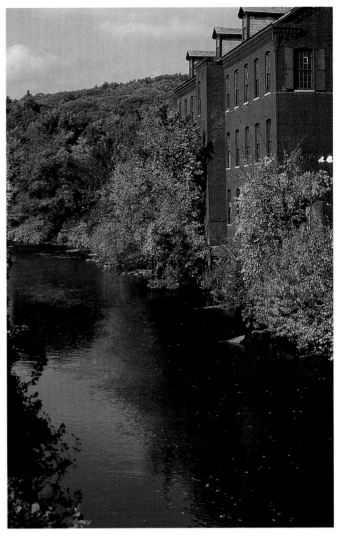

CLEANING UP A RIVER'S ACT

Rank and lifeless by the 1960s, this length of the Nashua River in Massachusetts (above, left) was a toxic stew of untreated sewage, running red with dye from paper mills. Today (above, right) it is a haven for anglers and canoeists and a model for communities striving to clean the waters they have fouled.

The river's death-and-rebirth saga began back in the 1960s, at what seemed a hopeless point in the history of North American water. Lake Erie was said to be on its deathbed. In Cleveland, Ohio, the Cuyahoga River caught fire. And one of the most blighted rivers in America was the Nashua, which was polluted to such an extent its fumes blackened paint on nearby buildings.

But a woman named Marion Stoddart started a campaign to restore the Nashua and its tributaries. She built coalitions with business people, labor leadership, and paper companies—the worst polluters. Within a few years people cleaned up their businesses, changed state laws, and testified before Congress. With federal help eight treatment plants were built or upgraded, and a broad conservation zone called a greenway was created along about half of the Nashua and two major tributaries. Today most of the industry is still there—and many parts of the river are safe for swimming.

acknowledge that when we tamper with natural systems—a watershed, an ecosystem—the consequences have a way of looping back on us and catching us by surprise. The path that nature favors is not necessarily the straightforward, linear one we expect.

"We of the genus Homo ride the logs that float down Round River," he wrote, "and by a little judicious 'burling' we have learned to guide their direction and speed." By "burling" Leopold meant trimming and smoothing the knots and irregularities of the logs. We try to control the things in nature that keep our civilization afloat; we straighten them out where we can, we do our best to direct their courses downstream, rather than take chances with the current.

Leopold saw the process as inadequate. "We burl our logs with more energy than skill," he observed. To preserve the functioning of a natural system, we need to learn ways of dealing with it besides hacking off the parts we don't understand or don't think we need. And all the burling in the world won't change the system's fundamental nature—it will curve, loop, and connect according to its own logic.

> Hydrologists have demonstrated that the meanderings of a creek are a necessary part of the hydrologic functioning. The flood plain belongs to the river. The ecologist sees clearly that for similar reasons we can get along with less channel improvement on Round River.

Now, a half century after Aldo Leopold spun his tale about real, mythical, and metaphorical rivers, we are thinking about them less simplistically. The problems are not getting simpler, of course, and at times our rate of progress can seem maddeningly slow, but, we have become more aware of the consequences of tampering with these systems.

I now live along the Muddy Branch, also a tributary of the Potomac. The creek, as it courses through our neighborhood, is flanked on both sides by a buffer zone of woods, as has been required by the local building code since the seventies. An artificial holding pond collects much of the neighborhood runoff, slowing its rush to Muddy Branch and, as a bonus, provides habitat for herons, frogs, and dragonflies. Exploring the creek with my children I notice that after a rain Muddy Branch gushes more than it should—there are some heavily built-up areas upstream—but for a suburban creek it is doing fine. A recent biological survey found 36 species of fish living in its waters. Even Little Falls Branch has shown some improvement: Though a 1976 study found it completely lifeless, more recent investigations have turned up a handful of pollution-tolerant fish and insect species.

Sadly, the Minnehaha Branch of my childhood explorations did not survive the sixties. Its floods and erratic flow became so problematic that, as a kind of euthanasia for creeks, the county encased it in concrete pipe and buried it. Now it lies beneath a narrow, grassy swath that winds through the neighborhood, emerging a mile or so downstream.

But despite what the engineers and bulldozers did thirty-some years ago, the contours of the land dictate that a creek should still be there. So sometimes, when I'm back in my old haunts, I check on the progress of a muddy little rivulet that forms after a rainstorm, and which has cut a small channel through the turf. Here and there people have tried to save the grass by filling the shallow gully with rocks and sticks. It's a neighborhood of intelligent, accomplished, and professional people, but they don't understand. When it rains, the water just swirls around the obstacles and keeps digging.

USING FORCE
Harnessing Earth's dynamic forces as a means of propulsion, a kayaker runs Virginia's Great Falls of the Potomac.

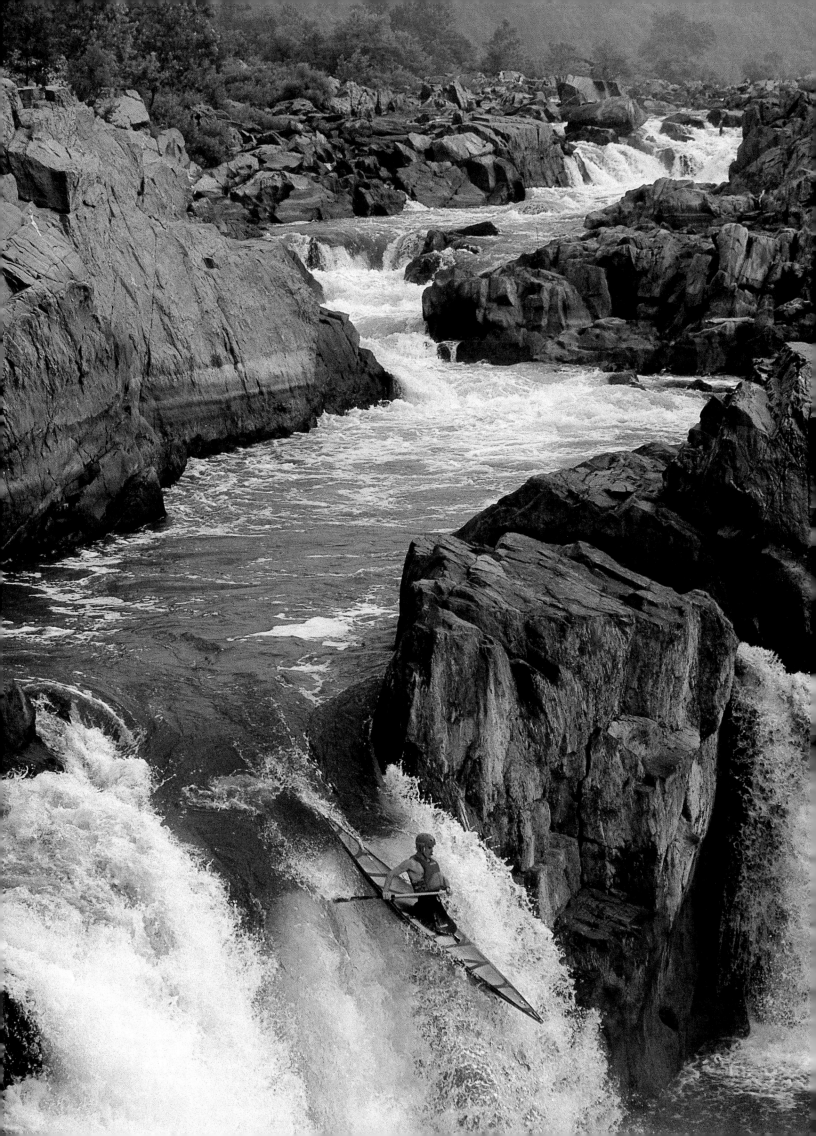

Other Worlds, Other Forces

ALAN CUTLER

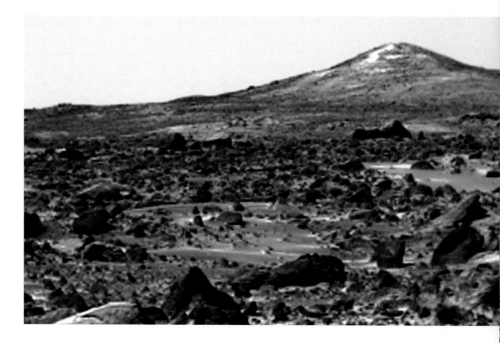

In 1877 the Italian astronomer Giovanni Schiaparelli, observing the planet Mars, reported that he had discovered what appeared to be a strange network of lines crisscrossing the Martian surface. He called these lines *canali*, Italian for channel or canal. The English-speaking public, as well as many scientists, misinterpreted the term to mean artificial canals, drawing the exciting, but mistaken, conclusion that not only water but an extraterrestrial civilization had been discovered on the red planet. Other astronomers saw the lines too, and by the end of the 19th century many were convinced that Mars was inhabited. Some speculated that what they were witnessing was the last gasp of a dying civilization beset by planetary climate change, the canals a final heroic measure to conserve water in the face of increasing desertification. In 1895 one professor of astronomy wrote that improved telescopes would soon make it possible "…to see cities on Mars, to detect navies in [its] harbors, and the smoke of great manufacturing cities and towns… .Is Mars inhabited? There can be little doubt of it… conditions are all favorable for life, and life, too, of a high order. Is it possible to know this of a certainty? Certainly."

More powerful telescopes and later images from space probes revealed instead that the "canals" were optical illusions. The environmental plight of the Martians may have been pure fantasy, but Mars and the other planets of the solar system continue to fascinate and enthrall both scientists and the public alike. The nine planets and their moons, although condensed from the same swirling cloud of cosmic dust as the Earth when the solar system formed 4.6 billion years ago, have all evolved on strikingly different paths. Each of these alien worlds has a distinct identity, shaped by varying combinations of forces. By providing alternative planets for scientists to study, the extraterrestrial planets give perspective on the Earth's physical systems and the underlying processes that drive them.

Many of the differences among the planets arise from two simple variables: distance from the sun and size. Not surprisingly, planets closer to the sun tend to be warmer than those farther away—average temperatures on Mercury's surface are hot enough to melt lead; Pluto is cold enough to freeze the Earth's atmosphere. Most of Pluto's surface, in fact, is thought to be coated with frozen nitrogen, the primary constituent of air. But planetary temperatures are not due to just mere distance from the sun: Venus, though farther from the sun, is actually hotter than Mercury because of the heightened greenhouse effect produced by its carbon-dioxide-rich atmosphere. And, amazingly, Mercury's surface may harbor pockets of ice in the shady depths of craters near its poles where the ice is perpetually sheltered from the sun's intense heat.

The overall composition of a planet's atmosphere is also tied to its size and position in the solar system. Early in the history of the solar system planets relatively close to the sun—Mercury, Venus, Earth, and Mars—had much of their original atmospheres of hydrogen, helium, and other light gases blown away by the solar wind, a stream of charged particles radiating from the sun. Farther out, the planets Jupiter, Saturn, Uranus and Neptune escaped the brunt of the solar wind and were massive enough that even light hydrogen atoms were held by

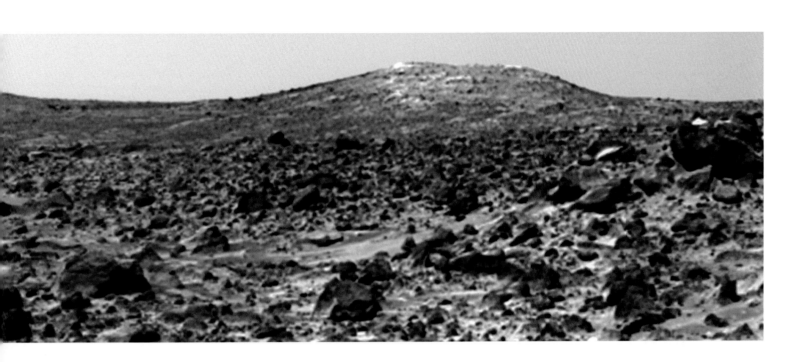

their gravitational pull. Today the atmospheres of these gas giants consist largely of hydrogen and helium, and they are essentially large balls of gas and liquid slush, with relatively small cores of solid rock.

The atmospheres of the inner planets were replenished by volcanic emissions of water vapor, carbon dioxide, and other gases from the planetary interiors. Mercury, so small and close to the sun, could not hold on to even these gases and now has a very thin atmosphere. Venus, almost exactly the size of Earth, retained a dense atmosphere, but its water vapor was lost to space, presumably due to the heat and intensity of the sun's radiation. On Earth, situated half again as far from the solar furnace as Venus, temperatures were cool enough for most of the water vapor to condense and rain out of the atmosphere, producing in time our planet's familiar lakes, rivers, and oceans and its lush, hospitable, water-carved surface.

But what about Mars? By the 1960s most scientists had come to doubt that Mars could harbor significant amounts of water—at least not in a liquid state. All evidence seemed to indicate that the Martian atmosphere was too thin to prevent liquid water from simply boiling away. It was regarded as the desert planet, and the main forces sculpting its surface were thought to be meteorite impacts and fierce winds that, despite the thin air, sometimes kicked up dust storms big enough to engulf the planet's entire surface. But in 1971 the Mariner 9 spacecraft orbited Mars and began sending back images, some of which showed features that looked uncannily like dry river channels.

Later space probes confirmed these observations, and it is now generally agreed that water once flowed on the surface of Mars. There are even features that might be shorelines of ancient seas. The fate of the Martian water remains an open question, how-

Earth's sheer volume of liquid water makes it unique in the Solar System. But Mars once had flowing water, as well, as evidenced by the dry river bed visited by NASA's Pathfinder probe in 1997.

ever, and many of the dry channel systems have a peculiar teardrop shape, unlike anything found on Earth. If the water lies frozen beneath the planet's surface, as many scientists suspect, then perhaps it will gush out from the ground during episodes of warmer temperatures, quickly forming the channels and then soaking back into the soil to refreeze. Whatever the explanation, it is clear the water cycle on Mars works differently from that of Earth. There may not have been the extraterrestrial canal engineers or Martian navies that people had once imagined, but water has indeed left its mark on Mars, and, as before, it has galvanized human interest in the evolution and fates of other worlds.

Getting the Picture

PHOTOGRAPHS BY

Virginia Beahan

AND *Laura McPhee*

TEXT BY

John McPhee

In John McPhee's *Annals of the Former World,* from which the following text was adapted, a geologist declares that the rise of plate tectonic theory this century "was a change as profound as Darwinian evolution, or Newtonian or Einsteinian physics." Out of rocks, fossils, and seismographs emerged a new conception of the Earth, as shaped by unimaginable forces over unfathomable spans of time. It unified disparate threads of geological knowledge into a coherent whole. This revolution in scientific thinking has in turn offered fertile ground for new literary and artistic explorations of our planet and its restless inhabitants.

HIKING TRAIL INTO DORMANT

HALEAKALA CRATER, MAUI, HAWAII

Getting the Picture
Remember About Mountains

AT A GIVEN PLACE—A GIVEN LATITUDE AND longitude—the appearance of the world will have changed too often to be recorded in a single picture, will have been, say, at one time below fresh water, at another under brine, will have been mountainous country, a quiet plain, equatorial desert, an arctic coast, a coal swamp, and a river delta, all in one Zip Code. These scenes are discernible in, among other things, the sedimentary characteristics of rock, in its chemical composition, magnetic components, interior color, hardness, fossils, and igneous, metamorphic, or depositional age. But as parts of the historical narrative these items of evidence are just phrases and clauses, often wildly disjunct. They are like odd pieces from innumerable jigsaw puzzles. The rock column—a vertical representation of the crust at some point on the earth—holds a great deal of inferable history, too. But rock columns are generalized; they are atremble with hiatuses; and they depend in large part on well borings, which are shallow, and on seismic studies, which are new, and far between. To this day, there remains in geology plenty of room for the creative imagination.

GEOLOGISTS MENTION AT TIMES something they call the Picture. In an absolutely unidiomatic way, they have often said to me, "You don't get the Picture." The oolites and dolomite—tuff and granite, the Pequop siltstones and shales—are pieces of the Picture. The stories that go with them—the creatures and the chemistry, the motions of the crust, the paleoenvironmental scenes—may well, as stories, stand on their own, but all are fragments of the Picture.

The foremost problem with the Picture is that ninety-nine percent of it is missing—melted or dissolved, torn down, washed away, broken to bits, to become something else in the Picture. The geologist discovers lingering remains, and connects them with dotted lines. The Picture is enhanced by filling in the lines—in many instances with stratigraphy: the rock types and ages of strata, the scenes and times of deposition. The lines themselves to geologists represent structure—folds, faults, flat-lying planes. Ultimately, they will infer why, how, and when a structure came to be—for example, why, how, and when certain strata were folded—and that they call tectonics. Stratigraphy, structure, tectonics. "First you read ze Kafka," I overheard someone say once in a library elevator. "Ond zen you read ze Turgenev. Ond zen ond only zen are—you—ready—for—ze Tolstoy."

And when you have memorized Tolstoy, you may be ready to take on the Picture.

GEOLOGISTS ARE FAMOUS FOR PICKING UP two or three bones and sketching an entire and previously unheard-of creature into a landscape long established in the Picture. They look at mud and see mountains, in mountains oceans, in oceans mountains to be. They go up to some rock and figure out a story, another rock, another story, and as the stories compile through time they connect—and long case histories are constructed and written from interpreted patterns of clues. This is detective work on a scale unimaginable to most detectives, with the notable exception of Sherlock Holmes, who was, with his discoveries and interpretations of little bits of grit from Blackheath or Hampstead, the first forensic geologist, acknowledged as such by geologists to this day. Holmes was a fiction, but he started a branch of a science; and the science, with careful inference, carries fact beyond the competence of invention. Geologists, in their all but closed conversation, inhabit scenes that no one ever saw, scenes of global sweep, gone and gone again, including seas, mountains, rivers, forests, and archipelagoes of aching beauty rising in volcanic violence to settle down quietly and then forever disappear—*almost* disappear. If some fragment has remained in the crust somewhere and something has lifted the fragment to view, the geologist in his tweed cap goes out with his hammer and his sandwich, his magnifying glass and his imagination, and rebuilds the archipelago.

Recreational jeep trails in desert, near Palm Springs, California

I USED TO SIT IN CLASS AND LISTEN TO THE terms come floating down the room like paper airplanes. Geology was called a descriptive science, and with its pitted outwash plains and drowned rivers, its hanging tributaries and starved coast-lines, it was nothing if not descriptive. It was a fountain of metaphor—of isostatic adjustments and degraded channels, of angular unconformities and shifting divides, of rootless mountains and bitter lakes....

There were festooned crossbeds and limestone sinks, pillow lavas and petrified trees, incised meanders and defeated streams. There were dike swarms and slickensides, explosion pits, volcanic bombs. Pulsating glaciers. Hogbacks. Radiolarian ooze. There was almost enough resonance in some terms to stir the adolescent groin. The swelling up of mountains was described as an orogeny. Ontogeny, phylogeny, orogeny—accent syllable two. The Antler Orogeny, the Avalonian Orogeny, the Taconic, Acadian, Alleghenian orogenies. The Laramide Orogeny. The center of the United States had had a dull geologic history—nothing much being accumulated, nothing much being eroded away. It was just sitting there conservatively. The East had once been radical—had been unstable, reformist, revolutionary, in the Paleozoic pulses of three or four orogenies. Now, for the last hundred and fifty million years, the East had been stable and conservative. The far-out stuff was in the Far West of the country—wild, weirdsma, a leather-jacket geology in mirrored shades, with its welded tuffs and Franciscan melange (internally deformed, complex beyond analysis), its strike-slip faults and falling buildings, its boiling springs and fresh vol-canics, its extensional disassembling of the earth.

GEOLOGISTS, DEALING ALWAYS WITH DEEP time, find that it seeps into their beings and affects them in various ways. They see the unbelievable swiftness with which one evolving species on the earth has learned to reach into the dirt of some

Continued on page 76

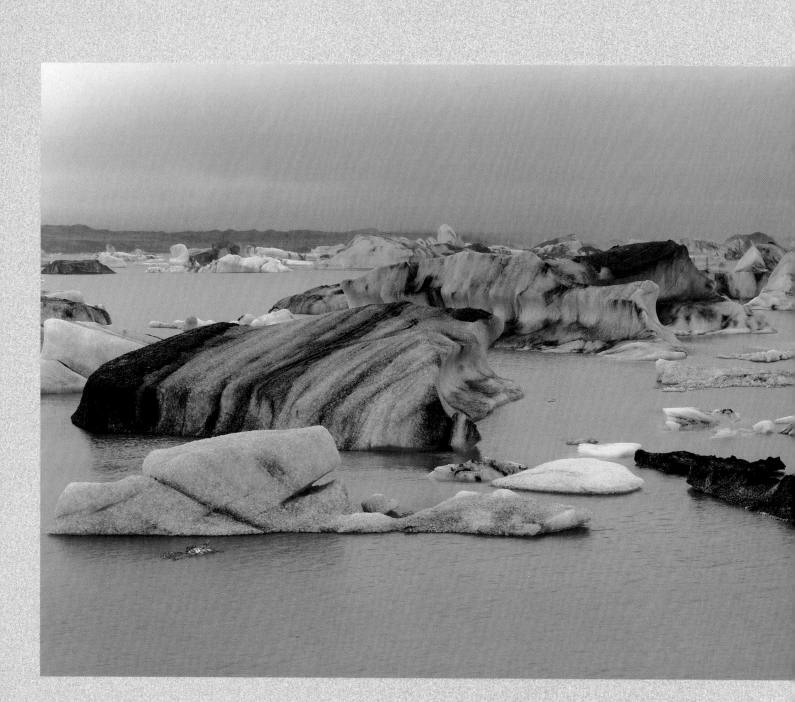

A pulsating series of ice sheets seems to have been set up in the discernible history of the world roughly once every three hundred million years.... So critical is the Earth's temperature that a drop of just a few degrees will cause ice to form and spread. A cool summer. Unmelted snow. An early fall in some penarctic valley. An overlap of snow. A long winter. A new cool summer. An enlarged residue of snow. It compacts and recrystallizes into granules, into ice. Because it is white, it repels the sun's heat and helps cool the air on its own. The process is self-enlarging, unstoppable, and once the ice is really growing it moves....

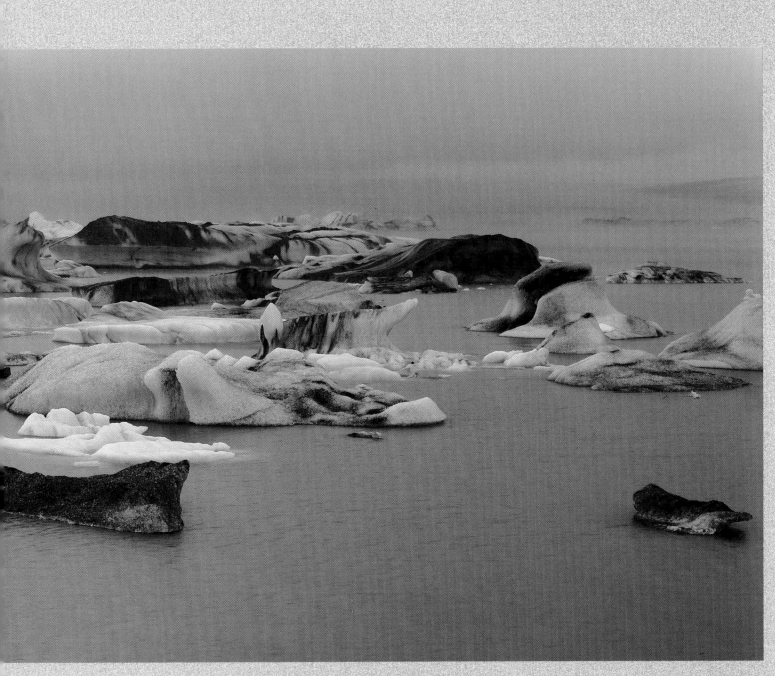

DEBRIS-LADEN ICEBERGS FROM BREIDAMERKERJOKULL GLACIER, SOUTHERN ICELAND

The continental ice sheet moves toward the equator and keeps on going until it cannot stand the heat. At the latitude of New York City, generally speaking, the ice melts as fast as it advances, and thus it goes no farther, and leaves on Staten Island its terminal moraine. Ocean temperatures will have dropped because of the cold, and therefore the oceans are providing less snow to feed the ice. On all fronts, the ice retreats—not necessarily to disappear. The climate warms. The oceans warm. The snow pack thickens in the Great North Woods. A glacier spreads again. Once the pattern is set, the rhythm is relatively steady. For us, the ice is due again in 90,000 years.

The Mediterranean is full
of tectonic rubble, no other
single example being as large
or as destructive as the Italian
microcontinent, also known
as the Adriatic Plate. Its west-
ern boundary is a subduction
zone off the Campanian coast
whose melt has become
Vesuvius, and whose compres-
sional distortions have
become the Apennines....
In the Jurassic, the Italian
microcontinent made its
attempt to become a perma-
nent part of Africa. As Africa
moved northeast with the
opening of the Atlantic,
it returned Italy to sender,
picking up the Tethyan
ocean crust that became
the ophiolites of the Alps.
The Alpine collision began
in the Eocene, about 50
million years ago, and has
not completely stopped.

VIEW ACROSS ERODED LANDSCAPE TOWARD
THE STILL-RISING APENNINE MOUNTAINS,
SOUTHERN ITALY

Remember about mountains: What they are made of is not what made them. With the exception of volcanoes, when mountains rise, as a result of some tectonic force, they consist of what happened to be there. If bands of phyllites and folded metasediments happen to be there, up they go as part of the mountains. If serpentinized peridotites and gold-bearing gravels happen to be there, up they go as part of the mountains. If a great granite batholith happens to be there, up it goes as part of the mountains. And while everything is going up it is being eroded as well, by water and (sometimes) ice. Cirques are cut, and U-shaped valleys, ravines, minarets. Parts tumble on one another, increasing, with each confusion, the landscape's beauty.

BOULDERS IN HOT CREEK,
NEAR MAMMOTH MOUNTAIN, CALIFORNIA

VOLCANIC SAND BEACH, MAUI, HAWAII

While the Pacific lithosphere slides overhead, the Hawaiian heat source stays where it is, making islands. There are five thousand miles of Hawaiian islands, older and older to the northwest, reaching to the trench just east of Kamchatka. Almost all of them have long since had their brief time in the air, and have been returned by erosion and seafloor subsidence into the fathoms from which they arose....

LAVA FLOWING INTO THE SEA FROM KILAUEA VOLCANO, HAWAII

As successive lavas and intruded magmas, the islands build up from the ocean's abyssal plains to surprising volumes and heights. Mauna Kea and Mauna Loa, from seafloor to summit, are by far the highest mountains on earth. Their base is a hundred miles wide, and they are 33,000 feet high. Kilauea continues to build. The Pacific Plate continues to move. As Kilauea goes off the top of the plume, something new will rise. In fact, it is already rising, 20 miles offshore—a new Hawaiian Island, 12,000 feet high at this writing, and 3,000 feet below the present level of the ocean.

The human consciousness
may have begun to leap and
boil some sunny day in the
Pleistocene, but the race by
and large has retained the
essence of its animal sense
of time. People think in five
generations— two ahead,
two behind—with heavy
concentration on the one
in the middle. Possibly that
is tragic, and possibly there
is no choice. The human mind
may not have evolved enough
to be able to comprehend
deep time. It may only be able
to measure it. At least, that is
what geologists wonder
sometimes, and they have
imparted the questions to me.
They wonder to what extent
they truly sense the passage
of millions of years. They
wonder to what extent it
is possible to absorb a set of
facts and move with them, in
a sensory manner, beyond the
recording intellect and into
the abyssal eons. Primordial
inhibition may stand in the
way. On the geologic time
scale, a human lifetime is
reduced to a brevity that is too
inhibiting to think about.

NEWLYWEDS AT CUMAE, SITE OF ANCIENT
GREEK AND ROMAN RUINS, ITALY

Water flowing from reservoir, part of two-thousand-year-old irrigation system, Sri Lanka

Continued from page 65

tropical island and fling 747s into the sky. They see the thin band in which are the all but indiscernible stratifications of Cro-Magnon, Moses, Leonardo, and now. Seeing a race unaware of its own instantaneousness in time, they can reel off all the species that have come and gone, with emphasis on those that have specialized themselves to death.

I ONCE DREAMED ABOUT A GREAT FIRE that broke out at night at Nasser Aftab's House of Carpets. In Aftab's showroom under the queen-post trusses were layer upon layer and pile after pile of shags and broadlooms, hooks and throws, para-Persians and polyesters. The intense and shriveling heat consumed or melted most of what was there. The roof gave way. It was a night of cyclonic winds, stabs of unseasonal lightning. Flaming debris fell on the carpets. Layers of ash descended, alighted, swirled in the wind, and drifted. Molten polyester hardened on the cellar stairs. Almost simultaneously there occurred a

major accident in the ice-cream factory next door. As yet no people had arrived. Dead of night. Distant city. And before long the west wall of the House of Carpets fell under the pressure and weight of a broad, braided ooze of six admixing flavors, which slowly entered Nasser Aftab's showroom and folded and double-folded and covered what was left of his carpets, moving them, as well, some distance across the room. Snow began to fall. It turned to sleet, and soon to freezing rain. In heavy winds under clearing skies, the temperature fell to six below zero. Celsius. Representatives of two warring insurance companies showed up just in front of the fire engines. The insurance companies needed to know precisely what had happened, and in what order, and to what extent it was Aftab's fault. If not a hundred percent, then to what extent was it the ice-cream factory's fault? And how much fault must be—regrettably—assigned to God? The problem was obviously too tough for the Chicken Valley Police Department, or, for that matter, any ordinary detective. It was a problem, naturally, for

a field geologist. One shuffled in eventually. Scratched-up boots. A puzzled look. He picked up bits of wall and ceiling, looked under the carpets, tasted the ice cream. He felt the risers of the cellar stairs. Looking up, he told Hartford everything it wanted to know. For him it was so simple it was a five-minute job.

III

WHEN THE THEORY OF PLATE TECTONICS congealed, in the 1960s, it had been brought to light and was strongly supported by worldwide seismic data. With the coming of nuclear bombs and limitation treaties and arsenals established by a cast of inimical peoples, importance had been given to monitoring the Earth for the tremors of testing. Seismographs in large numbers were salted through the world, and over a decade or so they revealed a great deal more than the range of a few explosions. A global map of earthquakes could be drawn as never before. It showed that earthquakes tend to concentrate in lines that run up the middles of oceans, through some continents, along the edges of other continents—seamlike, around the world. These patterns were seen—in the light of other data—to be the outlines of lithospheric plates: the broken shell of the earth, the twenty-odd pieces of crust-and-mantle averaging sixty miles thick and varying greatly in length and breadth. Apparently, they were moving, moving every which way at differing speeds, awkwardly disconcerting one another—pushing up alps—where they bumped. Coming apart, they very evidently had opened the Atlantic Ocean, about 180 million years ago. Where two plates have been moving apart during the past 20 million years, they have made the Red Sea. Ocean crustal plates seemed to dive into deep ocean trenches and keep on going hundreds of miles down, to melt, with the result that magma would come to the surface as island arcs: Lesser Antilles, Aleutians, New Zealand, Japan. If ocean crust were to dive into a trench beside a continent, it could lift the edge of the continent

and stitch it with volcanoes, could make the Andes and its Aconcaguas, the Cascade Range and Mt. Rainier, Mt. Hood, Mt. St. Helens. It was a worldwide theory—revolutionary, undeniably exciting. It brought disparate phenomena into a single story. It explained cohesively the physiognomy of the earth. It linked the seafloor to Fujiyama, Morocco to Maine. It cleared the mystery from long-known facts: the glacial striations in rock of the Sahara, the Equator's appearances in Fairbanks and Nome. It was a theory that not only opened oceans but closed them, too. If it tore land apart, it could also suture it, in collisions that perforce built mountains. Italy had hit Europe and made the Alps. Australia had hit New Guinea and made the Pegunungan Maoke. Two continents met to make the Urals. India, at unusual speed, hit Tibet. Eras before that, South America, Africa, and Europe had, as one, hit North America and made the Appalachians.

THE HIMALAYA IS THE CROWNING achievement of the Indo-Australian Plate. India, in the Oligocene, crashed head-on into Tibet, hit so hard that it not only folded and buckled the plate boundaries but also plowed in under the newly created Tibetan Plateau and drove the Himalaya five and a half miles into the sky. The mountains are in some trouble. India has not stopped pushing them, and they are still going up. Their height and volume are already so great they are beginning to melt in their own self-generated radioactive heat. When the climbers in 1953 planted their flags on the highest mountain, they set them in snow over the skeletons of creatures that had lived in the warm clear ocean that India, moving north, blanked out. Possibly as much as 20,000 feet below the seafloor, the skeletal remains had formed into rock. This one fact is a treatise in itself on the movements of the surface of the earth. If by some fiat I had to restrict all this writing to one sentence, this is the one I would choose: The summit of Mount Everest is marine limestone.

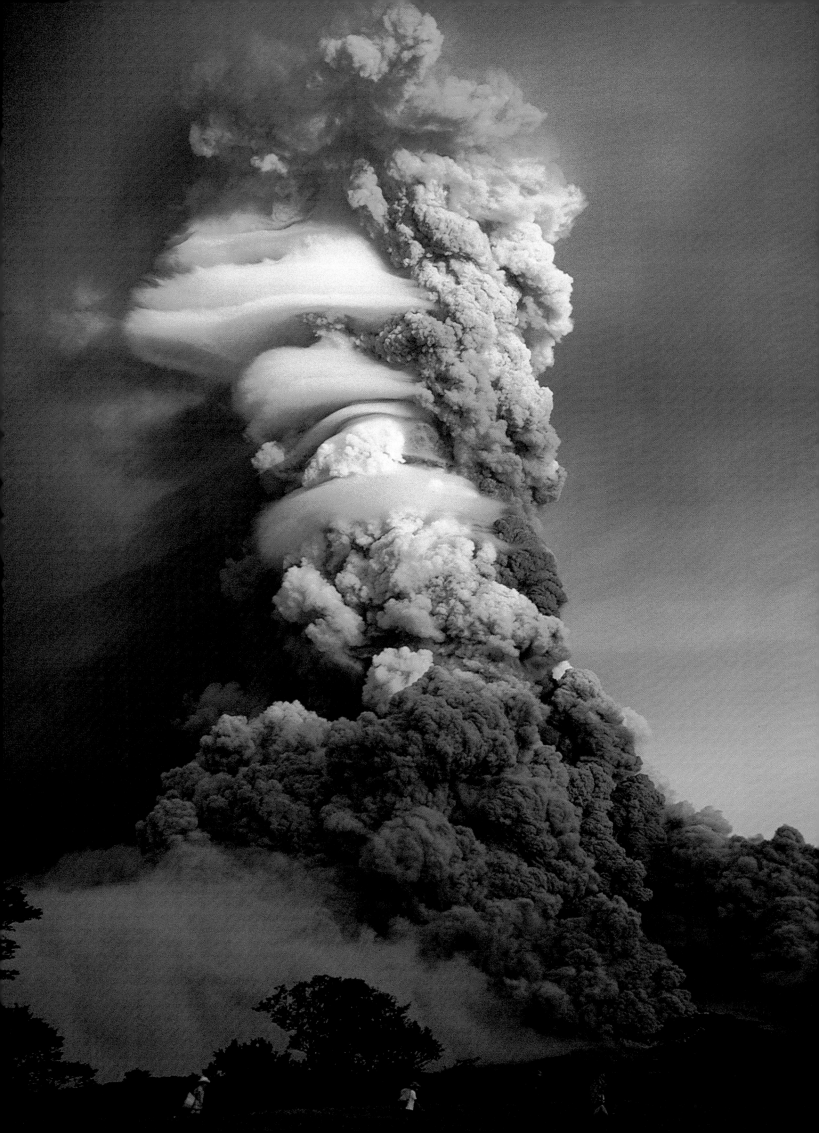

Global Synergies

William Melson

THE ROCKY CRUST AND UNDERLYING MANTLE ARE NOT MERELY THE SOLID FOUNDATIONS FOR THE DYNAMIC SYSTEMS OF OUR PLANET, BUT ACTIVE PARTICIPANTS. POWERED BY HEAT WELLING UP FROM THE EARTH'S INTERIOR, VOLCANIC ERUPTIONS AND GEOLOGICAL UPHEAVALS HAVE BEEN MAJOR FORCES BEHIND THE EVOLUTION OF THE ATMOSPHERE, OCEANS, AND DIVERSITY OF LIFE.

For many people, the phrase global change brings to mind human impacts on the environment, especially warming climates and the extinction of species. Human activities have indeed changed the environment in many ways, and there is good reason to be concerned about human-mediated change in the future. But change is as old as the Earth. At times in the past 4.6 billion years, the Earth's climates have been far warmer and far colder than the present. And the Earth has undergone, and rebounded from, at least five major extinction events. When we think about global change we must consider the Earth as a system that has changed because of interactions among its parts—the atmosphere, ocean currents, the Earth's dynamic interior, and living organisms.

In the past 40 years, our understanding of the Earth's dynamic interior has taught us that its internal forces affect everything from climate to life. Yet we rarely appreciate that the geological forces that originate inside the Earth are fundamental to our planet's capacity to support life.

All life exists in a thin layer embedded between two vast heat engines. One engine, which heats the Earth's oceans, atmosphere, and land, is driven by energy from the sun. The other engine is fueled by the Earth's internal heat, which results mainly from the slow decay of radioactive elements such as uranium and thorium. Although these elements are present in the Earth's rocks at only trace levels (a few parts per million), they produce the energy that powers two of the Earth's major forces of change: plate tectonics and volcanism.

Plate tectonics is the slow motion of the Earth's relatively thin rocky layer, or lithosphere, that underlies continents and ocean basins. The lithosphere moves because of gigantic convection currents that are produced by the Earth's internal heat engine in the mantle. The mantle is a hot denser layer of semisolid rock that lies between the lithosphere and the core. In the mantle, masses of hot rock rise and then sink as they cool, much as water in a boiling pot rises from the bottom as it heats and then descends along the pot's walls as it cools. This process of convection also breaks the lithosphere into fragments, or plates, that slowly move apart or move together, changing the structure of the Earth's surface. And as the number, size, and latitudes of continents and ocean basins shift over geologic time, the evolution and diversity of life responds.

Still adding to Earth's atmosphere, a Guatemalan volcano ejects gases skyward.

Everything changes, nothing remains without change.

—BUDDHA

Many of the discoveries that led to the theory of plate tectonics were made from 1960 to 1980 and came from evidence collected from the ocean floor. In 1975 and 1976, I spent four months on board the *Glomar Challenger*, the first research ship designed for drilling into the deep ocean floor in order to retrieve geologic samples from it. The theory of plate tectonics asserted that the ocean basins are young geological features, continually being formed along mid-ocean ridges where the lithosphere spreads apart and molten rock from the Earth's mantle erupts onto the ocean floor. Thus, drilling into the Earth should yield only young rock, in geologic terms—mainly less than 200 million years.

We drilled deeply into the northern Mid-Atlantic Ridge at a number of sites located between the Azores and the Equator, removing rock samples and examining them in our shipboard lab. From our samples, we confirmed our hypothesis that the Mid-Atlantic Ridge is an extremely young volcanic field, continually generating new oceanic crust. As a result of seafloor spreading, North America and Africa are slowly drifting apart, widening the Atlantic Ocean at a rate of about two centimeters per year.

Such continental breakups caused by seafloor spreading have left their mark on the diversity and distribution of present-day plant and animal species. Marsupials, the group of mammals that includes kangaroos, wallabies, koalas, and opossums, are a good example. Marsupials give birth to immature young that attach themselves to the mother's nipple, which in most species is surrounded by a pouch. Today marsupials are abundant and diverse only in Australia, but they evolved in North America about 100 million years ago. At that time North America was much closer than it is today to South America, western Antarctica, and Australia. Over time, the early marsupials migrated throughout the adjacent landmasses and evolved into many species. Shortly after the evolution of marsupials, however, placental mammals also evolved. (The offspring of placental mammals develop fully inside the female's uterus before birth unlike the young of marsupial mammals.) As placental mammals evolved and spread, they occupied many of the same habitats as marsupials. Where marsupials and placentals came together, as in North America, most of the marsupials became extinct because they could not survive competition with the more intelligent and adaptable placentals. Today, only one marsupial family, the opossums, successfully coexists with placental mammals in North America.

In Australia and South America, however, marsupials flourished and diversified. By 65 million years ago, seafloor spreading had created sizable ocean basins that isolated these two continents from other landmasses that harbored placental mammals, including North America. In the two isolated continents of the Southern Hemisphere, marsupials occupied a variety of habitats and diversified into many different forms, some resembling moles, elephants, camels, and even wolves, such as the Tasmanian wolf, which became extinct in historic times.

The most recent chapter in the story of marsupial evolution occurred about three million years ago with the formation of the isthmus of Costa Rica and Panama that connects North and South America. As two oceanic plates converged, the ocean that had separated the two continents narrowed, and volcanoes formed. Over time, the erupted magma piled up, eventually rising above sea level and creating a land bridge between the two continents. Although a relatively small-scale event in terms of plate tectonics, the creation of the land bridge had profound consequences for the evolution of life in the Americas. When landmasses converge, previously isolated populations of species can intermingle. The migration of placental mammals across the land bridge from the north into South America contributed to the extinction of most of the marsupials that evolved there. As species compete for the habitat niches, some may lose the battle and become extinct. Exposure to new diseases and new predators also takes its toll.

Continued on page 86

ANCIENT CLUES

Only glassy yellow rafts remain of diatoms that reproduced by simple cell division, their myriad openings arranged in elaborate patterns unique to individual species. Of the living algae that once inhabited these silica shells, about 70,000 species, both fossil and recent, have been described, and that may only be the half of it. As small as they are diverse (some 25 million would fit in a teaspoon), diatoms are both abundant and essential. They make up about a quarter of plant life by weight, and produce at least a quarter of the oxygen we breathe. In life they provide high quality nutrition to animals as small as protozoas and as large as baleen whales. In death they ram down ocean floors, where their oil-rich plasma is eventually buried and transformed into petroleum.

PILING UP THE PAST

Black volcanic rubble recalls the eruptions that formed the island of Mauritius nearly ten million years ago. Now it has been heaped into piles to expose the fertile soil that nurtures sugar cane, the island's top export crop. Where the sweet stalks now sprout, the flightless dodo bird roamed until hunted to extinction within 90 years after the Dutch settled the uninhabited island in 1598.

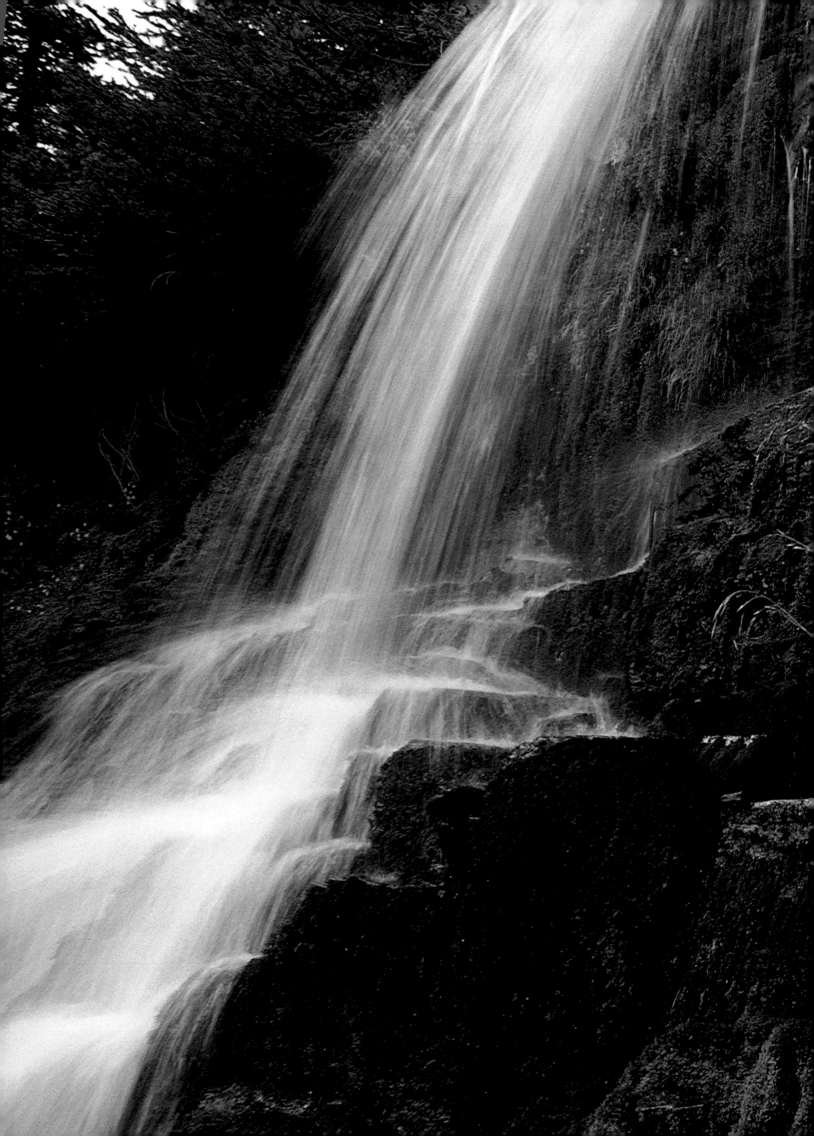

SPLASH OF LIFE
Lava formed these cliffs in Oregon—
now the waters of Vidae Falls help sculpt
their shape. They also support some
600 plant species, including hot red
penstemon blossoms.

Every moment Nature starts on the longest journey, and every moment she reaches her goal.

—JOHANN WOLFGANG VON GOETHE

Continued from page 80

The formation of the supercontinent Pangaea was perhaps the most dramatic convergent event in terms of impact on the evolution of life. Pangaea (Greek for "all land") formed from the northward movement of Gondwana, a large continent in the Southern Hemisphere that had assembled millions of years earlier. As Gondwana drifted north it joined North America, Europe, and Asia, creating a single great landmass that covered two-fifths of the globe. Seaways that had intervened between the continents were destroyed, and mountain ranges rose where once there had been seafloor. (The present Appalachian Mountains are a deeply eroded remnant of that event.) Shortly after the final assembly of Pangaea at the close of the Permian Period 250 million years ago, 80 to 95 percent of marine invertebrate species perished in the largest biological extinction in the fossil record. As yet, there is no consensus as to the cause or causes of this extinction, but the convergence of continents may have played a role.

In general, global biodiversity is richest when the continents are widely dispersed across the globe, as they are today, and poorest when the continents are assembled as they were in Pangaea. When the Earth's landmass is fragmented and separated by large bodies of water, plants and animals evolve in isolation, which enhances the development of new species. In addition, when continents are numerous, the length of coastline increases, providing increased shallow-water habitats for bottom-dwelling organisms.

Today there is an interesting, but disturbing, parallel to the ancient tectonic process that brought formerly isolated animal and plant populations into contact. The movement by humans of plants and animals from one continent or island to another can seriously endanger native species. When moved to a new region, whether by intention or accident, alien species are freed from the forces of competition, predation, and disease that kept them in check in their natural environments. The gypsy moth, for example, introduced from Europe for commercial silk production, has wreaked havoc throughout our eastern forests. The zebra mussel, probably a stowaway in the ballast water of ships, has caused widespread economic and environmental damage from Canada to the Gulf of Mexico. And the HIV virus has spread from Africa to all parts of the globe as a result of the ease and speed of human travel. What continental drift might do in million of years can now be done in several hours or days.

The slow dance of the continents does more than isolate or connect animal and plant communities. It can strongly influence global climates. The middle Cretaceous, near the end of the dinosaur era, from about 90 to 120 million years ago, for example, was unusually warm. The Earth's internal energy probably played a major role in this unusual episode in two ways: by an increase in the rate of seafloor spreading and in the incidence and magnitude of volcanic eruptions. Increased volcanic activity may have raised the atmospheric levels of the greenhouse gas carbon dioxide, creating a warmer climate.

When the rate of seafloor spreading is high, the oceanic lithosphere is hotter and thicker. As a result, the volume of the ocean basins decreases, sea level rises, and water spills onto the continents. As vast seaways advanced over much of the continents because of the rise in sea level, a shallow sea stretched from the Gulf of Mexico to the Arctic Sea. This was one of the greatest and the last of the marine floodings of the interior of North America. At that time, the continents were still drifting apart after the breakup of Pangaea, and newly formed ocean basins brought equatorial waters northward, warming climates in high latitudes. In general, this period of high sea level and others like it at other times in geologic history correlate with episodes of biologic diversification among marine invertebrates.

We are unlikely to read in the newspapers about the geologic changes that occur over the course of millions of years as a result of the Earth's internal processes. But those processes that cause immediate impacts on life, such as volcanic

eruptions, frequently make the headlines. Most volcanoes delineate plate boundaries either at zones where plates move apart or where they come together.

Volcanoes also form in the middle of plates above "hot spots," such as those that lie beneath Iceland, Hawaii, and Yellowstone National Park. Hot spots form above rising hot mantle plumes that partially melt through the thin overlying plate. Repeated eruptions of thick lava from a hot spot in the Pacific Ocean have built the Hawaiian Islands. Cut off from other landmasses, oceanic islands form isolated habitats, which leads to the evolution of endemic species, native species that are found nowhere else in the world.

The isolation of island animal and plant communities, however, makes them particularly susceptible to extinction triggered by alien species introduced to the island by humans. The mongoose—a weasel-like placental carnivore—was imported to Hawaii to rid sugar cane fields of rats, also an alien invader. A daytime hunter, the mongoose rarely encounters the nocturnal rats, but instead preys on native ground-nesting birds, many of which are threatened with extinction.

Large volcanic eruptions can profoundly affect the Earth's atmosphere and climate. When highly explosive volcanoes erupt, they can project a fine mist of particles tens of miles into the Earth's stratosphere. These aerosols, which can remain suspended in the stratosphere for years, form a haze that reflects the sun's radiation back into space. Because less solar radiation reaches the Earth, surface temperatures cool. The 1991 eruption of Mount Pinatubo in the Philippines, for example, ejected three to five cubic kilometers of fragmented magma into the stratosphere, making it the largest eruption of the past century. As a result of the aerosols ejected into the atmosphere, 1992 was the coolest year since 1986, interrupting six years of record-breaking high temperatures, possibly the result of the buildup of carbon dioxide, methane, and other greenhouse gases in the atmosphere.

The 1815 eruption of Tambora Volcano on Sumbawa Island in Indonesia had an even greater effect on climate. The volume of the erupted magma was between 30 and 150 cubic kilometers. About 12,000 people died in the eruption on Sumbawa and the surrounding islands, and another 80,000 perished later in the Northern Hemisphere as a consequence of climatic effects. Following the eruption, a gigantic veil of finely broken rock and aerosols spread over both hemispheres, reaching North America and Europe in the late fall of 1815. On average the temperature in 1816 dropped by about 1.1°C (about 2°F). Widespread snowstorms struck Canada and New England between June 6 and 11, 1816, and severe frosts occurred throughout the summer, leading to crop failure and widespread famine. Eruptions of this magnitude will certainly occur again, most likely within the next few hundred years, although when is uncertain.

Volcanoes, however, are not only engines of destruction. Volcanic eruptions are also the ultimate source of most of the gases that make up the Earth's atmosphere. As they erupt beneath the sea and on land, volcanic gases are noxious to life. They are highly acidic and lack "free," or uncombined oxygen, that can be used by organisms for respiration. Yet over geologic time, their accumulation and their interaction with other parts of the Earth's complex system produced our modern life-supporting atmosphere. Volcanic gases, for example, are cleansed rather quickly through the synergy between the Earth's lithosphere and atmosphere. Because the acids readily dissolve in water, rain dilutes them. As dilute acid rain falls on rocks, it reacts with minerals in the rocks to produce clays, salts, and other compounds that are neutral or weakly acidic.

The most striking feature of our atmosphere, however, is its uniquely high oxygen content. The atmospheres of the other planets contain at best traces of free oxygen, as did the Earth's early atmosphere. How then do we have an atmosphere that contains about 21 percent by volume of free oxygen? And what mechanisms sustain this

abundance, what keeps plants and animals from using it up?

The most important source of free oxygen is photosynthesis, the chemical process that plants and algae use to produce energy. Photosynthetic organisms use energy from the sun to convert carbon dioxide and water into energy-rich sugars. Oxygen is released as a by-product. At what time, however, did photosynthetic organisms appear? The most recent evidence comes from fossils with a variety of shapes and sizes found embedded in 3.5 billion-year-old rocks in western Australia by William Schopf of UCLA. From the diversity of the fossils he found, Schopf concluded that photosynthetic organisms had already undergone considerable evolution. Over time, as photosynthetic organisms became more abundant, carbon dioxide was depleted and oxygen accumulated, resulting in our atmosphere's present composition.

There is little question that life processes put the bulk of the free oxygen into the atmosphere, and that simple life created the conditions for complex life. At night, when the sun's energy is not available, plants respire, much as animals. That is, their cells use oxygen to burn the sugars and starches they made during the day. Carbon dioxide is released as a by-product. Plants, however, always produce more oxygen during photosynthesis than they use during respiration.

Decomposers—bacteria and fungi—remove oxygen from the air to metabolize organic material, and they release carbon dioxide as a by-product. Unlike plants, however, decomposers never restore free oxygen to the atmosphere through photosynthesis.

Decomposition would seem to nullify the effects of photosynthesis by removing free oxygen from the atmosphere as fast as photosynthesis can add it. But it doesn't. The reason is that large amounts of organic material are buried in the Earth's crust, trapped by the Earth's internal forces millions of years ago. The remains of plants and animals collected in deep sedimentary basins that plate tectonics created at the margins and interiors of continents and on the ocean floor. Burial removed the carbon-rich material from contact with the oxygen-rich atmosphere, thereby preserving free oxygen for the many organisms, including people, which depend on it. Without these geologic reservoirs, our oxygen-rich atmosphere would have been depleted long ago.

Over millions of years, tectonic forces acting on the buried organic material created the coal, oil, and gas that fuel our modern society. But as we burn fossil fuels today, we are undoing what biological processes produced and geological processes preserved. So far, it appears, we have not appreciably affected the atmosphere's oxygen content. Rather, it is by raising the level of carbon dioxide that we are having our greatest effect—an effect that most scientists agree is increasing global temperatures, despite the transitory moderation caused by recent large volcanic eruptions. And surely, as is evident from past changes in global climate, rapid shifts in climate will trigger changes to life on the planet. But the exact nature and the extent of those changes are difficult to predict.

Long-term predictions of change will always be imperfect because of the complexity of the Earth's systems, which function on a global scale. We must be able to understand the synergistic interactions of these systems and be mindful of the likely impacts of our activities. Our challenge is to act prudently in light of the knowledge we have acquired. The noted theologian and paleontologist Pierre Teilhard de Chardin summarized the complex system in which we are embedded: "Each element of the cosmos is positively woven from all others. . . . It is impossible to cut into this network, to isolate a portion without it becoming frayed and unraveled at its edges."

ACID REIGNS
Less than a century old, the marble figures on Rome's monument to King Victor Emmanuel are already crumbling. The chemical action of sulfurous smog transforms marble into fragile, flaking gypsum.

New Spins on Ancient Cycles

ALAN CUTLER

Carbon makes up only 0.025 percent of the Earth's crust—far less than silicon, iron, or even magnesium—but its ability to combine with other elements into a near-infinite variety of complex molecules makes it the key ingredient of the biosphere. As organisms live, breathe, die, and are buried, carbon cycles between the biosphere, atmosphere, and the lithosphere. From traces of carbon and the types of minerals and fossils found in rocks billions of years old, it is clear that the biologically-driven carbon cycle has been operating from almost the beginning of the Earth's geologic history.

Despite its biological importance, most of the Earth's carbon is not found in the bodies of living organisms. More than 99.9 percent is buried in the planet's crust as petroleum, coal, and other hydrocarbons, and vast deposits of so-called carbonate rocks—limestone, dolomite, chalk, and a few others. This fossil carbon is recycled to the surface through the slow geological processes of erosion and plate tectonics, though our society's appetite for fossil fuels has lately sped up the process considerably.

Of the carbon that today circulates through the biosphere via the ancient processes of photosynthesis and respiration, human beings are appropriating an increasingly large share for their own use. Many forests and other natural ecosystems have been converted to cropland, pastureland, cities, and roads, or are harvested for wood to be used as fuel, paper, or building materials. As the human population continues to expand, so does our impact on the global carbon cycle. A study by Stanford University biologists in 1986 estimated that human beings "co-opted" more than 30 percent of the net primary productivity (the total "food" yielded by photosynthesis) from all ecosystems on the Earth's land areas and 2 percent of that produced in the oceans. Given that we are only one of several million species on Earth, this is an astonishingly large share. When the researchers incorporated the amount by which global productivity has likely been reduced as a result of human activities—through pollution, erosion and soil loss, desertification, and urbanization—the impact on the biosphere is even more astounding: As much as 40 percent of the potential productivity of land ecosystems is appropriated by human beings.

Our effect on the Earth's biological cycling of the elements does not stop with carbon. Human beings have profoundly altered the global nitrogen cycle. Another crucial element for all life forms, nitrogen is a building block for proteins, chlorophyll, DNA, and other biological molecules. It is by far the most abundant element in the atmosphere, accounting for nearly 80 percent of dry air, but very few organisms are capable of converting atmospheric nitrogen into a biologically usable form. Nitrogen molecules consist of two nitrogen atoms linked by an extremely strong chemical bond. Breaking this bond requires either a large jolt of energy (such as from a lightning flash) or special enzymes produced by only a few types of bacteria and algae. The bacteria live in the soil or as symbionts in the roots of certain plants, especially legumes such as peas and soybeans. For billions of years the biosphere has depended entirely on these natural processes to obtain "fixed" nitrogen, that is, nitrogen in a ready-to-use chemical form.

But an important new variable was added to the equation in the early part of the 20th century—synthetic nitrogen fertilizers. During World War I, an industrial process of nitrogen fixation was developed by German engineers, though it was initially used to manufacture explosives, not fertilizer. In the decades since the invention of synthetic fertilizers, its manufacture and use has grown exponentially to meet the demand for increasingly high agricultural yields to feed the growing human population around the world. Synthetic fertilizer is often overapplied, however, and either builds up in the soil or leaks into neighboring ecosystems to agricultural fields

During the past century, through the production of synthetic fertilizers, combined with the planting of nitrogen-fixing crops and the burning of fossil fuels (which releases nitrogen oxides into the air), human beings are estimated to have doubled the rate by which nitrogen is fixed in ecosystems on dry land, and much of this excess nitrogen is ultimately washed into aquatic ecosystems as well. Though nitrogen is largely beneficial to life, there is such a thing as too much: Soils and natural waters overloaded with nitrogen can become too acidic for some species, and high levels of nitrates in human drinking water can lead to health problems.

Other, less predictable, changes may be in the offing as well, as different species and biological communities respond to the nitrogen bonanza in their own idiosyncratic ways. The European heathlands, which historically have grown in nitrogen-poor conditions, are reported to be declining in some areas due to invasion by nitrogen-greedy grass species. Toxic algal blooms in estuaries and coastal waters have also been linked to excess nitrogen from agricultural runoff.

The vast and complex Earth system, of which the carbon and nitrogen cycles form a part, will ultimately adjust to whatever alterations our species imposes on it. Whether we will be able to adapt to these changes, whatever they are, whenever they come, with a similar degree of equanimity, is another question.

Nature's slow, inexorable carbon cycle is played out in England's white chalk cliffs (above) Tiny sea creatures use carbon dioxide to make their shells, which combine over eons to form the cliffs. Rains and pounding seas dissolve the carbon, which flows back into the water for reuse by new generations of sea creatures. Humans have sped up the carbon cycle (below), pumping carbon-based fuels out of the ground, then burning them to generate energy and operate motor vehicles. Released into the air, carbons are then washed back to Earth by rain.

Time and Complexity

The Earth's biosphere is the result of nearly four billion years of evolution. Not until the 20th century were scientists able to accurately measure the scope of the planet's history. Is our youthful species the crowning achievement of evolution—or an afterthought? How does the evolutionary timescale alter our perception of the nature of change, and humans as a force of change? What are the sources of and threats to biological complexity? These essays consider change and complexity from a time perspective—from time that is unfathomably long on our planet, to time that is running out fast for fragile ecosystems.

Scales of Change

Stephen Jay Gould

OUR PERCEPTION OF TIME PROFOUNDLY INFLUENCES OUR PERCEPTION OF CHANGE. A DRASTIC
CHANGE AT ONE SCALE MAY APPEAR TRIVIAL AT ANOTHER. HOW CAN WE EVALUATE THE
SIGNIFICANCE OF CHANGES THAT OCCURRED OVER TIMESCALES BEYOND OUR LIMITED HUMAN
EXPERIENCE? OR OF CHANGES WE OBSERVE TODAY IN THE CONTEXT OF PLANETARY TIME?

Thomas Browne, the great 17th-century English physician and philosopher, expressed the comfort that a literal view of Biblical time—an earth less than 6,000 years old, with humans created so near the outset, on the sixth day—could provide to a frail creature with such strong needs to judge his own species as the nub of universal purpose in God's benevolent system: "Time we may comprehend," wrote Browne in one of his celebrated aphorisms, "tis but five days elder than ourselves."

Among the major scientific revolutions that have defined our intellectual history and that, paradoxically, always dethrone various underpinnings of previous beliefs in the cosmic importance of human life, geology's discovery of "deep time" ranks among the most portentous—for if earthly time must be measured in billions of years, and human time in but a fraction of one percent of this cosmic immensity, then Browne's comfort evaporates. How can we view human existence as the goal and purpose, the apotheosis of all that came before—if that before encompasses nearly all of time, with our belated appearance reduced to a mere eye blink at the end, the thinnest of gildings upon a vast edifice. No scientist ever matched a great writer and humanist, our own Mark Twain, in forceful expression of this crucial basis for any scientific understanding of time and change. Soon after the completion of the Eiffel Tower in 1889, then the world's tallest human monument, Twain wrote:

> Man has been here 32,000 years. That it took a hundred million years to prepare the world for him is proof that that is what it was done for. I suppose it is. I dunno. If the Eiffel Tower were now representing the world's age, the skin of paint on the pinnacle-knob at its summit would represent man's share of that age; and anybody would perceive that that skin was what the tower was built for. I reckon they would, I dunno.

Twain used Lord Kelvin's estimates, then current, for the age of the Earth and human appearance. We would now revise both figures considerably upward—the Earth's age to 4.6 billion years, the appearance of modern *Homo sapiens* to about 120,000 years—but Twain's point remains undiminished. Human time, compared with Earth time, resembles a superficial layer of paint atop a grand building.

The predatory *Anomalocaris* was just one player in the explosion of new life forms a half billion years ago.

It is not the strongest of the species that survive, nor the most intelligent,
but the one most responsive to change.

— CHARLES DARWIN

Robert Burns, in a romantic couplet that caught the theme of his era (and of our own time) in brisk epitome, wrote:

Look abroad through nature's range.
Nature's mighty law is change.

If we grant this claim that change pervades nature, then we must, above all, try to comprehend the phenomenally different modes and meanings of change across the range of nature's highly various scales. The greatest impediment to this quest lies in our human tendency to view our own scale as exclusive and canonical. Such a bias might not have led Dr. Browne and his compatriots far astray, for they equated human time with Earth time. But our modern understanding precludes such emphasis upon the scale of direct human perception—for a mere gilding cannot reveal or explain the lily.

In one of the most famous images in our intellectual history, Francis Bacon argued that our attempts to understand nature face four major obstacles based on limits of human mentality and culture. Bacon referred to these impediments as "idols," naming them *idola tribus, idola specus, idola fori,* and *idola theatri*—or idols of the tribe, cave, marketplace, and theater.

Of the last three, idols of the cave refer to mental peculiarities of individuals, idols of the marketplace to errors imposed by the use of language, and idols of the theater to fallacies inherent in older systems of philosophy. But Bacon gave pride of place to his most important first category, idols of the tribe, defined as limits *"fundata in ipsa natura humana"*—founded in human nature itself. Interestingly, Bacon identified the most pernicious idol of the tribe as our inherent tendency to read and interpret the entire universe within the strictures of our limits, scales and perceptions. "It is false," he writes, "to use human senses as the measure of things," to base all our conclusions "reached either by sensation or by reason, upon analogies to man and not upon analogies to the universe." The images in the mirror of the human mind, he

continues, cannot provide a good measuring rod for external reality—for when we mix our own nature with the true nature of things *("suam naturam naturae rerum immiscet")*, we can only "distort and corrupt" the world outside ourselves. A brilliant manifesto—but, remember that Bacon could not know the full extent of the problem, for he lived in Browne's age and didn't grasp the special distorting power of this idol of the tribe when we extrapolate our meager limits into nature's temporal vastness.

I shall consider only two among time's many scales of change in this essay—human time measured by the decades of our personal lives (with a millennium recognized as the longest useful increment we can imagine for our narratives of human history), and planetary time measured in millions and billions of years (with that same millennium now representing an unmeasurable moment in almost all geological circumstances—its evidence often missing from the record entirely, or compressed onto a single "bedding plane," or lamination within sedimentary strata). In fact, a fuller accounting of all scales could not proceed beyond planetary time, for the 13 to 18 billion years of universal history since the big bang lie in the same ballpark as the 4.6 billion years of our own planet's time.

But we could proceed downwards from human time into several realms of far greater quickness. In a biological world still close to us, how can we fathom the fullness of the adult mayfly's single day of life? The early pre-Darwinian evolutionist Robert Chambers, in a brilliant metaphor based on our failure to appreciate scales of time, wrote in 1844 that we fail to recognize such a slow process as evolution because so little change can unfold in the day of our entire lifetime—just as the mayfly would remain oblivious to human growth and aging, and would probably view any vertebrate as immortal and unchanging, based on the range of possible observations during the earthly day of its own totality:

Suppose that an ephemeron [a mayfly], hovering over a pool for its one April day of life, were capable of observing the fry of the frog in the water below. In its aged afternoon, having seen no change upon them for such a long time, it would be little qualified to conceive that the external branchiae [gills] of these creatures were to decay, and be replaced by internal lungs, that feet were to be developed, the tail erased, and the animal then to become a denizen of the land.

At least I can imagine the mayfly's limitations and dilemmas, but I don't even know how to think about the temporal world of some basic particles that endure for an effectively unmeasurable fraction of a single second. I'm not even confident that time, as we can conceive or express the concept, has any meaning at such a scale.

In any case, following Chambers's insight and metaphor, let me illustrate the power of Bacon's primary idol of the tribe—errors based on trying to understand phenomena of widely different scales by the single measuring rod of familiar human time—with two opposite examples from my own field of evolutionary theory: first, reading too much into genuine change in human time; second, misreading planetary time by applying standards and perceptions of human time.

The paradox of the visibly irrelevant: A staple of textbook discussion and journalistic reports about evolution properly resides in cases of observed and gradualistic evolutionary change within the lifetime of a scientific observer, or a few centuries of human record keeping at most—insects that evolve resistance to DDT and other pesticides, plants that adapt to grow on previously poisonous soils of mine tailings, and the famous peppered moths that developed darkened wings when industrial soot removed the lighter lichens and blackened the tree trunks of Britain, thus rendering darker moths less visible, when they alight on trees, to bird predators that hunt by sight. We celebrate such cases as our finest proofs of evolution's reality—as well we should, I suppose, especially given the common legend that

evolution, if a genuine process at all, must occur too slowly for documentation by human observers.

But our texts and popular articles almost invariably commit a classic error of scaling when they make the further, almost automatic, claim that such tiny changes must represent a standard rate for evolution, fully capable of changing a small terrestrial ancestor into a gigantic aquatic whale in the full majesty of geological time. In other words, we see such tiny changes as powerful only because their obvious weakness can be accumulated to strength by stacking immense numbers of insignificant increments end to end over planetary time.

In fact, when we recognize the magnitude of difference between human and planetary scales, we must acknowledge an exactly opposite situation and dilemma. These observable changes in human time are far too fast, and far too potent, to represent the ordinary pace of evolution in planetary time. To state the paradox more generally: any change rapid enough to be measurable, or even perceptible at all, in human time must race like the whirlwind through planetary time, converting a small terrestrial mammal into a whale in a geological moment, not at the Earth's own scale of millions of years.

The leading American evolutionist George Williams provides a striking example in his 1992 book, *Natural Selection.* The English sparrow, Williams notes, entered North America in the mid-19th century, quickly spreading over the continent to become one of our most familiar birds. In some regions, these sparrows have evolved sufficiently "that certain linear measures, such as lengths of various bones, have changed by as much as 5% in about a century." Of a change of this magnitude, Williams writes: "At this rate, no birdwatchers will notice in their old age that the bird looks any different from what they remember from childhood. From most people's perspectives, English sparrows are staying much the same."

So here we have a change not even fast enough to rise to the level of visibility in the lifetime of a passionate amateur observer, and therefore known

only by quantitative techniques used by scientists. But Williams calculates that this rate of change (an increase of .05 percent per century), if maintained for the short geological increment of a million years, would turn "sparrow-size into ostrich-size bones, and back again, about 54 times" during this geologically rather trivial interval!

Thus, these small changes in human time—generally regarded when we don't think properly about scaling, as the source of geologically slow change as well—extrapolate to such great effect in instants of planetary time that they cannot represent the processes or material of evolution at the larger scale of life's history. We may therefore summarize the "paradox of the visibly irrelevant": if it's fast enough to be visible at all in human time, it cannot represent the relevant process that produces large-scale evolution in planetary time.

The misinterpretation of punctuated equilibrium: In 1972 Niles Eldredge and I developed a theory of evolution that we called "punctuated equilibrium." We pointed out that the majority of conventional sexually reproducing animal species originate rapidly in geological time (the punctuation) and then remain stable for long periods, with five to ten million years as the average duration for marine invertebrate species in the fossil record (the equilibrium).

We developed punctuated equilibrium to correct a misperception induced by Bacon's primary idol of the tribe—the limited scope of human perspective and its false application to phenomena of very different times and sizes. The punctuations of our theory represent ordinary events in the formation of new species, properly viewed as glacially slow in human time, but scaling to geological moments in planetary time. The previous error had resided in the false assumption that "glacially slow" in human perception must translate to similar gradualism in the fossil record—thus leading to an expectation that paleontologists should be able to document the origin of new species by discovering slow and continuous transformation in fossils collected through a sequence of strata accumulated during millions of years.

Most new species arise when small populations of the parent species become isolated at the periphery of the parental geographic range and then diverge extensively enough to become distinct from other populations. If a human observer spent an entire career living in such an isolated area, scrupulously trying to document the changes in such an incipient species, he would note little, if anything, during his lifetime—for most species probably require a few thousand years for full separation from their ancestors, and 30 years of a human career span only a fraction of this totality. Thus, our human observer would conclude that the formation of new species, by his measuring rod, proceeded just about as slowly as anything perceptible possibly could. He would be justified in concluding that evolution represented the slowest kind of change that a human being could notice directly.

But when we move to the planetary time scale of paleontology, this glacial slowness becomes a geological instant. Five thousand years—a generous interval for the origin of a species—represents, after all, just one tenth of one percent of five million years, the average duration for a species. So if a species originates in five thousand years and then remains stable for five million years, its origin—although slow as slow can be in human time—will flash by in a planetary moment. In fact, since even the thinnest layers within sedimentary strata usually compress the evidence of more than five thousand years onto a single surface, the origin of most species will be effectively instantaneous by the measuring rod of nature's own historical record.

If we move from these particular evolutionary examples to a general consideration of our usual concept of change in planetary time, we note that the same idol of the tribe—misreading all disparate scales in terms of human time—has been identified as a chief impediment by both classically opposed schools for explaining geological history: the uniformitarians and the catastrophists alike. (Uniformitarians believed that all grand changes in geological immensity—from Grand Canyons to

Mount Everests—formed gradually by accumulating daily changes of human time bit by bit, as in eroding a few sand grains a day to carve the Grand Canyon in a million years. Catastrophists believed that such grand changes could occur rapidly, but very rarely, by occasional catastrophes of truly global scale.)

An interesting reason underlies this common appeal by adherents to such different theories of planetary change. If we misconstrue planetary time by limiting ourselves only to the changes that we can mark as efficacious in human time, then what do we miss (in a human lifetime) that might actually regulate change in the immensity of geological history? The uniformitarians and catastrophists agree that restriction to human time causes us to ignore the major force of planetary time. But the two schools hold diametrically opposite views about the nature of the crucial missing ingredient!

Uniformitarianism and the specter of impotence: Charles Lyell (1797-1875), guru of the uniformitarian view that then became canonical in geology but has again been questioned in our own times, claimed in his epochal textbook, *The Principles of Geology,* that we should explain the Earth's history entirely in terms of slowly-acting present processes operating throughout time at their current ranges of intensity. Given the immensity of planetary time, Lyell argued, ordinary causes can do all the work required—with Grand Canyons carved grain by grain, and mountain chains raised over millions of years, either truly inch by inch, or at most by piling up long series of merely local catastrophes (earthquakes and volcanic eruptions).

Why then, Lyell inquired, had previous geologists generally favored the catastrophist alternative of occasional, sudden global paroxysms as the chief agent of history? In a brilliant argument about the influence of scale on our perception of natural processes, Lyell claimed that we have always noted the slow and gradual changes continually at work around us. But we perceive them as so weak and slow—the specter of impotence—that we never allow ourselves to imagine such processes playing

Continued on page 104

SHORT DIVISION

The eons-long processes of evolution have their roots in the relatively rapid event of biological reproduction.

WORLDS WITHOUT END

A field of galaxies seen by the Hubble Space Telescope—each containing billions of stars—represents but an infinitesimal fraction of the variety of structures found from here to the farthest reaches of the universe.

KNOCKOUT PUNCH

Not all geological changes come gradually. One day just 50,000 years ago, a chunk of iron and nickel three-quarters of a mile wide streaked in from space and plunged into the Earth—creating Meteor Crater in today's Arizona.

any role in constructing the truly grand phenomena (the purple mountains' majesty), or the truly inspiring events (from the origin of life to the origin of human consciousness) that mark the passage of planetary time.

The solution, Lyell and the uniformitarian school argued, lies in recognizing the power of planetary time to accumulate any impotency of human time into any desired degree of grandeur by simple summation. We could not even consider such a uniformitarian view until 18th- and 19th-century geologists discovered deep time in a great scientific revolution that overthrew Dr. Browne's comfort. Lyell expresses the transforming power of deep time in a powerful metaphor about human history:

> How fatal every error as to the quantity of time must prove to the introduction of rational views concerning the state of things in former ages, may be conceived by supposing that the annals of the civil and military transactions of a great nation were perused under the impression that they occurred in a period of one hundred instead of two thousand years. Such a portion of history would immediately assume the air of a romance; the events would seem devoid of credibility, and inconsistent with the present course of human affairs. A crowd of incidents would follow each other in thick succession. Armies and fleets would appear to be assembled only to be destroyed, and cities built merely to fall in ruins. There would be the most violent transitions from foreign or intestine war to periods of profound peace, and the works effected during the years of disorder or tranquility would be alike superhuman in magnitude.

The gradualism of Darwin's evolutionary theory flows directly from this uniformitarian reform so forcefully advocated by his intellectual hero and mentor, Charles Lyell. Darwin made the same argument for biological change that Lyell had advanced for geology: We deny evolution because we have not been able to imagine the power of tiny changes, well known to us in historical examples from agriculture and animal husbandry, to render the grand pageant of life's history over deep time. In a famous passage in the *Origin of Species,* Darwin wrote:

> It may be said that natural selection is daily and hourly scrutinising, throughout the world, every variation, even the slightest; rejecting that which is bad, preserving and adding up all that is good: silently and insensibly working, whenever and wherever opportunity offers, at the improvement of each organic being in relation to its organic and inorganic conditions of life. We see nothing of these slow changes in progress, until the hand of time has marked the long lapse of ages.

Catastrophes and the specter of invisibility: Georges Cuvier (1769-1832), guru of the catastrophist view, argued that we had failed to understand the major causes of planetary change because another limitation of human time had blinded our sight. Lyell complained that we saw the true causes of deep time during human time, but could not appreciate their power because we had not developed the mental skill to imagine their accumulated force over periods beyond our visceral understanding. Cuvier, on the other hand, complained that we could not see geological causes during human time at all.

Suppose, Cuvier argued, that most geological change occurred during rare episodes, short even by standards of human time, of truly global catastrophes—from universal flooding of lands, to effusions of all the Earth's volcanoes at once. We would certainly have noted such processes if we had ever witnessed them! For people of a literalist Biblical bent, for example, Noah's flood represented the one dimly remembered catastrophic episode during human time on Earth. But if such catastrophes occur only rarely in human time—say once every 50 million years or so—then we have probably experienced no example during our recent tenure, for the probability of seeing even one event of such rarity during our mere 120,000 years of existence

THE LAYER LOOK

Strata of sandstone, laid down 370 million years ago, have been sculpted by erosion into beehive domes in northwestern Australia's Bungle Bungle range. Relentless as the moon's phases, the forces of nature continue to renew the Earth's face.

Now, my suspicion is that the universe is not only queerer than we suppose, but queerer than we can suppose.

—J.B.S. HALDANE

as *Homo sapiens,* and our 10,000 years or so of effective record keeping, must be calculated as effectively nil. But, given the depth of time, one global paroxysm every 50 million years provides enough oomph to render the pageant of our planetary past.

Cuvier and Lyell enjoyed the rare advantage of literary mastery as well as intellectual brilliance. Cuvier also developed a metaphor from human experience—quite opposite to Lyell's, but equally effective—to explain why our parochial focus on human time precluded our understanding of the forces that shape planetary time. He wrote in 1812 (my translation from Cuvier's French):

> When the traveller voyages over fertile plains and tranquil waters that, in their courses, flow by abundant vegetation, and where the land, inhabited by many people, is dotted with flourishing villages and rich cities filled with proud monuments, he is never troubled by the ravages of war or by the oppression of powerful men. He is therefore not tempted to believe that nature undergoes her internal wars, and that the surface of the globe has been overturned by successive revolutions and diverse catastrophes.

How shall we choose between these different versions of Bacon's primary idol of the tribe—Lyell's "pervasive but impotent" versus Cuvier's "effective but invisible"—to explain why our limited perceptions in human time have failed to supply the empirical observations and mental tools needed to understand change on the maximally different scale of planetary time. During most of the 20th century, scientists accepted Lyell's consensus, and uniformitarianism prevailed.

The rebirth of catastrophism has been powerfully spurred since 1980 by the proposal, and virtual proof by accumulating evidence, that at least one recorded event of mass extinction in the history of life—the Cretaceous dying that exterminated dinosaurs, along with some 50 percent of all invertebrate species—was triggered by the impact of an asteroid or comet, surely a global

paroxysm by anyone's standards. We should therefore force Lyell and Cuvier to shake hands and make peace. They both identified an important component of change in planetary time. And they both correctly, and forcefully, recognized how our parochial perspectives of human time had precluded any genuine understanding of change on the natural scale of our earthly home.

However, in expostulating on Bacon's idol of the tribe, and arguing that human time provides such a poor model for explaining geological scales, I may have fostered the idea that I regard human time as mean, trivial, and irrelevant for any conceivable purpose. I only ask that we recognize the principle of disparate scales, and learn to understand that the appropriate tools for one scale may fail dismally at others. When, for reasons of history and constraints of human mentality, we have favored one scale—human time—as a unique domain for universal insight, then a focus upon other neglected scales—planetary time for this essay—may be justified. But I do not mean to denigrate the importance of human time in any way. I only wish to identify its appropriate domain of genuine primacy.

If my previous examples illustrate the errors we make by applying themes and limits of human time to issues properly considered in planetary time, we should also consider the opposite situation—for a case that could not be more important to us, in both moral and practical terms—where we have erred in crucial questions about human time because we have often misthought the issues at planetary scales. Consider the set of current problems, sometimes viewed apocalyptically, involving interactions of the Earth and human culture, and often viewed as threats by humanity upon permanent planetary health or existence: the environmental and biodiversity crises, nuclear warfare, the greenhouse effect, the ozone hole, the population bomb.

Now I love the majesty of planetary time, but this extended majesty bears little relevance to a large set of immediate issues more appropriately discussed, for both logical and practical reasons, in human time. Consider two major categories:

Moral questions: As a feature of logic, moral content arises as an emergent property of consciousness: one cannot ask a question about ought until one can contemplate alternatives. Nature is amoral—not immoral of course, but simply not imbued with features subject to moral analysis. Nature just is. We may brand such a process as natural selection cruel in human moral terms because hundreds die so that one may improve the population, but I can't imagine how amoral nature could be blamed for employing such a mechanism. Moral questions only intrude upon nature with the origin of *Homo sapiens*, and all legitimately moral issues about nature can therefore only be posed in human terms.

The paradox of the visibly irrelevant reconsidered: Many processes perceivable in human time, and deemed slow by our standards, cannot be viewed as causes of similar processes in planetary time because, paradoxically, they run too fast, not because they move too slowly. In another expression of the same theme, many visible processes in human time bear little relevance to planetary time not only because they reach any conceivable completion in a geological moment, but also because they can do no permanent harm at the Earth's own ample scale. They may injure the Earth for an insignificant moment of her own existence, but our planet can then bandage up and go about her business at her own majestic scale.

Most issues of our environmental crises fall into this category, although we often express them, with inappropriate vanity about the extent of human power, in terms of permanent planetary danger. For example, we develop catastrophic scenarios about a global greenhouse effect unleashed by industrial and automotive carbon dioxide. We often envisage a scenario of permanent earthly harm as a result, leading to a desiccated planetary hothouse without oceans or life at all—the transformation of Gaia into Mars, so to speak. But, in fact, a full greenhouse, with entirely melted ice caps, would still yield an Earth with lower average temperatures than several prosperous times of our geological past. In our planetary history of continental drift, both poles have often stood over open oceans, thus leading to a much warmer Earth without ice in high latitudes.

As another example, we often portray nuclear war as a permanent poisoning that would leave the Earth both lifeless and radioactive. But, by the calculation of Luis Alvarez, the great physicist who developed the theory (and who also worked on the Manhattan project to build the atomic bomb), the asteroid or comet that provoked the Cretaceous extinction hit with ten thousand times the megatonnage of all the current world's nuclear weapons combined. And the Earth not only survived that catastrophe. Life reorganized in interesting ways, and moved mightily forward, although full recovery did require planetary time measured in millions of years. The human lineage achieved its opportunity to evolve only because dinosaurs died in this event, thus finally giving the previously ineffective mammals their grand and fortuitous chance.

For an odd set of disparate reasons—ranging from a deep moral concern easily confused with spatial and temporal depths of consequences, to our old sins of arrogance and parochialism (Bacon's idol of the tribe once again)—we tend to express our legitimate fears about environment, ecology, and biodiversity in the broadest and inapplicable terms of planetary time. That is, we proclaim ourselves stewards of the planet (a better metaphor at least than previous assertions about lords of all, but still a form of arrogance), or we fear that our environmental depredations will permanently harm, if not destroy, the Earth for her geological duration—as in the worst-case scenarios sketched above for greenhouse warming or nuclear destruction.

In one sense, an environmentalist using the rhetoric of permanent apocalypse might say: I admit that such statements about planetary destruction might seem a bit hyperbolic, but what harm have we done by exaggerating a legitimate point in order to focus public attention? Such may be the customary rhetoric of persuasion, but any

TIME'S TORTURE
Gnarled and twisted with years, eastern California's bristlecone pines are the world's oldest living trees.

Let the great world spin for ever down the ringing grooves of change.

—LORD ALFRED TENNYSON

overblown argument breeds the considerable danger of clever table turning by your adversaries—as has happened again and again in this arena, hence my own strong feelings about the fallacy of describing genuine dangers of human time in inapplicable terms of planetary time.

In fact, the pro-development lobby constantly presses this theme against environmentalists by making the same inappropriate argument based on planetary time. They may say "why worry if we lose even a large fraction of the earth's species to anthropogenic extinction. After all, no species is immortal; all become extinct. Moreover, mass extinctions clear ecological space for interesting developments down the evolutionary road."

Only one principled argument can counter this deep fallacy of scaling. Environmentalists must drop their rhetoric about deep time and recognize that the crises they fear are both entirely real, and truly scary. But these crises unfold in human time, and humans never need to excuse themselves for devoting their passion and concern to issues legitimately within the compass of human time alone. Instead, we must learn to celebrate, vigorously and muscularly, the relatively small span of human time as the only proper domain for moral questions about the natural world, and for almost all practical concerns about anthropogenic change. We need no apology for focusing on human time. We have a perfectly legitimate parochial interest in our own lives, our children, our bloodlines, the glories of our cultures, the integrated beauties of art and environment, and the species that happen to share the planet with us at this particular geological moment.

Yes, a full greenhouse will not injure the earth in planetary time, but melted ice caps will drown most of our major cities (built at sea level as ports and harbors), and shifting agricultural belts will disrupt our populations. Yes, the megatonnage of a nuclear war may count as a mere blip compared with the force of the late Cretaceous bolide. But an all-out nuclear war will destroy our friends, our lovers, our cultures, and ourselves, perhaps even our entire species (though bacteria and beetles will pull through). What could be more irrelevant to both our moral and practical concerns than the evolutionary assurance of deep time—that ten million years after a mass extinction unleashed by nuclear holocaust, the Earth's fauna will recover and move on in interesting ways. *Homo sapiens* enjoys virtually no prospect of lasting ten million years, not to mention our family lineage or our local culture.

We have every right to protect what we legitimately admire in ourselves, so long as we do so by reciprocal precepts of the golden rule. The prospect—even the virtually assured fact—of planetary recovery in ten million years can only mark an inappropriate scale for such inquiries. To say that we should allow a species to die by preventable human disruption of habitat because all species must die in the fullness of geological time makes about as much sense as refusing to treat an easily curable childhood infection because each human being must eventually perish.

This plea to use the appropriate scale of human time for most questions about our relationship with the natural world raises a final point about human uniqueness—another reason for regarding human time with affection and respect, and not with denigration for its temporal triviality relative to planetary time. During most of planetary history, very few questions of any kind could have been meaningfully posed at the scale I have labeled as human time. Only the evolutionary invention of human consciousness, the most powerful biological innovation (in terms of potential for imposing changes at all scales) since the origin of life itself, has made human time a relevant scale for consideration at all.

Human culture and scientific invention represent the most potent force—in terms of potential for change at unexampled rapidity—ever unleashed upon our planet. Biological evolution, at its most rapid conceivable rate (faster by far than our previous example of a 54-fold expansion from sparrow-to-ostrich-and-back-again in a million years), cannot possibly achieve even one percent

of the potential speed of human cultural change. Cretaceous bolides may be much more potent for a moment, but such impacts occur too rarely to affect the Earth in a sustained manner. So long as human culture endures, the Earth will face the unprecedented power of a force for change that, in a mere 10,000 years—an effectively unmeasurable moment of planetary time—has transformed the surface of this planet by agriculture, urban design, and the technologies of a thousand inventions from gunpowder to the mariner's compass, in a manner so rapid, and to an extent so unprecedented, that the magnitude of difference from previous patterns can only inspire astonishment.

So long, that is, as human culture endures. And this feature of our lives, ultimately, remains up to us. We may never exceed the Cretaceous bolide in potency or immediate effect. But we may also use our mental and moral might to win the greatest evolutionary prize of all: persistence into earthly time. The novel forces that make the small scale of our human moment so relevant for the first time in our planet's history represent both our greatest danger and our finest hope.

A literary epilogue from Charles Lyell provides a memorable image for this immediacy of human might. In *The Principles of Geology,* Lyell wrote at length about Mount Vesuvius, the classical icon and symbol of a natural catastrophe in human time. What spot on earth could better illustrate nature's power over frail humanity? The volcano that killed the greatest of Roman naturalists, Pliny the Elder, in A.D. 79 (in the same eruption that buried Pompeii and Herculaneum), when he sailed his ship too close and went ashore at the point of action in his combined scientific and human desire to make good observations and to aid his friends on shore. (This image of Pliny's death with his boots on remained so evocative that, 1,500 years later, another hero of this essay, Francis Bacon, remembered the tale as he also lay dying from the consequences of a scientific experiment—not nearly as dramatically to be sure, but just as finally! Bacon, wishing to learn if cold would retard putrefaction, stopped his carriage on a winter day, bought a hen from a poultry woman, stuffed it with snow, and died several days later from bronchitis brought on by overexposure. In a last letter, he wrote to the friend who sheltered him in his final illness: "I was likely to have had the fortune of Caius Plinius the elder, who lost his life by trying an experiment about the burning of the mountain Vesuvius: for I was also desirous to try an experiment or two.... As for the experiment itself, it succeeded excellently well; but...I was taken...with this fit of sickness.")

Lyell then pointed out that however spectacular Vesuvius had been in eruption, however destructive (or merely efficacious) in shaping local history, even this primary symbol of natural catastrophe could never match the immediate power of human action—even in Roman times, before the invention of gunpowder, not to mention nuclear weaponry. Lyell notes that Vesuvius posed its greatest danger in human time when Spartacus, in 73 B.C., housed his revolutionary army of slaves in the then-dormant crater, not when the mountain erupted in A.D. 79. For Spartacus almost conquered the Roman empire, while Vesuvius could only bury a local city or two. But Spartacus survives only as a dim memory today, a mere 2,000 years later (brought to life for most people only by Kirk Douglas's portrayal in film), while Vesuvius still looms over Naples, a symbol (and sometimes an actuality) of the continuity that forges planetary history. Lyell wrote:

> The inhabitants, indeed, have enjoyed no immunity from the calamities which are the lot of mankind; but the principal evils which they have suffered must be attributed to moral, not to physical causes—to disastrous events over which man might have exercised a control, rather than to the inevitable catastrophes which result from subterranean agency. When Spartacus encamped his army of ten thousand gladiators in the old extinct crater of Vesuvius, the volcano was more justly a subject of terror to the Campania, than it has ever been since the rekindling of its fires.

Time in Rocks, History in Bones

ALAN CUTLER AND
ANNA K. BEHRENSMEYER

Over our planet's long history it has undergone changes almost impossible for our finite brains to imagine. Oceans have come and gone; mountain ranges have risen and then eroded to nothing; ice sheets have covered continents; species and entire ecosystems have evolved, thrived for a time, and then perished. Understanding the processes that caused these changes and their continuing consequences for the biosphere is essential for understanding how our planet works. But most of these events occurred long before any human eyes were present to witness them, and spanned periods of time too vast for any human mind to comprehend.

How, then, can we know anything about them? And how can we test our ideas? One can't grow mountains or ice caps in the laboratory or conduct repeated experiments on extinct dinosaurs and woolly mammoths. The sciences of the Earth's past—geology, paleontology, and interdisciplinary fields such as paleoecology and paleoclimatology—have had to devise other ways of attaining scientific precision and rigor besides those of the more orthodox laboratory sciences.

The rise of computer technology over the second half of the 20th century has made it possible for earth scientists to generate computer models of many large-scale phenomena— mountain ranges, cycles of hot and cold global climates, entire biological populations—that are impossible to study in real time. By systematically changing the models' variables, researchers can conduct experiments on these electronic worlds in ways analogous to the experiments of a laboratory chemist. Computer models of the general circulation of the Earth's atmosphere and oceans allow climate researchers to experiment with different arrangements of continents and oceans over the globe. This not only indicates what climate patterns would have been like at times in the geological past when the Earth's tectonic plates were configured differently, but by comparing the results with climatically informative fossils and geological deposits from that period, such as warm-water corals, desert dunes, or glacial till, researchers can test and refine the computer models, increasing their value for predicting future climate shifts.

As promising as these new computer methods may be, our increasingly precise knowledge of Earth's history depends just as much on new approaches and innovations that can hardly be described as high-tech. The ultimate source of our information about our planet's eventful past is still the geologic record of fossils and rock strata, collected by scientists often wielding no more than hammers, chisels, and shovels. The assumptions that researchers make about the nature of the record and the questions they choose to ask of it matter far more than the sophisticated hardware they have at their disposal.

Paleontologists, for example, have long been troubled by the incomplete and obviously biased sample that fossils provide of ancient life. For any given species, it's usually only those anatomical parts that can resist decay—bones, teeth, shells, and the cuticles of leaves—that survive as fossils. And, within any ecosystem, it's usually only those species with tough, resistant skeletons that are preserved in abundance, if at all. Depending on the vagaries of sedimentation and burial of fossils, some types of habitats, some geographic areas, and some intervals of geologic time have rich fossil records, while others are virtually unknown.

In 1940 the Russian paleontologist I. A. Efremov proposed that these problems, though unfortunate, were not unmanageable. If these biasing factors were themselves subjected to rigorous study—by systematically comparing decay rates among organisms or comparing burial rates in different habitats—then paleontologists could account for them in their interpretations, and therefore both sharpen and solidify their conclusions about the past. He called this new approach taphonomy, literally the "laws of burial."

But the concept of taphonomy lay almost dormant among American and Western European scientists until the late 1960s and early 1970s, when it was revived by paleontologists intent on using the fossil record to test new ideas of ecological and evolutionary change—particularly those relating to human evolution.

At various sites in East and South Africa, teeth and bones of early hominids such as *Australopithecus* could be found among the abundantly preserved bones of other species of mammals—elephants, pigs, antelopes—many of which were similar to species living in the African savanna today. But the fossil species and their relative proportions often changed

With no written language, humankind's earliest ancestors left only their bones to communicate with their descendants. A four-million-year-old set of fossil hominid teeth, found in East Africa's Lake Turkana region, is an incomplete yet valuable data set for modern humans to study.

from layer to layer in the deposits. Did these changes represent ecological shifts that might have influenced human evolution? Or were the changes just flukes of preservation, the types of fossils present in each bed just the luck of the draw?

Simple enough questions, but even to begin to answer them has required years of field research by taphonomic researchers surveying the bones, sediments, and animal populations of present-day African habitats, such as Kenya's Amboseli Park, to determine how faithfully bones accumulating on a land surface (later to be buried) represent the community of animals living there, and whether the bones themselves might yield information about the conditions of their burial.

The picture emerging from this work has been encouraging. Bone accumulations do indeed provide an informative census of the common species in the kinds of habitats in which our fossil ancestors lived. The biases that exist—the durable bones of large species such as elephants tend to be disproportionately preserved—are relatively consistent and predictable. The success of this taphonomic research has, in fact, attracted the interest of wildlife scientists, for whom maintaining accurate census records of certain species is often difficult and expensive. It is far easier to census naturally dead animals than live ones, and the bone accumulations record years to decades of an ecosystem's dynamics rather than single months or seasons.

For students of the Earth's past, taphonomy confirms the point that the fossil record is an invaluable record of past ecological change. Even for habitats and species that are relatively similar to today's, the range of possible variations and their complicated patterns of change extend far beyond what can be found simply by studying modern ecosystems. The ecological past is not directly comparable to the present, nor can it necessarily be used to predict the future. But it can give us insights into the types of changes that are possible and reveal what kinds of organisms survive through such changes and which do not. It serves as a constant reminder of the persistence of change as a theme in the Earth's history.

The Pleasures of Change

Dorion Sagan and Eric D. Schneider

MANY HARSH CRITICS OF DARWIN'S THEORY OF EVOLUTION WERE PHYSICISTS. THE IDEA THAT COMPLEXITY COULD ARISE NATURALLY FROM CHAOS APPEARED TO DEFY THE NEWLY FORMULATED LAWS OF THERMODYNAMICS. LATER ADVANCES IN BIOLOGY AND PHYSICS SHOWED THERMODYNAMICS AND EVOLUTION TO BE NOT ONLY COMPATIBLE, BUT INTIMATELY CONNECTED.

THE LAW OF CHANGE

The strange fact that the human mind is able to imagine eternity and its perpetual fascination with numbers, geometric shapes, and other changeless forms have had a dramatic impact on our perception of reality. For the last few centuries the timeless has been epitomized by the mathematical equations of the physicist, who has tried, ever since Newton, to discover eternal laws behind our changing natural world. It is curious that we should be so obsessed with the eternal when we live in a world of incessant change, where perhaps the most truly incorruptible, eternal, and changeless thing is our ability to even imagine such permanence!

In ancient Greece, Pythagoras led a cult that worshiped the triangle, a perfect form, and believed that numbers had a separate existence outside of time. Numbers, used for proofs, could establish truths unequivocally. An idea, true for all time, will not change (as things influenced by time do) and is therefore eternal. After Pythagoras came Parmenides, who deeply influenced not only the Greek philosopher-scientists but the entire course of Western thought that followed. Parmenides preached Being and the logical impossibility of change,

arguing that something always was what it was and was not what it was not, and therefore could never become what it was not. He had a greater influence than did his intellectual rival Heracleitus, the poet of Becoming, who held the opposite conviction that change, not permanence, was the ultimate reality. Parmenides could not deny the evidence for change perceived by the senses; instead he elevated reason, which could intuit the changeless, above the senses, which he considered untrustworthy.

Later, Plato, who named one of his dialogues "Parmenides," also became enthralled with the notion of incorruptible, unchanging ideas lying beyond our transitory world of aging and death, of rust and dust. To him, ideas formed a higher, heavenlike plane of existence, of which our world of ever changing things is only an imperfect, corruptible copy. Through Aristotle, this Platonic idea of a realm outside of time, perfect and eternal, came to influence the Church, which in turn influenced the entire course of Western intellectual tradition.

But in a way we are now coming round to Heracleitus's way of thinking. Heracleitus taught the importance of change. He liked to point out that even things that seemed the same were different

Harnessing the sun's energy, the seeds of a dandelion ride the wind to spread their genetic legacy.

later in time. "You cannot step into the same river twice," said Heracleitus in his most famous fragment. Heracleitus was referring to the particles of water, replaced and different although the river may seem the same. And each of us is such an ever changing river: every five days your stomach grows a new lining, a new liver comes every two months, and the biggest organ of your body, your skin, is itself entirely replaced every six weeks. What we see as constant identity is really an illusion. You are a manifestation of continuous biochemical turnover, a ceaseless swirling of organic change. Despite the usefulness of viewing changing nature as ruled by unalterable, eternal laws, science is now taking a more realistic view—of a thoroughly evolutionary universe that is permeated with change, in which even the laws of the universe may change. In this universe, the Second Law of Thermodynamics, which describes nature's irreversible processes, has a special significance.

Thermodynamics—from the Greek roots *thermē*, meaning heat, and *dynamis*, meaning power or force—is the study of energy flow and balance in simple and complex physical systems, and it governs many of the important changes we see in living systems as well. The First Law states simply that energy is conserved; it may be converted from one form to another—from, say, electricity to heat—but it will not disappear. The Second Law is more complicated. According to it, even though energy is conserved, it inevitably degrades. In other words, the amount of energy available to do work, unless it is replaced, will always decrease over time, because some fraction of the energy will be lost as diffuse, unusable heat energy. The Second Law also describes the universal tendency for things to become less organized over time. If we look at the world, we find that disorganization—pollution, decay, attrition, death—is inescapable.

A more technical definition of the Second Law is that entropy (a mathematical measure of disorder) tends inevitably to increase in isolated systems.

An isolated system is one that is sealed off to the exchange of matter and energy with the outside world; a closed system is sealed off to matter but not energy. A sealed terrarium is an example of a closed system. Wrap up the terrarium with opaque insulating material and you've got an isolated system. The distinction is important because an isolated system, deprived of energy influx, allows scientists to study material and energy transformations on their own without any input from the outside world.

Closed systems, in contrast, may use an external energy source to run complex internal processes. For example, closed systems of microbes sealed in 1967 by the late University of Hawaii biologist Clair Folsome continue to survive decades later because the communities of bacteria inside the closed test tubes can use sunlight to recycle the matter of their bodies and wastes. Earth, with its incoming meteorites and occasional outgoing space probes, is almost but not quite a closed system.

The counterpart of isolated and closed systems is an open system—such as you—that is totally dependent on a flow-through of matter and energy—the food you eat, the water you drink, and the air you must breathe. Heracleitus, in his prescient if incorrect emphasis on fire as the sole stuff of the world, was recognizing the importance of open systems: ones that use fuel to maintain, burn to grow, and change to stay the same. Such systems, from a gushing stream to a tree sucking water through its roots and then evaporating it on its leaves, to a living cell, to a steam engine taking in coal and water and putting out steam, heat and motive power, are defined less by their constituents than by the way those constituents are organized to handle the energy flowing through them, without which they would cease to exist.

Thermodynamics' original application was to machines. The Second Law was put forth in the 19th century to formalize observations of Victorian engineers who found that steam engines were inevitably inefficient. No steam engine, regardless of how well designed or well built it was, could ever

completely convert the energy in its fuel into useful work, some was inevitably lost as wasted heat.

At the time, railroad and ship steam engines determined the superiority of industries and navies, and French physicist Nicolas Leonard Sadi Carnot (1796-1832), the estranged son of a Napoleonic minister of war, was irked that England produced more efficient steam engines than France. Driven by patriotic fervor, he initiated the first studies of thermodynamics, leading to the realization that it was not simply the temperature of the steam-producing boiler that made pistons pump hard and fast, but rather the difference between the temperatures of its boiler and radiator. "The production of heat is not sufficient to give birth to the impelling power," Carnot wrote in his essay "Reflections on the Motive Force of Heat." "It is necessary that there should be cold; without it, the heat would be useless."

Heat must flow from hot to cold and it is the gradient, the difference of temperatures over a distance, that sets up the conditions for the flow to take place. By making engines with greater gradients, industrialists increased the efficiency of their heat engines. According to the Second Law, gradients inevitably break down or dissolve as things become more randomized over time. A drop of cream in your coffee will spread out, never to return to its original state: There are many more ways for cream molecules to mix with rather than to separate from the coffee molecules. Modern thermodynamics bases its understanding of how things become more mixed up over time on probability theory: It is far more likely for all differences to degrade into a uniform state of randomized confusion than into one of elegance, organization, or design. A living being or a work of Shakespeare would never be expected on the basis of chance alone. The messiness of your desk and the cooling of your morning coffee are examples of the same thing—the Second Law.

Thermodynamics, as it took shape in the 19th century, presented Victorians with a picture of the future taken from the gritty inner clunkings of

RANDOM ORDER

Chemical reactions in a dish show spontaneous patterns and complicated oscillations. Such examples of complexity arising in simple systems—in which external energy maintains internal order—provide an analogy for the rise of life from primordial chemical reactions.

imperfect heat-leaking steam engines. Its bleak prospect of universal cooling included an icy Armageddon—a universal end of unrecoverable loss. One book depicted Old Man Death with icicles in his beard staring out wanly at an ocean frozen in mid-wave. Considering that machines undergo wear and tear, break down, and ultimately attain a state of complete disrepair, how is it that for billions of years the sum of life has become more complex?

Surprisingly, the rules of change that apply to nonliving systems are also obeyed by the growth and evolution of living matter. Just as Charles Darwin showed the kinship of humans to other life forms—startling Victorians with the notion that people were not specially created but evolved gradually from "lower" animals—so today we realize the kinship of biological change with change in nonliving matter.

Living organisms function as open systems that internally organize even as they produce waste and

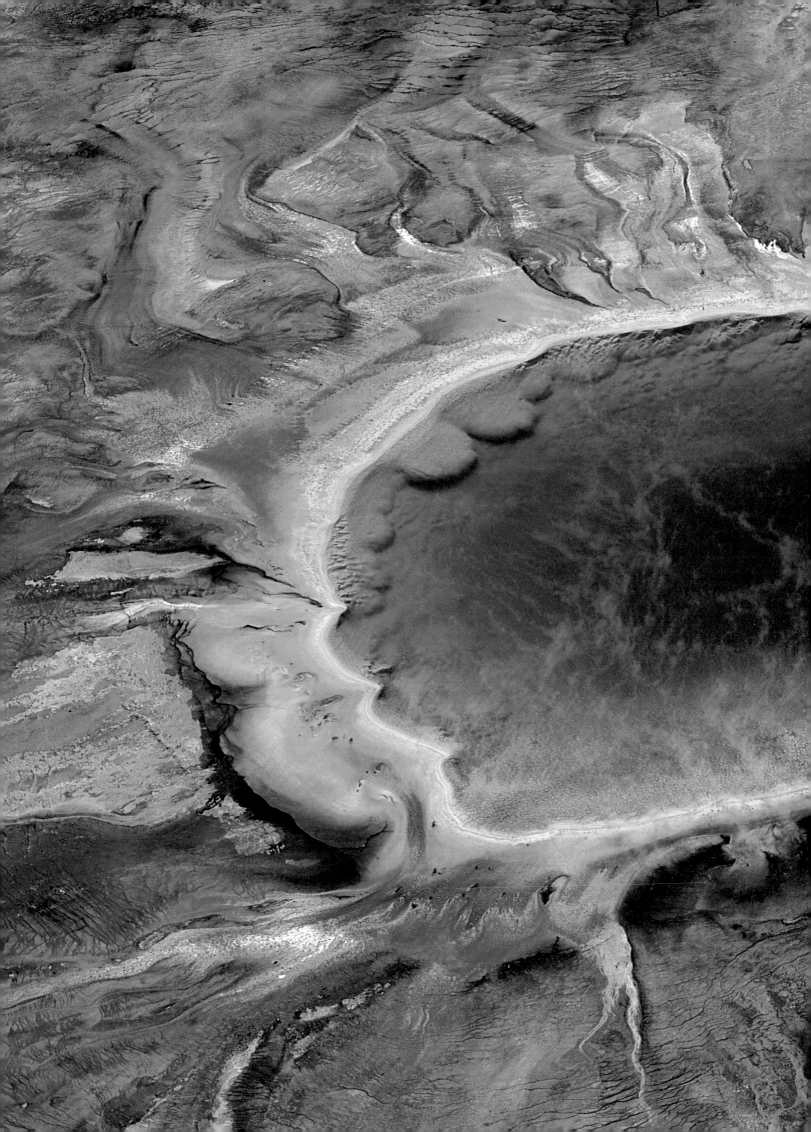

heat and disorganize the greater environment. Ironically, exquisite self-cooling life, by fostering waste, heat, pollution, and chaos inevitably in its wake, accelerates the move toward equilibrium. Death is simply what happens when the living organism, obeying this trajectory of the Second Law, relinquishes its complexity and succumbs to the greater equilibrium. Individual life itself comes to its final state—yet, more often than not, reproduction has occurred. Collectively, life goes on.

In contrast to the sealed experimental boxes in physics labs, life has not reached an end-state of equilibrium. Life takes in liquids, solids and gases from the outside not only to function but to maintain and reproduce its internal organization. To live on. Biologists have a technical term for such behavior: *autopoiesis* or "self-making"— from the Greek roots *auto* for self and *poiein* (as in poetry) for making. As an automobile propels itself, so a living being metabolically makes itself. Living beings are natural purposes, designed by nature. And both evolutionary biology and thermodynamics are charged through and through with a mandate—to change—that is implicit in the Second Law.

And yet change also moves in a direction of increasing complexity, as in the growth of a red maple tree from a spinning seedling, the succession of organisms that emerge from developing ecosystems, or the finished production of this glossy book from thought, paper pulp, and human labor. At first glance, this shouldn't happen. The Second Law mandates that things should be doing the opposite, falling apart instead of evolving into more and more complex things. It turns out that the appearance of complexity and organization, as epitomized by living beings, actually aids randomization, abetting the Second Law and nature's craving for a uniform state. Organized structures can be very efficient at breaking down energy gradients and bringing a system to a balanced, uniform condition. A tornado, for example, is a highly organized natural structure, and its purpose is to reduce the barometric gradient between high- and low-pressure air masses—and the tornado will spontaneously organize to accomplish that purpose. Once the air masses reach their more probabilistic state of calm and equilibrium, the complex whirling tornado has fulfilled its function, and disappears.

Startlingly, life itself also displays such gradient-reducing traits —fulfilling natural unconscious purposes—that one is led to wonder whether our conscious and unconscious drives and desires also reflect a thermodynamic imperative. As thermodynamicist Jeffrey Wicken says, "I see no way to dodge the Kantian challenge. In Kant's conception, an organism was a 'natural purpose' in which each part and process was jointly cause and effect, ends and means, of the operation of the whole."

Just as nature abhors a vacuum, she detests temperature and other differences and will destroy them over time, achieving end states of higher probability and more likely distribution of atomic components. Our very biological urges to eat, drink and mate—related to reproduction and growth— have their roots in these inanimate tendencies. It is the temporal nature of thermodynamic processes to have an end in equilibrium, stasis, a point of no further changes in state, which gives all natural systems a direction. And it is in moving toward these endpoints that under certain conditions nature crafts an equilibrium-creating system from available materials. Out of the pressure differences between two conflicting air masses arises the tornado, a complex and cycling storm that elegantly, if violently, equalizes the air pressure. Living beings are

NETWORK OF LIFE

The broad, bold veins of a leaf feed a plant's photosynthesis energy system. Sunlight powers the process, but it is this network of veins, resembling the meandering streets of a suburban housing tract, that deliver life-giving nutrients. This view is a close-up of the mahoe, one of Hawaii's 185-odd endangered plants.

complex equalizers of another kind. We thrive on the energy gradient created by the sun, and necessarily excrete liquid, gas, and solid waste while giving off low-grade heat as is our thermodynamic wont; so, too, our technologies run on high-quality fuel that becomes low-quality exhaust and pollution. We owe our complexity and organization to the chaos and low-grade energy we produce.

The improbability of being you is high—you could never come into being or exist as an isolated system—something so complex or improbable could never happen without an abundant flow of matter and energy. But you are as organized as you are because you are part of a planetary thermodynamic system—the biosphere—which has been continuously trapping and rerouting the high-quality energy of sunlight and producing the low-quality energy of heat, for more than three billion years. The replicative machinery of the DNA molecule does not exist in isolation, but ensures, transgenerationally, that this system lives on.

Living things constantly try to maximize their share of energy—bigger leaves and taller trunks to catch more light; swifter legs and stronger jaws to catch more prey. Even sensory perception and intelligence seem to be an adaptation towards finding and exploiting energy sources. The first organisms with heads, the Ediacaran fauna that came before the more famous Cambrian trilobites and their kin, have been interpreted from fossils to have been languid, happy, and dull sunbathers with photosynthetic inclusions in their cells. When multicellular organisms started feeding on each other, concentrating their sense organs toward one end to help them recognize the primeval equivalent of sushi, murderous life began devouring its own gradient—flesh.

Life would, if it could, take all the sun's energy and turn it into itself. The changes we see in evolving life reflect nature's equalizing tendency to destroy differences—specifically the difference between the energy-rich sun and the energy-poor space around it. And solar energy captured by one life form gets passed around as others reach for their share. No species in an ecosystem can hold a monopoly on energy. In fact, the entire biosphere is part of a single system running on and degrading the sun's energy. Life helps spread the sun and would—like the tornado without the differentiated air masses around it—cease to exist in the sun's absence. So why and how do complex things such as tornadoes, puppies, and trees emerge from an equilibrium-craving thermodynamic world that tends toward disrepair?

The answer to this apparent contradiction was first recognized by Nobel prize-winner Erwin Schrödinger; we call it the Schrödinger Paradox. In a series of lectures at Dublin's Trinity College in 1943, Schrödinger argued that life is not some mysterious stuff with special properties somehow beyond the normal operations of chemistry and physics. In a set of three lectures, later printed as the short classic, *What Is Life?*, Schrödinger combined chemistry and physics to put biology on a different track. He saw two processes in life: order from order—genetics; and order from disorder—thermodynamics. At the center of life, he saw the gene (and its yet-to-be-discovered DNA), producing order from order—progeny, as an almost perfect replicant of the parent. (His prediction that life must be predicated on some chemical substance helped spur the later discovery of the DNA double helix and its replicating chemistry.) Schrödinger noted that in a thermodynamic world, which tends toward stasis and decay, one would not, at first glance, expect the highly improbable structures of living beings to evolve. Life is not exempt from the laws of physics and chemistry; its complexity and ability to maintain itself must have a source. He postulated that the kind of organization, order, and complexity we see in living beings must somehow be imported from outside the biosphere. He argued that it was sunlight that provided the crucial input. By feeding on the energy of the sun, living beings are able to become more ordered and can resist the thermodynamic imperative to fall into final disrepair. Order can then emerge from disorder.

EATING THE SUN

Temperature maps of Earth taken from space satellites have confirmed Schrödinger's general view. From a thermodynamic point of view, life's basic activity is to convert short-wavelength (low-entropy) photons of visible and ultraviolet radiation from the sun and reradiate them as longer-wavelength infrared radiation. The living systems of Earth's biosphere thermodynamically turn solar radiation into living matter and heat. In the main, the biosphere is a solar phenomenon. In photosynthesis, the most important chemical reaction to develop in the history of life on Earth, photons from the sun are hijacked, their energy co-opted to run life and power the building of the biochemical stuff we call bodies. Today virtually all surface life, not just plants, depends on this photosynthetic hijacking of photons. The great majority of beings in our biosphere require direct sunlight, and those that do not—such as bacteria living thousands of meters beneath the surface of Earth inside solid rock, and red medusoid worms in dark ocean-bottom sea gardens where magma and gas effervesce through cracks in Earth's interior—nonetheless require energetic gradients in order to maintain their own metabolism, reproduce, and evolve. Animals like ourselves either eat photon-degrading plants or the animals that eat them. And this feeding off the sun—which connects all life in intricate networks of energy exchange, sending photons like wayward angels through a maze of earthly tasks—is a preeminently thermodynamic process. Far from violating the Second Law, life exemplifies it. The trees of the Amazon rain forest—the heart of the most complex, biodiverse, and organized ecosystems on Earth—process massive quantities of sunlight and radiate the heat back into space. Sucking water through their roots to their leaves, where it evaporates, the

INFO EXCHANGE
Swapping genetic information, three bacteria engage in a process that ensures their mutual survival. Like most living things, bacteria do not exist exclusive of all other life forms—their ecosystems require frequent interaction.

sun-loving trees of rain forests lie at the center of a process that generates atmospheric coolness (through cloud cover and carbon cycles) and complexity (reproducing life) locally while creating heat waste farther out. Life is cool, you might say, and life likes it cool.

Consider the temperature of our planet's surface. Situated between Mars and Venus, our planet is cooler than would be expected based on more normal planets. The average temperature on the Earth's surface is about 18°C, though the temperatures of the neighboring two planets, solar luminosity, and distance from the sun would dictate a considerably warmer 36°C. Carbon dioxide, the famous greenhouse gas,

All things must change to something new, to something strange.

—HENRY WADSWORTH LONGFELLOW

accounts for the majority of the atmospheres of Mars and Venus. On Earth, however, CO_2 has been systematically sucked from the atmosphere by life, which uses carbon to produce the carbon-hydrogen compounds of organic bodies. The result has been planetary air conditioning—the lowering of the global mean temperature of our biosphere. But even more important to planetary cooling is the evapotranspiration of trees, which produces light-reflecting clouds above Earth and spreads out the heat, reducing the differences between cold space and hot sun. Just as nature abhors a vacuum, she abhors temperature differences and will find ways to reduce them. Life is a natural temperature- difference-reducing computer. The paradox of evolutionary complexity and thermodynamic degradation does not make them incomprehensible polar opposites. Evolution is a means of thermodynamic degradation in a universe of time and change.

THE INEVITABILITY OF CHANGE

Already early in this century, Russian scientist Vladimir Vernadsky studiously avoided the term life, which he considered distracting, speaking instead of living matter, which forces us to focus on physical and chemical processes rather than any preconceived notion of a special kind of matter. Life is a kind of "green fire," and we are, as he liked to say, children of the sun—part of the Earth-solar system. All life is a solar transformer, connected by Vernadskian space and Darwinian time.

Among living matter's earliest representatives were early photosynthetic cells—purple bacteria. Comparative analyses suggest that these bacteria, like their cousins today, used hydrogen sulfide (H_2S) rather than water (H_2O) to make their organic (carbon-hydrogen) bodies. Hydrogen sulfide, which is spewed from volcanoes, would have been more plentiful on the early, more tectonically active Earth. But as Earth cooled and tectonic activity subsided, sulfide was less available for these bacteria. Mutations occurred, ones that

appear to have allowed some bacteria to alter the chemical reactions of their metabolism so that they could now make their bodies by breaking down the hydrogen bond in water instead. Life had been living in water since its origins 3.5 billion years ago, but the use of water as a new resource led to new waste: oxygen, which caused toxic reactions in the bodies of most then-extant living organisms. The rock record of rust—vast "red beds" (and unusual earlier deposits called banded iron formations)—demonstrates that significant quantities of oxygen began to build up in our atmosphere about two billion years ago. Today of course you cannot read, use your finger muscles to turn the page, or think without the metabolic energy of oxygen gas. Earth's oxygen-rich atmosphere, combined with the hydrogen-rich compounds of life, has energized the entire surface of Earth. In evolutionary retrospect, we can see that our oxygen-energized atmosphere is a result of the chemistry of the life forms that first appeared on Earth. Evolving cells found a way to get at the oxygen in water, transforming the solar gradient into a hydrogen-oxygen gradient.

Later, when volatile and at first universally deadly oxygen was produced, it created yet another crisis and challenge for evolving life. Change was again necessary; in this case a symbiotic alliance took place. The life forms that could metabolize oxygen were incorporated into the life forms that could not survive in the new oxygen-rich atmosphere. As often in life, teamwork was a viable response to crisis. Tiny, matrilineally descended inclusions in our cells called mitochondria evolved from ancient oxygen metabolizers. Genetic evidence suggests with near incontrovertible accuracy that these mitochondria—found in the cells of all fungi, plants, and animals—descended from lineages of ancient respiring bacteria who were among the first to thrive in the toxic oxygen environment. Today oxygen-breathing animals such as ourselves not only tolerate the oxidizing atmosphere but depend on it to think and move.

Life's tendency to change and to evolve toward higher levels of complexity reflects its status as an open system; using energy and inevitably producing waste as a result, life changes itself to metabolically stay the same, as well as to reproduce, which is itself an extension of metabolism. But as shown above, life also changes in response to the toxicity of its own growth—which creates incomplete waste that can be broken down by further evolution. The cyan-green bacteria that first mutated to use the hydrogen in water for foodstuff were among the first to be poisoned by the toxic environment they created. The inevitable production of wastes by open thermodynamic systems means that living matter cannot rest or settle like a slacker but must always be open to new challenges of change. It is to life's advantage to find ways of reducing transient energy and material gradients. Change, both as a response to the surrounding environment and as a necessary adaption to its own entropic wastes, is intrinsic to life and its evolving complexity. Indeed, the very principle of life is to maintain internal complexity in order to foster external molecular chaos and gradient reduction in accord with the Second Law. DNA helps it to do this. We humans have created pollution crises by our own spread, and by the spread of our technology. But like the bacteria and other life forms before us, the changes we wreak upon the global environment are the result of our capture and use of energy, and this inevitably creates wastes in accord with the Second Law. Life traps and reroutes the sun's photons—and even uses solar energy to recycle wastes and dead bodies back into structural materials and food; and in doing so, life maintains and increases its earthly complexity over time.

Like an eons-long storm, it recycles the elements it needs into new life forms and new generations, keeping (in a way that most inanimate matter does not) the past alive in the present. Each of us is a kind of relic, a living fossil harkening back to the early solar system. You may think you are 12 or 30 or 62 years old, but as a material form of entropy-producing memory—that is, life with its continuous 3.5 billion-year-old history—you are approximately one-third the age of the universe.

THE PLEASURES OF CHANGE

The challenges and pleasures of life, both personally and cosmically, are not, surprisingly, in achieving some sort of final stasis, permanence, stability, or eternity—some steady-state heaven or nirvana of eternally solved problems—but in the process of dealing with change, of energy flow and all the changing it inevitably entails. The pleasures we find in eating and sex are directly linked to our metabolic maintenance, growth, and reproduction. And through partaking of such delights, our metabolic maintenance and energy-transforming growth is perpetuated and continued in subsequent generations. Even those most human motivators—desires for food and shelter, sex and money, marriage and fame—seem to be far-reaching reflections of these cosmic tendecies. Food maintains metabolism; shelters house metabolizing organisms; sex, money and the rest increase the chances that metabolizing processes will be present in our children, long after our inevitable thermodynamic demise as individuals. In the short run, during our individual lifetimes, we produce entropy by maintaining our identity, which necessarily entails the elimination of liquids, gases, and solids into the environment.

In the long haul we assure entropy production by mating, thereby making new organisms like us that continue the special form of dissipation known as metabolism. From a cosmic vantage point, our interest in sex, eating, and preserving ourselves and others—life's greatest pleasures—are byproducts of the entropy production such activities engender. We are children of the sun. Our growth and reproduction are manifestations of the Second Law as is the evolution of life. With the origin of life a kind of rift opened up in the fabric of space-time. The great difference between the eons-long storm of life and a hurricane that reduces the gradient between high and low pressure systems, of course,

is that the solar gradient is so immense. Whereas the gravitational difference resolved by a whirlpool lasts seconds, life's creative destruction of the solar gradient has already lasted billions of years.

Life's role, its purpose in the cosmic sense of thermodynamic change, is to reduce gradients. This is what we are doing when we burn fossil fuels, turning oil in Earth's crust into a gas in the atmosphere. Life finds ways to exploit energetic differences and funnels them into its own growth just as heat in a heated cabin seems single-mindedly to seek ways to the cool outdoors by leaving through the tiniest hole or crack. Although life exhibits the same kind of manic purpose found in the inanimate behavior of cool-seeking heat, life needs to be trickier, because its gradient-reducing systems, namely the open thermodynamic systems of life, self-destruct if they deplete an energy source too greedily. Thus life, though it obeys nature's meta-drive to bring everything to the perinirvana of uniform stasis, is forced to moderate itself in order not to destroy, along with the gradients, the very means of its gradient reduction—which is life itself.

We can trace an understanding of life, its desire, thought, and pleasure. Far from being islands of wisdom unconnected to the mute and unfeeling universe about us, we are energy transformers whose information processing abilities (wisdom, thought, planning) reflect nature's more-than-human, more-than-living thermodynamic cravings—to reduce differences in nature. Our intricacy and the improbability of our existence is an offshoot of the improbability of differences that existed prior to us—such as the creation of a universe with its radiating suns. The intelligence of a tornado is linked to solving the problem of reducing barometric pressure differences. Life, which has been reducing the far greater solar gradient continuously for over three billion years, now has evolved far greater problem-solving abilities. On this view, the goal-setting, responsive tendencies of intelligent life do not look so extraordinary in themselves—they are an ordinary part of an extraordinary universe.

A thermodynamic perspective on evolution teaches us that the only constant is change. Life grows and changes its surroundings. By maintaining its metabolism, life repeats the process of its own origins and its own development, incarnating memory. We become aware of, if not almost hypnotized by, life's accelerating organization as it grows, exporting chaos to its surroundings. Meanwhile, the rest of the universe continues on its merry forgetful way.

We are literally living time capsules, museums in motion. By looking carefully at modern cells, we may find glorious exhibitions showing vestiges not only of the metabolisms of the earliest life forms but of the ways by which life first evolved. Contrary to the prevailing 20th-century view of life as a mere speck in space and tick in time, our tininess in the vastness of space is in fact inversely proportional to our potential importance to the universe. We know an oak grows from an acorn, but we do not know what happens when life originates in a universe. Life, though localized on the surface of a small planet orbiting a medium-sized star at the outskirts of a typical spiral galaxy, is a most promising ends and means. The combined evolution of humans and high technology raises the possibility that in the far future the universe in toto may be grist for life's thermodynamic, gradient-reducing mills. If this is so, then life, despite its minuscule size, may be bound up with the immense task of changing the entire universe. Whether you're religious or not, it is clear that life has really started something.

LIFE AFTER DEATH

In nature, life and death have no positive or negative values attached. The death of a mourning dove is but an opportunity for an America burying beetle to perform its duty, a process that will soon render the late bird a fresh source of nutrients in the food chain. Scavengers like the burying beetle, which is now nearly extinct, are an essential link in the cycle of life.

Microbial Minds

BY LYNN MARGULIS

The vigorous movement within any living plant, animal, or fungal cell seen under the microscope will startle you. The interior of nucleated cells swarms with action, like a city seen from a bridge. The cytoplasm streams and flows. In some cells colorful granules, mitochondria, and other organelles course about on fixed tracks as though obeying invisible traffic signals. Watch the frenetic activity of microscopic life in a drop of pond water, where galaxies of tiny organisms chase madly about as each pursues its own cryptic agenda. You will likely be impressed, even awed, by the interpretable microcosmic affairs before you: attraction to the opposite gender, sex acts, sunlight avoidance, pursuit and capture of prey, and much more. Close observation reveals the complexities of the life of the little.

We consider ourselves to be at the summit of all life forms after 3,500 million years of evolution. We are most proud of the mass of cells we call our brain, and its near-miraculous ability to process information, creating the intricacies of personality and culture. But for sheer scope, human information flow does not begin to approach the Earth's ancient microbial systems, where bacteria have traded and processed vast quantities of information for eons.

For the first 2,000 million years of the 3,500 million years life has existed on Earth, it consisted solely of bacteria. Human beings evolved very recently— Modern *homo sapiens* appeared only about 120,000 years ago. We are complex descendants of mergers of different kinds of bacteria that glided, swam, or floated in primeval waters. Other animals, plants, and fungi—all of us— descend from such contingently organized aggregates of ancestral bacteria. Symbiosis, living together of different life forms in intimate permanent alliance, has been a major force in evolutionary change in Earth's history. Ancient bacteria and their symbiotic progeny, the protists (algae, amoebas, and their kin), invented all the essential miniaturized chemical systems— fermentation, photosynthesis, oxygen

respiration, nitrogen fixation, and many others—that drive the biosphere. Upright posture, opposable thumbs, and even the oversize brains of human beings are mere evolutionary footnotes to the grand text of innovation made possible by microbial symbiosis.

I suspect that the interaction, alliance, and eventual merger of different kinds of microbes are at the basis of the evolution of our oversize, story-telling brain. Animal thought and consciousness originate at the cell level; awareness and intelligence owe their beginnings to bacterial behavior in ancient microbial communities. Animal cell movement, and ultimately human thought, possibly evolved from partnerships between wiry, fast-swimming killer bacteria and their fatter, slower-moving microbial victims. Relatives of both predator and prey are still around today, we hypothesize, in two independent forms: lithe, energetic bacteria called spirochetes and lumbering, sulfur-loving archaebacteria. The archaebacteria in our scenario not only resisted their spirochetal attackers, but trapped many within their bodies. Two thousand million years later, remnants of this struggle persist. Today, these former spirochetes—now cilia—move, swim, grow, and feed only as integral parts of their hosts. Over millions of years the chimera, part spirochete/part archaebacteria, reproduced as a whole new entity that became the ancestral nucleated cells of animals, plants, fungi, and protists. The trapped partners' muted struggles generate movements within cells, including those that propel swimmer protists visible under the microscope.

If this yet-to-be-proven evolutionary tale is accurate, our nerve and brain cells, like all the others of our bodies, are products of this ancient merger. Thought, then, is underlain by cell movement: Impulses carried by our nerves and processed by our brains originate in the thrashing of captive spirochetes; concepts and signals of thought are the products of physical abilities already present in bacteria.

This is not the way we people like to think of our minds. However, we accept that computers, for example, have precedents: electricity, video screens, electronic circuits, and silica semiconductors. The power of the computer is the way in which these parts

and others are configured. So, too, humankind has precedents in the organization, recombination, and interaction of our basic parts. Hundreds of biologists, psychologists, philosophers, and the others who make inquiries of mind-brain have failed even to identify these basic parts, the former microbes, analogues of a computer's working components. Without knowledge of how the original ancestral microbes began their lives and how they have behaved and interacted, we can't understand the mind-brain of any animal.

Nor can human thought, the last refuge of human superiority, be isolated from prior accomplishments of life. All our favorite inventions were anticipated by earlier life forms, why not thought? If bacterial "cold light" (glow-in-the-dark bioluminescence) preceded electric lightbulbs by over 2,000 million years, if the protist *Sticholonche* propelled itself with microtubular oars through the Mediterranean long before Roman galleys rowed the same waters, if pillaging ant legions traversed jungle highways, pods of whales migrated from polar to tropical seas, and birds blackened the skies long before the traffic of cars, submarines, and airplanes, is it farfetched to suggest that bacterial symbionts created biospheric information pathways long before humans evolved? We are not just bacteria, though our cells evolved from them, because our powers of thought and movement transcend the sum of their microbial parts.

Human history spans changes analogous to the leap from bacteria to mind-brain. Our inquisitive and aggressive nature led to our technology. This, in turn, catapulted us far beyond our

An angiogram reveals blood vessels in a human brain (above), but it yields little information on the business of thinking. Some scientists believe that processes inside cells of swimming bacteria (opposite) may in fact be precursors of our own consciousness, and that cells in our brain swap information with each other—and the outside world—in ways we can't perceive.

perceived biological limits. Once, spiral-shaped bacteria had to swim furiously to survive. Now, millions of years later, stripped down, reconditioned, packed as parts of our brains, they still express their ancient biological urges; their remnants conceive and direct the actions of a highly complex amalgam of former symbionts which we recognize as human.

The vigorous movement, streaming and flowing inside our cells, is

exactly the antidote to death. Life itself is growth, expansion, and nonstop interaction among tiny, strongwilled, once free-living and still free-living beings. We cannot think that the microbial mergers and transformations that formed our cells and those of our ancestors will ever cease. Change is the only stable rule. Our descendants will differ as much from us as we do from spirochetes and other bacteria.

Coral
Complexities

PHOTOGRAPHS BY

David Doubilet

TEXT BY

William Kiene

A coral reef is the epitome of ecological complexity—richly productive, spectacularly diverse, and highly integrated. In a reef the dividing lines between plant and animal, colony and individual, biology and geology are difficult to discern. Reefs today are scenes of unparalleled natural beauty. They are among the oldest and most persistent ecosystems on Earth, yet they are also extremely fragile. Around the world, reefs are in serious danger from a variety of human activities.

A GOBY AND MICROSCOPIC ALGAE
SHARE THE MANTLE OF A GIANT
CLAM, WHICH NOURISHES BOTH.

Coral Complexities
A Reef Heritage in our Hands

I

A MOUNTAIN CLIMBER GRIPS A VERTICAL cliff face in the Italian Alps. Brilliant warm sand runs through the fingers of a sunbather on the beach of a tropical island in the Pacific. An oil-rig worker examines fragments of limestone drilled a thousand feet beneath the ranchlands of west Texas. A Bedouin and his camel tread through the dry primeval desert of Oman. The hand of an Aborigine applies brightly colored paint to the smooth wall of a cave in northwest Australia.

All of these people is are linked through the sand and stones they touch—the remnants of reef ecosystems. Since the earliest stages of life on Earth, a changing combination of marine organisms has created reefs by accumulating their calcareous remains on the tropical sea floor. These fossil remains form limestones that are preserved in the geology of many regions of the world and tell an evolutionary story of how different species once held the role that corals hold today—the major architects of reefs. For more than two billion years, forces that moved continents, altered climates, drowned coastlines, and drained seas also orchestrated a changing chorus of plant and animal species that colonized, built, abandoned, and replenished the reef ecosystem. The inhabitants that exist on coral reefs today are the dazzling descendants of this impressive evolution.

The sand particles sifting through the sunbather's fingers are minute fragments of corals and other calcareous marine life. The beach is an enormous pile of tiny skeletal remains eroded from the coral reefs lying just offshore. Over thousands of years, the large and small calcareous remains of many generations of corals and other reef inhabitants have built massive limestone foundations on which the present reef community grows. The coral reef structures created by this building process can be enormous, often tens of meters thick and covering several square kilometers of the sea floor. The communities that built reefs in ancient seas constructed structures similar to these modern-day coral reefs. As a result, fossil reef limestones form

some of the most spectacular geological features of the Earth's surface.

The mountain climber scales a spire of 225-million-year-old limestone rising more than 1,000 meters above an alpine valley. This enormous mass of rock was formed in a Triassic sea from the skeletal debris of fossil algae, sponges, and corals. This old reef rode great thrusts of the Earth to eventually come to rest high in the Dolomites of the Italian Alps. Tectonic movements have not only placed fossil reefs in mountain outcrops, but also buried them deep below the earth's surface, as is the case in west Texas.

Thick deposits of limestones are the targets for oil prospectors drilling the west Texas earth. In the right setting, porous reef limestones can contain huge volumes of oil. Within the rock fragments examined by the oil-rig worker are traces of unique reef builders from an ancient Paleozoic sea, where carpets of microbial life captured calcium and fine sediment from seawater to create dome-shaped limestone mounds called stromatolites. Stromatolites joined other algae and invertebrates to create the old reefs of west Texas. However, stromatolites alone built the first reefs to emerge in the Precambrian ocean more than two billion years ago.

The Bedouin who leads his camel across a dry Cretaceous seabed in Oman passes great piles of bizarre fossil bivalves called rudists. A hundred million years ago, these mollusks evolved and invaded the reef environment. Rudists colonized reefs in such large aggregations that they displaced almost all of the other reef residents. Shaped like horns, the shells of these extinct mollusks grew to more than a meter in length and accumulated to build reefs covering many square kilometers of the sea floor. The colossal growth of these Cretaceous reefs suggests rudists discovered the secret for rapid assembly that corals use today—the hosting of symbiotic algae within their tissues.

II

MOST CORALS ARE NOT INDIVIDUALS BUT colonies of thousands of small identical animals.

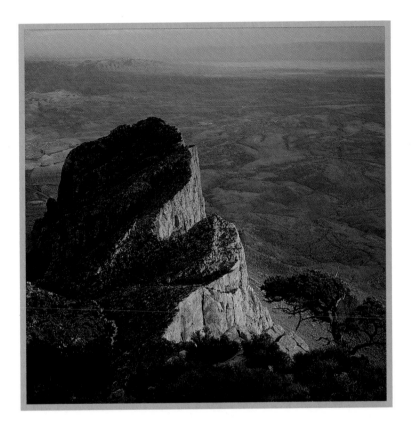

Coral reefs are the legacy of a long ecosystem evolution that began at the earliest stages of life on Earth. A diverse community of reef builders in a Permian sea, 250 million years ago, created the limestone of these cliffs in the Guadalupe Mountains of west Texas.

A coral begins life as a tiny, free-swimming larva. Each year, a single night of sexual reproduction by corals releases gametes and produces the larvae. The newly formed coral larvae settle on the sea floor and transform into polyps. A colony begins when a single polyp asexually buds a new and identical copy of itself. As each new polyp is born, it begins to build a skeleton beneath its body.

Coral polyps are prolific skeleton builders due to an alliance they form with tiny algae. Living inside the coral polyp, microscopic algae capture the energy of sunlight through photosynthesis and transfer some of this energy to the coral. This energy aids the coral's skeletal building process. Continuous budding and skeletal construction by a coral colony over hundreds of years can build a colony several meters in diameter. These coral structures are a key factor in the enormous productivity and diversity of the reef ecosystem. Legions of large and small marine organisms make a home on, beneath, around and within coral colonies. This symbiotic sharing of living space and resources by coral reef organisms allows efficient recycling of limited resources. As a result, coral reefs are some of the most biologically productive environments on Earth, just as their ancient reef-building ancestors must also have been.

The lesson taught by the geological history of the reef ecosystem is one about change. Periods of evolution, colonization, and diversification in reef communities ended with global extinctions and ecosystem failure. Yet ecological reorganizations by

Continued on page 144

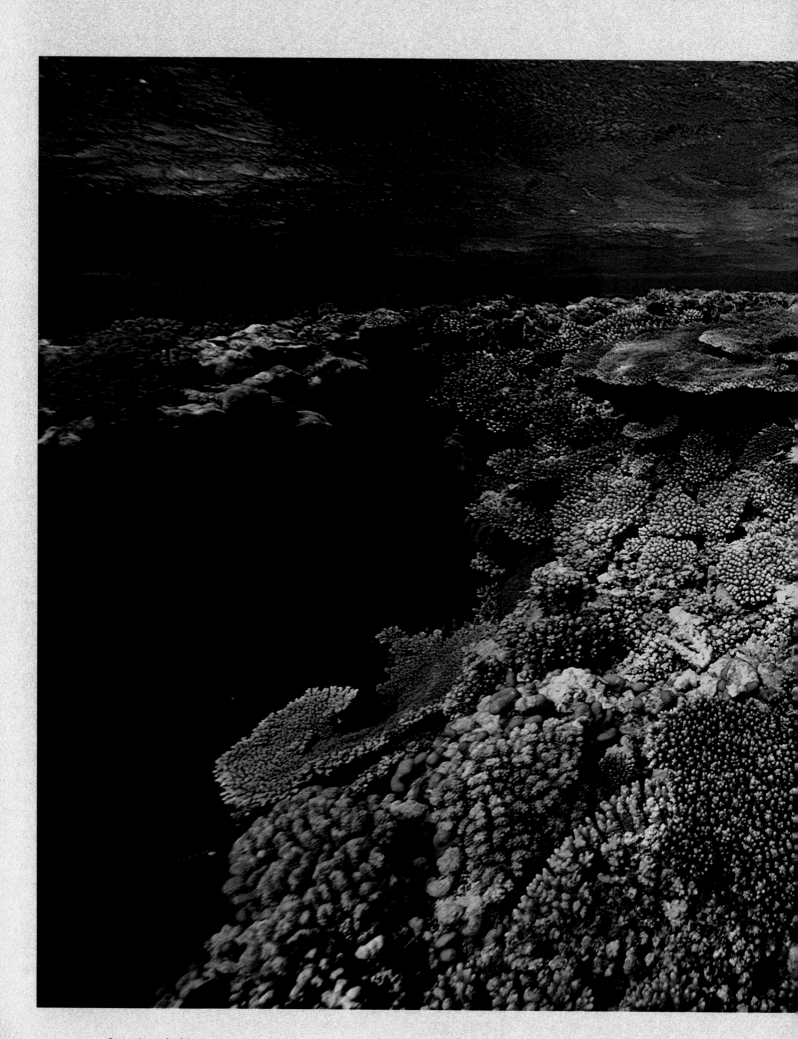

Space is a valuable resource on coral reefs. Here, in tropical Pacific waters, great numbers of coral species compete for a place in the sun.

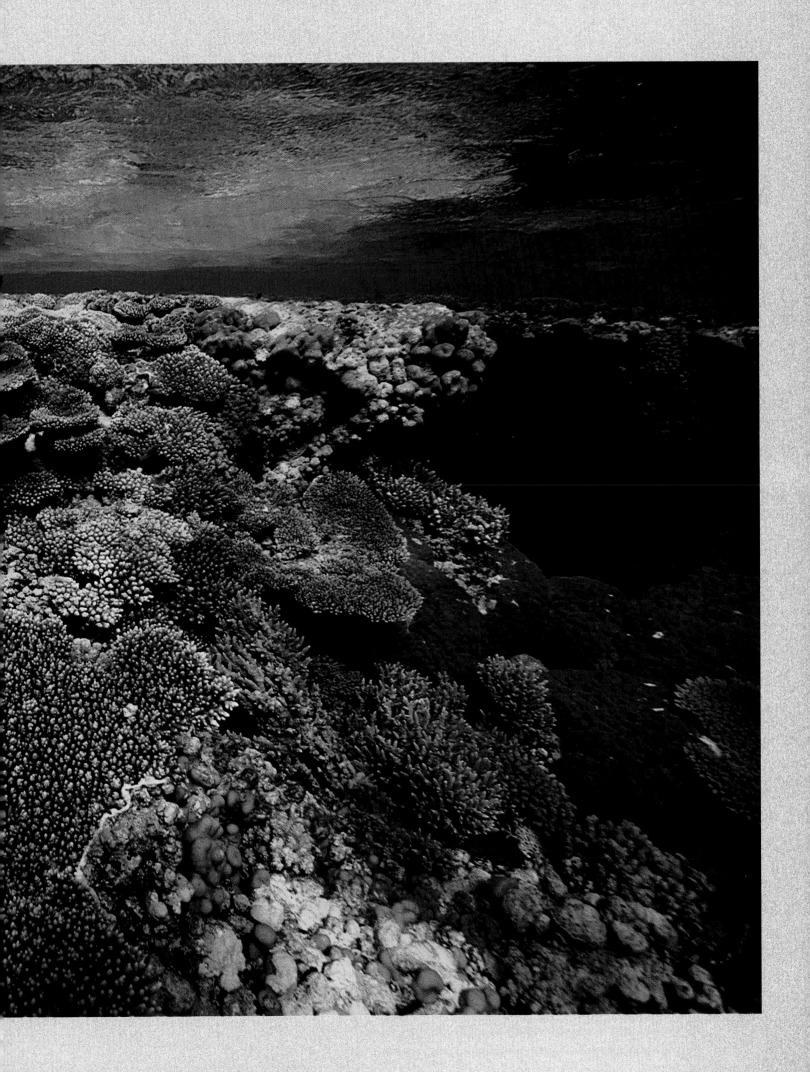

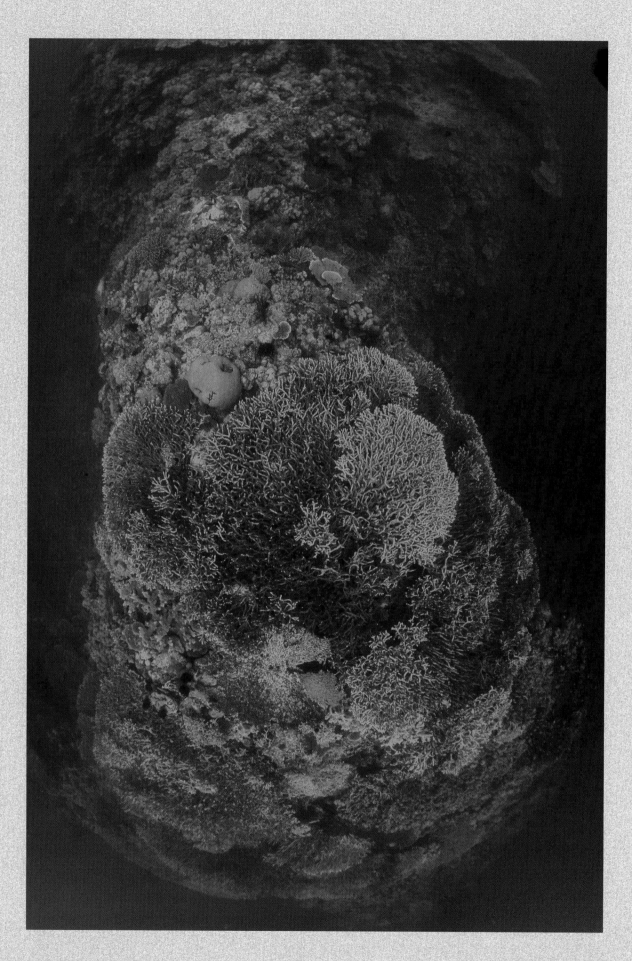

Multitudes of tiny coral polyps form colonies and erect elaborate structures.
By night, polyps capture plankton; by day, the sun brings energy to symbiotic
algae living within polyps. More species pack this habitat than any other in the
ocean—around, beneath, and within corals, other species make their homes.

The parrotfish uses its hard teeth to excavate algae living beneath the reef's surface.
The reef limestone is ingested, ground within the fish's digestive tract to remove the
algae, and then expelled as sand. This grazing by parrotfish can produce large volumes
of sand that accumulate as reef shoals and islands.

Shores of young volcanic islands, like this one in Indonesia, often provide the shallow sea floor on which corals begin their growth. The reefs become established when coral larvae settle and grow into colonies. When a coral colony dies, its hard skeleton provides the foundation on which new colonies develop. Over thousands of years, successive generations of corals have accumulated thick deposits of limestone that lie beneath the thin veneer of life we see on coral reefs today. The tiny invertebrate architects that have assembled these reef structures interact within a web of complex relationships with other plants and animals. Humans, however, have become interwoven with this network in often destructive ways. Coral reefs are important sources of food, building materials, recreation, and income for people all over the world; yet increasingly, our connections to the reefs have inadvertently broken many of the ancient bonds that have held this ecosystem together.

Rare Banggai cardinalfish (above)—found only on reefs of eastern Sulawesi, Indonesia—are a prized aquarium fish. A market for these and other beautiful reef fish provides employment for local collectors as long as fish populations remain healthy. An Indonesian fisherman (opposite) checks his wooden fish trap. Fish caught in this way provide food as well as profit for the fisherman and his family. As the demand for fish goes up, destructive methods are often employed to increase the harvest, including the use of explosives and poisons such as cyanide, which both stuns large numbers of fish and destroys reef habitats. The worldwide demand for seafood and the profitability of the business have caused overharvesting not only of coral reefs but of many ocean habitats. Informed consumption and management are essential if the ocean's resources are to remain plentiful in the future.

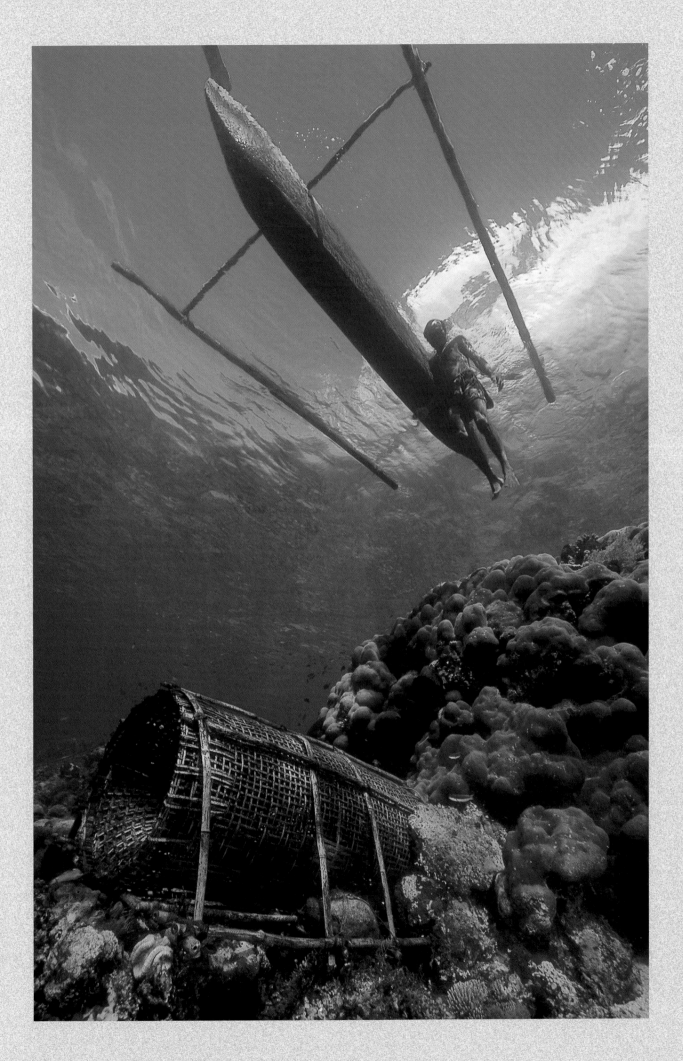

Immune to its deadly sting, this fish resides within the tentacles of a sea anemone, an arrangement that benefits both the fish and the anemone. The anemone's sting is a deterrent to predators of the fish, while the fish in turn will chase away potential predators of the anemone. Intimate partnerships, like this between very different members of the ecosystem, have evolved to make coral reefs one of the most diverse and productive biological habitats on earth. During the long evolutionary history of marine life, the fossil record of reefs tells us that these partnerships were periodically disrupted by major changes to the marine environment. Since the 1970s we have witnessed a similar dismantling of the reef coalition. However, this recent breakup, proceeding at an alarming rate, is caused by our increasing influence on the condition of the sea.

Black band disease advances over the surface of this brain coral, killing tissue and exposing the coral's pale, dead skeleton. Pollution that weakens the coral's natural defenses has made corals susceptible to this bacterial infection. The spread of coral diseases illustrates how human activities have emerged as powerful forces of change shaping the future of coral reefs and our planet.

Continued from page 133

new inhabitants eventually rebuilt the reef environment. These reorganizations were gradual, occurring over hundreds of thousands of years, influenced by powerful forces of nature. These same forces predestine today's living coral reefs to face similar evolutionary cycles of reef building and demise in the future.

It is, however, the future that is uncertain. The biggest concern is not that the world's coral reefs will undergo change but that we are witnessing the change: divers frequenting favorite dive spots have observed the death of vast numbers of corals; once abundant coral reef fish are now rare on many reefs; wide tracks of once healthy corals are now choked by blankets of large algae. Although similar to the demise in reef organisms in the geological past, the speed of these changes appears to be unprecedented in Earth's history.

III

HUMAN BEINGS—WITH THEIR ABILITY TO fundamentally alter the oceans, the atmosphere, and the landscape—are rivaling the geological processes that orchestrate change in the Earth's ecosystems. Moreover, humanity's impact on coral reefs seems to be escalating. Pristine coral reefs are fewer in number; and the decline in reef health is often linked to changes caused directly, or indirectly, by a growing human population.

Humans are voracious consumers of fish. Fish play fundamental roles in the reef's food chain by eating plants, by preying on other animals, and as prey for other fish. These roles redistribute the biologic products essential in maintaining the reef economy. Without this transfer of products, the ecosystem's economy will falter. Because of the global growth in human population, demands for

fish have reached the limits of the ocean's supply. Since coral reefs are home to such large numbers of fish, the reefs are being mined of their fish resources. As fish numbers decline, destructive fishing practices are frequently employed to squeeze the few remaining fish from reef habitats. Coral-destroying dynamite, poisons, and crowbars are some of the tools used to extract hidden fish from their coral reef homes.

The dying of coral on a global scale, not seen until recently, could also be a sign that the Earth's climate is warming; and our practice of burning fossil fuels may be the cause. The optimal water temperature for reef corals is very near the upper limit that corals can tolerate, about 30°C. Rapid increases above this temperature, like the warming of the tropical ocean during periodic El Niño climate cycles, can kill corals. When water temperatures increase to unusually high levels, corals will expel their internal symbiotic algae. Devoid of their essential symbionts, coral polyps are without color. If the polyps are not repopulated by the algae in a matter of weeks, this "bleaching" will kill the coral. Implicated in causing this warming are increasing amounts of atmospheric carbon dioxide and other gases that are byproducts from the burning of fossil fuels. Historical records show that our increased use of fossil fuels, such as oil, has paralleled the increase in heat-trapping gases in the atmosphere. It is ironic that we burn the petroleum drawn from ancient fossil reefs, and in turn contribute to the demise of today's living coral reefs.

Pollution also threatens coral reefs. Poor land-use practices, even by people far away from the ocean, can erode soils and the nutrients they contain into rivers and eventually into coastal environments. The turbidity caused by this runoff decreases water clarity, and sediments can smother a coral reef. More destructive, however, are the nutrients. They promote the growth of large algae that can out-compete corals for space on the reef. Other chemical pollutants, carelessly disposed, are making their way into reef waters and may be contributing to the diseases and death of reef inhabitants.

The history of reefs through time shows that the reef ecosystem is resilient. The demise of reefs in the geological past made way for other organisms to colonize and rebuild reef habitats. However, these recoveries were slow, occurring over millions of years. Very simple communities, such as those that build stromatolites, often initiated the reef reconstructions. If overfishing, coastal runoff, and a number of other catastrophic injuries continue to disrupt the world's coral reefs, we cannot expect new reef builders to rapidly evolve and repair the damage.

IV

THE DESTRUCTION OF THE EARTH'S NATURAL heritage by humans is now an old story. The impact of human societies on coral reefs indicates how difficult it is for people to recognize their connection to our planet's ecosystems. There are, however, some societies that need an undisturbed environment not just for their physical survival but for the survival of their entire culture.

The harsh landscape of the Kimberley Plateau in Western Australia is the setting for a huge complex of fossil reefs. These reefs stand in the landscape as if the water recently drained away, even though it did so more than 350 million years ago. Caves in these ancient reefs are sacred sites for Aboriginal people. Paintings on cave walls depict the Wandjina, ancestral spirits of creation, fertility, and rain. The Aboriginal artist renews a painting of the Wandjina, an act that perpetuates his society's understanding of the forces that made the features of the world. The enduring image of the Wandjina recalls the powers of the Dreamtime, when the world was created, and symbolizes the close connection between the Aboriginal people and their surrounding landscape. Strong, resilient bonds are similarly necessary between the inhabitants of reef ecosystems to ensure their survival during dramatic environmental change. The most powerful force behind such change today is in our hands. Perhaps all societies must know and support the bonds that connect people to Earth's natural systems if they are to coexist with them.

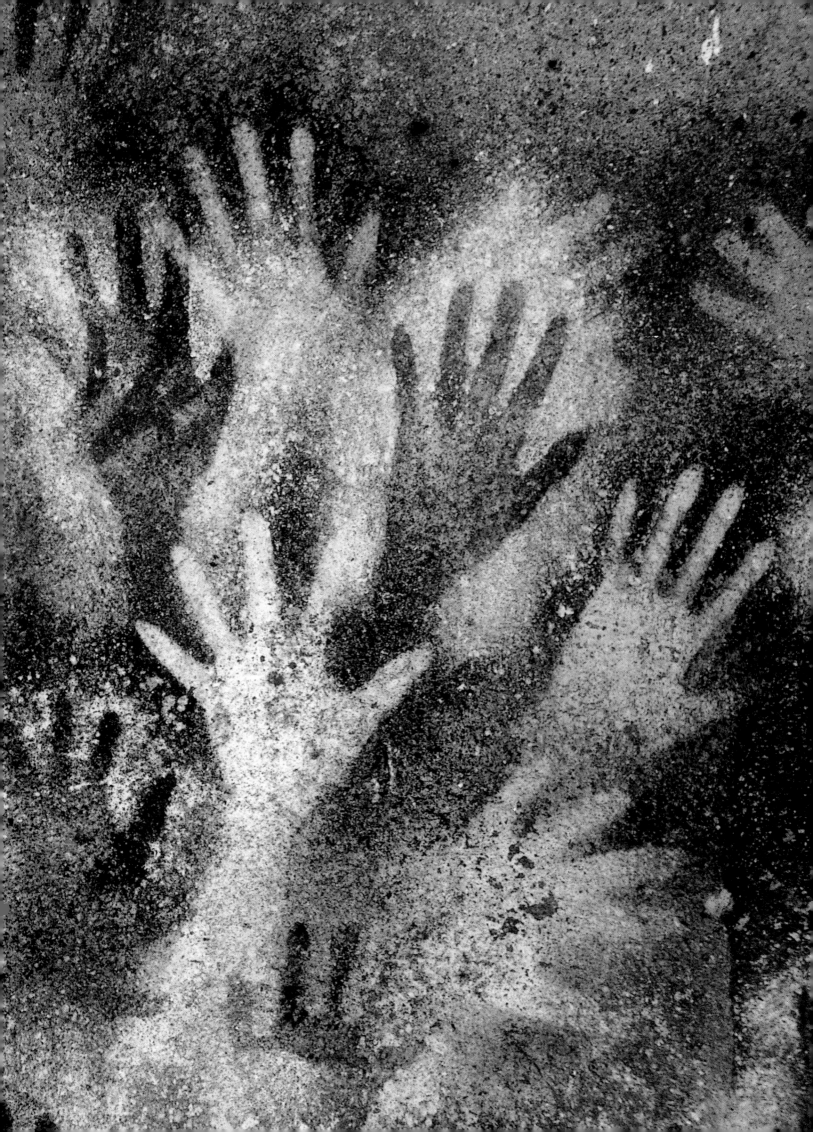

What They Will Know

David Quammen

FOR BILLIONS OF YEARS, EXTINCTION HAS BEEN A NATURAL FORCE OF ECOLOGICAL CHANGE. BUT IN RECENT MILLENNIA, WAVES OF SPECIES EXTINCTIONS HAVE CORRELATED SUSPICIOUSLY WITH MIGRATIONS OF HUMAN POPULATIONS. HUMANITY'S ECOLOGICAL PAST CAN SHED LIGHT ON TODAY'S EXTINCTION CRISIS—AND RAISE WARNINGS FOR THE EARTH'S BIODIVERSITY.

Biologists and paleontologists of the distant human future—if there are any such scientists then, if there is any such future—will find interesting questions to consider when they look back at the brief stretch of geological time within which we presently sit. The most basic of those questions will be: *What happened?* The answer, so it seems, based on current evidence and trends, will be that the defining event was a mass extinction, a great loss of biological diversity on the same order of magnitude as just five other episodes in the history of life. The rise of *Homo sapiens* as a hunting-and-gathering primate, and then as an agriculturalist, and then as a civilized creature with vast capacities for controlling landscape and resources, will be seen to coincide with this sudden disappearance of other species. It won't be a pretty thing to contemplate. But it will be fascinating to professionals.

Let's posit these future scientists at a remove of, say, two million years. For convenience, let's give them a couple of names—call them, oh, Dr. Zeta and Dr. Glebb. Dr. Glebb is an ecologist who studies rats. He knows everything there is to know about how *Rattus synanthropus*, the sole species alive in his day, maintains its teeming populations among the old, abandoned, intercontinental subway tunnels, feeding mostly on bacterial scum and leaked sewage. Dr. Zeta is a paleontologist whose specialty is nonhuman primates, an obscure and long-vanished group that includes lemurs, lorises, tarsiers, gibbons, orangutans, monkeys, gorillas, and several other extinct lineages. Dr. Zeta has never laid eyes on a monkey or a gorilla—not a live one. She knows them from fossils, stuffed specimens, pickled organs, and DNA files in archaic digital code. The only extant non-human primate is the white laboratory chimpanzee, still so crucial to medical research; but the white chimp doesn't interest her, since it's incapable of existence on the outside. The phrase *on the outside,* by the way, is Zeta's equivalent to the quaint and obsolete formulation from an earlier era: *in the wild.* There is no wild. Trees still exist, a modest catalogue of species, but parcels of trackless forest do not. The Amazon is now just a river, a brown waterway flowing among endless urban sprawl, not a region of wilderness. The Congo basin has been tastefully paved. Drs. Glebb and Zeta don't lament these realities. They are scientists, not nostalgists. They share a fascination with the ecological secrets of survival, and therefore too with survival's converse, extinction.

Human hands, here stencilled on a south Patagonian cave wall 7,000 years ago, have altered the course of nature worldwide.

To create a little flower is the labour of ages.

—WILLIAM BLAKE

Having studied the fossil record as well as the scientific literature, Zeta and Glebb know as much as our 20th century paleontologists do, and more, about mass extinctions. They know that the age of dinosaurs ended abruptly with the Cretaceous. They know that the Ordovician extinction claimed most of the world's marine animal diversity, at a time when land animals didn't yet exist. They know about the Permian extinction, largest of all, and about the Devonian and the Triassic events. They may even know, based on astronomical evidence undiscovered in our era, that all five of those cataclysms derived from a single, recurrent cause—a cyclic pattern of destruction wreaked by falling asteroids, or somesuch. And they know something else. *Besides the big five,* says Dr. Zeta, *there was that sixth mass extinction, about 65 million years after the Cretaceous. Remember that one, Glebb?* Glebb says: *Do I remember? How could I forget? The last of the six. The one that doesn't conform to any pattern, the one that's more mystifying in its way than all the others. Falling asteroids had nothing to do with it.* Glebb and Zeta exchange a dour look. They know that the sixth extinction is the anthropogenic one.

They don't know your name or mine, but with the wisdom of hindsight across the long reach of time they know that we, and people like us, were responsible. When Zeta and Glebb ponder its meaning, they ponder us.

Among the less basic questions facing them, there's the matter of etiology. *What caused it?* Dr. Zeta has often wondered. *Humans did, yes, of course, by force of our prepotency, sheer abundance, and insatiability*—that much is still obvious after two million years—*but, I mean, specifically how and wherefor? What were the mechanisms? What immediate forms of human activity yielded such exterminations?* Timing and scope are also at issue. *When did it start?* asks Dr. Glebb. *How long did it continue? How many species were ultimately lost?* And they're curious about the aftermath. *How many species survived? Why those in particular? With what abiding effects on the course of life?* Lastly, as scientists, they need a label. They might know this event as the Holocene extinction,

after our own current geological epoch. But the Holocene epoch stretches back just 10,000 years, to the end of the last ice age, not quite far enough to encompass all the relevant data. They might call it the Quaternary extinction, after that wider bracket of geological time embracing both the Holocene and the Pleistocene. It was during the Pleistocene that the crucial changes began—*Homo erectus* of eastern Africa gave rise to *Homo sapiens,* and the savvy primate then dispersed every which way, colonizing all reachable and habitable regions of the planet, with what appear to have been devastating effects upon local faunas and floras. But the term *Quaternary extinction* doesn't quite fit, it's too baggy, since the Quaternary period covers almost two million years, whereas the human-caused obliteration of species seems to trace back, at most, about 50,000 years. So a better label, for its precision, might be the Late Quaternary extinction. In its handy, short form: the LQE.

Whatever they may call it, and however hard they may study, future biologists and paleontologists are bound to find the whole matter puzzling. Rat ecology could be instructive, but only marginally. Pickled gorillas will be more poignant than eloquent. If we ourselves can't comprehend the dynamics of the LQE, or fathom its implications, or account for its seeming inexorability, or prevent it, how will Zeta and Glebb ever figure the thing out?

They'll want to know: *What on Earth were you people thinking?*

The very idea of extinction was unimaginable in the recent past. Just two centuries ago, well-educated people generally embraced the notion of a Great Chain of Being—that is, an incremental hierarchy of living creatures, each one designed and delivered to Earth by the divine Creator. God had made all species, yes? Therefore, who could be so irreverent as to contemplate the unmaking of even a single one? Nobody—or at least, nobody who professed orthodox piety. The historian Arthur O. Lovejoy, in his classic book *The Great Chain of Being,*

traced this notion of nature's divinely appointed fullness and labeled it "the principle of plenitude." That principle, asserting axiomatically that the Great Chain could not suffer losses or gaps without ruination of the whole, had found expression by observers as sharp-minded as Alexander Pope: "From Nature's chain whatever link you strike, Tenth, or ten thousandth, breaks the chain alike." Thomas Jefferson put his own skepticism about extinction into a scholarly paper published in 1799. Discussing a giant sloth-like beast called *Megalonyx* that was known from fossil remains found in West Virginia, Jefferson wrote:

> In fine, the bones exist: therefore the animal has existed. The movements of nature are in a never-ending circle. The animal species which has once been put into a train of motion, is probably still moving in that train....If this animal has once existed, it is probable on this general view of the movements of nature that he still exists.

But no one ever sighted a living *Megalonyx* in the Shenandoahs, and later research suggests that it was extinct by about 11,000 years ago, shortly before the end of the Pleistocene. Eventually it became known in the paleontological literature as *Megalonyx jeffersonii*, though not because the poly-mathic Virginian had been right in his syllogistic argument for its survival.

Paleontology itself was a branch of science that didn't yet exist. But about the same time that Jefferson published his amateur paper under the title "A Memoir on the Discovery of Certain Bones of a Quadruped of the Clawed Kind in the Western Part of Virginia," a more expert biologist in Paris, Georges Cuvier, was doing work that would help turn the tide of opinion toward accepting extinction as reality. Cuvier, like Jefferson, focused especially on the remains of a gigantic American ground sloth. In his case it was *Megatherium*, as preserved in fossils that had been shipped from Paraguay. He also studied elephant-like beasts that would eventually be classified as *Mammuthus*, as well as other

Continued on page 154

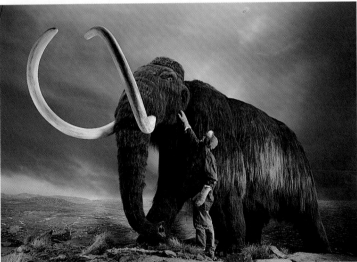

MAMMOTH CHANGES

For almost as long as humans have been making tools, they have been changing the face of nature. A set of spear points (top), chiseled from stone 11,000 years ago in Washington State, were probably used to hunt and kill big game like the woolly mammoth (bottom, in a museum recreation). Many scientists believe the mammoth, like many other large animals of the Pleistocene era, was hunted to oblivion in Europe and Asia, then became extinct as human populations spread across North America.

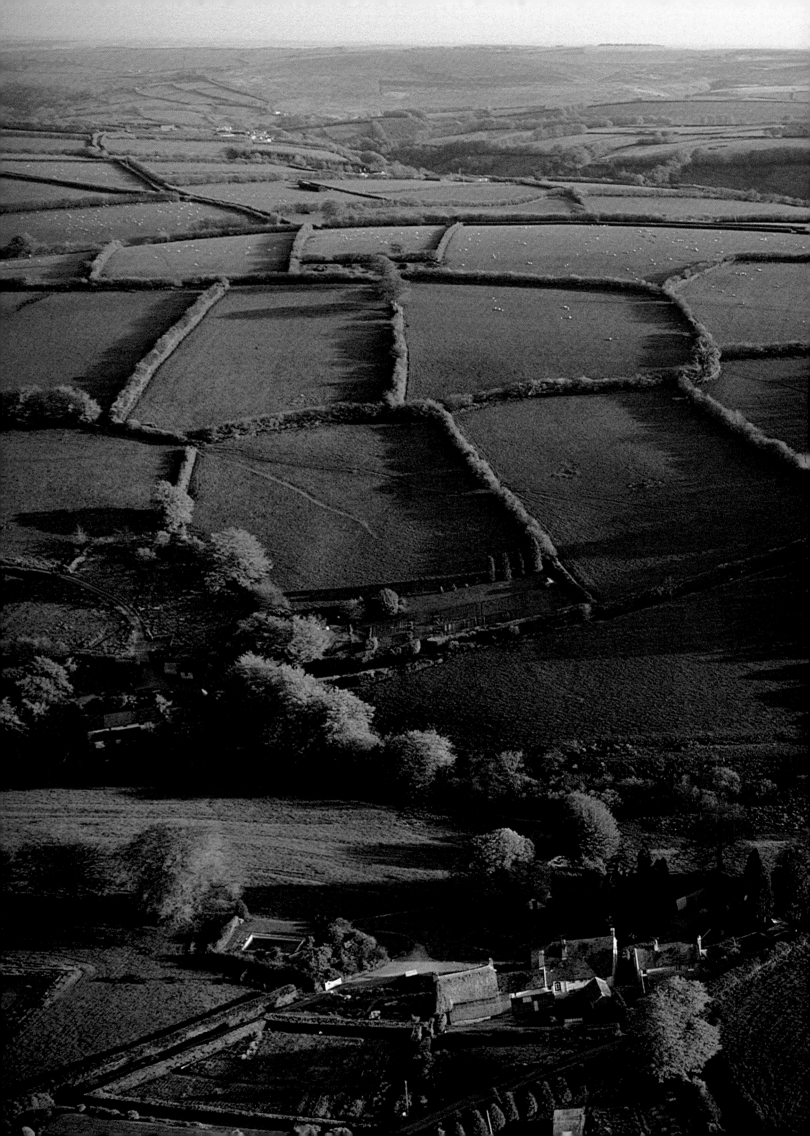

THREATENED TENEMENTS
When English farmers cleared the forests centuries ago, they created an agriculturally rich but biologically impoverished landscape. Natural communities survived in the thick, impenetrable hedgerows between the fields, like these in Somerset, southwest England. Hedgerows support their own distinct community of plants and animals and serve as migration corridors for many species. Ironically, these human-created habitats are threatened today, as modern farming practices demand ever larger fields without obstructions.

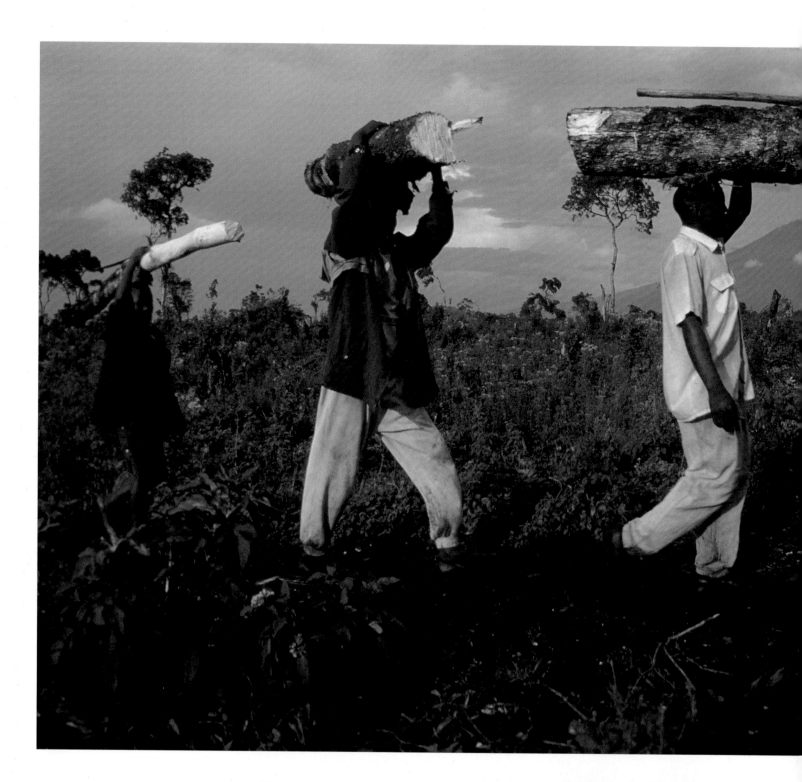

Area of
undisturbed forest

Area disturbed
by agriculture

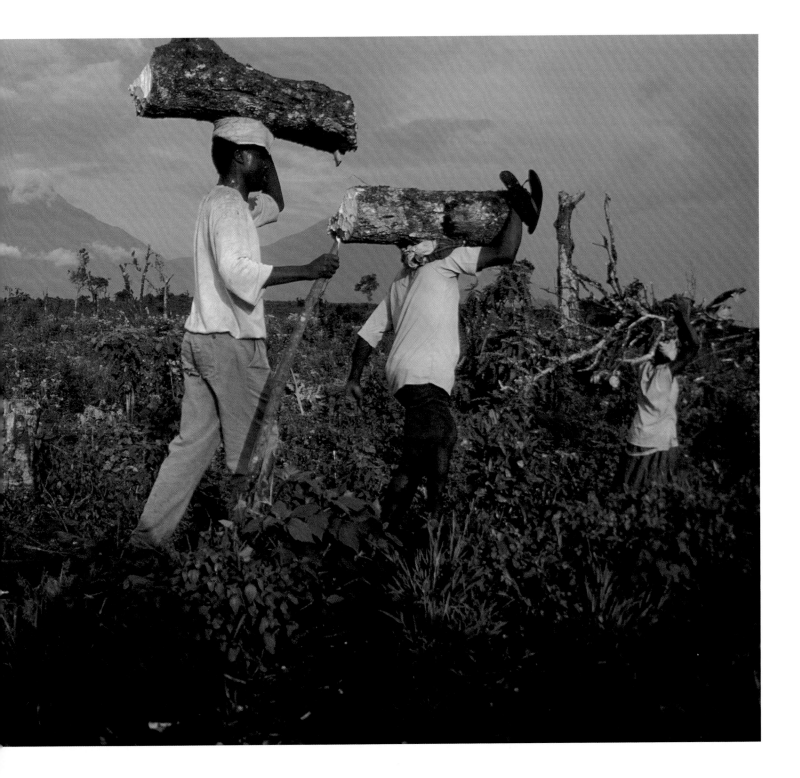

LAST STAND OF THE MOUNTAIN GORILLA

The African continent, birthplace of our species, continues to be the scene of some of the more poignant conflicts between humans and biological diversity. Efforts by conservationists have slowed the slide of the mountain gorilla (opposite, near left) toward extinction, but long-term preservation of gorillas and other species must take into account the cultural, political, and economic realities of the region.

Refugees from political violence in Rwanda carry firewood cut from the fringes of Virunga National Park in the Democratic Republic of the Congo (above). The park's forest habitats, vulnerable even in times of peace, harbor approximately half of the world's 600 mountain gorillas. In a radar image (opposite, far left), subtle differences in vegetation and surface texture reveal the extent to which natural habitats have been altered and fragmented, leaving the Virunga Mountains an isolated ecological island.

AFRICA
Area Enlarged

The important thing is not to stop questioning.

—ALBERT EINSTEIN

Continued from page 149

large, missing mammals whose remains had been lately unearthed. "Many of the animals Cuvier analyzed," according to the historian of paleontology Donald K. Grayson, "we now know to have become extinct near the end of the Pleistocene." Conventional opinion held that, though eliminated from Europe, these big ground sloths, mammoths, cave bears, woolly rhinos, and other unexpected creatures must have survived in other, less civilized landscapes, thereby preserving the Great Chain intact. Cuvier closed that hopeful loophole, arguing convincingly that they were extinct. Colleagues on this side of the Atlantic followed his lead, so that by 1825 a volume titled *Fauna Americana* could describe ten species of extinct North American animals, among which were a mastodon, a mammoth, a long-horned bison, a tapir, a moose-antlered deer, and Jefferson's ground sloth. These lost and rediscovered forms were all Pleistocene mammals, part of a very different story from that of the giant Mesozoic reptiles whose fossils had begun coming to light about the same time. The Pleistocene mammals, unlike the dinosaurs, were entangled with human prehistory.

The increasing supply of strange fossil forms, and the careful labors to describe and date them, brought scientists of the early 19th century to a pair of dramatic recognitions. The first was simply that extinction does happen, playing a fundamental role in shaping and reshaping the natural world. The second was that, within the relatively recent past, a major wave of extinctions had struck the large-bodied fauna of North America, South America, Europe, and maybe elsewhere. These ideas helped liberate the thinking of Charles Darwin, who built extinction into the logical structure of *Origin of Species:* "The theory of natural selection is grounded on the belief that each new variety, and ultimately each new species, is produced and maintained by having some advantage over those with which it comes into competition; and the consequent extinction of less-favoured forms almost inevitably follows." Darwin himself, during his voyage on the *Beagle*, had noticed striking

disparities between the living and fossilized faunas of South America—disparities reflecting differential extinction and survival. "It is impossible," he wrote in his journal, "to reflect on the state of the American continent without astonishment. Formerly it must have swarmed with great monsters; now we find mere pigmies compared with the antecedent, allied races." If the Creator was directly responsible for every species, as orthodoxy decreed, then even a pious naturalist was forced toward admitting that He just didn't make sloths like He used to. But of course Darwin, by the end of the *Beagle* journey, had already begun groping toward his own explanation for the source of species: competitive struggle, selection, evolution.

Forty years later the same pattern of impoverishment that astonished Darwin was noted by Alfred Russel Wallace, the naturalist whose career most closely converged with Darwin's. Besides co-discovering the theory of natural selection, Wallace studied the geographical patterns of faunal distribution on Earth, and by way of books such as *The Geographical Distribution of Animals* (1876) and *Island Life* (1880) he founded the discipline now called biogeography—that is, the study of which species live where, and why. Discussing the vacancies left by recently extinct mammals, Wallace wrote:

> It is clear, therefore, that we are now in an altogether exceptional period of the earth's history. We live in a zoologically impoverished world, from which all the hugest, and fiercest, and strangest forms have recently disappeared....Yet it is surely a marvellous fact, and one that has hardly been sufficiently dwelt upon, this sudden dying out of so many large mammalia, not in one place only but over half the land surface of the globe. We cannot but believe that there must have been some physical cause for this great change.

What was the cause? He suspected glaciation. Later scientists have offered other hypotheses. The point here is that, having sorted through a welter of data from all over the world, Wallace neatly

focused the mystery of the Pleistocene megafauna extinctions. Species of hyena, rhinoceros, antelope, hippopotamus, and elephant had disappeared from Europe, he noted; big felines, horses, camels, and mastodons had vanished from North America; South America too had been abruptly emptied of horses and mastodons, as well as giant ground sloths and giant armadillos. "It is clear that so complete and sudden a change in the higher forms of life," Wallace recognized, "does not represent the normal state of things."

Later research has only expanded the list, and intensified the mystery, of Pleistocene extinctions. North America lost more than 70 percent of its genera of big-bodied mammals, including such creatures as the dire wolf (*Canis dirus*), the giant short-faced bear (*Arctodus simus*), the saber tooth (*Smilodon fatalis*), the American lion (*Panthera leo atrox*), the American cheetah (*Miracinonyx trumani*), the Mexican horse (*Equus conversidens*), the western camel (*Camelops hesternus*), the long-legged llama (*Hemiauchenia macrocephala*), the mountain deer (*Navahoceros fricki*), the shrub ox (*Euceratherium collinum*), the Columbian mammoth (*Mammuthus columbi*), as well as other species of horse, proboscidean, peccary, goat, ox, and bison. Australia lost about 60 species of big animal, many of which were imposing forms of marsupial such as giant wombats and carnivorous kangaroos, but also including such non-mammalian megafauna as a 20-foot-long cousin of the Komodo dragon, a giant horned tortoise, and a 200-pound flightless bird known as *Genyornis newtoni*. A parallel set of megafauna extinctions occurred on Madagascar, the big island off Africa's eastern coast. Madagascar's turn came later than the end of the Pleistocene, but it reflected a similar trend, with big-bodied mammals disappearing while small-bodied mammals survived, and big-bodied reptiles and birds also affected. The losses there included perhaps sixteen species of giant lemur, two species of giant tortoise, a pygmy hippo, an aardvark, and several giant flightless birds, including the so-called elephant bird *Aepyornis maximus*, which stood almost ten feet tall. What caused the disappearance of these peculiar beasts, and of the others lost from South America and Europe, all during a relatively short stretch of millennia? Although the mystery seemed notable to Alfred Wallace, he didn't solve it. Neither did Darwin. Experts are still arguing about what happened.

Some of those experts believe that climate change accounts for the Pleistocene extinctions. Toward the end of the last glaciation, according to this view, habitats became drier and more constricted, seasonal rhythms shifted, and vegetation shrank away, resulting in crises of dearth and competition among the big herbivore populations and the big predators that depended upon them. These crises didn't strike every region simultaneously. But the global climatic shift delivered a severe jolt to ecosystems all over the planet—so say the climate hypothesists—and some of those ecosystems eventually suffered major losses of species in consequence. It's plausible. It's undramatic, and therefore bears a certain air of sobriety. But discrepancies in the timing of the losses, from one continent to another, raise doubts about that explanation. If the Australian extinctions occurred 20,000 years ago, or maybe 30,000 or even more, why were the North American extinctions delayed until 13,000 years ago, and the Madagascar extinctions until just 1,000 years ago? The main alternative to the climate hypothesis is the idea that bands of humans, recently arrived on the landscape in each case, hunted the more vulnerable megafauna to extinction.

That's the overkill hypothesis. For more than three decades, its leading proponent has been Paul S. Martin, now an emeritus professor of geosciences at the University of Arizona (and a provocative advocate, lately, of introducing elephants to the American West, as a step toward repairing the ecological loss of the mammoths and restarting elephantid evolution on this continent). Back in 1966 Martin published a paper titled "Africa and Pleistocene Overkill" in the journal *Nature*. In further papers and edited volumes since then, he has

The certainties of one age are the problems of the next.

— R.H. TAWNEY

refined the idea, mustered more evidence, encouraged a useful debate among the opposed schools of opinion, and answered criticisms of his overkill scenario. One of the volumes was *Quaternary Extinctions,* co-edited by Martin in 1984 and including his own chapter titled "Prehistoric Overkill: The Global Model," making a broad but judicious argument. "If man's role in the process was negligible or quite incidental," Martin wrote, "it would be an amazing coincidence that extinctions of most large mammals occurred when they did." The coincidence he had in mind was between humanity's arrival, in this place or that, and the end of a great age of big beasts.

But when *did* humanity arrive in this place or that? The archeological evidence suggests—or, at least until a few years ago, it suggested—that humans first reached North America shortly before the Pleistocene megafauna disappeared. Likewise in Australia, although the match there was not quite so precise; likewise in Madagascar. As Martin wrote: "A rapid rate of change can be anticipated whenever a land mass was first exposed to *Homo sapiens.* The vulnerable species in a fauna first encountering prehistorical people will suddenly vanish from the fossil record." In the Americas, that correlation seemed especially strong. A culture of big-animal hunters now known as the Clovis people (after their characteristic stone spearheads and other tools, first identified at a site near Clovis, New Mexico) began spreading across the U.S. about 11,500 years ago; they were presumed to have come via the Bering land bridge from Asia, and to have moved quickly eastward and southward; by 10,500 years ago they had reached southern Patagonia, and around that same time the giant ground sloths and other vulnerable South American megafauna went extinct. More recent evidence and bold new interpretations, though, have pushed back the date of first human presence and suggested a pre-Clovis people who might have arrived by sea (from southeast Asia? or from Europe, along the edge of the northern ice?) and who might or might not have preyed upon big terrestrial mammals. Meanwhile, for Australia the

evidence has shifted in the opposite way—from weakly supporting Martin's hypothesis to supporting it more strongly. The dating of the Australian extinctions had been uncertain, due largely to limitations in the reach of the standard technique, measuring carbon-14 decay. But a paper published on January 8, 1999 in *Science,* by Gifford H. Miller and a team of colleagues, announced a more precise dating of the extinction of *Genyornis newtoni,* that ostrich-size bird. Improved techniques (including a process called amino acid racemization, especially applicable to eggshells) have allowed Miller's group to show that the big bird came to its end, abruptly, everywhere throughout Australia, about 50,000 years ago. This was just after humans had arrived (not tens of millennia afterward, as the previous extinction dates had implied), and during a period when Australia's climate was cooling mildly but not drastically. Miller and his co-authors draw the conclusion: "Simultaneous extinction of *Genyornis* at all sites during an interval of modest climate change implies that human impact, not climate, was responsible."

In some parts of the planet, where evidence of Pleistocene extinctions is less pronounced (mainland Asia, for instance), the overkill may have been more gradual and less crucial, merely exacerbating the travails of mammal populations that were already suffering climatic stress. In other regions, such as South America and Australia, it seems to have been mortally fast. Paul Martin has suggested a speedier variant in those cases—a cycle of human invasion, discovery of abundant and incautious game, bounteously successful hunting, human population growth, onward dispersal, and further slaughter, driving prey species rapidly to the point of extinction. Martin's term for the speedy version is *blitzkrieg.*

The most isolated land masses of the planet, where human arrival occurred late, were most susceptible to blitzkrieg. The most isolated faunas, unprepared for this fearsome new predator—with its stone-point weapons, its spoken language, and its collaborative hunting strategies—would have suffered worst. Madagascar was not just an island

but an ancient one, long separated from Africa by a deepwater channel. Australia was an island continent. And the American hemisphere, except when the Bering land bridge rose above water, was essentially a huge, two-continent island. This pattern, as highlighted by Martin, represents our earliest warning of the complicated, fateful relationship between insularity and extinction.

The second major phase of the Late Quaternary extinction began about 3,500 years ago in the western Pacific Ocean, when a lineage of humans now known as the Lapita people began moving eastward, colonizing one remote island after another. The forms extinguished during this phase were mostly birds. Many were endemic species or subspecies confined (by their flightlessness, or by reluctance to fly over water) to a single island.

The people possessed some advanced technological skills—they made decorative pottery and built good oceangoing canoes. Besides their pots, they brought with them pigs, chickens, and dogs, and also transported inadvertently a species of rat originally native to Asia, *Rattus exulans.* Having left behind the safer waters of New Guinea and New Britain, where one big island was visible from another, they ventured east across wide sea gaps, reaching Fiji, Tonga, and Samoa by about 3,000 years ago. Within another millennium, descendants of this lineage had colonized most of Polynesia as far east as the Marquesas, and 500 years later they had gotten north to Hawaii. Still later, about 1,000 years ago, another vanguard of pioneers found their way down to New Zealand. Wherever they went, their arrival and settlement was hell on the local avifauna. Evidence of their travels lived after them in various forms: pottery shards, the bones of extinct birds, and populations of *Rattus exulans,* the canoe rat.

No one knows for certain, but we can reasonably assume that the early Pacific colonizers killed birds for food and for decorative feathers, that their dogs and pigs preyed on ground-nesting birds and

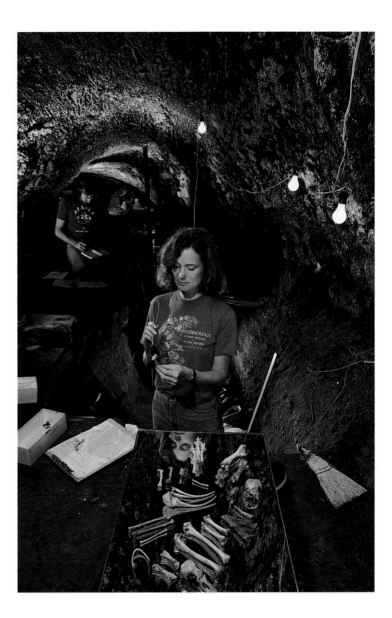

DEEP RESEARCH

The biggest threat to a species is not necessarily the overanxious human exploiter. After studying the fossil record in Maui's lava tubes in Hawaii, Smithsonian Institution researcher Helen James concluded that landscape modification and predators introduced to the islands by the first Polynesian settlers—pigs, dogs, and rats—are agents of extinction more deadly than human hunters.

eggs, that the rat made itself pestiferous in these previously rodent-free ecosystems, and that human settlement entailed destruction of habitat by cutting, burning, and setting loose non-native plants. Many endemic species of pigeon, dove, rail, parrot, and other land bird proved incapable of surviving this combined attack. (Nesting colonies of petrel, shearwater, and other long-flying seabirds were also presumably hurt, but at least they could relocate elsewhere.) Hawaii alone lost 60 unique birds, among which were ten or eleven species of goose (most of them odd, flightless forms), three species of flightless ibis, eight species of flightless rail, three species of long-legged owl, an eagle, a hawk, two species of crow, and more than a dozen species of honeycreeper. According to David W. Steadman, who has studied bird bones from archaeological sites on a number of Pacific islands and synthesized data gathered from still others, more than 2,000 bird species were wiped out during the Lapitan-initiated wave of colonization and ecological conquest. This was centuries before Captain Cook set eyes on Hawaii, and centuries also before the first Dutch sailor, far away in a different ocean, clubbed a dodo to death on the island of Mauritius. It may seem ironic, but phase two of the LQE was caused by the same lineage of invasive humans who would later be thought of as "native peoples."

Some islands of the Pacific escaped settlement during that era. One was Lord Howe Island, a small volcanic outcrop roughly 300 miles off the southeast coast of Australia. Never having been touched by phase two of the LQE, Lord Howe became an exemplar of phase three, beginning in 1788 when the British ship HMS *Supply* stopped there on its way back from a mission to Norfolk Island, farther east. At Lord Howe, the hungry sailors found fish in the bay, tasty turtles, and several different forms of avifauna—a pigeon, a white fowl-like bird on stout legs, a dusky brown bird with a long bill—that one crewman described as fat, good, and easy to kill. The island harbored fifteen kinds of land bird, all

of which were endemic at the level of species or subspecies, and all of which were instinctually unwary, having adapted to this benign insular ecosystem. The *Supply* returned several times within a few years, collecting turtles for the Sydney market; then whaling ships began using Lord Howe as a stopover for food and water. Before long, the endemic pigeon (*Columba vitiensis godmanae*) and the white gallinule (*Porphyrio albus*) were extinct. After settlement of the island in 1834, the red-fronted parakeet (*Cynanoramphus novaezelandiae subflavescens*) was eradicated, for the offense of raiding crops. These early extinctions on Lord Howe, caused by human overkill, were just the start.

One night in 1918 the ship *Makambo* hit a nearby reef. Confusion ensued, lifeboats were launched, a woman drowned, and then the *Makambo* grounded on Lord Howe Island itself. From the wreck, rats got ashore. These weren't *Rattus exulans,* the canoe-borne species that had wandered with the Lapitans; they were the hardy, acrobatic, aggressive, and vastly adaptable *Rattus rattus,* also known as the black rat, the ship rat, and (for its role in medieval European history) the plague rat. *Rattus rattus* thrived on Lord Howe to the degree that, in 1927, a bounty program yielded 13,771 rat tails. "Rat hunting was an important source of income during the economic depression of the 1930s," according to one account, "but had no effect on rat numbers." By the end of that decade, six more endemic land birds were extinct. These six losses—of a thrush, a warbler, a fantail, a silvereye, an owl, and a starling—have been ascribed to extermination by rats.

DEATH ON THE WING

A mosquito fills its abdomen with blood from a Hawaiian i-iwi bird—and in exchange gives its host a lethal dose of avarian malaria. Prior to European expansion, mosquitoes were unheard of in Hawaii—they probably arrived in the water casks of whaling ships. The disease-carrying stowaways have taken a heavy toll on native birds. During one outbreak, "birds literally dropped out of the sky," said biologist Carter Atkinson.

BAD GOOD IDEA

Following a lumber clear-cut in Washington State's Okanogan National Forest, a worker drip-torches the debris in preparation for replanting. But the new forest will be little more than a tree farm, not a fully functioning ecosystem. After a hundred years of timbering, the Pacific Northwest is home to dwindling tracts of old-growth forest. The fight to preserve it has involved the federal government in an agonizing mix of social, ecological, and economic problems.

The Lord Howe story carries three larger lessons. First, human overkill causes extinction, as it has since the Pleistocene. The overkill might be committed for food, or for feathers or fur or oil or blubber or some other organic resource, or to eliminate an annoyance, or for sport, or for no rational reason. Second, invasive species (especially the more opportunistic ones that travel in humanity's shadow) cause extinction. The invaders might be cats, pigs, goats, or other domestic animals gone feral; they might be an especially assertive species of rat, monkey, snake, toad, mussel, or snail; they might be animals or plants. Third, insularity itself is conducive to extinction.

The first two forms of trouble come as direct attack. Insularity is more complicated. The insular ecosystem might be an oceanic island harboring naive birds and ungainly reptiles, or it might be the last fragment of a great mainland forest, surrounded by an ocean of human impact, within which are marooned the survivors of a formerly widespread species. The Asiatic lion (*Panthera leo persica*), in the Gir forest of western India, is now an insularized subspecies, facing jeopardy similar to what once faced the Lord Howe pigeon. Its population is so small and so constricted, its gene pool is so diminished, that any combination of concerted attack (such as hunting) and bad luck (such as disease or drought) could obliterate it. The muriqui (*Brachyteles arachnoides*), South America's largest monkey, is another insularized creature, confined now to just a few dozen small forest fragments in northeastern Brazil. The grizzly bear (*Ursus arctos*) of the greater Yellowstone ecosystem is an insular population, also balanced precariously near the threshold of genetic and demographic viability. Because we live today in a world of chopped, tattered, and fragmented landscapes, Lord Howe Island stands as a paradigm for the mainlands. Its three gloomy lessons point like survey lines from the past to the future.

But the Lord Howe case doesn't cover everything. Two other cardinal truths belong with those three. The first is that habitat destruction causes extinction. Clear-cut enough rain forest, and you will exterminate a species of fig wasp. The second is that extinction itself, when it disrupts ecological relationships upon which other species depend, can disrupt communities. Exterminate a species of fig wasp, and you may also lose a species of fig.

Overkill, invaders, insularity, habitat destruction, cascading effects—these are the fatal five. Any one of them may be implicated in a given case, and any combination may interact ruinously. Taken together, they constitute a bare outline of what scientists presently know about the dynamics of extinction. If the literature of conservation biology somehow survives in a dusty archive for two million years, Drs. Zeta and Glebb will know that much too.

And now it's our turn. Chain saws, the consumer society, government-subsidized clear-cutting to create jobs and plywood and throwaway chopsticks, dryland ranching for beef that isn't wanted, a human population passing 6 billion and likely to hit 10 billion within the next 150 years, suburban sprawl, second homes in the mountains, grilled swordfish, tuna wasabi, runaway cats, transplanted mollusks, mountain bikes and SUVs and Hummers and snowmobiles eating the landscape, poor rural people slashing forest and burning slash to grow rice for starving babies, tribal folk receiving medical help that converts their high-mortality sustainable societies into boom cycles, outlanders using shotguns to kill monkeys to ship bushmeat back to markets that serve other outlanders bearing chain saws. We're doing it all, simultaneously, with unprecedented puissance and speed: committing overkill, destroying habitat, chopping the landscape into islands, transporting alien species into ecosytems where they wreak havoc, and causing extinctions that tip like dominoes to cause other extinctions. Some people choose to think of this modern phenomenon as "the biodiversity crisis," suggesting an isolated event without precedent. I choose to think of it as phase four of the late Quaternary extinction.

Do I need to recapitulate all the sad dreary facts and dire alarms that you've already heard? Do I need to review all the estimates of tropical deforestation, all the details of ecological fragmentation and climate change and genetic impoverishment, all the extrapolations of how many beetle species and worm species are lost monthly before they've ever been identified, all the projections of human population increase and resource consumption into the next several hundred years, all the trends and hard numbers that have convinced most professional biologists that *Homo sapiens* is indeed perpetrating a mass extinction? No. I don't think it's necessary. You've heard all that before. You've deplored and lamented it as much as the next concerned person. But what you haven't done, I hazard, is contemplate the Late Quaternary extinction in its oneness.

For a sense of the whole, we can add up the parts. Phase four began, let's say, with the demise of the passenger pigeon, a species that had once been the most numerous vertebrate on the North American continent. The last bird was a captive named Martha; she died her peaceful but lonely death in 1914, at the Cincinnati zoo. Phase three began with the extinction of the dodo, first victim of the age of European empire. The final dodo seen alive (and promptly killed) was on an islet off Mauritius in 1662. Phase two began when the Lapita people, reaching Fiji after a long crossing from Vanuatu, set loose a plague of canoe rats and then walloped a flightless rail into oblivion, roughly three thousand years before the present. Phase one began in Australia, 50 millennia ago, when aboriginal hunters proved too deadly for the big bird *Genyornis.* These facts are known. Also known is their sum effect: that in the course of four phases we have emptied Earth's landscapes, proficiently and inexorably, to take ever greater shares of everything for ourselves.

What can't be known, at least not by us, is just how far the current phase will proceed. Or where it will end. Or how boring and grim and lonely this planet will seem when it finally does. Someone else, in the far future, will be obliged to know that.

OUT OF WORK

A baby California condor, hatched at San Diego Wild Animal Park, will have to fend for itself in a world utterly unlike that of its Ice Age ancestors. Great scavengers like the condor require big dead animals on which they can feed—an increasing rarity as the wilderness is tamed by humans.

Future Shifts, Future Shocks

BARBARA BOYLE TORREY

For thousands of years, as human populations grew, people spread around the globe, settling the land and clearing it for agriculture. But in the past 200 years, as the world's population has doubled and tripled, a different but equally potent kind of human migration has been taking place.

For the first time in human history, nearly half of the world's population lives in urban areas. The shift to cities is irrevocable. From now on, almost all future population growth will be in cities and towns instead of in rural areas. In the next 30 years, for example, the number of people living in urban areas is expected to double. The fundamental change in where people live affects human systems, such as economies, and natural systems, such as air and water.

Why does it matter to the natural world where people live? It matters because urban people have quite different impacts on the world than rural people. Some of the differences between the habits of rural and urban people are likely to create long-term challenges for the natural world. But contrary to what is commonly thought, the differences may also bring benefits.

Urban populations have very different consumption patterns from rural populations. This is true not only in wealthy, industrialized countries but also in developing countries around the world. In China during the 1970s, urban populations consumed more than twice the amount of pork that rural populations did, even though rural farmers were raising the pigs. As economic

development progressed, rural diets improved in China. But even in the 1980s, the urban populations ate 60 percent more pork than the rural populations did. Urban dwellers also use more durable goods. In the early 1990s, households in urban areas of China were twice as likely to have a television and 25 times more likely to have a refrigerator than rural households.

Land-use patterns also differ between urban and rural areas. Most cities were not formally planned but sprang up where there were advantages in the local environment. Many cities, for example, evolved where transportation was easy, such as along rivers or coastal areas, as in New York City and Tianjin, China. Other cities, such as Charlotte, North Carolina and New Delhi, developed close to agricultural regions so that they could feed their nonfarming populations.

None of the environments that eventually became urban areas, however, were expected to accommodate the dramatic increases in populations that took place in the 20th century. This unanticipated growth has affected land-use patterns far beyond the original borders of many cities. Delhi, for example, was first built on good agricultural land next to the Yamuna river. Recent growth has engulfed many agricultural villages. These land-use changes are almost always irreversible: Once agricultural land has been converted to urban purposes it rarely reverts to agriculture.

Cities also alter the natural flow of water by replacing porous agricultural soils with nonporous paved surfaces. Land that is impervious to rain is susceptible to flooding, and the size and

frequency of floods increase as more land is paved. In addition, flooding may be accompanied by overflow of sewage systems leading to pollution in the urban area and beyond. Coastal pollution in Brazil, for example, increased as untreated sewage from rapidly growing Sao Paulo overwhelmed waste treatment facilities and flowed into the three most important rivers serving the Sao Paulo metropolitan region.

Energy used for transportation, cooking, heating, and household appliances is much higher in urban areas than in rural villages with a variety of consequences. In China air quality has worsened because the per capita consumption of coal in towns and cities is more than three times the consumption in rural areas. In Jakarta, the use of wood for cooking and heating led to major deforestation around the city. Recently, Jakarta changed from burning wood for energy to burning kerosene and gas, but this switch only trades the problems of deforestation for those of increased carbon dioxide emissions into the atmosphere.

Urban consumption of energy, whether from wood, coal, or oil, also creates urban heat islands. As cities use energy, they generate heat. They also absorb more heat from the sun than agricultural lands because buildings and paved surfaces change the local albedo (the ability of a surface to reflect heat from the sun). As a result, urban landscapes absorb more heat from the sun than agricultural lands and become heat islands. New York City, for example, is estimated to be 1.1° C warmer than adjoining rural areas. Because they are warmer than their surroundings, cities

UNITED STATES

Los Angeles
4,000,000
12,900,000
14,200,000

New York
12,000,000
16,500,000
17,600,000

Mexico City
3,500,000
17,600,000
19,000,000

URBAN MIGRATION

Environmental impact depends on both the numbers of people and where they live. As the world's population grows, it is increasingly concentrated in cities, alleviating some enviromental problems, but worsening others.

BRAZIL

São Paulo
2,300,000
17,300,000
20,800,000

Buenos Aires
5,250,000
12,200,000
13,900,000

Cairo
2,100,000
10,580,000
14,400,000

Lagos
1,000,000
12,200,000
24,400,000

Karachi
1,100,000
11,000,000
20,600,000

INDIA

Mumbai (Bombay)
2,800,000
16,900,000
27,400,000

Beijing
1,700,000
11,700,000
19,400,000

CHINA

Dhaka
400,000
18,000,000
19,000,000

Calcutta
4,450,000
12,500,000
17,300,000

Shanghai
4,300,000
13,900,000
23,400,000

Tokyo
6,200,000
27,700,000
28,700,000

Jakarta
2,800,000
9,500,000
21,200,000

Urban population growth, 1950-2000
- More than 100 million
- 50 million-100 million
- 10 million-50 million
- Fewer than 10 million

Population growth for largest cities in 2015 (populations shown for years 1950, 2000, and 2015)
- 1950
- 2000 (estimate)
- 2015 (projected)

SOURCE: UNITED NATIONS

can affect local and regional weather patterns, increasing rain and fog and decreasing snowfall. Urban heat islands also tend to trap atmospheric particles, adding to air pollution in the cities and surrounding regions.

Despite these problems, cities continue to attract people. One of the reasons is that urban areas provide better access to such services as education, health care, and entertainment, which means that people in urban areas—in this century at least—are better educated and healthier than rural dwellers. As a result, since 1950 infant mortality in every developing region of the world has been lower in urban areas than in rural ones. The urban advantage in reducing infant mortality rates, however, has its limits and may depend on a city's rate of growth as well as its size. In both Latin America and the Middle East, infant mortality rates are lower in smaller or slowly growing cities than in larger or rapidly growing ones.

Partly because the fertility rate is lower in cities than outside them, the rate of growth of the world's population is slowing. In many African countries, for example, urban women have an average of about five children, while in rural areas they have an average of almost seven. Similarly, in Latin America, urban women have approximately three children, and rural women have six. The urbanization of the world, then, is likely to continue to slow population growth, with potential benefits for the natural world.

The continued transition in the Earth's population from a rural to an urban concentration is likely to be a major force of change in the 21st century, and devising ways to lessen the impact of city dwelling on the natural world will put considerable demands on human ingenuity. Such tools as remote sensing by satellites, for example, can help monitor changes in urban expansion and project future growth.

Pollution control technology can improve air quality dramatically as it has in Los Angeles and London. Management of water supplies is also becoming more efficient. All these technologies, however, require money. Not surprisingly many of them are being used in wealthy industrialized countries but not yet in developing nations.

Creating an ecological city requires more than funding, however. It requires a strong sense of civic consciousness and responsibility. For urban areas trying to ameliorate their environmental impact, this civic, or social, capital is perhaps the most important form of capital available to cities. If we are to adapt successfully and sustainably to a new, more urbanized world, we need to learn much more than we know today about the intended and unintended forces that cities unleash on the natural world. Then we can marshal the resources needed to act on that knowledge.

Adapting to Change

Scientists can justifiably claim that as a society we are learning more about the dynamic complexity of nature. The claim can also be made that our scientific and technological advances have increasingly insulated people from nature, leaving them an idealized and oversimplified conception of it. In urbanized, industrialized societies nature can seem to be an abstraction, something separate from daily life; but all human beings ultimately depend on nature for survival. In these essays, we meet people struggling to maintain a connection with nature as they adapt to the pervasive forces of cultural and technological change.

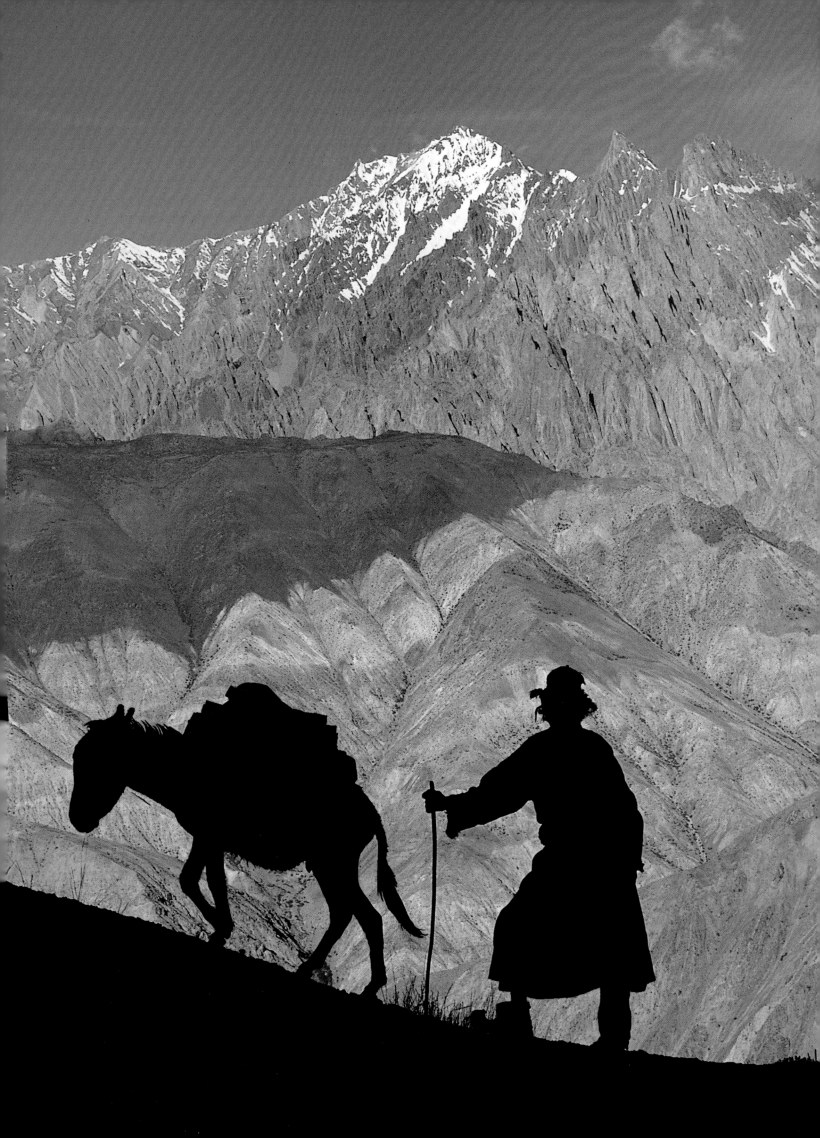

Learning from Ladakh

Helena Norberg-Hodge

FOR CENTURIES THE PEOPLE OF LADAKH, IN THE MOUNTAINS OF NORTHERN INDIA, WERE ABLE TO SUSTAIN A THRIVING SOCIETY IN AN EXTREMELY HARSH ENVIRONMENT. TODAY LADAKHIS ARE FACED WITH NEW PROBLEMS AND PRESSURES AS THE 21ST-CENTURY GLOBAL ECONOMY ENCROACHES ON THEIR TRADITIONAL WAYS OF LIFE.

Even if you know, it is better to ask another.
—LADAKHI SAYING

Scorched by the sun in summer, the Tibetan plateau freezes solid for eight months in winter, when temperatures drop as low as minus 40°C. This is the fiercest of climates: winds whip up tornadoes along the empty corridors of desert; rain is so rare that it is easy to forget that it exists. The region of Ladakh spans an area of about 46,000 square miles (approximately the same as the state of Pennsylvania) in the northern Indian State of Jammu and Kashmir. Its small villages are dispersed throughout glacial valleys up to 13,000 feet high. The growing season is short, and the climate severe, but for generations, Ladakhis have lived a relatively self-reliant existence, meeting their basic needs through agriculture and animal husbandry and supplementing this through regular trade with Tibet and Kashmir.

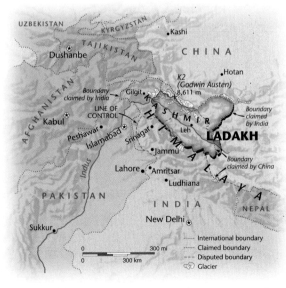

A visitor to Ladakh sees a landscape that has been created with great care: fields carved out of the mountainside and layered in immaculate terraces, one above the other; the staple crops of barley and wheat, thick and strong, forming such patterns as an artist might have sown. Around each house, vegetable and fruit trees are protected from goats by a stone wall on which cakes of dung, to be used as fuel for the kitchen stove, lie baking in the sun. On the flat roof, animal fodder—alfalfa and hay, together with leaves of the wild iris—has been stacked in neat bundles for winter. Apricots left to dry on yak-hair blankets and potted marigolds give a blaze of brilliant orange. And as you wander through the fields, or follow the narrow paths that wind between the houses, smiling faces greet you.

Accessible only by foot until recently, the culture of remote Ladakh is finally feeling the pressures of the outside world.

The smiles and apparent well-being of these mountain people surprised me when I came to Ladakh in 1975 to study their language and folklore. As I wrote later:

> At first I couldn't believe that the Ladakhis could be as happy as they appeared. It took me a long time to accept that the smiles I saw were real. Then, in my second year there, while at a wedding, I sat back and observed the guests enjoying themselves....Only then did I recognize that I had been walking around with cultural blinders on, convinced that the Ladakhis could not be as happy as they seemed....

Before coming to Ladakh, I had never questioned the necessity of "progress." Supermarkets gave us easy access to an amazing variety of goods and products; new roads meant shorter journey times; television was a window into different worlds, and fast food a necessary time-saver. Of course, I knew that as a species, humans were placing a great deal of pressure on the environment. And I realized that people around me were stressed by their jobs, that they worried about money, and often were not particularly happy. I had never thought of these problems as anything other than inevitable side effects of progress. Nor had I wondered if there might be alternatives to development, or considered that these alternatives might be healthier for us all.

Ladakh was still essentially unaffected by the West when I first came there. But dramatic changes came swiftly, providing stark and vivid lessons. Ladakh showed me that progress is, at best, a double-edge sword; that every movement forward, toward a technologically more complex way of life, could also be interpreted as a movement backward, away from a simpler, yet richer life. Stepping back from my own culture, my experiences in Ladakh have given me the opportunity to observe a very different way of life, one that throws a revealing light on Western culture.

Those of us who live in industrialised societies often assume that ignorance, disease, and constant drudgery were the lot of pre-industrial societies; and poverty, disease, and starvation in the developing world might at first sight seem to substantiate this assumption. But in Ladakh, I saw something very different. The Ladakhi people exuded a tremendous sense of well-being, vitality, and high spirits. In terms of physique, almost everyone was trim and fit—only rarely underweight and even more rarely obese. Even without obvious muscle, both men and women were extremely strong; and like many other mountain peoples, they seemed to have almost unlimited stamina. The old were active until the day they died. Of course people got ill—respiratory infections and digestive disorders were relatively common, along with skin and eye complaints—but the general level of health was high.

The Ladakhis' language, art, architecture, medicine, religion, and music all reflected their Tibetan heritage: Their written language was classical Tibetan; their spoken language, a dialect; and with the Dalai Lama as their spiritual leader, Mahayana Buddhism was the predominant religion. The majority of Ladakhis were deeply rooted in the Buddhist values of compassion, forgiveness, and respect, and the understanding that all beings are important elements of the whole.

Sunyata or emptiness, a central Buddhist concept, refers to the idea that nothing has a static, separate permanence, that everything is connected and changing. Because of this profound acceptance of the fact that no one and no thing is fixed, Ladakhis seemed totally lacking in what Westerners would call pride—for them, there was no permanent, separate self to try to make better, superior, more important than other selves. How, after all, can something that is part of a larger interdependent whole and continually changing be declared good, better, best, worse? For this reason it was virtually impossible to humiliate a Ladakhi—there was no pride to dent! This did not mean that Ladakhis lacked self-respect; rather that their sense

HERE THEY COME

They fill the restaurants, they choke the streets, but most importantly, the tourists who pour into Ladakh from around the world bring money—and what local people perceive as a higher standard of living. But as westerners permeate their society, what is to prevent Ladakh from assimilating the very western characteristics its visitors hope to escape?

RITUAL DANCE
Performing for tourists, Tibetan dancers share their cultural heritage—yet the very performance makes the practice less an ancient tradition than a modern show.

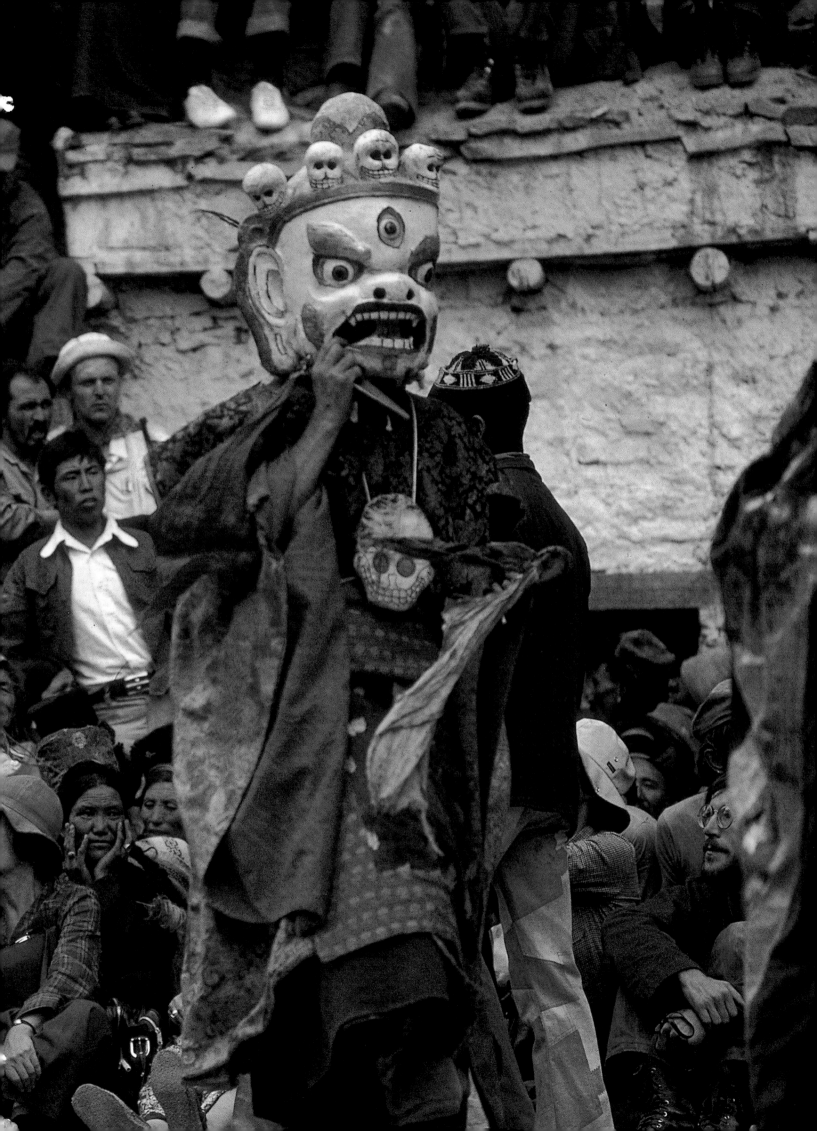

of security, well-being, and self-respect were so great that they felt no need to prove themselves.

For 2,000 years, the vast majority of Ladakhis were self-supporting farmers, living in small scattered settlements in the high desert. Natural resources were scarce and hard to obtain; nevertheless, Ladakhis had an amazing abundance of time. They worked at a gentle pace and had an amount of leisure unknown to most working people in the West. Remarkably, Ladakhis only worked, really worked, for four months of the year. In the eight winter months, they of course had to cook, feed the animals, and carry water, but work was minimal. Indeed, most of the winter was spent at festivals and parties. Even during the summer, hardly a week passed without a major festival or celebration of one sort or another. The pace of their lives was relaxed and easy. They breathed pure air, got regular and prolonged exercise, and ate whole, unrefined foods.

Decisions affecting their livelihoods and communities were made at a local and household level, with women playing key roles. Much farming work was shared within communities, often in smaller subgroups called *chutso*. Likewise, small groupings of households called *paspuns* helped each other out at times of birth, death, and marriage. These human-scale political structures allowed for flexibility and led to immediate accountability, as almost all transactions were carried out face to face.

Fundamental to the Ladakhi sense of prosperity was the idea of frugality. This had nothing to do with miserliness; rather, it was frugality as intended by its original meaning of fruitfulness: getting more out of a little. Nothing whatever was just discarded. What could not be eaten by people could be eaten by animals; what could not be eaten by animals could be used as fuel or to fertilize the land. When no amount of stitching could sustain a worn-out robe, it was packed with mud into a weak part of an irrigation channel to help prevent leakage. Virtually all the plants, shrubs, and bushes that grew wild, either around the edges of irrigated land or in the mountains—what other people might call weeds—were gathered and used for some purpose. Soil in stables was dug up and used as fertilizer, thus recycling precious animal urine. Dung was collected not only from the stables and pens but also from pastures. Even human night soil was not wasted: each house had composting latrines. Earth and ash from the kitchen stove were used for chemical decomposition, producing better fertilizer and eliminating smells. Thus, conservation and recycling were an integral part of their traditional way of life.

In the 70's, life in Ladakh was still largely based on its own centuries-old foundations. The region had been protected from both colonialism and development by its lack of resources, its inhospitable climate, and its inaccessibility. In the old days change had come slowly, allowing for an adaptation from within. During the intervening years, however, external forces have descended like an avalanche, causing massive and rapid disruption. Within a few decades, unemployment and air and water pollution have reached alarming levels.

The first motorable road into Ladakh was built in 1962 by the Indian government as a response to military conflicts with Pakistan. But the process of change began in earnest in 1974 when the Indian government opened the area to tourism. At about the same time, concerted efforts were made to develop the district through such methods as importing subsidized food grains and processed foods, building ever more roads, and promoting pesticides and other chemical improvements for agriculture. As everywhere else in the world, development in Ladakh meant subverting the local in favour of the global economy.

This made the region ever more dependent on systems controlled by faraway, unknown forces. In the traditional culture, basic needs were provided for without money. The Ladakhis grew barley at 12,000 feet, managed yaks and other animals at higher elevations, and built houses with their own hands from materials in their immediate

surroundings. The only thing they needed from outside the region was salt, for which they traded.

And in the village-scale economy, people knew they had to depend on others in the community, and so they took care of one another. But in the new economic system, the distance between people has increased. The fabric of local interdependence is disintegrating, and so too are the traditional levels of tolerance and cooperation.

The modern economy defies common sense. In Leh, the capital, people no longer build with traditional mud bricks, turning to cheaper imported cement. It seems incomprehensible that building with local mud has become prohibitively expensive, but as land, labor, and resources have become increasingly commodified, people are compelled to pay for the mud they use, for the labor to extract it, and for the truck to haul the mud bricks back to their property. Building with mud is slower; time in the modern sector has come to mean money. Still, it seems improbable that heavy, processed material, transported over the Himalayas, competes with mud, free and abundant, there for the taking. Yet that is exactly the case. Hidden subsidies to roads, fuel, and industrial processing render small-scale local economies inefficient. Even local agriculture is being undermined by subsidies for imported grain, which make it cheaper to buy a pound of wheat flour from the Punjab (approximately four days' lorry ride away) than from the nearest village. It has become uneconomical to grow your own food—an unimaginable concept within the traditional economy. In this way, Western-style development operates to undermine local systems.

It has been especially alarming to see how mutual aid is being slowly replaced by dependence on faraway forces. In the traditional village, repairing irrigation canals was a task shared by the whole community. As soon as a channel developed a leak, groups of people would start working away with shovels patching it up. For centuries, people worked as equals and friends—helping one another by turn. Now people see it as the government's responsibility and will let a channel go on leaking until the job is done for them.

Modernization has also brought with it intense psychological pressures. To Ladakhis, the consumer culture that is portrayed in advertising and the media appears far more successful than it is in fact. Western and Indian films and television helped create this distorted image: For young Ladakhis, the rich, beautiful, and brave seem to lead lives filled with excitement and glamour. By contrast, their own lives come to seem primitive, silly, and inefficient. Not so apparent are the negative aspects of peoples' lives in the West—the environmental decay, crime, poverty, inflation, and unemployment, along with the stress and fears of growing old alone, of isolation.

Another cost of progress is the impact on gender roles. I have seen the strong, outgoing women of Ladakh replaced by a new generation—unsure of themselves and extremely concerned with appearances. Traditionally, the way a woman looked was important, but her capabilities—including tolerance and social skills—were much more appreciated. And despite their new dominant role in the economy and politics, men also clearly suffer as a result of the breakdown of the family and community ties. They are deprived of contact with children; when young, machismo may interfere with displays of affection. In later life, as fathers, their work keeps them away from home.

Even more painful changes are the growing ethnic and religious rivalries that I have witnessed as a consequence of unemployment and psychological insecurity. Earlier there had been cases of friction between individuals, but for 500 years Buddhists and Muslims had lived side by side without any group conflict. The first signs of tension appeared in 1986, when I heard Ladakhi friends starting to define people according to whether they were Muslim or Buddhist. In the summer of 1989, fighting broke out between the two groups. In Ladakh, as in many other parts of the world, development has caused artificial scarcity of jobs and other resources, which inevitably leads to greater

competition and puts pressure on people to conform to a standard model of success that they simply cannot emulate. To strive for such an ideal is to reject one's own culture and roots—in effect to deny one's own identity. The resulting alienation gives rise to resentment and anger, and almost certainly lies behind growing violence and fundamentalism around the world.

The story of Ladakh—the relative success and viability of its traditional culture, as well as the social and environmental changes wrought by development—can play a valuable role in highlighting some of the foundations necessary for a sustainable future for us all. Ladakh demonstrates the importance of a more localized place-based economy. When you are dependent on the earth under your feet and the community around you for your survival, you experience interdependence as a fact of daily life.

In fact, with the exception of religious training in monasteries, traditional Ladakh culture had no separate process called "education." Learning in Ladakh was primarily the product of an intimate relationship between the community and its environment. Children gained knowledge from grandparents, family, and friends. While sowing, they would discover that one side of the village was a little warmer, the other side a little colder; they learned to recognize even the tiniest wild plant and how to use it, and how to pick out a particular animal on a faraway mountain slope. For generation after generation, Ladakhis grew up learning how to provide themselves with clothing and shelter. Education was location-specific and nurtured an intimate relationship with the living world. It gave children an intuitive awareness that allowed them, as they grew older, to use resources in an effective and sustainable way. They learned about connections, process, and change, about the intricate web of fluctuating relationships in the natural world around them.

In the industrialized world, we tend to live our lives at one remove from reality, relying on mediated information, images, and concepts. Tashi Rabgyas, a Ladakhi scholar, told me after spending a few months in England, "It's amazing how indirect everything is here. They write about the beauty of nature, they talk about it, there are potted plants and plastic plants, pictures of trees on the wall, and television programs about nature. But they don't ever seem to have contact with the real thing."

Of course, many people in the industrialized world have some contact with nature, but it is usually as recreation, not as a central part of their lives. Therefore we have come to see nature as a luxury to be consumed if and when our schedules allow, as opposed to a foundation for all life that requires nurturing, care, and respect.

I have learned from Ladakh that human beings can and have lived in harmony with one another and with nature, and that social and environmental breakdown are not inevitable, but largely the result of what we commonly refer to as development or progress. Twenty-five years of grassroots experience has also put me in touch with the movements around the world that are redefining development and progress. In every sphere of life, from psychology to physics, from farming to the family kitchen, there is a growing awareness of the interconnectedness of all life. More and more people are committed to ecological and spiritual values and to living on a human scale. The numbers are growing and the desire for change is spreading. These trends are often labeled new, but the story of Ladakh shows that, in an important sense, they are very old. They are, in fact, a rediscovery of values that have existed for thousands of years—values that recognize our place in the natural order, our indissoluble connection to one another and to the earth.

CARRYING ON
A home of hand-laid stone and rough-hewn logs awaits a crop-laden Sumdah woman crossing her threshold. The elements of the Earth are barely altered to accommodate her lifestyle, evidence of her people's perpetual intimacy with their environment.

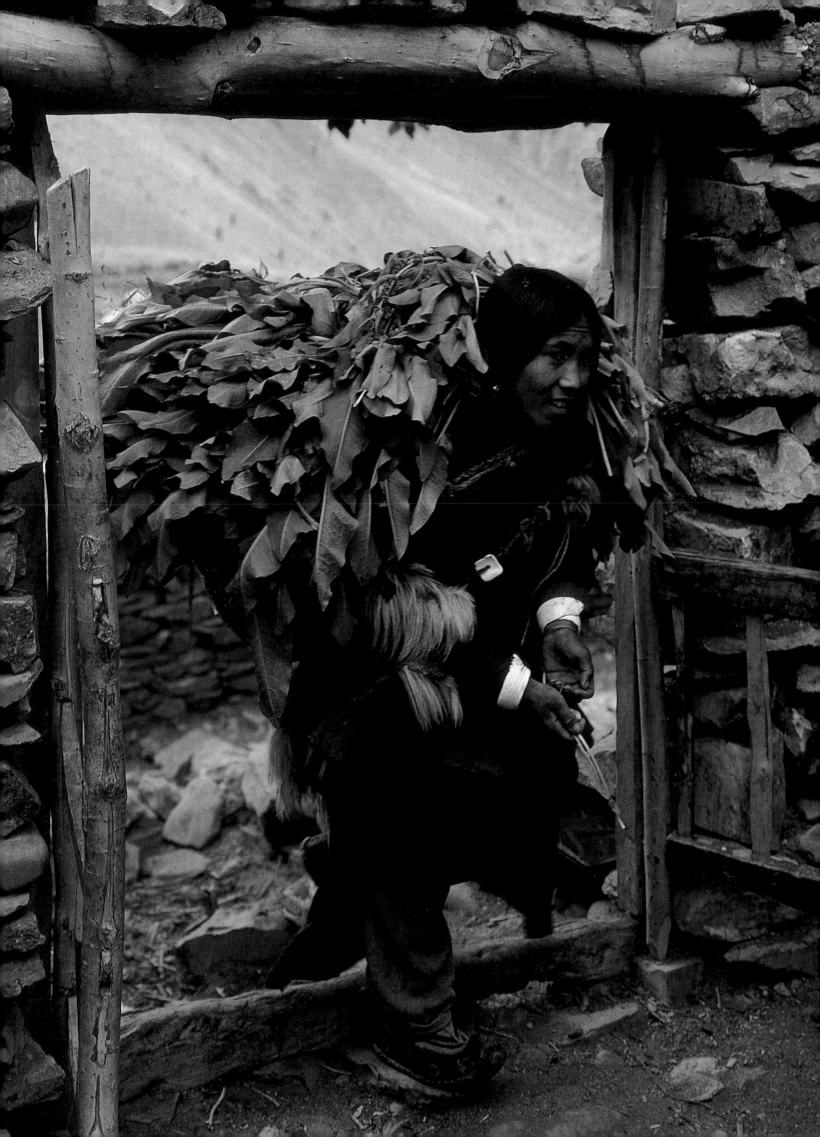

Reflections Along Magadi Road, Kenya

BERNICE WUETHRICH

Driving out of Nairobi, toward East Africa's Great Rift Valley, I am surprised by what I see. I anticipate open sparseness, the occasional gazelle, brown scrub, and cracked land in this all-too-dry summer. I am stealing a day to travel south, after having been in the west of Kenya, filming a community health project for the "African Voices" exhibition at the Smithsonian's National Museum of Natural History. This is my first visit to the Rift Valley, where carved stone tools that litter the ground like leaves speak of our ancient origins, and where Masai people herd their livestock in search of water and grass. Open your eyes, I tell myself. Look around.

"Obey Your Thirst" a billboard commands, picturing two hip teenagers drinking Sprite as big blue bubbles rise around them. I pass the Jolly Bar and Butchery, the PJ Hair Saloon, Hotel Name Lock. Not a gazelle in sight. Women wash leafy greens in a muddy roadside stream. Among those walking down the road are Masai youth, women, and men. They are adorned with beaded jewelry, draped in bright red cloth. In the West, the image of such proud and elegantly attired Masai has come to represent an exotic, unchanging Africa. Indeed, the Masai have herded their cattle across this landscape for many hundreds of years; their skills and conservation ethics helped ensure the survival of East Africa's majestic wildlife. Now all that threatens to unravel.

I drive past a Shell Convenience Store and vendors selling used clothes on outdoor stands in Longai Town. This crowded road cuts through Masailand—historically open savanna across which men have grazed their livestock. But bit by bit, the land was sold on the cheap to wealthy landowners, ranchers, real estate investors. Growing numbers of landless Masai are migrating to cities in search of work. Ole Dapash, a Masai friend who works tirelessly on behalf of his people, calls this "assimilation through impoverishment." Perhaps the grimmest option open to Masai, it is not the only one. Across Kenya and Tanzania, Masai are fighting for the survival of their communities, and many say that their survival depends on the survival of East Africa's grasslands and spectacular wildlife. It's a connection that Masai have long made, but one that has been widely missed or misconstrued by Western conservationists.

A Masai proverb says: "God gave us cattle and grass. Without grass there are no cattle, and without cattle there are no Masai." The proverb speaks to the vital place cattle hold in Masai livelihood and culture. It also alludes to the Masai connection to wildlife. Over the last several millennia, East Africa's grasslands have evolved as a result of the interaction of people and their livestock, wildlife, and all the elements of nature. Masai herding practices complement the life cycles and grazing patterns of wildebeest and gazelle. Masai herders benefit from the elephant, as it tramples through forest and opens up new pasture. Conservation values are embodied in their lifestyle. "Masai preserved the wildlife by simply not killing. Their whole ideology shuns eating wild game," says Naomi Kipury, an anthropologist who grew up herding cattle, sheep, and goats with her Masai family. "If nature is not complete, no life is complete," Ole Dapash explains. How can these values remain when human population in parts of East Africa's savanna is growing at three to seven percent a year? When tourism degrades the ecosystem? And when most conservationists advocate separating people and wildlife?

In the 1930s, when Western conservationists first crusaded for a national park in Tanzania's Serengeti grasslands, they argued that "only by placing man and animals in two permanently separate compartments" could nature be preserved. This view, then articulated by British conservationist Major R.W.G. Hingston, remains yet entrenched. Its implicit dismissal of Masai environmental ethics has shaped conservation policies as well as scientific research. Most ecosystem studies, for example, exclude people from the environment—yet local people have been a dynamic force of change in the East African landscape for thousands of years.

My car crosses a dry streambed, and I imagine it during the rains, gorged with rushing water, all the brown and dying bush green and lush. Standing by the roadside up ahead are three women selling their handmade jewelry. I stop and buy exquisitely beaded necklaces and pendants that smell of the animal hide they're sewn on. The women drive a hard bargain.

Cash is scarce, food can be too. But Masai are struggling to be included as equal partners in determining the policies that affect their lives. Ole Kamuaro, a community consultant in Nairobi, says that this means they must have

access to the tools and information held precious by many scientists and government officials. To this end, Kamuaro advocates grassroots collaboration with scientists who are developing a cutting-edge computer model for ecosystem management. The model is unique precisely because it includes human activity in its complex rendering of the world. Masai are working with ecologists at Nairobi's International Livestock Research Institute to make the model true to life, gathering data on Masai household nutrition and economic status; on the location of roads, water wells, and homesteads; on the size and health of cattle herds. This data will be integrated with data on plants, wildlife, soil, and rainfall. Called SAVANNA, the model will be used to predict how different policies would affect people, land, and wildlife. It will help evaluate controversial land-use policies—rather than leaving them to the capricious powers of money and politics.

Yet it is highly unusual for Masai to be included in such a project, and their participation is challenged. "Some argue that Masai don't need such a complex tool, they've been managing their ecosystems successfully for years without any form of scientific intervention," says Ole Kamuaro. "I argue that our needs, aspirations, and world view have changed over the years." And such changes are in fact evident in Tanzania's Ngorongoro Conservation Area, home to one of the largest concentrations of wildlife left on Earth—and to some 4,500 Masai households.

In one scenario, SAVANNA was programmed to evaluate the impact of increased family farming in

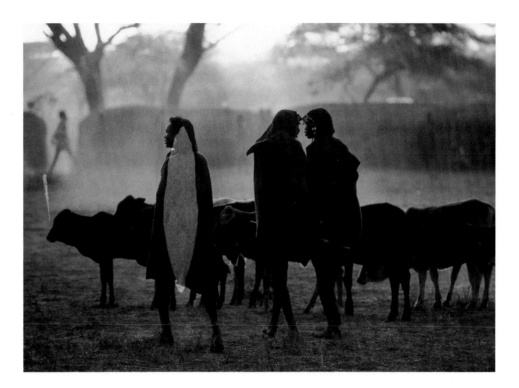

Until recently, most European-based efforts to conserve Kenyan wildlife excluded the people with the most to gain or lose: the native Masai people. New programs seek to utilize centuries of practical wisdom gained from the Masai's long coexistence with nature.

Ngorongoro. Many conservationists strongly oppose all agriculture there, fearing it will harm wildlife. However, most Masai want and need to farm, to supplement their diet and meager household income. The model set human population growth in the area at its current growth rate, 3 percent a year for 15 years, which yielded a total of 7,010 Masai households. Each new household was allowed to cultivate a small plot of land. The impact on wildlife was minimal, as agriculture still occupied only a fraction of the total available land. However, the impact on the Masai was great. Increased food security from farming meant the Masai could keep more of their cattle, rather than being forced to sell livestock to

generate cash to buy food—an economic spiral down.

No longer is Masai ecosystem management mainly a matter of applying knowledge of livestock and wildlife acquired over generations. Choices are dictated by the world around them, and just as the Masai helped shape the vast savanna, they want to shape the world of today and tomorrow.

As I descend into the Great Rift Valley, sisal trees grow absolutely erect along the roadside. Nestled in a dip of land is an *enkang*, a circular cluster of Masai houses that blends with the texture of the hills. I hear a radio blaring music on the country's state-sponsored station. Do not go looking for an unchanging Africa, I tell myself, Look for what is there.

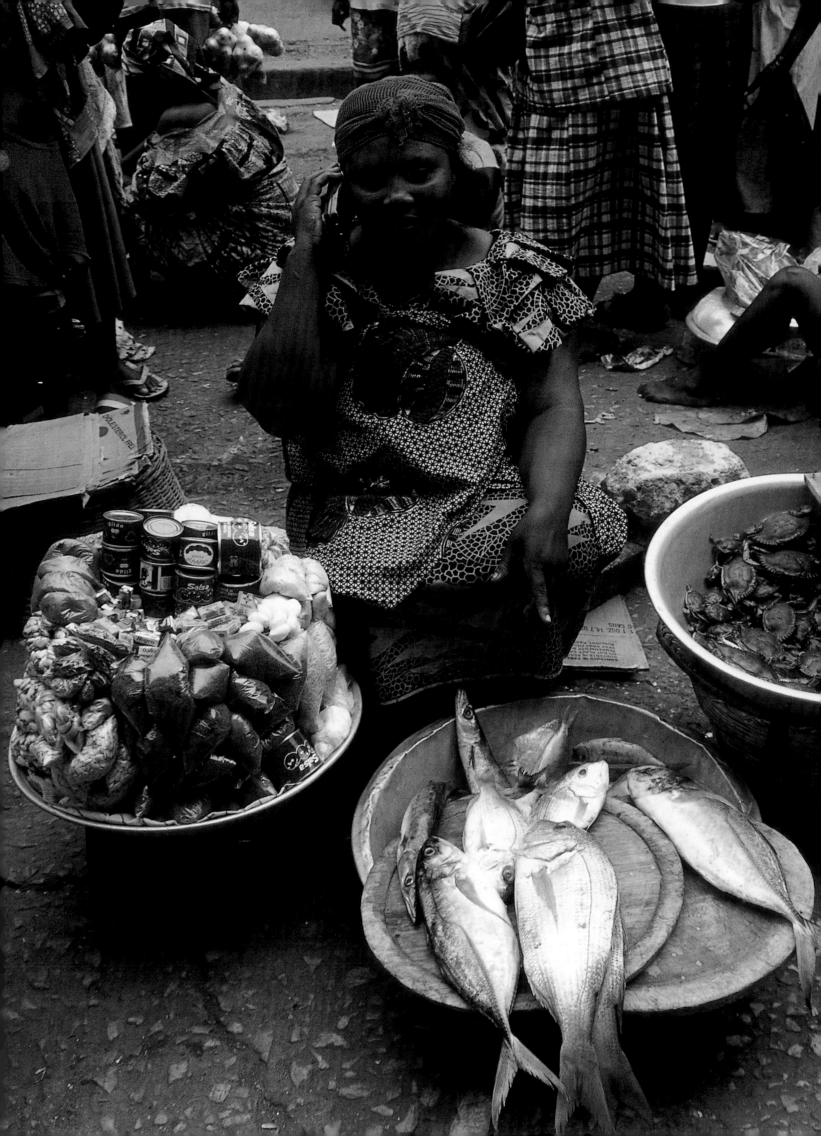

Changing Places in Africa

Edward S. Ayensu

THE CULTURAL HERITAGE OF AFRICA IS OLDER THAT OF ANY OTHER CONTINENT, AND MANY OF ITS PEOPLE STILL OBSERVE TIME-HONORED WAYS OF LIFE. BUT THERE IS ALSO A STRONG TRADITION OF RECEPTIVENESS TO NEW IDEAS. CAN THE NEW TECHNOLOGIES OF THE INFORMATION AGE HARNESS THE AFRICANS' INVENTIVE SPIRIT WHILE ALSO PRESERVING TRADITIONAL LIFESTYLES?

A few years ago I observed an old woman at one of the stalls of an African open-air market, the traditional merchandising center of my home capital city, Accra, Ghana. A fish seller—outgoing, confident, and experienced in her work—attracted a good crowd. All at once she produced a tiny cellular telephone, flipped it open, and punched in a number. Business was unusually brisk that day, and she urged her wholesaler to quickly send more seafood from the Tema fishing harbor, some 20 miles to the east.

Today, cell and wireless phones are in evidence everywhere in Africa; people in the rural areas are able to ring up their urban families and friends. Africans have already begun to seize the day. Like the Accra fish vendor, the so-called ordinary people clearly possess a goodly share of humanity's innate inventiveness. But in the century to come Africans will need to make the same quantum leap that others around the globe have made before them. Can they adapt their present rural setting directly into the computer-based information society of the 21st century? Can they bring something new to the global technological culture? Today's cutting-edge technologies will succeed only insofar as they support historical cultural institutions.

For most of the 20th century, the best anthropological evidence pointed to Europe as the birthplace of the unique traits of mind that identify the modern human species. Technological proficiency was assumed to be a European, not African, trait. Elegant ivory harpoon points and bone blades unearthed in southern France and northern Spain and dated to 30,000 B.C. were the earliest known artifacts to clearly embody the human creative "spark." Had scientists discovered in the European soil the true dawn time of humanity? Then, in the early 1990s, searchers in East Africa unearthed bone and ivory tools almost identical to those found earlier in Europe. Their age—90,000 years. Thus science gained further evidence that the precious and prehistoric gifts of intellect that identify us as humans first appeared in sub-Saharan Africa, the true biological motherland. From there the fire of the mind traveled outward to all the world and elevated our kind into a special niche in nature's hierarchy.

How ironic, then, that sub-Saharan Africa, probable birthplace and cradle of our creative genius, has become the global epicenter of human poverty and privation. Outbreaks of cholera, typhoid, AIDS, and a host of other killers haunt the region's

Drawing on their long tradition of adaptation, Africans are ready to seize their role in the information age.

malnourished millions. Africa needs a new deal, but not a handout which, in the past, has spoiled Africans for the hard work ahead. Foreign aid improperly administered has corrupted many a leader and ruined millions of young people.

But despite our many problems, I am optimistic. Throughout history, ever since the days of prehistoric toolmakers, Africa and Africans have had many successes in adapting new technologies to their needs. This is our past and it can also be our future. Most people, when they first visit Africa, see our rural and urban societies as underdeveloped. Yet our visitors from abroad soon begin to sense a collective vitality and restless energy that have waited too long for proper employment. I have watched this phenomena all my life, and have concluded that African societies in all their diversity may actually be highly advanced settings for training in computer science and technology. Think of how Japan's cultural tradition of miniaturization fed directly into their amazing success in consumer electronics. In the coming century, who knows what valuable cultural nuggets—ways of thinking, working, and looking at the world—will be found among the many peoples of Africa. And, owing to centuries of privation and frustration of their creative energies, many Africans are keen to enter the computer age on their own terms.

Many of our illustrious epochs, such as that of the Queen of Sheba's Ethiopian Line of Kings, Great Zimbabwe with its magnificent stonework, and the peaceful and prosperous reign of the knights of Zinder in the Sahel, are probably unfamiliar to most non-African readers and even to many Africans. The achievements of precolonial African civilizations were ignored or denied by European scholars until just the last few decades. They refused to believe that Africans had a cultural heritage of such sophistication. But precolonial Africans had made technological advances in fields ranging from metalworking to medicine.

Iron smelting first appeared in sub-Saharan Africa in the first millennium B.C. Whether this technology came by diffusion from cultures elsewhere, or was independently invented by black Africans is a point of scholarly controversy. But it is clear that Africans developed a variety of unique smelting techniques, leaving no doubt as to their ingenuity and keen inventive spirit. The village furnaces designed by African iron smiths forged steel at high temperatures not obtainable in European blast furnaces until 2,000 years later. It was perhaps from these dispersed furnaces of Iron Age Africa that the sword was first "drawn from the stone," as the magic of the early makers of steel blades was described in the legends of King Arthur.

Africans employed their skills with the blade to save human lives, too. Sophisticated surgical practices such as cesarean sections and the suturing of blood vessels and intestines were known to African healers centuries ago. There are records of Masai surgeons performing operations to remove abcesses of the liver and spleen. Inflamed tonsils were treated by scarification. As more information has become available about ancient African civilization, the more impressive their technological, medical, and mathematical achievements have become.

If ancient Africa was such fertile ground for technological innovation, why is it now lagging behind the rest of the world? While the story is long and complicated, we can view a few selected snapshots from the seasons of Africa's colonial discontent, by way of explanation. From the earliest days of the Arab and Islamic slavers to the latter-day seekers of the land's mineral wealth, various foreign elements increasingly determined the region's economic fate. With quick profits to gain and inflexible quotas to meet, the foreigners discounted Africa's best talent and somehow suppressed Africa's genuine inventive genius. At best, the outsiders viewed the indigenous peoples as curiosities—living ethnological specimens rather than fellow human beings. Thus was the stage set for disaster.

NEW AND OLD WAYS

African physicians perform the delicate procedure of open-heart surgery in an Ivory Coast hospital. Doctors formerly had to be educated overseas, but now African medical schools are increasingly able to provide the necessary training. Drawing on older traditions, a Ghanaian herbalist offers his customers cures for a wide variety of ailments.

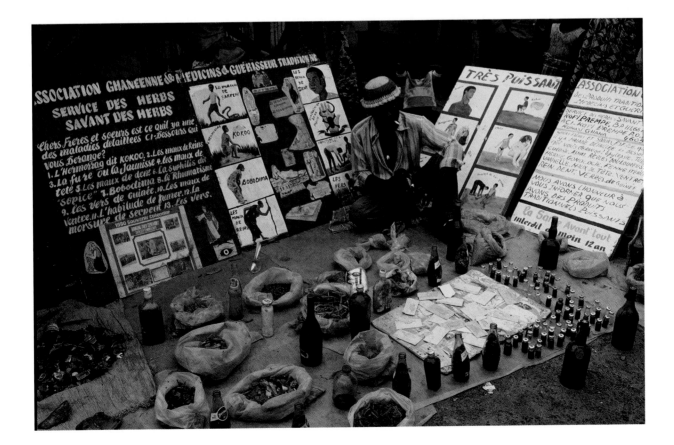

Tragedy touched Africans through a series of economic adventures administered by outsiders—themselves the servants of distant potentates. Beginning in the early 1500s the Portuguese established in Africa a plantation system of monoculture based on slavery—later exported to the New World by European opportunists. This shameful trade in human beings endured for centuries. The colonial era in Africa truly took its grim shape in the late 1800s, as the various European powers vied for pieces of the continent's wealth. On November 15, 1884, Otto von Bismarck hosted in Berlin a gathering of his squabbling European associates to divvy up in a gentlemanly fashion the spoils of the colonial landgrab. They cared nothing for the self-determination of the Africans, of course; they drew boundaries for no other reason than to suit their own colonial economic and political ambitions. What they drafted were lines of infamy in an arbitrary grid work across the map of Africa. Today bad old borders separate friends, crowd enemies together, and generate mischief everywhere. And the hell it would entail at this late date to fix these poorly conceived national boundaries is too painful to contemplate.

In 1890 Leopold of Belgium launched his commercial invasion of the Congo to bring out rubber. And so the cultural and economic rape, as some scholars see it, began in earnest. To add yet another insult, in 1889 cattle imported from India brought the great plague of rinderpest. This insidious disease wiped out as much as 90 percent of African domestic cattle, with catastrophic impacts on many indigenous African societies.

Yet even ill winds blow some good. Africans have in some ways benefited from their one-sided partnerships with European empires. There are some English-speaking West Africans who, in view of recent homegrown dictatorships, consider the legacy from the English occupation to be quite useful. My friends in neighboring countries prize their French heritage. Yet only in rare and inspired moments did the white colonials and the black Africans ever approach a real partnership. Truly memorable moments occurred, as when individual blacks and individual whites learned to trust and respect each other. However, this exceptional behavior on the part of some enlightened individuals had little influence on colonial policy.

White masters did, however, impress upon black subjects the modern-day requirement for technology and know-how. And, upon occasion, foreign science and technology actually met endogenous African needs. I recognize the fine work in cocoa-bean genetics and hybridizing done by the British authorities in Ghana and Nigeria. As a result, my country produces the best cocoa for the finest chocolate in the world—a superior grade included in the most prestigious European and American products.

Now that the frenzied, enormously hopeful, and ultimately catastrophic early years of African independence have entered history, and now that South Africans have begun to lance wounds that have festered since the bad old days and have started a healing process, all Africans can look forward to mutually beneficial dealings with friends throughout the continent and throughout the world. In my estimation, economic growth will progress best on a case-by-case basis, initiated within the private sector. But governmental, intergovernmental, and extragovernmental interventions are surely required to shatter the obstacles that stand in Africa's way. We have little margin for error either. It is as if we must pass through the eye of a needle, or, rather, the eyes of many needles, to get from here to there. But in confronting these problems there is also great potential for harnessing Africans' inventive spirit.

Consider the issue of public health—public disease might be a better term—across the vast African continent. Studies by the World Health Organization indicate that in many African countries more than 20 percent of all children die before

A PERFECT FIT

Africa's legendary oral culture—a treasure trove of spoken history, songs, and story-telling—is fertile ground for planting a modern information culture. And the populace is anxious to buy into that kind of future. Even as war raged in Somalia, some public schools managed to stay open (above). In the Democratic Republic of the Congo, radio stations (left) and other electronic media outlets spread information and provide training for the rising technology-savvy generation.

ANCIENT GLORY

The monumental stonework of 14th-century Great Zimbabwe astounded the first European visitors to southern Africa and still testifies to the sophistication of sub-Saharan civilizations. This African kingdom owed much of its prosperity to the skills of its metalworkers and its control of the flourishing gold trade.

Wisdom lies neither in fixity nor in change, but in the dialectic between the two.

—OCTAVIO PAZ

the age of five. An estimated 1.5 million children die each year from respiratory tract diseases such as pneumonia, whooping cough, and measles. Though recent years have seen a great reduction in acute malnutrition of children, nearly 30 million girls and boys are underweight and about 40 million suffer from retarded development.

Diarrheal diseases bring death to perhaps two million children each year, and cholera lingers, posing a major threat to both children and adults. Death from tuberculosis knows no age limit. Malaria, the main cause for concern among the parasitic diseases, is becoming increasingly difficult to control. Nor are these alarming illnesses confined to rural areas; city-dwellers are susceptible to these killers as well—and to the global scourge of HIV/AIDS.

Sixty-five percent of the nearly 37 million people in the world with AIDS reside on the African continent. It is now the leading cause of death in Africa, surpassing age-old killers such as malaria, tuberculosis, and other infectious diseases. The government of South Africa recently estimated that their population suffers 1,500 new HIV infections a day. The projected rise in death rates is likely to cause average life expectancy to plummet from the current 64 years to only 40 years by 2010. These statistics represent but one country. Yet a similar story can be told in many countries across the continent.

Without choosing to be, Africa has become a continent-wide laboratory for AIDS research, for example. Traditional healers, using their knowledge of their local flora to experiment with herbal treatments for AIDS, have had successes that are regrettably unknown outside of their communities at present. Ghanaian scientists working with healers have identified a number of herbs whose antiviral properties have successfully increased white blood cell counts and appear to reduce the viral load of HIV-infected cells. Communication links will allow healers to share their expertise among their fellow Africans and with the world at large.

I have always believed that the therapeutic value of plants will feature prominently in the search for new medical starting materials for the next generation of wonder drugs as we enter the 21st century. And the African continent, with its extensive biological diversity, should play a major role in the judicious exploitation of its resources.

My own research in medicinal plants over the past three decades has convinced me that the current high cost of treating HIV/AIDS patients through the administration of very expensive medications from the developed world can be dramatically reduced if researchers, particularly in Africa, can exploit the medical and nutritional value of the continent's native plants. My conviction may sound unusual to many in the developed world, but for those in Africa and elsewhere in the developing world whose health delivery systems are based on traditional herbal treatments, the curative nature of these plants is well known.

Current HIV/AIDS experiments in my country involving traditional medical practitioners and highly trained modern western medical research scientists indicate that there is tremendous potential in the administration of herbal preparations in early medical intervention for people who have tested HIV-positive. These initial indications of the potential of herbal preparations have led my collaborators and me to speed up our efforts in screening our native plants for phytomedicine with regard to finding new ways of developing low-cost treatment for HIV/AIDS through the application of novel plant-based compounds.

I believe that most of our rural and urban peoples possess traditional economic, cultural, and intellectual assets which are wasted or actually destroyed by the industrial development of today. Development might be more rightly described as the transition from one age into another, the dying age embodying many holdovers from the much despised era of ruthless colonial exploitation. As the old passes, African vitality can

find a most welcome outlet in the electronic cottage industries of the new information revolution.

In the highly industrialized nations with the new economics of microprocessors, some major industries are reversing the trend toward urbanization. While the forms of community development are vastly nontraditional, they are also wonderfully appropriate. I believe that Africa's traditional geometry of the village, the market-logistical network, and the tribal center is far more efficient and functional than might be suspected. In fact, these age-old patterns are worthy models on which to base the continent's future growth.

Instead of people being displaced so they can travel to the machines, information can be instantly distributed to the places people prefer to live, thus shifting the work to the suburban and rural areas. This is still a dream in Africa but not a distant dream. People of the industrialized world are learning that the village tradition need not be displaced to make way for factories. With a tool like the microprocessor, there is no necessity to create human jungles in the form of high-density cities. In a century, for instance, Germany has developed a form of suburban subassembly plant that could pass for a nicely landscaped neighborhood school or social center.

The village is Africa's most beloved and, until recently, one of its strongest institutions. Today the village is beset with fallout from Africa's unchecked population growth, natural catastrophes, the rape of the environment, abominable governance at the national level, and a swarm of lesser devils. The village has deteriorated, becoming a place where people live too little and die too soon. But it still survives, and it holds the key to Africa's rebirth.

The implications of our present village tradition with respect to agricultural development and health are enormous. Traditional knowledge about horticulture, animal husbandry, and herbal medicine is ripe for transformation into information databases that are married to microprocessor communication networks. With the pertinent information instantly available, local people will be able to design decentralized and flexible service-delivery systems that are well adapted to local conditions and expectations.

With the introduction of the microprocessor and reliable communication links, our villages could quickly become corresponding members of great memory banks. Information would, at first, flow out of villages into cyber-repositories to be sifted and processed before it becomes available online in the languages spoken in each region. With training, villagers will be able to access practical support in the form of truly appropriate technology.

In today's world, computer chips and satellite hookups (even to the most remote and disadvantaged rural areas) can take the place of leather drumheads lashed to sections of hollow log. This last was the hardware of Africa's ancient contribution to wireless telegraphy, the "talking drums." These talking drums allowed people to communicate across great distances without any wires to connect them. Now Africans are once again communicating without wires, but the distances across which they can communicate with today's wireless technology span the globe.

Africans are quite adaptable to new ideas and goods, a fact many outsiders find surprising. They may have expected traditional people with so many conservative values to reject change. Not so. The highly recommended marriage of apparent opposites—ethnic lore with cutting-edge technology—is both practical and proactive, two necessary attributes for the rebirth of the region. As with the talking drums of yesteryear, Africans have a long history of overcoming handicaps through the inspired application of their innate abilities. My dream is that, as befitting our history as the cradle of the human creative spirit, in the new millennium Africa will become once again a "giver" to world culture, a rich source rather than an impoverished recipient of new ideas and inventions.

The Changing Landscape of Knowledge

BERNICE WUETHRICH

In the dry southeast of Madagascar, a eucalyptus-lined road crests a hill that is studded with triangle palm trees. Local people call the palm *lafa*. It is a rare plant that grows nowhere else in the world but on this island. Hill and palm belong to the Andohahela nature reserve—one of Madagascar's largest. Although local people long used lafa wood to build their houses, fronds to shield the sun, and fruit to feed their children, the palm has been officially "protected" since 1939, when the French colonial government created the reserve.

During colonial rule, a labor camp operated next to the hill. Tatsimo men were among those forced to build the road and plant the eucalyptus that marks the nature reserve. Before the reserve existed, villagers followed a footpath around the hill to a central market. The path led to other landscapes as well— a spiny forest of thorned plants, where *helos*, or spirits, resided in stones and trees. The land still brims with spiritual and material resources, but the well-trodden path is severed at the edge of the Andohahela reserve, which remains strictly off-limits.

Therefore—as you might well imagine—when a Tatsimo villager views the eucalyptus, the hill, and the palms, he may see something very different than does a biologist bent on conserving rare species.

"Whether you understand it or not, there is always history in the landscape," says anthropologist Wendy Walker. That history is social, cultural, biological—and ever evolving. Understanding its depth and complexity presents a challenge to biologists who wish to conserve or collect rare species in so-called pristine areas. Walker, who spent two years in Madagascar learning about Tatsimo concepts of nature, urges an expansive view of the meaning of biodiversity, one that can encompass ways of thinking that may differ radically from that of biological science.

"We need to move beyond thinking about a particular area simply as a place to save or as a source of biodiversity. There are very intricate ways in which local people relate to their landscapes," Walker says. Without appreciating such dimensions, conservation efforts are bound to trip on their own well-meant boundaries.

Fortunately, more and more conservationists are recognizing the value of local knowledge and engaging in dialogue with groups such as Madagascar's Tatsimo. Since indigenous people acquire their detailed knowledge of a landscape over generations of learning and teaching, get-rich-quick projects by outside groups are bound to fall short. However, well-conceived projects open to the perspectives of local people can give birth to dynamic exchange, where knowledge crosses boundaries like seeds carried by the wind.

Some researchers are collaborating with indigenous populations to identify and conserve plants likely to contain medicinal compounds, searching for cures for cancer, AIDS, and dozens of ailments. The hope is that sharing knowledge will lead not only to new medicines but also to better conservation, increased economic opportunities, and possibly whole new paradigms for the treatment of disease.

The desire to harvest the world's plant pharmacopoeia is undoubtedly as old as our species. Some of the earliest written records document such efforts. Script on Egyptian papyrus from 1550 B.C. refers to the use of tree oils to repel mosquitoes as protection against a disease now thought to have been malaria. Of today's drugs, almost half have an origin in natural products. Renowned among them are alkaloids produced by the rosy periwinkle, a flowering shrub native to Madagascar. Doctors prescribe its chemical compounds to treat childhood leukemia and Hodgkin's disease. Quinine, the first antimalarial drug known to Western medicine, comes from the bark of cinchona trees. Jesuit missionaries learned of its curative properties from native people in the Peruvian highlands and introduced the drug to Europe about 1640. It is still in use.

The search for powerful new medicines in the tropics continues today. Walter Lewis, a biologist at Washington University in St. Louis, Missouri, and his team have collected promising plant species in the Andean foothills of Peru and adjacent Amazon basin since 1982. They worked with a linguistic anthropologist and gradually built strong ties with the Aguaruna and Achuar tribes of the Jivaro people. Over generations, these forest-dwelling people had become intimately familiar with the region's abundant flora, and developed a medical practice utilizing some 500 of the region's 10,000 plant species.

Lewis is keenly interested in Aguaruna treatment of malaria. Some strains have developed resistance to most standard drugs—including quinine—and each year the disease kills

about two million people worldwide. Pregnant women and their fetuses are especially vulnerable. After years of joint work—and signing contracts that assure future benefit sharing with Peruvian universities and indigenous clans —Aguaruna medical practitioners led Lewis to some ten antimalarial plants. They instructed Lewis on the plants' harvest and preparation. Back in his lab, Lewis isolated plant compounds that kill the parasite in human red blood cells. "Without the collaboration of the indigenous people who are partners, we'd be nowhere," Lewis says candidly.

His project is part of the International Cooperative Biodiversity Groups program, which promotes cross-cultural collaboration in the process of drug discovery. The aim is to improve human health, encourage conservation, and provide economic benefits to local people.

So that their Aguaruna partners realize benefits from conservation efforts, Lewis's team helped them develop nurseries to grow medicinal plants—several types of which have become scarce in the wild. The concept of conservation is relatively new to Aguaruna. As seminomadic people, they moved their villages about every ten years, a practice that allowed previously occupied land to rebound from clearing and harvesting. In the 1970s the Aguaruna villages became permanent. This change in lifestyle called for a change in thinking, since a sedentary population can quickly denude the surrounding area of wild resources. Now Aguaruna cultivate medicinal plants on hundreds of hectares of land, some in secondary forest, others interspersed in their original settings.

The landscape of the Andean foothills is changing as villages expand, and as people attend to old resources in new ways. The landscape of knowledge is also transforming, for Aguaruna and for the international team of biologists working with them. The convergence of two knowledge systems, both born of astute observation and experimentation, is not only sowing fertile ground for new medical practices, but also cultivating a cross-cultural dialogue that promises profound rewards.

Snakeweed, held by a rancher/medicine man in Arizona's Sonoran Desert, may hold a treatment for arthritis. Scientists are scattering worldwide, racing the environmental clock to assess traditional therapies using various plant species—some of which may be endangered.

Ritual Earth

TEXT BY

Michael Atwood Mason

To some, nature represents a beneficient and nurturing provider. To others, it is the domain of pitiless, impersonal forces. Nature may be at once something fragile—something we need to protect—and something powerful— something to be protected from. It is, of course, all of these things, and in the diversity of ways that people around the world chose to recognize their bonds with nature, we can see a reflection of its complexity.

PHOTOGRAPHED FOR PUBLICATION IN 1913, A RITUAL DANCE FULFILLED WHITE AMERICANS' PERCEPTION OF INDIANS' ONENESS WITH NATURE.

— Photograph by
Edward S. Curtis

Ritual Earth
Understanding Ourselves Through Nature

*People take all learning from the external world
and understand themselves in terms of…
surrounding Nature.*

—GASTON BACHELARD
Essai sur la connaissance approchée

I

ONE SUMMER MORNING, WHEN I WAS FIVE
years old, my grandfather and I set off from our
island cottage for the main dock across the lake.
There we could retrieve mail, collect a Toronto
newspaper, and my grandfather could plug his elec-
tric shaver into an outlet at the base of a street
light. Without electricity or running water in our
cottage, the lamp post was the closest my grand-
father could come to carrying out his routine. As
I positioned myself in the bow of the motorboat,
my grandfather yanked at the pull-starter; the
engine turned over, and the sound echoed across
the lake. My grandfather maneuvered the small
boat away from our dock, turning it gracefully
toward the open water. The bow rose up as the boat
accelerated. Suddenly, he cut the motor. The bow
dipped, then veered back toward the shore. Star-
tled, I quickly turned toward my grandfather.

"Be quiet," he whispered. "Look…"

Then I saw it, among green and brown cattails,
a tall gray-blue bird standing motionless, survey-
ing the water.

"A great blue heron," he said softly. "What a
strong and noble bird it is…" His voice trailed off
as we floated motionlessly. We watched, waited
until the bird flew off.

In these moments and many others like them
over the years, my grandfather shaped my per-
ceptions of the natural world. He did not simply
regard a bird on the edge of the lake with a cur-
sory glance as we sped to the main dock and our
chores. Instead, in the heron's physical height and
grace, he perceived composure; in its stillness, a
calm he sometimes lacked. He saw a character in
a dramatic play, engaged in a life-and-death strug-
gle for survival. The heron's strength and grace—
and the power of all nature—affected my

grandfather quietly yet profoundly. He frequently
paused to observe the natural world—but he was
always looking beyond the physical scene, reflect-
ing, and sensing vital, human qualities that he felt
were at play. During the years we spent together
my grandfather inspired in me a similar sensibil-
ity, ultimately instructing me in the beauty,
balance, order, and growth that he sensed in all of
nature—qualities symbolic of humanity's highest
ideals, which he cherished and respected.

II

NATURE HAS ALWAYS ENGAGED THE
human imagination. From my work as a cultural
anthropologist, I have come to understand that a
reverential attitude and respect for the natural
world is part of a universal human phenomenon.
Humans—individuals and entire cultures—con-
struct relationships with the natural world, and
they employ symbolic constructs that help to
establish and maintain their relationship to this
world. The chosen symbols do more than stand
for clear ideas: They often capture essential, unex-
pressed principles of life found in personal ideals,
social values, and cultural norms. Symbols are the
most effective way to communicate these inex-
plicable aspects of human experience, and each
one carries many meanings. Explanation is next
to impossible because all social facts—including
the symbols constructed by the human imagina-
tion—have numerous unknown and unknowable
origins. Years of study have made clear to me that
symbols frequently represent qualities of the
culture's social world that have parallels in the
natural world and in natural phenomena. There
seems to be a fluid interaction between the nat-
ural world and the human imagination that
reflects people's preoccupations with the life of
nature and their own lives.

Symbols are expressed in many forms: stories,
rituals, artwork, wisdom, and observations.
Somali herders in East Africa compose poetry
and songs praising the camel, which provides
both food and transportation and is at the

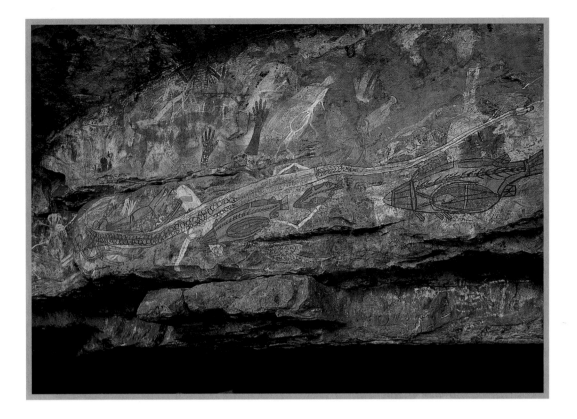

Born in the complex Aboriginal creation saga known as Dreamtime, creatures still hunted by some northern Australian Gagudju adorn a frieze in Kakadu National Park. The x-ray-type style, dating back some 9,000 years, here reveals internal organs of a huge python and three giant perch.
— *Photograph by Belinda Wright*

center of their social and economic life. Seven thousand years ago, Chinese artists in Asia created statues of the Millet Prince, whose abundant grain allowed their civilization to flourish. Such acts of the human imagination use symbols and create means by which human experiences can be shared, enacted, and reenacted. They link people to their environments and each other, and contribute to shaping their views of the surrounding world and themselves.

III

SO POWERFUL IS NATURE IN ENGAGING the human imagination that Ralph Waldo Emerson said, "The whole of nature is a metaphor of the human mind." Features of the landscape, animals, or plants stand in for human ideas and cultural notions. In American society, warmongers are "hawks," while peace-seekers are "doves"; the stock market is "bear" or "bull"; environmental movements have heroes and victims—the gentle

giant of the sea, the whale, and the spotted owl have come to symbolize the disregard for the environment by greedy, rapacious, profit-driven industries. Often symbolic representations of nature have more to do with the perceived characteristics, rather than a feature, of the nature world—specifically, a hierarchical ideal—and the perception of nature at any given time in history. In medieval Europe, for example, the "natural order"—the undeniable way we think things are or should be—was invoked to impose ideal notions of the propriety of certain behaviors and the impropriety of others: it was natural for serfs to spend their lives serving nobles. Today such limited freedom is considered unnatural. In much of sub-Saharan Africa, people understand villages and cities as sites where human authority is exercised, while they construe wild savannas and forests as the venues of spiritual authority. Nature must be understood as a reality imagined in different ways by different peoples throughout history.

Continued on page 206

Around the world, cultures adopt remnants of previous cultures to create for themselves a meaningful connection to nature. At the Callanish Standing Stones, a Neolithic Stone-henge-like assemblage on the Isle of Lewis in the United Kingdom, New Age travelers greet the dawn after observing the summer solstice.

— *Photograph by Jim Richardson*

Nature in the abstract adorns
the floor of a mosque courtyard
in Morocco, as a fountain of
flowing water is framed by
representations of the Garden
of Paradise. Even in complex
world religions like Islam, nat-
ural symbols evoke meditations
on the nature of God.
— *Photograph by Bruno Barbi*

One comes up short as four stilt dancers, imitating water birds, perch atop a mud wall following a performance in Mali. The performers flash eye-catching color as they totter above spectators who have gathered to affirm the spirits of deceased villagers as ancestors.

—*Photograph by Jose Azel*

"Forgive us, reindeer," the Koryak of northern Kamchatka say as they chase their animals with lariats, pull them from the herd, and dispatch them with a spear. They believe that only the spirits of the deer can deliver human souls to "the other side." Thus, an animal must die for a departed human being. In giving water to the dead deer, the utmost respect is paid for its sacrifice.

— *Photograph by Sarah Leen*

Purification and fertility rites seem almost universally attached to water. Massaged into ineffable bliss, a hotel patron in Kagoshima, Japan, finds solace in a bath sanctified by a shrine of a god of water and rain. The folded white Shinto element at left marks this as a sacred place, helping create a context where the power of water can be contemplated and experienced.

—*Photograph by Michael Yamashita*

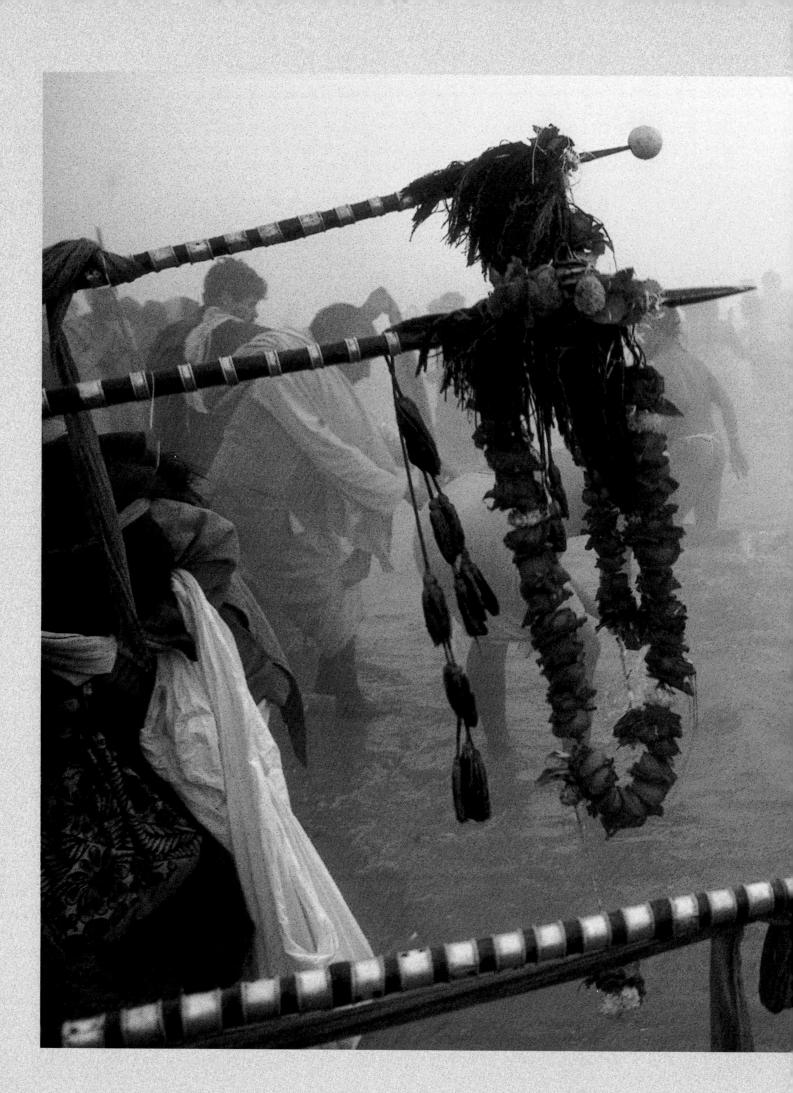

In an act of devotion a Hindi sadhu, or holy man, impales a lime on the end of a spear at India's largest religious festival, the Maha Kumbh Mela. The spear will be dipped ceremonially in the holy river, the Ganges. With its long course and powerful currents, the Ganges has long been integrated into India's complex religious system.

—*Photograph by Tony Heiderer*

Seagoing mammals get up close and personal during a whale-watching encounter off the California coast. Following the animals on their annual north-south transit, Americans display their curiosity for wildlife by venturing tantalizingly close and then respectfully retreating.

—*Photograph by Joel Sartore*

Continued from page 195

As societies are transformed and people's relationships to nature and their own societies are transformed by the forces changing our lives, how will the social imagination and cultural symbols change to fit the new and developing circumstances? Urbanization, for example, provides fewer and fewer opportunities for the American people to understand the symbolic importance of America's most well-known national symbol—the bald eagle. While the eagle is a long-standing symbol of might and valor, Americans are rarely able to witness firsthand the grandeur and power of the bird and thus understand the deeper symbolic meaning associated with our nation.

IV

DIVERSE PEOPLES AROUND THE WORLD are increasingly separated from the natural environment that has been the source of their cultural symbols and world view. Yet, as the conditions of life change, symbols have been carried along with the transformations. In the late 18th and early 19th centuries, Yoruba-speaking city-states in West Africa had extensive religious organizations; these societies honored diverse forces of nature as divinities, knew how to find natural healing agents in their environment, and played a key role in sustaining divine kings. An Islamic jihad slowly marched southward and caused many small wars, resulting in a large number of enslaved captives. Nearly 500,000 were forced to Cuba. They and their descendants created and practiced the popular Afro-Cuban religious tradition Santería. In Cuba they encountered flora and fauna similar to their homeland but a colonial social world that was radically different. As they labored in slavery, they continued to honor their ancestral nature deities, and they adjusted their herbal medicines and ritual practices to fit their new environment. Their religion is now prevalent in Cuba; and with the exodus of one million Cubans after the Revolution in 1959, Santería has grown in the United States. Latinos, African Americans, and Anglos in large urban areas have embraced its practices.

Santería, like many religions, connects specific deities with specific natural phenomena. Those

who practice the tradition engage in the religious experience through nature's symbols as well as engage or experience nature through its divinities. The sun is described as the palace of God, not because Santería practitioners literally believe that God resides in the sun but because the brilliance, illumination, and splendor of the sun reminds them of their God's greatest qualities. The owner of rivers is called *Ochún*; she is connected with life-giving rain and water. Ochún can achieve what no other divinity can: She renews and perpetuates the human community, connecting people with God and providing the resources for life by refilling the rivers. Just as the sweet water runs smoothly over stones, Ochún dances sensually through the world. Her favorite food is honey, another reflection of her sweet and joyful character. When angered, Ochún has the cruel sting of the bee. A myth of how Ochún ended a drought weaves many natural symbols into a single narrative and inspires the respect and reverence of Santería priests as they interact with the world that surrounds them: Rain had not fallen in a very long time and the world was in danger of collapse. Various deities tried to influence the will of *Olorun*, the distant High God who is called the owner of the sun. *Changó*, the warring god of thunder, made a dramatic sacrifice with fire, but his prayers for salvation did not move Olorun. *Yemayá*, the majestic mother of the ocean, also made sacrifice and pleaded for rain, but to no avail. Finally the youngest deity, the beautiful Ochún, asked if she could try. Although the other divinities laughed at her, the pure and sagacious *Obatalá*, god of creativity and mountains, said she too should have her chance. Ochún went alone into the forest and transformed herself into a vulture. Slowly she flew off toward the sun. After much hard work, she arrived at the High God´s palace. She pleaded with God, explaining the suffering and death that were taking place on earth. She prayed for rain. Impressed by Ochún's efforts, Olorun released the water and promised that she could speak to him whenever she wanted.

To this day, Ochún is called the messenger of Olorun.

The story tells of the Earth's and humanity's need for fresh water; it speaks of the transformative power of the forest, *el monte,* where plants overtake one another and spirits are thought to roam freely. And the vulture, the most common bird of prey in Cuba, plays a key symbolic role for Santería practitioners as a protective remedy that shields individual houses from negative spiritual influences. Vultures are large birds that ride the wind for hours, traveling long distances and searching the ground for food; because they eat carrion, they are linked to death, spirits, and mysterious powers. Ochún transforms into a vulture—Santería's link to its origins with the Yoruba people, who decorated their kings' crowns with birds— symbolizing the powers that the bird controls and the protection the vulture provides. When a vulture flies overhead, many priests of Ochún cross their arms in a gesture of reverence and ask for the goddess's blessings. So respected are these birds that the Afro-Cuban word for vulture, *mayimbe*, is used to refer to a powerful person in any context.

<div align="center">V</div>

IN A PARK IN THE MIDDLE OF CUBA'S capital city, Havana, I accompany a young priestess on a path to the Almendares River to gather herbs for a healing ritual. Along the bank, we find a tall ceiba, a sacred tree thought to draw powerful spirits. Facing the trunk, she pours libations and invokes her ancestors and the deities and makes a special prayer to the spirit of the tree and to Ochún. She explains why she has come and names the herbs that she seeks. As she turns and moves toward the river's edge, a vulture leaps into the air. My friend stops, crosses her arms, and respectfully asks for Ochún's blessings. As we stand on the riverbank, the priestess does not simply see a large bird take flight. She looks beyond the physical, reflects, and senses the presence of the goddess Ochún. "What a powerful goddess," I say, and think of my grandfather, now an ancestor.

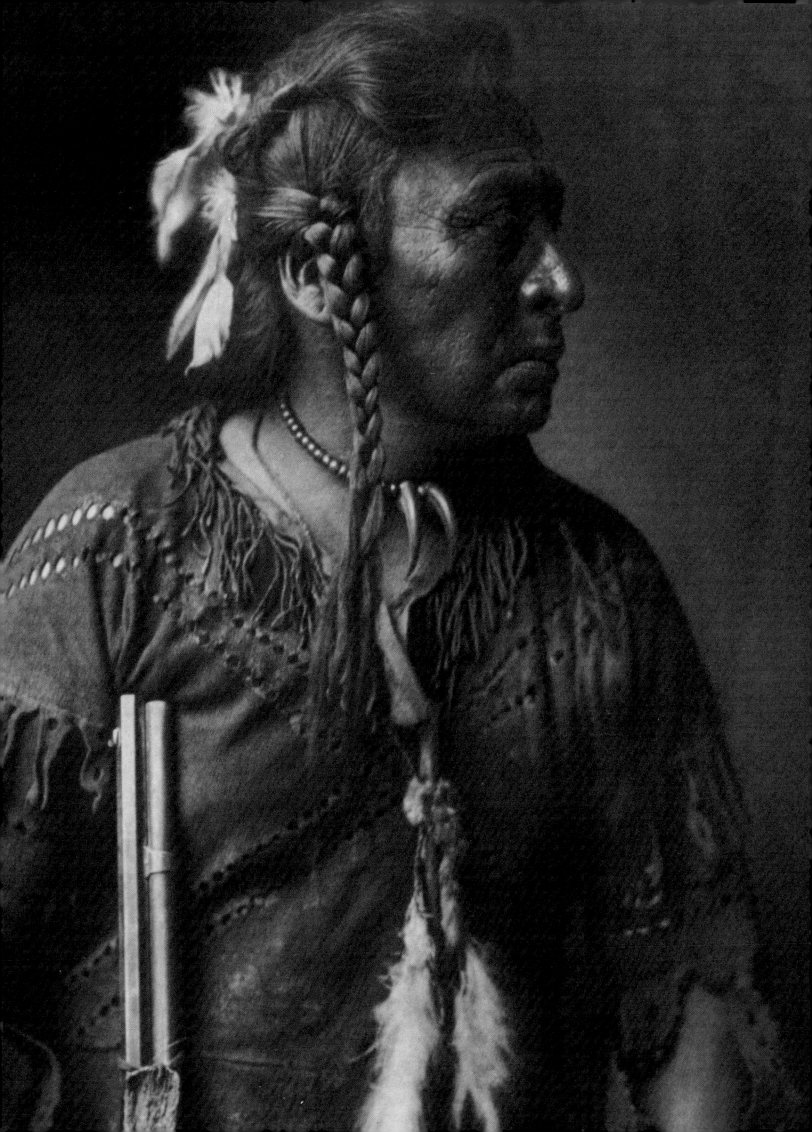

Leave It to the School Children

George P. Horse Capture

THE ECONOMIC FORCES THAT BROUGHT A MINING COMPANY TO THE FORT BELKNAP

RESERVATION IN MONTANA WERE INDIFFERENT TO THE A'ANININ PEOPLE'S SPIRITUAL TIES WITH

THEIR LAND. NO LAWS EXISTED TO PROTECT THE SACRED GROUND FROM DESECRATION.

ECONOMICS EVENTUALLY SENT THE MINERS AWAY AGAIN, BUT NOT BEFORE THEY REDUCED A

ONCE-PROUD MOUNTAIN TO RUBBLE.

HOME

Every summer we make our way westward from New York City, eventually reaching Montana and our home on the Fort Belknap Reservation. We don't actually have a house there, but it's our home anyway. This is where all our people live and are buried. Returning to Indian country from the East Coast is much anticipated throughout the year. Numerous work projects fill my briefcase, but somehow the excitement, children, grandchildren, and other relatives always fill the hours and days, and I eventually leave Montana with the work unfinished.

We know we are home when Snake Butte appears and the blue-gray silhouette of the Little Rocky Mountains rims the southern horizon—our connections to the earth. We are home at last.

After a wonderful night's sleep we drive to Hays, past Three Buttes to the west, past the fields of wheat on one side and the prairie filled with running horses on the other, past Peoples Creek flowing from the west. Making my way over Carrywater Road in the Little Rocky Mountains, I long to see my son, Junior, his wife, Teresa, and all my grandchildren. Junior is off to a meeting when I arrive, and Teresa has taken my grandkids

to the creek for a swim, so I go to look for them. I drive up to Little Peoples Creek, toward St. Paul's Mission. I appreciate the beautiful stream that carved its way through the canyon eons ago. Our tribal government scooped out ponds in this gravel creek bed to make swimming holes for the children. The water is clear and cool—a good place to escape the hot summer sun. Several families are having picnics and cooling off near the creek. I soon pass the Sundance grounds and the Powwow grounds, then I realize I've gone too far, somehow missed my grandkids. I continue up the beautiful canyon, though, between the quaking ash trees lining the road.

Driving up this newly graded mountain road is pleasant after driving on the wild streets of New York. The air is sweet. All is peaceful and beautiful. The incline is constant and the scenery gorgeous, but I am full of dread as I anticipate the scene ahead. I know what is up there. I know what is not up here. And as I emerge from the trees, I can see ahead a raw, tortured wall of earth. Devastation. I am depressed as I view a once proud monument reduced to rubble. This is what open-pit mining does to a mountain; it profits only those who live far away from the damaged landscape.

Photographed by Edward Curtis in the 19th century, the author's great-grandfather saw his sacred land crumble under the miner's shovel.

Such severe damage brings tears to my eyes, rage in my heart. This is like tearing off the breasts of your mother, revealing carnage and pain inside. The last time here, I could see the massive earth-moving trucks driving back and forth, but it's quiet now. It's quiet because the mining company has filed for bankruptcy. The only reason that the rape has stopped is because the price of gold has dropped. All the federal and state agencies did not stop it, nor could the environmental and local Indian groups—Red Thunder and the Island Mountain Protectors. But the stock market did. We all know, though, when the price of gold rises, miners will be back.

A breeze is blowing. I can see the long grass waving back and forth from where I stand. I stand here in the bright reservation sunshine with a darkened heart. Before me, in ruins, is what once was a beautiful mountain—home of thick grasses, colorful flowers, towering pine trees, a place of prayer for my people. Birds, insects, eagles—they all lived here. Now there is nothing, only death.

How did this happen? How did we allow this to occur? We are all thinking human beings—have we no decency or respect? Is the quest for gold and money all there is? Are these the ultimate forces of change?

ORIGINS

When one considers forces of change, it is easy to think of them in grand terms such as Manifest Destiny and agricultural inventions, but one must remember that forces affect people; they change human beings. We are all the same, you know. No matter where we are from, we all have bodies and we all should have faces. I would like to show you the faces of my people, so you can understand the impact of the forces on us. The American Indian people.

We are not newcomers. We have been on this hemisphere longer than any other humans. Estimates and theories place us here from 13,000 to 70,000 years ago. At intervals, scientists redefine their theories and come up with different dates, but at a minimum it would be safe to say that we have been here at least 13,000 years.

Unhappy with the way scientists have treated us—from physical anthropologists to archaeologists, and others—many Indian people have questioned the Bering Strait theory that the origin of the American Indian people begins with us crossing the Bering Strait and then populating the hemisphere. We have our own theories of origin. Some tribes believe they came from an opening in the earth, others believe they came from the sky, and some tribes, such as mine, have different beliefs.

Our story says it had rained for a long time, perhaps 40 days and 40 nights, until the earth was covered with water. On the surface of this gigantic ocean was Turtle and on its back was a number of animals, birds, and First Man. They drifted for a long time. Finally First Man said he did not want to do this anymore; they had to create a world so they could live in a proper way. He urged the animals to dive down to the ocean's bottom and get some mud for him. So one by one they dove into the murky depths. First the muskrat, then the beaver, then others, but they were all unsuccessful. Some were never seen again, others barely made it back. Finally a waterbird said it wanted to go. So at the urging of others, the animal dove down. It swam harder and deeper. Much time had gone by and the people on the back of Turtle began to worry. They thought they had lost another member of their family. Suddenly there was a splash on the ocean's surface. It was the little waterbird struggling as it made its way slowly toward the others. It was totally exhausted. In its beak was a bit of earth. Joyously, they pulled the bird aboard and gratefully acknowledged its success. First Man took the soil in his hand and rolled it back and forth in a circular motion. Slowly the mud ball grew larger. From a small round ball it grew until it became the world. Turtle and crew

A LAND UNTOUCHED

In the early 1900s a group of buffalo Indians rides toward the sacred mountains near Hays, Montana. Behind the riders meanders Little People's Creek—today little more than a tailings sluice for the mine.

The true past departs not, no truth or goodness realized by man ever dies, or can die; but all is still here, and, recognized or not, lives and works through endless change.

<div align="right">

—THOMAS CARLYLE

</div>

made their way to land. They disembarked and began to populate the world.

This is our story of creation. To this day, in gratitude for the brave deed it performed, we do not kill and eat that waterbird, the Mud Hen.

In my mind, the Bering Strait theory and our origin story are not incompatible. The Bering Strait is just another landmark we passed on the way coming here. Our origins could be somewhere else. During our journey here, we passed the Bering Strait and other places.

There are many ways to learn about American Indians. One of the best ways is by studying their languages. The languages of the tribes change little over the centuries and can be grouped into many large families. In the Athapaskan family are Chipewyan, Sarsee, and other tribes, including Navajo and Apache. In the Algonquian family are Cree, Blackfeet, Sauk, Fox, Shawnee, Cheyenne, and others including Arapaho and my tribe, at one time called Atsina. Some tribes in the Siouan family are Crow, Mandan, and of course Sioux. In this group also are Assiniboine. Some scholars estimate that there were 600 languages spoken in North America before contact with Europeans. Studying these languages allows us to determine relationships between tribes and theorize about tribal migrations. It is said that the Algonquian language group, which includes the language spoken by Pocahontas, was one of the first to arrive in this country.

Fifty-two names have been given to my tribe by explorers, priests, scholars, and others over the years. In the early 1800s we were known as Atsina, which is said to be a Blackfeet word. The common name used today, and used in our treaties, is Gros Ventre, a French term meaning big belly. The derivation of this name comes from a sign-language gesture where the hand moves down the chest and away from the body, denoting that we are Water Falls or Falls Indians. This refers to a spot on the Saskatchewan River where the early Canadian trappers first saw us. When the sign was used in a distant area, it was misinterpreted as "big belly." Similarly, Hidatsa people in North Dakota were also named Gros Ventre. Many believe we can never truly be ourselves until all these names are discarded and we reinstitute our tribal names. There is an effort within my tribe to restore our native name. Ours is A'aninin, the White Clay People.

HISTORY

Historical records indicate that in very early times our people came from northeast of Red River, which divides North Dakota and Minnesota. In about 1700, as our tribe moved west, it divided. Our group, A'aninin, went northwest, and Arapaho went west and south. We traveled and lived in the area between the north and south branches of the Saskatchewan River and were described by the first Europeans that saw us as "good buffalo hunting Indians." The estimate of our population in 1780 was 3,000 people.

Cree and Assiniboine, being allied with each other and the commercial fur trappers, obtained the gun before the other tribes in the Northern Plains. Together they began to push westward against our tribe and others in the region. We could not defeat this coalition, so we tried to stop their source of supplies by burning three forts in Canada. In 1826 we moved southward into what would become Montana. Our numbers were estimated in 1806 at approximately 300 lodges, with 7 people per lodge or tipi.

Around this time, the tribes of the northern plains were exposed to foreign diseases which decimated our populations. Smallpox ran rampant, causing immense mortality rates. Often 50 to 70 percent of the infected people died, primarily children and elders. When the foreigners actually arrived in our region, our traditional way of life was nearing its end.

In spite of these changes, our tribe continued to be quite active. We engaged enemies on the

Santa Fe Trail, trappers at Pierre's Hole in Idaho, and others across Montana. In 1833 German Prince Maximilian journeyed up the Missouri River. Our tribe met him where the Arrow River meets the Missouri River in Montana. Swiss artist Karl Bodmer painted the images of some of our people at this meeting. In 1847 there were 230 lodges of our tribe.

It is said that the last great herd of buffalo lived in our area. But by 1885 excess hunting had nearly exterminated this herd. Our people debilitated by the effects of deadly diseases, and our movements restricted more and more by treaties, we were unable to sustain ourselves with buffalo. Our country, though, was described as "beautiful, level country, well covered with grass," and in 1876 our population was estimated at 960.

As the tribes were suffering from these massive changes, they were squeezed into smaller areas. Intertribal conflicts broke out more frequently as one tribe fought against another. To establish firm tribal boundaries, our present reservation was established by the Fort Belknap Agreement, ratified by Congress on May 1, 1888.

The reservation was named after President Grant's secretary of war, William Worth Belknap. He was impeached by Congress in 1876 for accepting bribes and resigned before the trial to avoid further disgrace. The reservation encompasses more than 600,000 acres in Blaine and Phillip Counties in Montana. It is rectangular in shape, 25 miles from east to west, with the long side going north and south for 40 miles. The northern boundary is the Milk River, so named by Lewis and Clark because of its murky color. The southern boundary is the crest of the Little Rocky Mountains, which rise from the surrounding plains. We call them the Island Mountains or the Fur Cap Mountains. In this relatively small area there are three ecosystems: a river environment to the north with its cottonwood trees and irrigation capabilities; a mountainous area to the south, with rugged canyons, pine trees, and soaring eagles; and a rolling prairie once covered with buffalo grass. This is where we now live. It is a beautiful reservation.

GIANT TURTLE'S TRAGEDY

The Mountains

The tragedy of the mountains has taken many forms. One began long ago during the mountain-building process of the earth, before there were Indian people or miners. The intrusion of molten rock under this area created enough internal pressure to force the top-most layers of the earth's crust upward into the shape of a dome, capped by Madison limestone. The layers of this dome have eroded over the eons, creating spectacular canyons; the remains of the dome, our mountains, are covered with grasses, brush, and pine trees. The most important minerals in these mountains are of low-grade quality and include quartz, sericite, fluorite, sylvanite, and gold. The cursed gold.

Folk legends had it that the Indian people knew about the presence of the gold in the Little Rocky Mountains for a long period of time. The soft metal didn't fit within their lifestyle so they didn't use it, but they soon realized that the Euro-Americans would do anything to get it. Accounts say that "upon pain of death," the Indian people were forbidden to reveal the location of the gold.

During and before our early settlement in the 1850s, the white people relentlessly continued their movement westward on their quest for Manifest Destiny, wreaking havoc with the landscape, razing anything that produced money. Few of them were able to to really see what they were losing.

Over the past hundred years, forests have been devastated for their lumber, rivers dammed to produce electricity, air polluted by factories, and people removed from their land. As the juggernaut churned its way West, the forces of change either

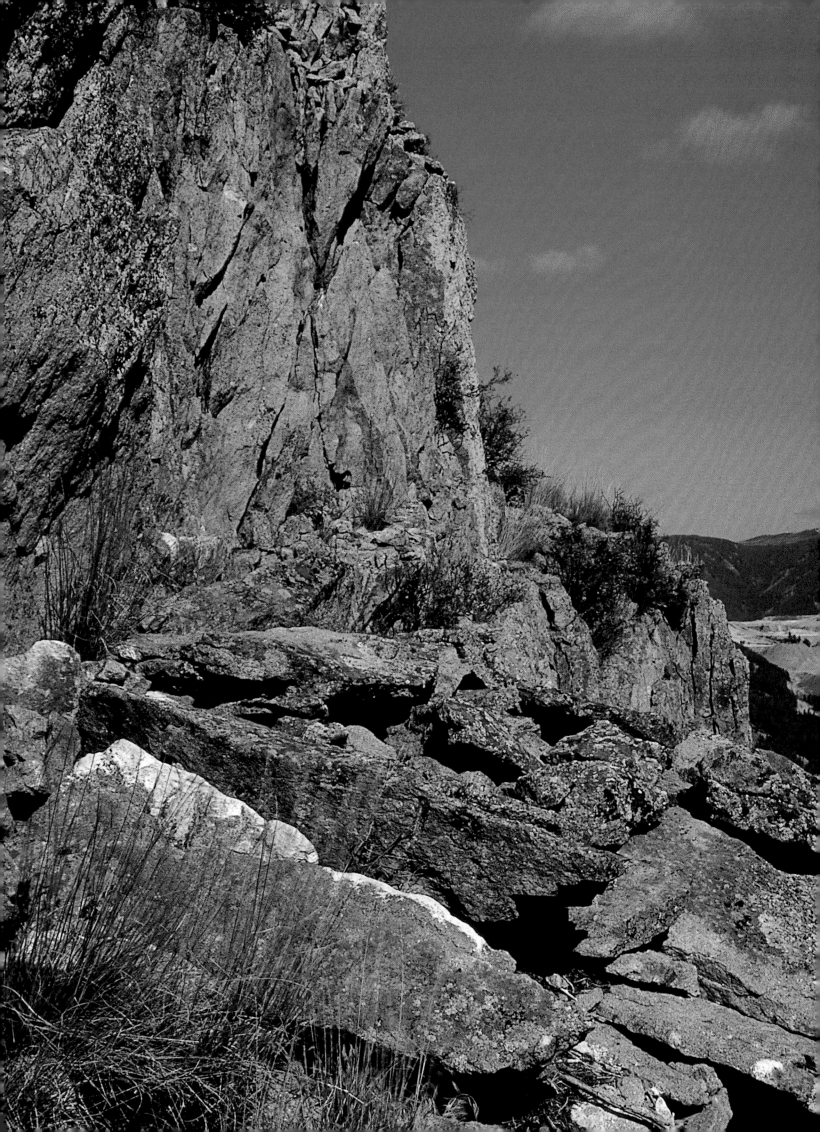

A MOUNTAIN VANISHES

The fate of two sacred mountains, Indian Peak in the foreground and Gold Bug Butte in the distance, stand in stark contrast. As Gold Bug is terraced into oblivion by miners, Indian Peak is left to itself.

Even while a thing is in the act of coming into existence, some part of it has already ceased to be.

—MARCUS AURELIUS

destroyed or swept before it those entities or native people that God created. By the late 1880s, in the northern plains, the tribes were restricted to reservations. But the forces continued to pursue them even there.

The Mining Law

A tragic force, mining laws were established long ago and continue to cause terrible damage today. The U.S. Congress passed the General Mining Law of 1872. This law, one of a series that encouraged people to go West, was originally intended to inspire prospectors. The law was generous, but only benefited a few—it allowed developers the exclusive right to mine hard-rock minerals from federal or public lands. It implemented a system for claims that protected prospector's discoveries from infringement by others, establishing that the finder of a valid claim can mine the minerals or "patent" as private property. So with their picks, shovels, and burros, prospectors sought the yellow riches, established settlements, and promoted the nation's Manifest Destiny.

The foreign intrusion began with French explorers, the Vérendryes, in 1743, and then Lewis and Clark from 1804 to 1806; next came the fur traders, who arrived after Lewis and Clark; then cattlemen after the rich grasslands of the Northern Plains; then miners, settlers, and others.

They followed the gold strikes: from California (forty-niners), then Colorado (fifty-niners), eventually making their way to Montana from the south. The first Montana gold strikes were near Drummond in the 1850s, then in 1862 at Grasshopper Creek. By 1866, Montana was the second highest producer of gold in the United States. Eventually miners heard about strikes in the Little Rocky Mountains, along the southern border of what became the Fort Belknap Reservation, and some made their way there. Although initially forbidden by law, miners crossed into the land anyway, setting up operations and panning for riches. Our population in 1883 was estimated at 970.

At first prospectors staked land claims. What earth scars they made were often concealed by foliage and pine trees. Later, companies using similar techniques mined on a larger scale. The riches attracted still others, and eventually the local, state, and congressional politicians bowed to the pressure of the numerous non-Indian constituents who demanded gold-bearing areas on Indian reservations be taken and mined by them.

In response the government commissioned William C. Pollock, Walter M. Clements, and George Bird Grinnell to meet with the Indian people and obtain their land. Less than two weeks before the Fort Belknap proceedings, these same commissioners met with the Blackfeet and purchased for 1.5 million dollars a vast tract from the western edge of the Blackfeet reservation where non-Indians could search for gold. It was twenty times as large as the proposed land sale on Fort Belknap. No worthwhile deposits were found, so the land became part of Glacier National Park. In the mid-1870s, Crow Indian people suffered a massive land loss for the same reason.

On October 7, 1895, W. C. Pollock and George Bird Grinnell met with the Indian people. The comments of the commission and Indian people regarding the sale of the mountains were recorded for history in Senate Document 117, 54th Congress, Session 1.

White Weasel (Gros Ventre): "You commissioners have come to get part of the reservation, and I can't very well spare any of it. I don't like to sell it. I don't want to sell. That is all I can say." (White Weasel here touches the stenographer's pen in testimony of his statement.)

Sleeping Bear (Gros Ventre): "The Indians are talking all different and I don't know what to do, so I think I will not sell; that is all I can tell you. I can't sell any of the reservation."

Black Wolf (Gros Ventre): "I can't sell any of the reservation; the reservation is small enough now; I can't sell any of it." (Black Wolf here touches

216

the pen in testimony of his statement.)

Jerry Running Fisher (Gros Ventre): "I am willing to sell a part of the reservation. I think I will do well afterwards if I sell a part of the reservation."

Bushy Head (Gros Ventre): "I am willing to do as you three men advised me. I would like to get more cattle; that is all."

Lame Bull (Gros Ventre): "Look at my hair; it is gray. I say the same thing as I said before—I don't want to sell."

Great-grandfather Horse Capture said, "I can't sell the Reservation myself; I leave it to the school children."

At the end of the day Mr. Pollock told the Indians, in part:

"We are sorry to find that you are not yet agreed... We told you on Saturday that we saw no way for you to get beef, cattle, flour, wagons or anything else after your present agreement expires, unless by the sale of some more of your land.... If the majority, the most of you, do not think this, all we can do is to go back to Washington without having done anything. If we do this and you come to the agent three years from now and ask him for something to eat, or for a wagon, or for some cattle, you will be very much disappointed when you cannot get it. If, then, you go back to your women and babies without anything, and they are crying for something to eat, you will be sorry that you did not think better at this time."

Mr. Grinnell also spoke.

"I see that some of you people are pretty blind; you can't see far.... You are like people looking through a fog—you see things near by, but the things far off are hidden.... I go about among different people and see them, how they are fixed, how many cattle they have got, how they farm; I don't see anybody as poor as you people."

"Two years from now, if you don't make any agreement with the Government, you will just have to kill your cattle and then you will have to starve...."

The document indicates that out of a total of 334 male adult Indians from the two tribes, 189, being a majority, signed the agreement. This included about five-sixths of the Assiniboines and only one-quarter of the Gros Ventres. The tribes deeded away 40,000 acres of land and received $360,000—nine dollars per acre. On October 9, 1895, the Grinnell Agreement was completed and the land lost to governmental pressure, coercion, and betrayal.

Much of the funds due the Indians of Fort Belknap may never have reached them. The Reservation agents of the time, Major Luke C. Hays (1895–1900) and his successor Major Morris L. Bridgeman (1900–1902) were later accused of fraud. Hays committed suicide before he could be indicted; Bridgeman was convicted of fraud and imprisoned.

That year, 1895, our tribal population was 596.

The New Technology

In 1979 the mountains began experiencing drastic, tragic change. Pegasus Gold Corporation of Canada, a mining conglomerate, entered into agreement with some western American subsidiaries and organized Zortman Mining Inc. Together they ushered in a new era and a new mining technique—the cyanide heap-leach process, which allows profitable mining of very low-grade ore. It requires removing immense amounts of ore at low cost: First, buldozers cut a road in the mountainside to the top. A flat working area is made by scraping off the soil to the bedrock. Next, a series of holes are drilled into the rock and explosives are inserted and detonated. The entire level is pulverized by the explosions. The heavy equipment moves in again and scrapes off the pulverized material, which is loaded into

THE LEGACY
For the youngsters living on the Fort Belknap Reservation, the swimming hole framed by old mine tailings is a recreational spot. To those who know the mine's history, the pool's polluted waters are a bitter reminder of a trust betrayed.

218

trucks and driven to a nearby leach pad and dumped. When all the debris is removed, the area is once again scraped level, redrilled, reexploded, and the rock is again pulverized and dumped onto the pad. Layer after layer is taken from the once proud mountain. The pulverized rock on the leach pad grows.

Once this pulverized material is piled high enough, it is saturated with a solution containing cyanide. As the liquid cyanide solution soaks through the debris and dissolves minerals, the gold flows toward the drains. Once the dissolving liquid reaches the plastic-lined bottom, it flows away from the pad in pipes to holding ponds. Later, the gold is removed. In this manner, huge amounts of mountain can be mined for its low-grade material or pulverized rock. According to the Billings *Gazette* (July 3, 1991), between 92 and 100 tons of rock are processed for each ounce of gold. The process mutilates the earth. It is like cutting down a forest to get one two-by-four-inch piece of lumber.

In 1923 our estimated population was 586.

There are documented environmental problems associated with this heap-leach method. The leach pad's plastic lining, on which pulverized material is dumped, eventually tears from trucks driving over it. The cyanide seeps through the tears into the soil. Eventually it reaches groundwater. The danger is both immediate and long-term. Other materials in the pulverized heap become more susceptible to leaching and erosion. The heavy metals in them, such as arsenic, copper, lead, and zinc, disintegrate easier and faster because they are no longer embedded in a solid form. As they erode, they drain downward when it rains. This is the real danger. When these drainages meet with sulfur-bearing minerals and air, they form sulfuric acid. Like acid rain, these runoffs kill fish and other living things.

Current monitoring of leach-pad drainage, open pits, waste rock, and tailings sites is inadequate and underfunded. Indeed, the state

authorities and others responsible for monitoring the discharge from mines often cite budget cuts as the reason for not determining how dangerous these drainage areas actually are. It is difficult for the Indian people themselves to conduct tests because we lack the resources and equipment to do so. We are not a big mining company with great resources. We are only ordinary citizens, mostly unemployed, who have not been trained in such things. Periodically others have come to our assistance, but the test results have been sporadic and may vary drastically with changing weather conditions. The areas adjacent to the mining debris contain no vegetation and nothing lives in the water. But a little farther down the creek, the setting may appear unchanged and natural. A high level of concern is difficult when everything seems normal to the observer.

Long after the West was settled, mining still continues under the mining act of 1872. Now, 128 years later, conditions have changed. Nineteenth-century surface mining and hydraulic placer techniques have given way to open-pit mining and cyanide heap leaching. The new methods destroy the landscape and the purity of the water. Today a number of concerned organizations and individuals are objecting to the provisions of the General Mining Law of 1872, which applies to an estimated 752 patents and 1,346 mining claims on 432 million acres of publicly-owned land in the western United States. Among these organizations is the National Wildlife Federation, whose 1997 publication "A Primer on the Mining Law of 1872" cites the following facts:

- Mining claims within National Parks, National Wildlife Refuges, Wild and Scenic River areas, and wilderness areas are still considered valid, so long as they were made before the boundaries of these areas were established. An estimated 752 patents and 1,346 mining claims exist within parks today.
- Mining companies pay no rent, severance tax, or royalty for mineral extraction; they can lease

their claims to other miners and collect royalties.

- Claim holders are required to pay only a $250 application fee, a $10 filing fee, and a $100 annual maintenance fee. These fees do not even cover the costs of issuing the documents.
- The law does not allow the federal government to determine when mining is an inappropriate use of public lands, nor does it address the impact of mining on the environment or require that the areas affected by mining be reclaimed after operations have ceased.

The agencies that administer public land, the Bureau of Land Management and the Forest Service, have inadequate regulations for environmental protection and reclamation; they generally defer to the policies implemented by state governments. In 1988 the General Accounting Office estimated that 232,000 acres needed to be reclaimed as a result of mining; and that over 235 million dollars were needed for reclamation. That was more than ten years ago.

The last great danger of hard-rock mining is the removal of a mountain made by God. It is like removing the sky and the clouds. All these things form a part of our universe, and they form a balance with each other, and with us. Without them we are incomplete. It is a tragedy that these sacred mountains and Giant Turtle, the Earth have been violated. They have a close association with our Maker, the One Above, the Great Spirit, with God. The most important way to communicate with the One Above and to become a man in our world is through a vision quest, which always takes place on a mountain. The questor climbs a prominent butte or mountain and fashions the rocks around him to build a "nest." With his pipe, tobacco, and buffalo robe, he fasts for four days and nights, praying to God and contemplating his life and the universe. Having some understanding of the nature of the American Indian's spiritual mind, I am certain that all the peaks in the Little Rocky Mountains have been fasted upon during a vision quest at one time or another. Just because the oral tradition of the Indian does not record the names of the mountains upon which they fasted does not mean they did not pray on them. All of these mountains are sacred and they are being removed for gold.

THE CHILDREN

I traveled down the mountain road, saddened by historical events that I live with, that haunt my people. Driving off the main road, I did eventually find my grandchildren. They were happily splashing away in a pond, oblivious to everything except being children.

Later, after talking with my wife, and after carefully looking at a map, I realized something. I found that the waters of the north fork, the middle and south fork, as well as South Big Horn Creek and King Creek, all eventually come together in Little Peoples Creek. King Creek begins at the foot of the Gold Bug Butte mine waste. Aided by gravity, the dissolved poisons flow downward to our reservation, past the Powwow grounds, the Sundance grounds, down the canyon, and into the ponds—where my grandchildren play.

The remnants of our two sacred mountains can still be seen in the Little Rocky Mountains. But how can a mountain that has been ravished by open-pit mining be reclaimed? Perhaps by throwing grass seed in the holes that remain.

As Giant Turtle approaches the new millennium, a point in our history is marked—the perfect time to pause, look back at our values, mining laws, policies, and actions and honestly evaluate what has been done. We must realize that our world is finite, our resources have limitations. What may have been acceptable for one era may not best serve another. But we must make changes for the future. Let's do it now; it means changing mining laws...and leaving our Earth to the school children.

Our tribal population—those living on or near the reservation with one-quarter or more A'aninin blood—is now 3,088.

Montserrat: After the Volcano

LYDIA PULSIPHER

Seven a.m. and it was already hot on this July morning in 1998. Ash suspended in the air cast a yellow haze across the island as heavier gray particles settled silently around us. We walked quickly from our car to the forest edge and dropped into a ravine and onto a trail, hoping the dense canopy of foliage would give us some relief from the heat and ash. Two friends and I were checking out what damage the island's recent volcanic eruptions might have done to the lush vegetation in Soldier Ghaut, a narrow valley extending north out of Montserrat's Centre Hills.

It was my first visit since 1980 to Soldier Ghaut. At that time I was studying the practices of small-plot horticulturalists who raised subsistence crops on the steep terraced slopes of ghauts, or ravines. Since then my research on Montserrat's cultural ecology had shifted from the north to the south part of the island. But I remembered the valley as being thick with *Heliconia* blossoms and fruit trees— avocado, cacao, mamey apple, cashew, and mango—and dressed in a hundred shades of green. On this morning in 1998, only the newest leaves unfurling in the morning dew are bright green, while the *Heliconia* blossoms are stuffed with dark gray ash. Despite its ghostly appearance, the forest in this ghaut is more or less intact—a contrast to places in the island's southern mountains that had been laid bare by more than three years of volcanic activity.

Montserrat is a 39-square-mile tropical island in the Eastern Caribbean. It is part of a volcanic arc that follows the edge of the Caribbean tectonic plate, which is slowly overriding the North and South American plates. This geological confrontation, which created Montserrat and most of the islands in the chain, today produces nearly continuous low-level seismic

activity, periodic major earthquakes, and volcanic eruptions throughout the region. Although Montserratians were vaguely aware of their island's volcanic origins and were used to frequent mild earthquakes, they had always thought the island's few fumaroles, soufrières, and hot springs were simply dying gasps from a volcanic past.

In 1995, however, Montserrat's then highest mountain, Chances Peak, unexpectedly sprang to life. Since then volcanic explosions, ash falls, and fast-moving flows of hot ash, gas, and rocks have destroyed or rendered unsafe two-thirds of the island's formerly habitable landscape. More than half of the population has left the island, and the remaining 4,500 Montserratians have relocated their homes and businesses to the island's northern hills, the only area thought to be out of the volcano's reach.

Even if the current episodes of volcanic activity cease, the main towns and rural landscapes where most Montserratians lived will be uninhabitable for decades to come. Much of this land is a barren and hot wasteland.

Heavy rains on the unstable volcanic deposits can trigger dangerous floods, mudflows, and avalanches. Every step down a trail or a road sends up a dervish of swirling ash that stings your eyes and catches in your throat. Ash corrodes metal, clogs gutters, scratches windshields, and leaves a gritty film everywhere, even on papers deep inside your briefcase. And on days when the volcano spews stones, Montserratians don government-issued helmets as they go about the task of rebuilding their lives.

Ironically, Montserratians have long used the materials that have been produced by the island's three volcanoes as they cycle between periods of activity and repose. Mineral-rich ash deposited by ancient eruptions was transformed by time into the fertile soils on which the people have grown the island's prolific gardens of flowers, vegetables, and fruit trees. Sulfur crystals welling up in bubbling fumaroles can be gathered, pulverized, and mixed with cocoa butter to form a healing salve. Hot springs provide natural baths to soothe arthritis and other joint complaints. Boulders flung onto the

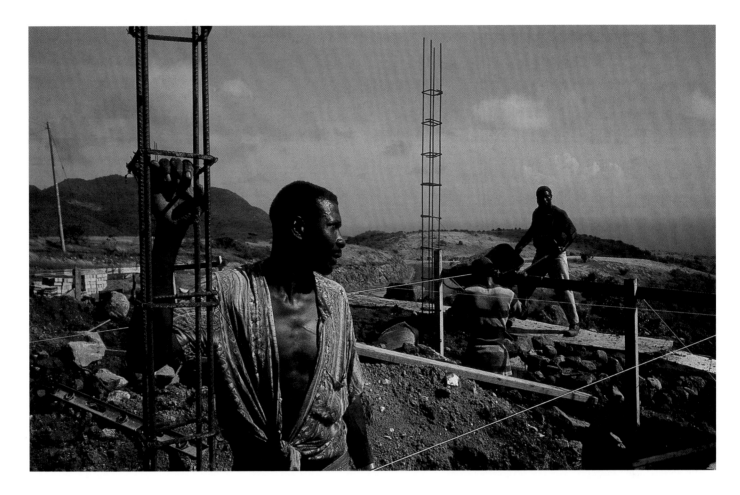

landscape by some long-ago volcanic event are now yard stones. Families often build houses around a group of these boulders, using them as perches for people gathered for a meal or a confab. Most of the masonry buildings in Montserrat are in one way or another made from the island's volcanic materials—stones, sands, gravels, and a cementlike material known as *terass*.

Now it appears that the millions of tons of ash deposited by Montserrat's recent volcanism may also have practical and economic value. Resourceful islanders are pursuing the possibility of mining and selling this ash and turning a persistent nuisance into a sustainable industry. It is hoped that the ash, mixed with cement, can substitute for sand (always in short supply on Caribbean

islands) to produce a lightweight, heat-resistant concrete block. Harvesting ash for building sand could also alleviate the harmful environmental effects of mining beaches, a damaging practice that has been difficult to control.

As Montserratians try to rebuild their economy and their lives, they do so without knowing exactly what the volcano will do. Eruptions and other activity are likely to continue, but how big, how often, and for how long? On a timescale that humans can comprehend, life on Montserrat will never be the same. But on nature's clock, what are now wastelands of ash and rock will become once again the kind of lush fertile landscape that we were so reassured to find surviving in Soldier Ghaut.

Following repeated volcanic eruptions in the south, workers rebuild their lives and island in the north, using prefabricated housing. Explosions of steam, gas, and rocks claimed 20 lives; and the intermittent rain of debris forced thousands to abandon their homes. Unaware of the centuries-old threat from the volcano, settlers had built in the fertile south. When eruptions began in 1995, continuing for more than four years, about two-thirds of the population left the island, at least temporarily; others swarmed into the sparsely populated north. Now the southern part of the island is off-limits, due to the dangers of pyroclastic flows and possible future eruptions.

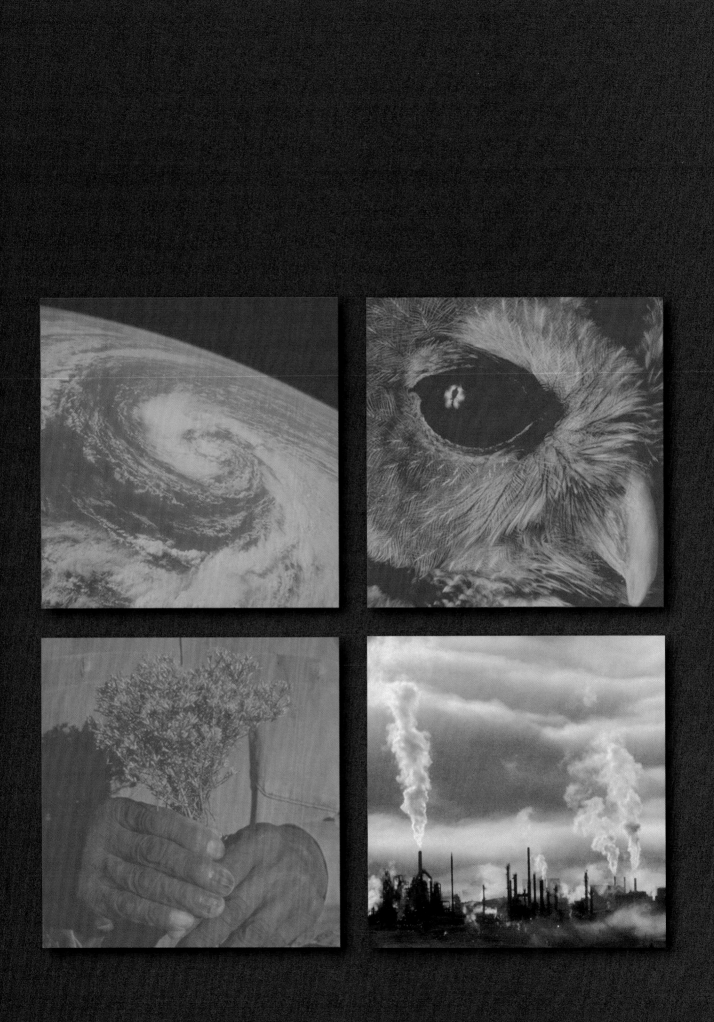

Changing Views

"Prediction is extremely difficult," wrote the physicist Niels Bohr, " espe-

cially about the future." Today many predictions about the future of

nature and our society warn of the catastrophic changes that may soon

engulf us. The issues are complex, and perspectives vary; the impact of

human beings on natural systems is without precedent in the history

of our planet. We must learn to live on the Earth in ways that are sus-

tainable and can accommodate the changes inherent in the natural

world. To do this, we will need new approaches to scientific questions,

new ideas about economic value, and, ultimately, new views of nature.

Biodiversity and Happiness

Gretchen C. Daily

IT IS EASY TO FORGET THAT EVEN IN THE 21ST CENTURY HUMAN SOCIETIES ARE SUSTAINED BY NATURAL ECOSYSTEMS, OFTEN IN WAYS NOT COMPLETELY UNDERSTOOD. WE NEED TO FIND NEW METHODS OF ACCOUNTING FOR THE SERVICES NATURE PROVIDES, BEYOND THE USUAL ECONOMIC INDEXES. WHAT WE TAKE FOR GRANTED TODAY, WE MAY LOSE TOMORROW.

My dad says that the key to happiness in life is making sure you can always see something good on the horizon—being able to imagine with excitement an upcoming event and open possibilities for the future. When I was a child, the horizon was defined by the school year's end and the time remaining until our family's summer vacation at Fallen Leaf Lake. All year long I would dream of getting ice cream from the little store down at the end of the lake, of taking a boat over glassy, smooth water in the early morning hours, and of how many crawdads I'd catch with a piece of Italian salami. Things didn't always work out as expected, but the mishaps were relatively minor and bonded the family together. With pangs of nostalgia, we still tell and retell stories about "the year we hiked into a hornet's nest," "the year the boat sank," and "the year Mrs. G.'s bathing-suit top flew off while she was waterskiing." Summers—the horizon—seemed to radiate with unplanned possibilities and adventure, which I enthusiastically looked forward to each year. When I was older, my family moved to Europe and the horizon took on new, broader dimensions. During school breaks we'd pack up the rusty old Volvo and strike out to explore new territory with little more than a road map and an English-something dictionary in hand.

Now—like most people's, I'm sure—my sense of well-being is quite sensitively tuned to the time horizon. It's nice to glance up from a busy day's work and feel a tinge of excitement for plans ahead: a cool evening run in the hills; a reunion with a good friend. While one's individual fate is inherently somewhat unpredictable, key to peace of mind is a feeling of assurance and optimism that good things lie ahead.

In this respect, something unsettling is happening: For those watching nature's horizon closely, both assurance and optimism are fading. For most of human history people lived as their great-grandparents had lived; the horizon changed slowly, and the landscape itself remained essentially fixed. Today the very realm of possibilities is changing so quickly that, even within one human lifetime, it is difficult to plot an imaginary course into the future. And optimism is diminishing: So many of today's changes seem to be in the wrong direction. The widespread faith that each successive generation would enjoy greater prosperity has, until recently, characterized life in America. Yet while U.S.

Eighteenth-century naturalist Joseph Banks collected beetles, seeking to learn both the range of species and how they related to each other.

per-capita income was doubling between 1957 and 1992, the proportion of people reporting that they were "very happy" actually declined from thirty-five to thirty-two percent. Although the decline might not be significant, there was certainly no increase associated with economic growth. Similarly, the Fordham Institute for Innovation in Social Policy calculated that, though real incomes increased by more than a third between 1970 and 1994, the Index of Social Health declined by 50 percent during the same period. Cherished aspects of the American Dream—like summer vacations on a pristine lake—seem to be receding from the reach of many. Contributing to such trends are profound environmental transformations that compromise the natural basis upon which economic prosperity depends. Nonetheless, there are promising signs on the horizon that indicate how we can better direct the course of these changes.

HUMANITY AS A FORCE OF CHANGE

I suppose that ever since human beings evolved, people have been pondering what it is that makes us unique. Certainly philosophers, religious leaders, poets, and plenty of ordinary people have had something to say about the topic. Some have extolled our virtues, proposing as unique our extraordinary intelligence; our development and use of tools; our complex communication systems, intricate social organization, intense feelings of love, and heroic acts of loyalty and altruism. Others, lamenting our fall from grace, have pointed to betrayal, infanticide, and our genocidal tendencies. With deepening understanding of the natural world, we have come to appreciate that other organisms have beaten us on all of these traits; although we might stand out in some degree, we aren't the evolutionary superstar we thought we were.

What does distinguish our species from all the others today, though, is the impact we have on the planet: *Homo sapiens* is one of perhaps 30 million species on Earth, yet it controls a disproportionate and rapidly growing share of the planet's resources.

The human population numbered only about five million at the dawn of agriculture and grew very, very slowly over virtually all of human history to reach a billion people around 1800. Since then billions have been added, in record time: in only 123 years, the second billion was added; in 33 years, the third; then in 14 and 13 years, the fourth and fifth billion. By the turn of the 20th century, in a mere 12 years, the population on Earth reached six billion. With the force of sheer numbers come other impacts unrivaled by any other species. Humans beings have:

- massively altered the biogeochemical cycles of major elements such as carbon, nitrogen, and sulfur, with dramatic changes in the chemical composition of the atmosphere, water, and soils.
- transformed minerals such as coal, oil, and metal ores from Earth's crust at rates that rival or exceed geological rates.
- annually dispersed millions of tons of synthetic chemicals while introducing 1,000 new ones per year to the approximately 100,000 now in the environment.
- converted vast tracts of diverse natural forest and grassland to uniform, managed forest, pasture, and food crops, greatly contracting the range of most wild species.
- inadvertently transferred species around the world while blocking (with highways, farm fields, and suburban sprawl) natural processes of dispersal.

Among the potential consequences of these impacts are the decline in sperm counts in humans and disruption of the reproductive systems of many other species; rapid climate change threatening food production, access to fresh water, and the security of low-lying coastal areas; and a mass extinction comparable to that in which the dinosaurs were wiped out. Humanity has unwittingly changed virtually every cubic centimeter of the biosphere.

As dramatic as these changes are, we cannot see most of them with the naked eye. Without the

aid of scientific instrumentation, complex analysis, and computer graphical display, one cannot grasp the enormity of these changes to the planet and to life on Earth—that is, the great impact on all life forms set in motion when we migrated out of our African homeland, perhaps just 50,000 years ago, and into virtually every other environment on the planet.

And what we can't see, we tend to ignore. Stanford biologist Paul Ehrlich likes to point out that, as sight-oriented creatures, we tend to be more disturbed by roadside litter than by much more serious, long-range threats to our health, homes, and our children's lives, such as pesticide residues on food, contamination of drinking water, and other carcinogens in our immediate environment. If we tasted our way through life, as many organisms do, we'd have a keener sense of the environmental changes going on around us than we do with our big eyes and dull chemosensory abilities. Adding to our sensory limitations and biases, we seem more inclined to point our technological innovations and powers toward the heavens than toward our earthly surroundings. As Oxford biologist Robert May has noted, "Our catalogues of stars are more complete (by any reasonable measure), and vastly better funded, than catalogues of Earth's biota."

BIODIVERSITY AND SURVIVAL

What do we know about the richness of Earth's biota and changes therein? Let's start by defining biodiversity: it is the full variety of life at all levels of organization, from variation in the molecular sequences of genes to that among distinct populations of a species to that among whole ecosystems, such as rain forests and arctic tundra. Although debates still rage over the precise definition of a species, out of convenience and often necessity, biologists tend to focus on the species level when characterizing biodiversity. Diversity at the other levels is extremely important, both scientifically and economically, but is much more difficult still to quantify.

DUPLICATING DIVERSITY

In a sealed Kennedy Space Center chamber, scientists attempt to grow crops in a hydroponic environment with carefully monitored levels of nourishment, water, and oxygen. Their work, aimed at developing space-bound agriculture, demonstrates how difficult it is to artificially duplicate the delicate self-perpetuating biosphere that envelops planet Earth.

To date, taxonomists have named about 1.8 million species; yet even a simple statistic like this is not certain because there is no central species catalog, and different museums are often found to have the same species registered under different names. Nonetheless, this 1.8 million must be seen as a very conservative number. Only a small fraction of Earth's tiniest creatures—insects, arachnids, crustaceans, fungi, microorganisms, and so on—are known, in spite of their paramount roles in running the show on Earth. Even in the best known groups (those that are the easiest to see, and the warmest and cutest among them such as birds and mammals), new discoveries continue to be made—about two to three new bird species per year and about one new mammal genus (typically containing several species) per year. So what's the grand total?

 Not everything that can be counted counts, and not everything that counts can be counted.

ALBERT EINSTEIN

Estimates range from a conservative 7 million to a bold 80 million species; yet most methods of extrapolation (which ignore a myriad of micro-organisms) yield estimates toward the lower end of this range.

But today our activities threaten to drive Earth's biological diversity to its lowest level in human history. Harvard biologist E. O. Wilson calls this the folly our descendants are least likely to forgive us. Biodiversity was at its highest level in the history of life when human beings first appeared on Earth. Of course, species have always come and gone—no one is here forever—but today extinction rates are thought to be at least a hundred to a thousand times faster than natural 'background' rates. In the past 2,000 years, 20 percent of Earth's bird species were driven to extinction by human activities. Of the extant fauna of today, 11 percent of birds, 25 percent of mammals, 20 percent of reptiles, 25 percent of amphibians, and 34 percent of fish appear to be on the brink of extinction. A conservative estimate of the rate of species loss globally is around three per hour. This corresponds to an estimated loss of 2,700 distinct populations per hour, according to Stanford biologist Jennifer Hughes and colleagues. The rate of loss for populations is much higher than the rate of loss for species because species typically lose many populations over an extended period of time before disappearing entirely from the face of Earth. Lion populations, for instance, once inhabited land from Africa to the Indian subcontinent, but today they are restricted to a tiny fraction of their original range, mostly to a few game reserves in Africa. Population diversity begins to erode long before the very last individual of a species perishes.

NATURE'S SERVICES

What are the societal consequences of extinction? I find it helpful to begin thinking about the importance of Earth's biodiversity by way of a thought experiment, proposed originally by Harvard physicist John Holdren. Imagine that a year from today, you will step into a spaceship and embark on a one-way trip to the moon. Let's assume for the sake of argument that the moon, miraculously, already has some of the basic conditions for supporting human life, such as an atmosphere, a climate, and a physical soil structure similar to that on Earth. After coaxing your family and friends into coming along, and packing your prized possessions, the big question would be: Of all of Earth's millions of species, which would you need to make the sterile moonscape habitable?

You could first choose from among all the species on Earth used directly in food, drink, spices, fiber, timber, pharmaceuticals, and industrial products such as waxes, rubber, fragrances, and oils. Oxford biologist Norman Myers has made a wonderful catalogue of these. Even being selective, this list could amount to hundreds or even thousands of species—and you still would not have begun considering the species needed to support and maintain life: the bacteria, fungi, and invertebrates that recycle wastes and maintain soil fertility; the insects, bats, and birds that pollinate flowers; and the herbs, shrubs, and trees that hold soil in place, nourish animals, and help control the gaseous composition of the atmosphere that influences Earth's climate. No one knows exactly how many species, nor which combinations, would be required to support human life. So rather than listing individual species, you would do better to sketch out the life-support services required for survival on your lunar colony. A partial list of the necessary services would include:

- production of a wide variety of ecosystem goods such as seafood, timber, forage, and many pharmaceuticals
- purification of air and water
- protection against natural disasters such as flood and drought
- detoxification and decomposition of wastes and cycling of nutrients
- generation and preservation of soils and renewal of their fertility

- pollination of crops and natural vegetation
- dispersal of seeds
- control of the vast majority of agricultural pests
- maintenance of biodiversity
- protection from the sun's harmful ultraviolet rays
- partial stabilization of climate
- provision of aesthetic beauty and intellectual stimulation.

These benefits, collectively called ecosystem services, are the conditions and processes through which natural ecosystems, and the species that are a part of them, sustain and fulfill human life. Selecting the species to bring with you to supply these services is not a task you'd want to defer until your last Sunday afternoon on Earth. Take soil fertility as an example. Soil organisms play crucial roles in maintaining soil fertility, and all higher plants (including croplands, gardens, beautiful landscapes) depend on them. The abundance of soil organisms is absolutely staggering: under a square yard of pasture in Denmark, for instance, just the top two inches of soil was found to be inhabited by roughly 50,000 small earthworms and their relatives, 50,000 insects and mites, and nearly 12 million roundworms. Just before the scientists cataloguing this stuff went blind, they decided to take a close look at the microorganisms in a pinch (one gram) of this soil. In it they found an estimated 30,000 protozoa, 50,000 algae, 400,000 fungi, and billions of individual bacteria of unknown numbers of species. Which should you choose to bring to the moon?

The task is not necessarily easier in the case of known species—those that have been given names. The species name on its own is no more helpful than a company name in the white pages of a phone book. Without the yellow pages—some minimal information on what these species do, with whom and how they interact—you would have little way of judging whether you were bringing on board a tree adapted to hot and dry or to cool and moist conditions; a tasty crop or a noxious weed; a

valuable insect pollinator or a vector of disease. Even with a year to plan the trip, packing would be difficult! Think of pollination services, for instance. Pollinators are important for the production of more than 150 food crops in the United States, ranging from almonds, apples, and alfalfa to melons, plums, and squashes. Considering the proportions in which these crops are consumed, Steve Buchmann of the USDA-ARS Carl Hayden Bee Research Center and Gary Nabhan of the Arizona Sonora Desert Museum estimate that about one in three mouthfuls of food is produced with the aid of animal pollinators. But there are over 100,000 known pollinator species, each with its own special capabilities and requirements: different kinds of bats, bees, beetles, birds, butterflies, flies, and so on. Which to bring to the moon?

The same difficulty pertains in pest control. About 25 to 50 percent of the world's crop production is destroyed by pests annually; fortunately, an estimated 99 percent of potential crop pests are controlled by natural enemies. But here again, knowing who the combatants are, which pest enemy is going for which pest, is crucial. Because of the deleterious effects of chemical pesticides, scientists are in search of better natural pest management (biocontrol) and are just beginning to identify and understand the players and their interactions. For life on the moon, these considerations add up to an argument for insurance: you would probably want to bring more species with you than the bare minimum.

The closest attempt to carry out our life-on-the-moon experiment on Earth was the first Biosphere II. In this experiment, a facility constructed on 3.15 acres in Arizona sealed off its inhabitants as much as possible from the outside world. Eight people were meant to live inside for two years without the transfer of materials in or out. The system was fueled with sunlight (through transparent walls) and electricity (at a cost of approximately a million dollars per year). As in the lunar colony, the experimenters had to decide which species should populate the closed ecosystem.

Continued on page 236

DUSTED
Airplanes spraying insecticides over Fort
Meyers, Florida, suppress the unwanted
mosquito population. But they also kill
butterflies and other insects that have
positive effects on the area's plants and
wildlife.

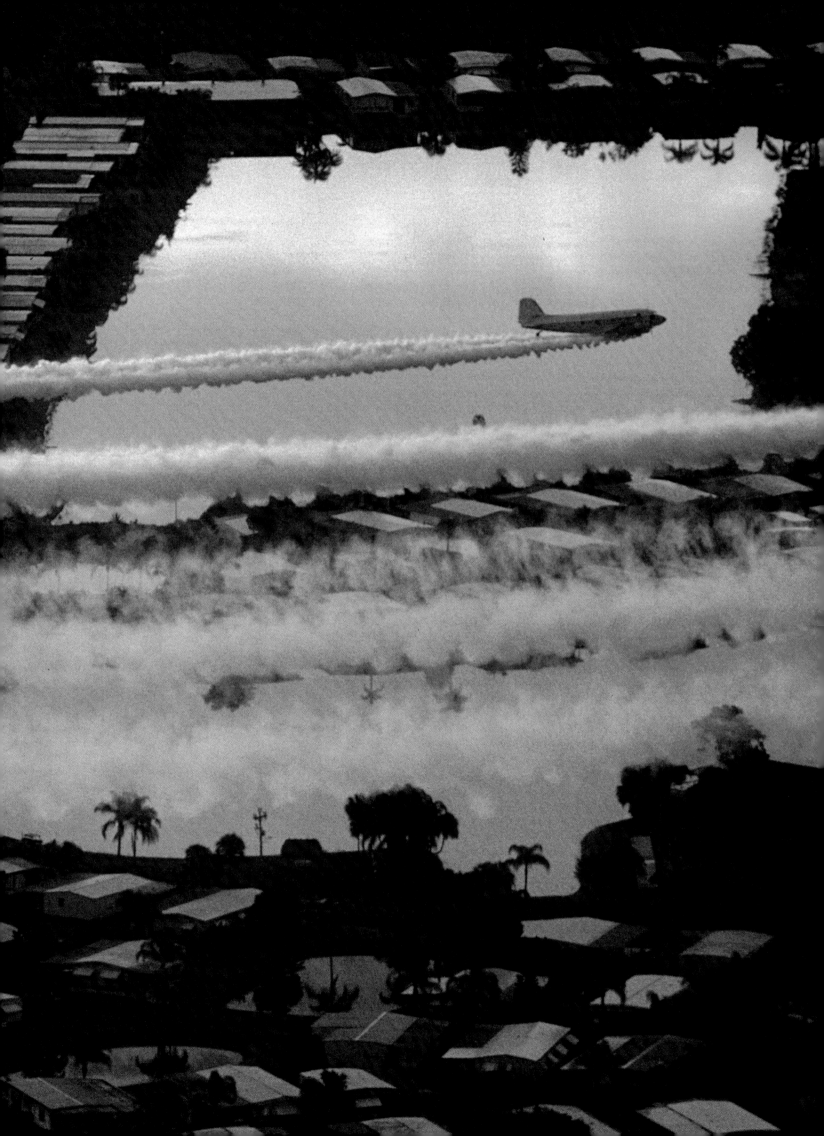

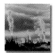

A hidden connection is stronger than an obvious one.

—HERACLITUS

Continued from page 231

Rather than fret over soil organisms, they simply hauled in tons of rich California soil and with it, they hoped, a wide array of fungi, arthropods, worms, and microorganisms. Then they added groups of other animals and plants. At the start, Biosphere II featured agricultural land as well as elements from an ambitious variety of natural ecosystems such as tropical forest, savanna, marshland, desert, and even a miniature ocean with a miniature coral reef.

In spite of an investment of 200 million dollars in the design, construction, and operation of this model earth, Biosphere II proved unable to supply the material and physical needs for the survival of the eight Biospherians. To put it mildly, many unexpected and unpleasant problems arose:

- oxygen concentration dropped from 21 to 14 percent (a level normally found at 17,500-foot elevations) and carbon dioxide levels skyrocketed with large daily and seasonal fluctuations, making it very difficult for the Biospherians to breathe
- nitrous oxide concentrations rose to levels at which brain function can be impaired
- 19 of 25 vertebrate species rapidly became extinct
- all pollinators rapidly became extinct, thereby dooming to eventual extinction the majority of the plant species
- there were population explosions of crazy ants and overgrowth of areas by aggressive vines and algal mats
- water purification systems failed

Ecosystem services operate on such a grand scale, and in such intricate and little explored ways, that most cannot be replaced on the scale required by innovation and technology. The bottom line of the Biosphere II experiment is that there exists no demonstrated alternative to maintaining the viability of Biosphere I—our Earth.

For millions or billions of years before humanity came into being, interdependent ecosystem services have been supporting and sustaining a biologically diverse Earth. It is easy to overlook the intricate connections between ecosystems, and easy to take them for granted. Disrupting them beyond repair has been a long-range outcome that, until the late 20th century, was unfathomable. Yet destructive impacts of human activities on natural ecosystems have escalated and globally imperiled biodiversity and ecosystem service delivery: Pollination, pest control, water purification, flood- and erosion-control services have all been seriously impaired, often at great economic cost.

VALUING NATURAL CAPITAL

How do we begin the task of protecting the ecosystems that provide us with these services? First, we must recognize that natural ecosystems and their biodiversity are capital assets which, if properly managed, will yield important life-support benefits over time. A forest ecosystem, for instance, may supply water purification, flood control, pest control, and other services along with the production of goods such as timber and pharmaceutical products. Relative to physical capital (buildings, equipment, etc.), human capital (skills, knowledge, health), or financial capital (readily tradeable assets in a growing array of forms), natural capital is poorly understood, little valued, scarcely monitored, and undergoing rapid depletion. Up until now, there has been little incentive to measure or manage natural capital. It has been treated as essentially inexhaustible.

Sustainable management of ecosystem services will require an innovative approach. To begin, we need to identify ecosystems' basic components—their service networks—so that we know what is in Earth's ecosystem yellow pages. Next, we need to understand how the services operate on different levels—physical, biological, economic, and cultural. And, finally, we need to establish financial mechanisms and social institutions to monitor and safeguard them.

Characterizing ecosystem assets thus involves an explicit cataloging of important services at a variety of scales. At the broadest level, it addresses these questions: Which ecosystems supply what services? For a given location, which are supplied locally, which are imported from elsewhere, and which are exported? Characterization involves finding answers to other questions as well, such as:

- What is the impact of alternative human activities (e.g., agriculture, forestry, industry) on the supply of services?
- How interdependent are the services? How does exploiting or damaging one influence the functioning of the others?
- To what extent, and over what time scale, are the services amenable to repair?
- Where do critical thresholds lie?
- How effectively, and at how large a scale, can existing or foreseeable technologies substitute for ecosystem services?
- What would be the social benefits and costs of managing ecosystem assets (e.g., land and water) in different ways?
- Given the current state of technology and scale of the human enterprise, how much natural habitat and biodiversity are required to sustain the delivery of ecosystem services locally, regionally, and globally?

Finally, characterization involves assigning some measure of importance, or value, to the services that are supplying benefits to society. Be it biological, aesthetic, or spiritual, no general, widely applicable methodology for doing this exists. It is important to emphasize that for the diverse human cultures across the globe, different types of services will require different valuation approaches. More important than valuation itself, however, is the development of institutions that will safeguard ecosystem services into the next millennium and beyond by rewarding their stewards.

Around the world, unique ways of capturing ecosystem service values, and rewarding economically those who safeguard them, are appearing. In parts of Zimbabwe, cattle ranchers are now finding ecotourism so lucrative that it pays to remove their livestock (and no cattleman does this lightly!) and to reestablish native game and other wildlife on their land for safari purposes. In Napa Valley, California, local residents are dismantling failed hydroengineering structures and returning to natural flood-control mechanisms of the river— that is, natural wetland areas. In the wheat belt of western Australia, farmers are restoring some farm fields to native habitat because they find this to be the most profitable way of restoring the hydrological balance on the cultivated land; this balance is maintained by deeply rooted native plants that keep destructive salts below the rooting zone of the wheat. In Costa Rica, a large orange-juice company is purchasing the local ecosystem services it needs (water supply, pest control, pollination, and orange peel disposal) from a natural protected area near the company. In Vietnam, community education and development projects have resulted in sustainable harvest of goods and services from a forest reserve that had been undergoing rapid degradation. And, finally, there is renewed interest in the diverse array of social institutions created by local indigenous communities to manage sustainably the harvest of ecosystem goods and services.

We are beginning to see on the horizon a growing understanding of the interdependence of human societies on natural resources. We also see the emergence of a wide array of innovative, locally tailored approaches for capturing ecosystem service values so that our individual immediate needs are aligned with society's long-term well-being. So far these changes amount to a faint glimmer on the horizon; they are occurring on a very small scale relative to what is required. But they provide an important beacon for where we need to go. They also supply important experiments for determining what does and doesn't work for striking out into new territory and, through trial and error and hopefully a good dose of common sense and cooperation, for charting a promising course for the future.

Natural Capital—NYC's Woodland Watershed

GRETCHEN C. DAILY

New York City's water was once considered so pure and salubrious that it was bottled and sold throughout the Northeast. It came from the Catskill Mountains, about a hundred miles to the north, and owed its high quality to the natural purification system of the Catskills' streams and woodlands. But in recent years, as development increased in the Catskill area, the natural system had become degraded by sewage and agricultural runoff. The United States Environmental Protection Agency (EPA) stepped in, requiring that the city prove it could protect the watershed or face a federal order to build a filtration plant.

At first the city administrators considered building the water filtration plant, but when they found that this would cost an estimated six to eight billion dollars, plus an additional 300 million dollars each year in operating costs, they turned to an alternative solution, namely restoring and safeguarding the natural purification system of the Catskills. This meant buying land in and around the Catskill watershed, as well as subsidizing upgrades to local sewage treatment plants, improving farming practices, and setting in motion environmentally sound economic development. The estimated cost of this option was an affordable 1.5 billion dollars.

The city floated an Environmental Bond Issue to fund the watershed protection plan as a way to capture the economic and public health values of the natural asset (the watershed) and distribute them to those who took responsibility for stewardship of the asset and its services.

The Catskills supply many other valuable environmental services in addition to purifying New York City's water. Their natural habitats help control floods, mitigate the buildup of the greenhouse gas by absorbing carbon dioxide, and—perhaps above all—give people a place where they can find beauty, serenity, and spiritual inspiration. Moreover, these benefits reach many other populations—animal and otherwise—besides water consumers in New York City. It would be absurd to try to express the full ecosystem service value of the Catskills in a dollar figure. In this case, fortunately, there was no reason to try: even a conservative estimate of the value of the natural asset was sufficient to induce adoption of a conservation policy.

The challenge today is to extend this model to other communities and to other kinds of ecosystem services. The EPA recently estimated that treating, storing, and delivering safe drinking water throughout the United States over the next 20 years without the benefit of natural capital would require an investment in physical capital of 140 billion dollars. Currently, more than 140 municipalities in the U.S. are considering watershed protection as a more cost-effective option than building artificial treatment facilities. This option is especially appealing because it aligns market forces with the environment—which means that the short-term economic incentives for individuals are in accord with long-term social well-being. Indeed, there is growing interest worldwide. For example, Rio de Janeiro and Buenos Aires, both with highly threatened watersheds of enormous biotic value, are investigating this

option. Costa Rica, which derives 99 percent of its electricity from hydroelectric plants, uses water from protected watershed areas to generate electricity. In 1995 Costa Rica established a small tax on water and electricity use, the revenues from which are now recycled into managing the protected areas to limit erosion and sedimentation and to maintain high water flows. As with the Catskills, this scheme will provide numerous ancillary benefits, including flood control, biodiversity conservation, and opportunities for ecotourism.

According to Walter Reid of the World Resources Institute, there is sufficient potential for safeguarding a whole suite of economically important watershed services to justify pursuing this option in the U.S. and worldwide. Of course the feasibility of watershed protection for drinking water supply will vary by geographic region, with ecological, economic, and political circumstances. And Reid estimated that in the U.S. about three-quarters of an acre per person on average is needed to sustain a supply of safe drinking water. This amounts to ten percent of the country's land area—a significant fraction. Extrapolating his calculations to the world yields an even cruder, but nonetheless illuminating, estimate—13 percent of world land area under the current population size, and 23 percent of land area under a projected future population size of ten billion. Managing this amount of land for water purity would require a major commitment but, if done strategically, could be amply repaid in securing other critical ingredients for human well-being and economic prosperity.

New York City has long gotten most of its drinking water from sources in the distant Catskill Mountains (above), brought to the thirsty city through miles of pipelines (left). In response to new requirements in the laws governing public water supplies, the city was faced with the choice of filtering some 1.2 million gallons of drinking water each day or developing a comprehensive water-quality protection strategy. It soon became apparent that addressing the source of the problem, rather than just its symptoms, was the most economical option. The city has implemented a program of land purchase and management to restore nature's own purification system.

Afterword

Robert Fri

Natural History and the 21st Century

Living successfully in a world shaped by powerful forces of change is not easy—but then it never was. Change has been constant for more than four billion years, and the ability to cope successfully with change is what characterizes our planet and life on Earth. What is new is that humanity itself has become a profound force of change. And so the question has become whether we can manage this force—that is, our own actions, views, and policies—so that future generations will have the options they need to develop fully. Or will our generation so deplete the Earth's resources that our descendants must live poorer, more brutish lives than we?

Our preference so far has been for consumption rather than self-control. We enjoy material prosperity and the personal convenience, comfort, and choice that come with it. In its pursuit, we seek to draw from the natural world the resources that make prosperity possible. To preserve the good life, we have even learned to control our environment to compensate for, and sometimes to resist, the natural forces of change.

Humanity is a force of change that is not likely to abate any time soon. Only a few of us are really comfortable with curtailments on our acquisitiveness or are content to live simply, with minimum necessities. Most of us are not, and continue to aspire to greater prosperity. Unfortunately, the latter group is both larger and growing far more quickly than the former, and the resulting pressure on the natural world is mounting rapidly—and is believed to be unsustainable. It is this concern that is at the core of the current sustainable development debate, one that began when the World Commission on Environment and Development first introduced the term in its 1987 seminal report. The report defined sustainable development as the ability "to meet the needs of the present without compromising the ability of future generations to meet their own needs."

The notion of unsustainablity—that the planet's resources will someday run dry—is among the most venerable of policy arguments on economic development. Indeed, in his classic 1798 "Essay on the Principle of Population," the English economist and cleric

Rings painted on oak bamboo branches in Costa Rica will tell ecologists the plant's rate of growth.

Thomas Malthus advanced the first modern prediction of unsustainable development. He argued that the demand for food to support a growing population in industrializing England would ultimately outrun the available food supply. The inevitable consequence of his thesis was a population that, over the long term, could exist only at subsistence food-supply levels.

Malthus turned out to be famously wrong—though not entirely, for it is only our species that has figured out how to control nature to increase food supplies. Today people in every developed country worry more about too many rather than too few calories. Malthus, however, was not alone. For the past couple of centuries other doomsayers have issued numerous warnings that the world is running out of something—oil, food, and strategic materials are perennial favorites. So far, however, these Malthusian outcomes remain elusive. Despite occasional scares and shortages (remember the oil "crisis" of the early 1970s?) economic development has not yet hit the resources wall.

But why haven't we run out of resources yet?

Malthus overlooked technology, and technology is the reason that limited natural resources have yet to restrain economic development. Technology operates in two main ways: The first is to increase productivity, getting more output from each unit of input. Agriculture is a good example. The supply of land is fixed, as Malthus knew, but technology has increased the yield per acre beyond anything that he could have imagined. Many experts believe that agricultural productivity can continue to rise, ultimately to a level that can support the world's growing population. Technology has similarly made the finding and exploiting of virtually all mineral and energy resources increasingly efficient.

Second, technology contributes new products that meet our needs as well or better than more resource-intensive old ones. For example, aluminum replaces copper in transmitting electricity, plastics replace metal in our automobiles, and recycled steel replaces virgin material in our soda cans. Telecommuting, a product of information technology, replaces whole transportation systems in the workplace. Economic research done mainly in the last 40 years shows conclusively that such substitutions, along with increasing productivity, account for the absence of natural resource constraints on economic development.

For technology to play this role, however, people need an incentive to use it. A system for creating these incentives contributed to preventing the Malthusian prediction—that resources will run out—from being true. The system is the free market, and its prices provide the incentive. For example, when oil supplies tightened during the oil embargoes of the 1970s, the price of all forms of energy rose. Rather than devote more of their budgets to energy, however, consumers adopted more efficient patterns of energy use.

Steam, smoke, and clouds mingle in Vancouver, Canada. Similarly difficult to distinguish are civilization's effects on environment.

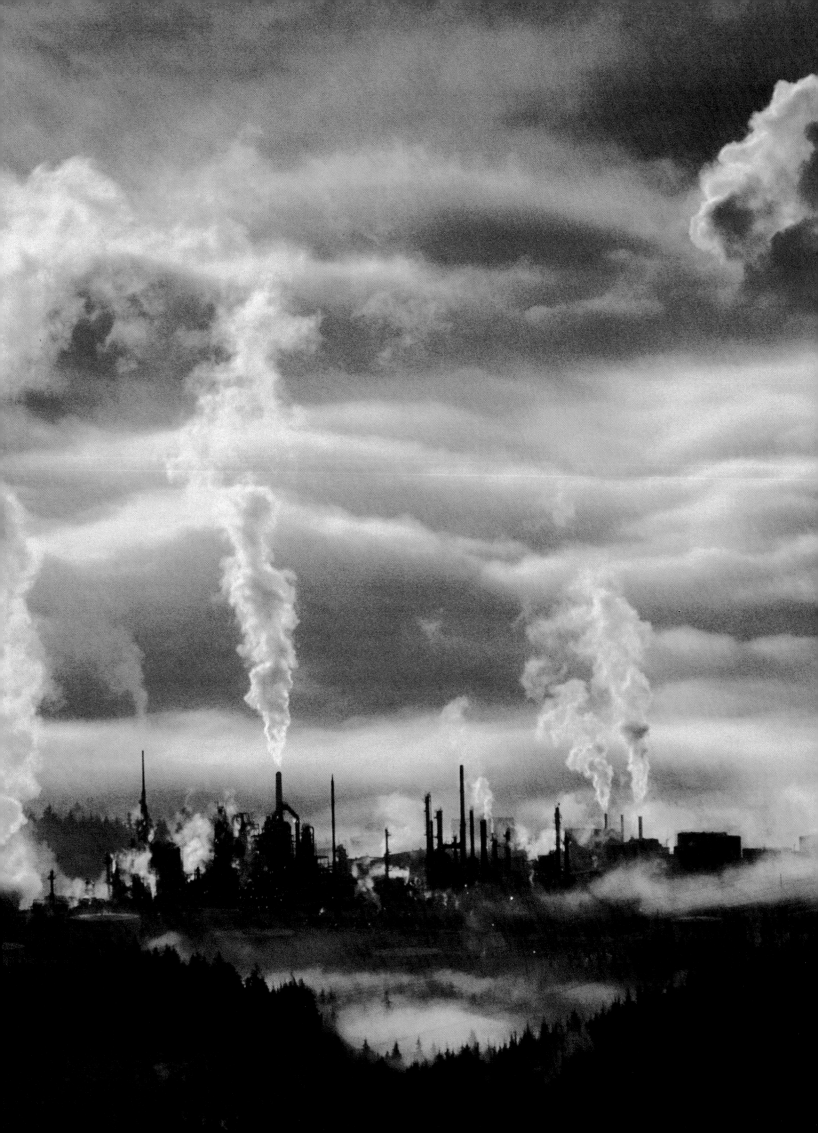

And with higher revenues, energy companies invested in new and more efficient methods of production. By the mid-1980s, energy prices returned to their long-term, downward-trending path. Most natural resources that are economic commodities—that is, are easily traded in markets—have similar histories.

The market does not work in this way for all resources, however, because an unregulated market treats some resources as free. The capacity of air and water to absorb and dissipate pollution is the most common example. This capacity is limited, and like any other limited natural resource, technology can make it more productive. Since air and water are used without cost, however, no economic incentive exists to put technology to work. To compensate, government finds ways to limit the amount of pollution that can be emitted. In response, polluters look for ways to cut emission at the lowest possible cost. In this way, government regulation creates the incentive that brings technology to bear in managing limited environmental resources.

If sustainable development only required providing economic commodities and controlling local pollution, free markets mediated by a bit of government regulation might work for the long haul. But sustainable development faces a more difficult problem. A new, enormously influential variable has been introduced: human activities that, for the first time in the history of this planet, have changed large natural systems at an observable rate. Climate, the oceans, and critical ecosystems such as tropical rain forests and coral reefs are changing at an accelerating pace. In consequence, resource management tools that have served well up until now are not likely to keep on working at this larger physical and political scale.

One problem is that of modeling large natural systems. Crafting models useful for regulating local pollution is not too difficult, but in the case of large natural systems, it's hard to see how models can reliably predict cause and effect. The systems to be modeled may be given to discontinuities, even to chaotic behavior. The historical record seems to suggest that this is so at any rate of change, making the phenomena hard to model. Moreover, the global systems of interest are in perpetual flux, and relying on models to isolate the effect of one change from all the rest is very difficult. These systemic problems, along with the considerable time scales involved in some models, seem to me to put the verification of deterministic models pretty well out of reach.

In addition, deciding how to manage natural systems at a global level introduces a whole new degree of political complexity into the balancing act. Experience shows that reaching an enforceable political consensus in international forums like the United Nations is hard enough. The difficulties of managing sustainable development, however, go deeper and are more profound than even this. Involving a great diversity of cultures brings to the consensus process an equally great diversity of values that people assign to

benefits and costs. In the case of sustainable development, this diversity can result in sharp disagreement. For example, the wealthy tend to place a great value on sustainability, while the poor are usually more interested in development. Different cultural views of the value of nature can cause other complications: Some value human dominance over nature, while others envision a more symbiotic relationship. In any case, the decision criteria seem vastly more complex than the rationalist criterion that is built into the standard policy model.

I am not trying to argue that we should abandon the notion that benefits should be weighed against costs, or that the more productive use of resources is essential to sustainability, or that marketlike incentives can powerfully induce productivity. Indeed, I believe that these policy tools will continue to provide for the sustainable use of economic commodities and environmental resources for a long time to come. But I am suggesting that these tools may have serious limitations when applied to the class of resources that I have called large natural systems.

The crucial limitation is lack of knowledge—about values, measurements, models, and consensus. In this concluding section, I therefore want to suggest some directions in which scientific research might move to provide the knowledge we need. The topics below are ones that particularly interest me as director of an institution that studies the diversity of life and culture. Others will raise additional—and possibly more useful—questions from the perspective of their own disciplines.

In any event, and in no particular order, here are five topics in which research might well produce valuable new insights for managing large natural systems and the impacts of forces of change:

Establish a way to measure ecosystem health. In 1998, at the annual meeting of the American Institute of Biological Sciences, Rita Colwell, now director of the National Science Foundation stated that "It is not enough to explore and chronicle the enormous diversity of the world's ecosystems. We must do that—but also reach beyond, to discover the complex chemical, biological, and social interactions in our planet's systems. From these subtle but very sophisticated interactions and interrelationships, we can tease out the principles of sustainability." And tapping into natural history museum collections for evidence of biological change will be an important part of this effort to establish an effective measure of ecosystem health.

Explore more efficiently for evidence of biological diversity. The diversity of living things is declining, so time is short to create inventories of it. Since speed is important scientists need to decide how to use the available time to maximize the amount of useful information they can acquire. For example, sampling strategies designed to confirm the existence (or absence) of new concentrations of biological diversity may sometimes be

more appropriate than comprehensive inventories of well-known habitats. Deciding how to conduct inventories is thus an important scientific problem.

Learn more about the functioning of large natural systems, especially the climate and the oceans. This information might improve the performance of large models, but that is not the best reason for pursuing it. Rather, this research can help scientists understand the characteristics of change in these systems—whether the behavior is chaotic or discontinuous, and the circumstances that govern this behavior. Because conducting experiments on these systems is often impossible, a study of the historical record of natural change seems a particularly important line of investigation for these issues. In fact such records, mostly held in museum collections, may be the chief source of data for verifying theories about the behavior of large natural systems.

Understand how to make nature and society more resilient to change. Since change is inevitable and even desirable, humanity should take care that its interventions do not create rigidities that make nature less adaptable to change. Some of my colleagues, notably Rick Potts, Director of Human Origins at the National Museum of Natural History, make a persuasive argument that human activity has a history of creating just such rigidities. As Potts suggests in his book *Humanity's Descent: The Consequences of Ecological Instability*, breeding plants and animals only to maximize agricultural productivity may risk making the food supply less resilient to a changing environment.

Explore how human cultures have incorporated values into societal behavior, especially values relating to nature. From such studies, policy makers might learn more about how to find common ground on the value of sustainable development. We might even find a way to encourage consensus to rise from the bottom up, which is almost always more effective than centrally imposed policy. Here again, a study of history should be instructive, especially the insights from cultural anthropology studies.

These are more than challenging questions for research. And such questions expose a critical insight—that in the sustainable development debate, science can and should shape the fundamental conceptual framework of policy. Addressing the issues that these questions bring forth requires researchers to assume a proactive role that can anticipate future problems. Science can and should lead, not follow. There can be no greater relevance of science to policy than this.

Yet another role is even more important. Whatever intellectual adventure lies ahead in meeting the new challenge of sustainable development, it seems to me crucial that scientists persistently tell the story of the natural world and of humanity's place in it. The story must be told in terms that help the public understand more fully the complexity and value of the large natural systems that sustain us. For only then can we expect the importance of sustainable development to be understood and, ultimately, implemented and practiced.

The former lives of recycled metals are hinted at in compacted bricks.

TWO BIRDS, TWO HANDS, ONE HOPE
Hands of two conservationists—one from Madagascar, one from Europe—hold two vanga birds from Madagascar, species in need of international protection. Once the island nation was called the naturalist's promised land. Now that promise is imperiled not only here, but worldwide. The course of nature is in the hands of humans, the only species with power to shape and challenge the forces of change.

Index

Illustration Credits

Cover Corbis; pg 1 Corbis; pg 3 top left Corbis; top right Joel Sartore; bottom left Joanna B. Pinneo; bottom right G.V. Faint/Image Bank; pg 4 Corbis; pg 5 top Joel Sartore; pg 6 center Joanna B. Pinneo; pg 6 bottom G.V. Faint/Image Bank; pg 6-7 NASA; pg 8-9 Frans Lanting; pg 10-11 Chris Johns; pg 12-13 Gerd Ludwig; pg 14 George F. Mobley; pg 17 William Andrews Clark Memorial Library, University of California at Los Angeles; pg 20 NASA; pg 23 Frans Lanting; pg 25 top Jim Brandenburg/Minden Pictures; pg 25 bottom Sarah Leen; pg 29 Alan & Sandy Carey.

PART ONE

pg 30 top left Corbis; top right Joel Sartore; bottom left Joanna B. Pinneo; bottom right G.V. Faint/Image Bank; pg 32 David Coulson; pg 35 top George F. Mobley; pg 35 bottom Maria Stenzel; pg 36-7 Victoria Sayer, Ventura County Star; pg 38 Corbis; pg 41 top Jodi Cobb; pg 41 bottom Library of Congress; pg 42-3 Joanna B. Pinneo; pg 45 top Luiz C. Marigo/Peter Arnold; pg 45 bottom Mike Yamashita; pg 46 Peter Essick; pg 49 both Mike Yamashita; pg 51 top David Leeson/Dallas Morning News; pg 51 bottom James C. Richardson; pg 52-3 Jay Dickman; pg 54-5 Peter Essick; pg 57 left Nashua River Watershed Association; pg 57 right George Steinmetz; pg 59 Skip Brown; pg 60 NASA; pg 62 Virginia Beehan & Laura McPhee; pg 65 Virginia Beehan & Laura McPhee; pg 66-7 Virginia Beehan & Laura McPhee; pg 68-9 Virginia Beehan & Laura McPhee; pg 70-1 Virginia Beehan & Laura McPhee; pg 72 Virginia Beehan & Laura McPhee; pg 73 Virginia Beehan & Laura McPhee; pg 74-5 Virginia Beehan & Laura McPhee; pg 76 Virginia Beehan & Laura McPhee; pg 78 Michael Quearry/Bruce Hunter; pg 81 Dr. Darlyne A. Murawski; pg 82-3 Joseph Rodriquez; pg 84-5 James D. Balog; pg 86 Corbis; pg 89 Robert Winslow/Earth Scenes; pg 91 top Kenneth Garrett; pg 91 bottom Index Stock Photography.

PART TWO

pg 92 top left Corbis; top right Joel Sartore; bottom left Joanna B. Pinneo; bottom right G.V. Faint/Image Bank; pg 94 O. Louis Mazzatenta; pg 96 Joel Sartore; pg 99 Keith R. Porter/Photo Researchers; pg 100-1 R. Williams (ST Scl), NASA; pg 102-3 Adriel Heisey Photography; pg 105 Sam Abell; pg 106 Joel Sartore; pg 108-9 Jack Dykinga; pg 110 Joel Sartore; pg 113 Kenneth Garrett; pg 114 Dr. Jeremy Burgess-SPL/Photo Researchers; pg 117 A.T. Winfree; pg 118-9 George Steinmetz; pg 121 Joel Sartore; pg 123 Dr. L. Caro-SPL/Photo Researchers; pg 124 Joel Sartore; pg 127 Joel Sartore; pg 128 Lynn Margulis; pg 129 Joseph McNally; pg 130-1 David Doubilet; pg 132 Ralph Lee Hopkins; pg 134-5 David Doubilet; pg 136-7 both David Doubilet; pg 138-9 David Doubilet; pg 140-1 both David Doubilet; pg 142-3 David Doubilet; pg 144 Stephen Frink/Waterhouse; pg 146 Francois Gohier/Photo Researchers; pg 148 Joel Sartore; pg 149 top Warren Morgan; pg 149 bottom Jonathan S. Blair; pg 150-1 Sam Abell; pg 152 rt Michael K. Nichols; pg 152-3 Michael K. Nichols; pg 154 Joel Sartore; pg 156 Joel Sartore; pg 157 Jonathan S. Blair; pg 159 Chris Johns; pg 160-1 Peter Essick; pg 163 Joel Sartore.

PART THREE

pg 166 top left Corbis; top right Joel Sartore; bottom left Joanna B. Pinneo; bottom right G.V. Faint/Image Bank; pg 168 Thomas Abercrombie; pg 171 top Tammy D. Mobley; pg 171 bottom John Page, ISEC; pg 172-3 Thomas J. Abercrombie; pg 174 Joanna B. Pinneo; pg 177 Thomas J. Abercrombie; pg 179 Robert Caputo/Aurora; pg 180 Edward S. Ayensu; pg 183 both Michael & Aubine Kirtley; pg 185 top Betty Press/Woodfin Camp & Associates; pg 185 bottom Gilles Press/Magnum; pg 186 James Stanfield; pg 188 Joanna B. Pinneo; pg 191 Joanna B. Pinneo; pg 192-3 Edward Curtis; pg 195 Belinda Wright; pg 196-7 James C. Richard-

son; pg 198-9 Bruno Barbey/Magnum; pg 200 Jose Azel; pg 201 Sarah Leen; pg 202-3 Mike Yamashita; pg 204-5 Tony Heiderer; pg 206 Joel Sartore; pg 208 Edward S. Curtis Collection; pg 211 Edward S. Curtis Collection; pg 212 Joanna B. Pinneo; pg 214-5 John Smart; pg 216 Joanna B. Pinneo; pg 218-9 John Smart; pg 220 Joanna B. Pinneo; pg 223 top Vincent J. Musi/NGS Image Sales.

PART FOUR

pg 224 top left Corbis; top right Joel Sartore; bottom left Joanna B. Pinneo; bottom right G.V. Faint/Image Bank; pg 226 Cary Sol Wolinsky; pg 229 Roger Ressmeyer; pg 230 G.V. Faint/Image Bank; pg 232-3 Joel Sartore; pg 234-5 Mark W. Moffett; pg 236 G.V. Faint/Image Bank; pg 239 both Maria Stenzel; pg 240 Mark W. Moffett; pg 243 G. V. Faint/Image Bank; pg 247 Jose Azel; pg 249-50 Frans Lanting.

Contributors

Edward S. Ayensu, Ghanaian scientist, botanist, and President of the Pan-African Union for Science and Technology, is former chairman of the botany department at the Smithsonian's National Museum of Natural History.

Virginia Beahan has taught photography at Harvard University and Wellesley College. She has worked collaboratively with Laura McPhee since 1987, and is the co-author of *No Ordinary Land*.

Anna K. Behrensmeyer is a curator and paleoecologist in the department of paleobiology at the Smithsonian's National Museum of Natural History. She reconstructs ancient land ecosystems using geology, fossils, and an understanding of the processes of organic preservation (taphonomy).

Daniel B. Botkin is President and founder of the Center for the Study of the Environment in Santa Barbara, California and is a professor of biology at George Mason University in Fairfax, Virginia. He is the author of *Discordant Harmonies: A New Ecology for the Twenty-First Century,* and four other books.

Alan Cutler is a geologist and writer based in Maryland. He is a research associate at the National Museum of Natural History and scientific consultant for the Forces of Change program.

Gretchen C. Daily is the Bing Interdisciplinary Research Scientist in the department of biological sciences at Stanford University. She has published over 75 articles and 2 books, including *Nature's Services.* Her primary scientific efforts concern the future course of extinction.

David Doubilet is among the world's most accomplished underwater photographers. Since 1972, his work has beeen featured in over thirty articles for NATIONAL GEOGRAPHIC as well as numerous books.

Robert Fri is Director of the Smithsonian's National Museum of Natural History and is a senior fellow emeritus at Resources for the Future, where he served as president from 1986 to 1995.

Michael Garstang is a professor of meteorology in the department of environmental science at the University of Virginia. He specializes in tropical meteorology of the earth's surface and lower atmosphere.

Stephen Jay Gould is the Alexander Agassiz professor of zoology and professor of geology at Harvard University and the Vincent Astor visiting professor of biology at New York University.

George P. Horse Capture is special assistant for cultural resources and senior counselor to the Director of the Smithsonian's National Museum of the American Indian and is former curator of the Plains Indian Museum at the Buffalo Bill Historical Center.

William Kiene is a research collaborator in the department of paleobiology at the Smithsonian's National Museum of Natural History. He lectures on the ecology and geology of coral reefs at Yale University's School of the Environment.

Lynn Margulis is distinguished university professor in the geosciences department at the University of Massachusetts at Amherst. She is author of *Symbiosis and Cell Evolution* and co-author of *The Garden of Microbial Delights, What is Life?* and other books.

Michael Atwood Mason is a folklorist who develops anthropological exhibitions at the Smithsonian's National Museum of Natural History. He has been studying Afro-Cuban Santería since 1988.

John McPhee is a journalist and author of numerous books including *The Control of Nature.* He currently teaches at Princeton University.

Laura McPhee teaches photography at the Massachusetts College of Art and Design. She has worked collaboratively with Virginia Beahan since 1987, and is the co-author of *No Ordinary Land*.

William G. Melson is a curator and geoscientist in the department of mineral sciences at the Smithsonian's National Museum of Natural History.

Helena Norberg-Hodge is Director of the International Society for Ecology and Culture and is author of *Ancient Futures: Learning from Ladakh*.

Jonathan Overpeck is Director of the Institute for the Study of Planet Earth and a professor of geosciences at the University of Arizona.

Lydia Mihelic Pulsipher is a cultural-historical geographer at the University of Tennessee. Since 1973, she has used archeology, ethnography, and field geography in her research on the island of Montserrat.

David Quammen is author of *The Song of the Dodo* and eight other books, the most recent of which is *The Boilerplate Rhino,* a collection of essays about human perceptions of the natural world.

Dorion Sagan is the author of *Microcosmos, Biospheres,* and co-author of the forthcoming *Into the Cool: The New Thermodynamics of Creative Destruction.*

Eric D. Schneider is a former national laboratory director for the Environmental Protection Agency and senior scientific advisor at the National Oceanic and Atmospheric Administration. He is currently affiliated with the Hawkwood Institute in Livingston, Montana.

Barbara Boyle Torrey is Executive Director of the behavioral and social sciences, National Research Council, National Academy of Sciences.

Bernice Wuethrich wrote the text for the "African Voices" exhibition at the Smithsonian's National Museum of Natural History. Her articles have appeared in *Science, Smithsonian Magazine,* and *International Wildlife*.

Forces of Change

PUBLISHED BY THE NATIONAL GEOGRAPHIC SOCIETY

John M. Fahey, Jr., President and Chief Executive Officer
Gilbert M. Grosvenor, Chairman of the Board
Nina D. Hoffman, Senior Vice President

PREPARED BY THE BOOK DIVISION

William R. Gray, *Vice President and Director*
Charles Kogod, *Assistant Director*
Barbara A. Payne, *Editorial Director and Managing Editor*
David Griffin, *Design Director*

STAFF FOR THIS BOOK

Kevin Mulroy, *Project Editor*
Patrice Silverstein, Alan Cutler, *Text Editors*
Sadie Quarrier, Martha Davidson, *Illustrations Editors*
Bill Marr, *Art Director*
Johnna Rizzo, *Assistant Editor*
Anne E. Withers, *Researcher*
Carl Mehler, *Director of Maps*
Michelle H. Picard, *Map Production*
R. Gary Colbert, *Production Director*
Lewis R. Bassford, *Production Project Manager*
Gillian Carol Dean, *Design Assistant*
Sharon Kocsis Berry, *Illustrations Assistant*
Peggy Candore, *Assistant to the Director*
Anne Marie Houppert, *Indexer*

NATIONAL MUSEUM OF NATURAL HISTORY

Barbara Stauffer, *Project Manager*
William Melson, Don Wilson, Melinda Zeder, *Science Advisors*

MANUFACTURING AND QUALITY CONTROL

George V. White, *Director*
John T. Dunn, *Associate Director*
Vincent P. Ryan, *Manager*
Phillip L. Schlosser, *Financial Analyst*

ACKNOWLEDGMENTS

The Forces of Change program examines the geological, environmental, and cultural processes that have shaped and continue to change our world. It consists of a permanent exhibit hall at the Smithsonian's National Museum of Natural History, traveling exhibitions, publications, interactive computer products, and public programs. The Forces of Change program has been made possible by a generous grant and on-going support from the National Aeronautics and Space Administration.

The W.K. Kellogg Foundation, the U.S. Department of Agriculture, the Mobil Foundation, Inc., the American Farmland Trust, the Environmental Protection Agency, and the U.S. Global Change Research Program have also made important contributions to the Forces of Change project and to this publication.

Forces of Change received invaluable support from many people. The NMNH project team would like to thank the following people in particular for their help, their hard work and their encouragement:

Pamela Baker-Masson, Bruce Falk, Robert Fri, Bob Harriss, Felix Lowe, Carolyn Margolis, Robert Sullivan, Herman Viola, Judy Mannes, Marsha Rehns, Becky Tarbotton, Bee Wuethrich, Don Edwards, John M. Eger, Terry Evans, Robert W. Kates, Annette Olson, the Olson family, Tom Veblen, Nick and Luz Cutler, Terilee Edwards-Hewitt, Tom Lindsey, Barbara Tilghman, Sarah Skorupski, Beth Rosenberg, and Anne Hall.

The Smithsonian Institution and National Geographic Society gratefully acknowledge permission to adapt material from John McPhee's books, *Annals of the Former World* (Farrar, Straus and Giroux, 1998) and *The Control of Nature* (Farrar, Straus and Giroux, 1989).